Praise for *Hidden Hospitality*

"A revelatory tribute to the resilience, ingenuity, and entrepreneurial spirit of African American hotel, motel, and resort owners. Through stunning visuals and untold narratives, Stovall brings to light a vital yet overlooked chapter of Black history—one where hospitality served as both refuge and resistance. This book is more than a history lesson; it is a celebration of legacy, community, and an unyielding pursuit of opportunity in the face of adversity. A must-read for anyone who values stories of triumph woven into the fabric of America's past."

—Ronald J. Stephens
Author of *Idlewild: The Rise, Decline, and*
Rebirth of a Unique African American Resort Town

"Calvin Stovall has created a fascinating and important book that brings near-forgotten personalities back to life, resurfaces significant advancements in hospitality, and gives Black hospitality pioneers their due at last."

—Arnie Weissmann
Editor in Chief at *Travel Weekly*

"*Hidden Hospitality* is a major contribution to Black history, American history, and the hospitality industry as a whole. Calvin Stovall's passion, leadership, and deep dedication to this project is unmatched and will result in a historical publication that will inspire and inform many for generations to come. This book should be featured in every hotel, resort, hospitality school, and university across the country and beyond."

—Evan S. Frazier
President & CEO, The Advanced Leadership Institute;
Founding Chair, Mosaic Hospitality Association

"Great books humble us, inspire us, change us, and make us want to make the world better . . . Stovall's passion, meticulous research, and gimlet eye for details shine. This is not a hagiography but a nuanced biography of ordinary people reaching for the extraordinary. How can a person practice hospitality when they live in inhospitable times? How can a person retain their humanity when faced with inhumane situations? How can a person persevere when they have every reason to give up? The lessons in this book are profound. You will be moved. You will be inspired. You will shout. You will be entertained, educated, and elevated."

—Dr. Jeffrey O
President & CEO, International Hospitality Institute

"By brilliantly documenting and bringing to life the remarkable, little-known history of African Americans in lodging and hospitality, Calvin Stovall not only sheds light on a legacy of innovative entrepreneurship, but further inspires the continued development of ownership and leadership in this industry."

—Gloria & Solomon Herbert
Publishers, Black Meetings & Tourism

"This isn't just hospitality history, it's American history. Calvin Stovall has unearthed the extraordinary stories of Black hoteliers with reverence and clarity, ensuring their contributions are no longer overlooked, and that they are getting the recognition they have long deserved."

—Anna Blue
CEO, Blue Moss Group

"No longer hidden. Thanks to Calvin, a more complete history of American hospitality is in full display."

—Ted Teng
Former President, CEO, The Leading Hotels of the World

"Calvin Stovall's beautiful homage to Black hoteliers is an incredible work of passion, love, and commitment in sharing the important untold stories and history of Black hospitality leaders, their hotels, and their guests. The vital role Black hospitality leaders played in the industry and in American history and society broadly has remained hidden for far too long. Thanks to Calvin, they are hidden no more!"

—Stuart W. Greif
Chief Strategy, Innovation & Operating Officer, Forbes Travel Guide

"Ralph Ellison wrote, 'I am invisible, understand, simply because people refuse to see me.' *Hidden Hospitality* makes available to us a long and neglected chapter of American history of sanctuaries for weary travelers and tired souls who navigated through a treacherous period [of] segregation. With scholarly acumen and masterful storytelling, Stovall unearths an understory of African American entrepreneurship filled with resistance, dignity, and ingenuity . . . [a] remapping of untold stories of courageous men and women who dared to create democratic spaces of beauty, equity, and belonging . . . In the most inhospitable of times, Black hospitality thrived—not merely as business, but as radical care."

—Walter Earl Fluker
Martin Luther King Jr. Professor Emeritus, Boston University

"Stovall brilliantly unearths the overlooked narratives of Black entrepreneurs who defied systemic barriers to establish vital havens for travelers and communities during segregation. It's a powerful and meticulously researched testament to resilience, business acumen, and the enduring spirit of hospitality. A truly illuminating and iconic contribution to American history that reshapes our understanding of the past."

—Jelani Millard
Founder of The Wapechi Collection

"*Hidden Hospitality* sheds light on the rich and often overlooked narrative of Black hotel ownership, weaving together the stories of pioneers and trailblazers who boldly carved a path in a challenging industry during tumultuous times of resistance and civil rights upheaval . . . Not just a collection of photos and chronologizing of the journey of Black hotel owners—it is a testament to resilience, passion, and the enduring spirit of the Black community in the face of adversity.

—Berkita S. Bradford

**PhD, Associate Professor & Department Chair,
Department of Hospitality and Tourism Administration,
North Carolina Central University School of Business**

"A compelling read, offering historical insights and unveiling the resilience, dignity, and entrepreneurial spirit of Black-owned lodging establishments . . . Profound and enlightening . . . Essential for those seeking a deeper understanding of the complexities of American society during the segregation era."

—Ron McCoy

**Grandson of Tookes Hotel Founder,
Dorothy Tookes, Tallahassee, FL**

"A profoundly important story. What will be so interesting for readers are the personal journeys, overcome obstacles, and lasting legacies of these pioneering individuals and families. Understanding their experiences will provide invaluable insights into American history, the evolution of the broader hospitality sector, and the enduring spirit of Black entrepreneurship. An amazing story!"

—Frances Kiradjian

Founder & CEO, Boutique & Luxury Lodging Association

"*Hidden Hospitality* . . . reveals a powerful truth: resilient operators driven by purpose shape markets and inspire legacies. For any investor looking to understand leadership beyond the balance sheet, this is essential reading . . . not only timely but essential . . . both history and blueprint—preserving stories that inspire the future of inclusive ownership and institutional capital in our space."

—William Huston
General Partner, Bay Street Hospitality

"Groundbreaking! *Hidden Hospitality* . . . reclaims a vital narrative, one of hospitality as a form of resistance, empowerment, and cultural pride . . . The depth of Stovall's research is matched by the stunning photography and archival imagery [that] breathe life into the untold stories. Our students— tomorrow's rising stars—must see the fuller picture of American ingenuity, hospitality, and determination. This book reminds us all to look deeper, honor legacy, and celebrate the rich, complex heritage of our industry. Reader—treasure this valuable look into the heritage of American hospitality."

—Leora Halpern Lanz
Associate Professor, Boston University
School of Hospitality Administration

HIDDEN HOSPITALITY

HIDDEN HOSPITALITY

Untold Stories of Black Hotel, Motel, and Resort Owners
from the Pioneer Days to the Civil Rights Era

Calvin Stovall Jr.

BROWN BOOKS
PUBLISHING GROUP

Hidden Hospitality
Untold Stories of Black Hotel, Motel, and Resort Owners from the Pioneer Days to the Civil Rights Era

Brown Books Publishing Group
Dallas, TX / New York, NY
www.BrownBooks.com
(972) 381-0009

A New Era in Publishing®

Publisher's Cataloging-In-Publication Data

Names: Stovall, Calvin, author.
Title: Hidden hospitality : untold stories of black hotel, motel, and resort owners from the pioneer days to the Civil Rights Era / Calvin Stovall Jr.
Description: Dallas, TX ; New York, NY : Brown Books Publishing Group, [2025] | Includes bibliographical references.
Identifiers: LCCN: 2024949513 | ISBN: 9781612547114((hardcover) | 9781612547244 (ePub)
Subjects: LCSH: Hotelkeepers--United States--History. | African American businesspeople--United States--History. | African Americans--Travel--United States--History. | Segregation--United States--History. | LCGFT: Illustrated works. | BISAC: HISTORY / African American & Black. | PHOTOGRAPHY / Subjects & Themes / Historical.
Classification: LCC: TX911.2 .S76 2025 | DDC: 647.94092--dc23

ISBN 978-1-61254-711-4
EISBN 978-1-61254-724-4
LCCN 2024949513

Printed in China
10 9 8 7 6 5 4 3 2 1

For more information or to contact the author, please go to
www.CalvinStovall.com.

Calvin Stovall would like to give a special thanks
to the sponsors of *Hidden Hospitality.*

In Loving Memory of My Dear Mother Valerie Stovall
(1944-1990).
I love you and miss you always.

A people without the knowledge
of their past history, origin, and culture
is like a tree without roots.
—Marcus Garvey

CONTENTS

PREFACE

African Americans have played a significant role in the hospitality industry since the late eighteenth century, yet their contributions have gone largely unrecognized, sometimes even by African Americans themselves.[1]

The Great Migration of African Americans out of the South began around the turn of the twentieth century and lasted through the 1960s. Over that period, more than six million Black people moved from America's rural south to the North, Midwest, and West seeking a better way of life and economic freedom. This migration points to an underappreciated fact of African American history, given our focus on slavery and discrimination: the dynamic movement of the Black experience. And such movement, in turn, often necessitated lodging and accommodations, resources in short supply in Jim Crow America.

Most downtown hotels across the country were off-limits to African Americans, unless they worked there. Even Harlem's Hotel Theresa did not allow African American guests until 1940, after having been in operation for nearly three decades. Jim Crow's reach extended to the beaches of Atlantic City, where Chicken Bone Beach was reserved for Black people because they were not allowed to bathe in the whites-only areas. Yet some white-owned hotels provided accommodations to a Black-only clientele, such as the Carver Hotel, the Hampton House, and the Lord Calvert (later Sir John) hotels in Miami.

While Black tourists and travelers fell victim to hospitality segregation, separate-but-equal facilities also spurred (or coerced) Black entrepreneurship across the nation. Despite facing tremendous opposition, African American hospitality pioneers built and operated first-class hotels and resorts throughout the Jim Crow era.

African American contributions to the hospitality industry are little known because they have been too little documented. *Hidden Hospitality* acknowledges and recognizes the entrepreneurial achievements of African Americans, and in doing so recovers yet another aspect of Black history too often shrouded in prevailing white supremacist narratives.

My purpose is threefold: First, to introduce readers to the inspiring stories of historical Black entrepreneurs and hoteliers fundamentally unknown to most readers. Second, to preserve the record of the memorable hostelries and resorts in Black

America. And third, to celebrate the African American hoteliers and resort proprietors who provided superior accommodations and recreational facilities despite Jim Crow's proscriptions.

In 2018, the film *Green Book* hit theaters in the United States. Starring Viggo Mortensen and Mahershala Ali, this award-winning movie is inspired by the true story of a 1962 tour of the Deep South by African American pianist Don Shirley and Italian American bouncer and later actor Frank "Tony Lip" Vallelonga, who served as Shirley's driver and bodyguard.[2] *Green Book* won Academy Awards for Best Picture, Best Original Screenplay, and Best Supporting Actor (for Ali).

For many Americans, *Green Book* was the first introduction to Victor Hugo Green's *The Negro Motorist Green Book*, for which it was named. Green's publication served as a guide for African American travelers at the dawn of the motorcar-trip age, from 1936 to 1967. The guide listed Black-friendly hotels, motels, restaurants, salons, and other business establishments across the nation. Road trips and vacations were vastly different experiences for African Americans than they were for white travelers. While it does not capture the full experience of Black travelers in the period, the film opened the eyes of many to the hostile and sometimes dangerous hospitality landscape such travelers had to navigate.

Hidden Hospitality presents the opposite side of this traveling gauntlet: the vibrant hospitality cultures and communities created by Black entrepreneurs since the nineteenth century. The story features many acclaimed Black hotel-owner pioneers who carved out a unique niche in American business history. They lodged some of the most famous Black performers and political figures of their period, contributing in crucial ways to the development of a Black popular culture that defined and shaped America in its own way. For example, hotels along the Chitlin' Circuit in small towns scattered throughout the South, Midwest, and around the East Coast became essential supports for Black popular culture. Brave African American hoteliers also played a significant role in the fight for equality and civil rights later on.

Along the way readers will be introduced, or reintroduced, to thriving Black communities such as Black Wall Street in Tulsa; Black Broadway in Washington, D.C.; Paradise Valley in Detroit; Seventh Ward in Harrisburg; Jackson Ward in Richmond; and the Fillmore District in San Francisco, all of which became thriving communities precisely because of the influx of visitors who brought new styles, new modes of performance, and new voices to

existing traditions. Without the hospitality resources in these communities, little of this would have been possible.

I could not include every noteworthy African American-owned hotel, motel, or resort in *Hidden Hospitality*. I have made every effort to include those directly connected with historical events or hoteliers who made significant contributions to the industry.

Hidden Hospitality unveils a world that is virtually unknown to most people, even those within the hospitality industry. Most of the hotels and resorts in this book are no longer in existence. As fate would have it, the passing of the Civil Rights Act of 1964 was partly, and ironically, to blame for bringing this era of Black hospitality to an end: the collapse of legal segregation impacted the hotels that had thrived in response, a pattern repeated in countless industries. Nonetheless, I was deeply inspired by the hostelries and resorts where my African American ancestors recovered from Jim Crow's humiliations and found acceptance, exuberance, celebration, relief, and recreation. It is my hope that you are equally inspired by their stories.

ACKNOWLEDGMENTS

I would like to thank God for choosing me to make this significant contribution to my race and the industry I love so much.

I want to thank my ancestors for their many sacrifices and their strength and perseverance. Your vision to build and create hotels, motels, resorts, and other beautiful accommodations for Black people (despite the racial discrimination and prejudice you had to endure) during such a hideous time in our nation's history is a true inspiration to all of us.

I would like to personally thank Anna Blue, Jennifer Fugolo, John W. Rogers, Sheila Johnson, Anthony Anton, Monica Smith, Jill Slater, Kieran Donahue, Stuart Greif, Evan Frazier, Ted Teng, A'Lelia Bundles, Eric K. Washington, Thomas R. Reynolds, and Fred and Karen Sock.

I would also like to express my sincere appreciation to all the numerous archivists, professors, museums, photographers, educational institutions, historical societies, and the many relatives and descendants of the Black hoteliers shared in this book. Thank you for helping make *Hidden Hospitality* a reality.

I would like to send a sincere note of gratitude to my publisher, Brown Books Publishing Group, and the entire BBPG team. Thank you for believing in this project and supporting me on this inspiring journey to share these untold stories with the world.

And a very special expression of gratitude to my beloved sons, Caden and Carson; my Pops, Calvin Sr.; and my brother, Kevin.

Lastly, I owe a special thanks to my lovely sister Starr for her ongoing encouragement, love, support, and always believing in me—even during those times when I didn't believe in myself. I love you to the moon and back, baby sis. I will forever be indebted to you.

ONE

BLACK PIONEERS
OF HOSPITALITY

IN THE BEGINNING

Even during the days of slavery and the emergence of harsh Jim Crow segregation, Black hoteliers welcomed guests and lodgers to dine, rest a night, and enjoy local fare. During the eighteenth and early nineteenth centuries, most Black-owned hotels were opened and operated by former slaves or children of slaves.

During the 1800s, Eliza Seymour Lee, daughter of Sally Seymour, a former slave and one of the most esteemed pastry chefs in Charleston, South Carolina, built a business empire along with her husband John Lee. The Lees acquired four properties they operated as restaurants/hotels, including the Lee House on Tradd Street, the Mansion House on Broad Street, the Jones Hotel, and Moultrie House on Sullivan's Island. Eliza was one of the most successful businesswomen in Charleston and celebrated as an entrepreneur and trailblazer who paved the way for future African American businesswomen.[1]

Black-owned hotels in the Jim Crow South and even the Northeast struggled against local restrictions and popular prejudices, but in the West and Southwest African Americans were more free from persecution and racist social norms. Here Black hospitality entrepreneurs could find a measure of independence and even, at times, success. Many of these hospitality pioneers flourished, often after gaining notoriety as successful restaurateurs or culinarians.

From the beginning, Black-owned hotels served as a focal point of the African American community. Black residents gathered at hospitality sites to dine, celebrate, recreate, be entertained, and organize politically, generally free from surveilling white eyes. These hospitality pioneers served a dual role: providing accommodations to underserved populations and offering themselves as centers for political and civic organization.

In this early period, many Black women succeeded as hoteliers. Some of these gifted entrepreneurs may have begun their careers in pivotal roles in their husbands' hotel ventures, while others began in less respectable professional roles. But in either case, many gained respect for their hospitality, business acumen, and community leadership. For several centuries of American history, hospitality provided a means to entrepreneurial success for individuals very often denied other avenues of personal and commercial expression.

Over the course of the nineteenth century, an even more sophisticated African American hotelier emerged. Black-owned properties included more rooms, offered more opulence, served more prominent locations, and included innovative room amenities and services. Moreover, the hotels increasingly began to capture the attention of white residents and travelers. This interest led to many of these hotels accommodating both Black and white patrons, and many often catered to distinguished guests including U.S. presidents, dignitaries, and politicians.

Racial divisions and Jim Crow mandates—both legal and extralegal—proliferated around the turn of the twentieth century, resulting in the growth of hotels and boarding houses that catered particularly to Black people. While legalized segregation and racial violence were primarily limited to the Southern states, African Americans in other areas of the country were subject to de facto segregation. Black people were regularly denied access to hotels, restaurants, Pullman cars, and other public accommodations regardless of their economic status, whether it was by law or custom.[2]

THE ROYAL NAVY HOTEL

Bridgetown, Barbados
Proprietor: Rachael Pringle Polgreen

Rachael Pringle Polgreen rose to prominence during an age when slavery gave people of color, and women above all, few chances to advance. Her rise would occur in the fissures of exploitation and sexual violence that marked the slave system's social order.

Rachael was born in Barbados in 1753 to an African slave and her owner, William Lauder. As an early teenager, her father began to make sexual advances toward her, forcing her to seek refuge with Captain Thomas Pringle. In exchange for sexual favors, Pringle offered Rachael her own home and freedom, at which point she took his surname.[3]

Rachael's relationship with Pringle lasted until she allegedly faked a pregnancy to gain more benefits, leading the captain to end their arrangement and return to Jamaica. Rachael soon found protection under another prominent white Barbadian, James Polgreen, whose surname she added to her own, becoming Rachael Pringle Polgreen. There is no record of a marriage.

With the small amount of capital she acquired from these relationships, Rachael opened a tavern and hotel—essentially a brothel—in Bridgetown that serviced sailors in the British Royal Navy, among other traveling dignitaries. What would become the Royal Navy Hotel acquired its name from an alleged encounter between Rachael and Prince William Henry—the Duke of Clarence and future King William IV of England—in which the royal reportedly destroyed the hotel in a drunken rage. When Rachael sent a bill demanding recompense, the prince sent a payment that covered the refurbishment of her hotel in more splendor and extravagance than before. The Royal Navy Hotel soon became a top destination

for wealthy traders and admiralty officers visiting the island.

Before long Rachael was an influential member of the local community, both admired and reviled in equal measure. She soon grew wealthy, and by the 1790s she was listed as the owner of a residence, two smaller houses, five tenements, and two other homes by Bridgetown's tax records.[4] By the time of her death in 1791 at the age of thirty-eight, she was not only a prominent business owner and hotelier but a slaveholder as well. One of her last actions was to provide for the freedom of six slaves in her will, written just two days prior to her death, and bequeathing the rest to those she had freed.[5] The Royal Navy Hotel stood in Bridgetown until it burned down in 1821.

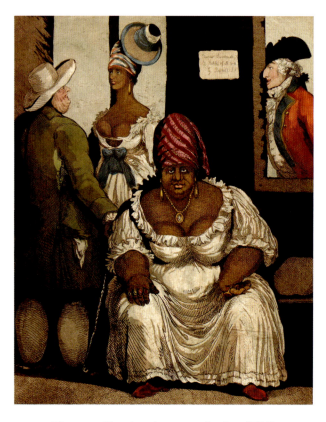

Thomas Rowlandson made this 1796 hand-colored print of Rachel Pringle-Polgreen in front of her Royal Navy Hotel in Bridgetown, Barbados, after a drawing by an unidentified artist with the initials "E.D."

THE JONES HOTEL

Charleston, South Carolina
Proprietor: Jehu Jones Sr.

The hospitality trade provided Jehu Jones Sr. with a bridge across the Southern color line. As a freedman in Charleston, South Carolina, Jones established himself as an entrepreneur and became well-known for owning the Jones Hotel.

Born into the slavery of Christopher Rogers in 1769, Jones grew up helping with his master's tailoring business. At the age of twenty-nine Jones purchased his freedom for $140 and opened his own tailoring shop. With the help of his oldest son, Jehu Jones Jr., Jones's business prospered, and by 1802 he had saved enough to invest in local real estate. By 1807 his investments had grown in value significantly, and he began purchasing his own slaves.

Jones purchased property on Broad Street two years later, and in 1815 he bought a second property at 33 Broad Street (later designated as Seventy-One Broad Street) for $13,000, which would soon become the Jones Hotel.[6]

Described as "the finest hotel in Charleston," the Jones Hotel became a popular stop for travelers, most of whom were wealthy whites. One of Jones's most esteemed guests was the inventor and painter Samuel F. B. Morse, whose portrait he proudly displayed in the hotel lobby. The reputation

of their hotel allowed Jones and his wife to prosper and soon catapulted the couple into Charleston's elite free Black society.

Jones died in 1833 at the age of sixty-four, and his $40,000 estate (worth approximately $1.4 million today) went to his three sons and his stepdaughter, Ann Deas.[7] Deas and Eliza A. Johnson, another local freedwoman in Charleston, bought and reopened the Jones Hotel as an inn in 1834, and Deas ran it until she sold the property in 1847.[8]

Seventy-One Broad Street, Jehu Jones Hotel. Reproduced by permission from the South Carolina Historical Society's Visual Materials Collection.

THE CITY HOTEL

San Francisco, California
Proprietor: William A. Leidesdorff

As Jehu Jones's career attests, the knack for entrepreneurship would remain the hallmark of most early successful Black hoteliers. On the busy streets of San Francisco's Financial District, droves of residents and vacationers stroll by a bronze statue of William A. Leidesdorff Jr. One of the best-kept secrets in the pioneering of the West, Leidesdorff's contributions as an entrepreneur and hotelier helped transform San Francisco into what it is today.

Leidesdorff was born in 1810 on the island of St. Croix in the Danish West Indies to a Danish-Jewish sugar planter and a native-born woman of mixed African and Carib ancestry, Anna Marie Sparks, a black

William A. Leidesdorff

plantation worker.[9] Leidesdorff left the island as a teenager, launching a successful career as a maritime trader. His fortunes increased and he soon became a master seafarer, sailing his 106-ton schooner, *Julia Ann*, between New Orleans and New York. In 1838, he added profitable trips from Hawaii to trade with the Mexican village of Yerba Buena on San Francisco Bay, exchanging sugar for animal hides.[10]

By 1841 Leidesdorff had decided to officially relocate to Yerba Buena, having quickly identified the commercial possibilities of the area. Here Leidesdorff became a man of many firsts, pioneering San Francisco's first steamboat service and building the city's first shipping warehouse. Perhaps his crowning achievement, however, was opening the City Hotel at the corner of Clay and Kearny Streets, the first in San Francisco.[11]

As his businesses grew, Leidesdorff became politically active and allied himself with Emanuel Victoria, "the Black governor" of Alta, California.[12] In 1844, he became a Mexican citizen and obtained a grant of thirty-five thousand acres along the American River, which he named Rancho Rio de Los Americanos. Leidesdorff accomplished yet another first in 1845 when he was appointed U.S. Vice Consul to Mexico by President James K. Polk, making him the nation's first African American diplomat (Polk, a Tennessee-born slaveholder, most likely was not aware of Leidesdorff's African ancestry). Leidesdorff's involvement in civic affairs continued after California became part of the Union in 1846.[13]

Leidesdorff died unexpectedly in 1848 at just thirty-eight years old. As a beloved member of his community, there was an outpouring of grief in response: businesses closed, flags were flown at half-mast, and a twenty-one-gun salute was performed in his honor. After an elaborate funeral, he was further honored by receiving a burial inside Mission Dolores Church, where you can still view his gravestone today.

Leidesdorff may have been America's first Black millionaire. When his estate was auctioned in 1856, it sold for more than $1.44 million (over $53 million today), a valuation abetted by the discovery of gold on the property shortly after his death.[14]

Today, there is a four-block-long Leidesdorff Street in San Francisco named in his honor. In 2014, a bronze statue honoring Leidesdorff, along with a plaque highlighting his accomplishments, was erected on the northeast corner of Leidesdorff and Pine Streets. The California State Legislature recognized Leidesdorff as the "African Founding Father of California."[15]

HOTEL KEEPERS, HEAD WAITERS, AND HOUSEKEEPERS' GUIDE
Publisher: Tunis Gulic Campbell

Though born a free man in New Jersey, Tunis Gulic Campbell's hospitality career was shaped by the peculiar institution of slavery. Campbell was the only Black student at an Episcopal school in Babylon, New York, which he attended from the ages of five to eighteen. While studying here, he trained for missionary service and went on to work for the American Colonization Society, but he eventually parted ways with the organization due to a disagreement with their program to transport free Black people to Liberia.[16] Riding a burgeoning wave of antebellum abolitionism, Campbell became an anti-colonization and abolitionist lecturer, and he often shared the stage with Frederick Douglass. As the founding member of an anti-colonization society, he pledged "never to leave this country until every slave was free on American soil."[17]

Between 1832 and 1845, Campbell supported his work with the abolitionist movement by working as a hotel steward in New York City and Boston. This experience likely inspired him to publish his *Hotel Keepers, Head Waiters, and Housekeepers' Guide*, a practical guide for the supervision of a first-class hotel. Campbell's book was a groundbreaking treatise on

interracial social skills, insisting that managers recognize the dignity of their staff and maintaining that employees be educated, prompt, clean—and paid fairly. According to historian Russell Duncan, white employers described Campbell as a man disposed "to elevate the condition and character of persons of his color."[18]

Tunis Gulic Campbell died in 1891 at the age of seventy-nine. His memory continues to be honored in the "Tunis Campbell Celebrations" that take place in Brunswick, Georgia.

Image of Tunis G. Campbell as featured in his 1848 *Hotel Keepers, Head Waiters, and Housekeepers' Guide*. Reproduced by permission from the Michigan State University Libraries

THE SEA GIRT HOTEL
Newport, Rhode Island
Proprietor: George Thomas Downing

Some early Black entrepreneurs found political influence as a result of their success in the hospitality field. One example of this is Thomas West Downing, who served pickled oysters and jellied turkeys at his luxurious Wall Street oyster house to New York City's elite, including famed visitors Charles Dickens and Queen Victoria. Downing's son, George Thomas Downing (born 1819) would exhibit his father's entrepreneurial propensities in his

Portrait of George T. Downing. Reproduced by permission from the Rhode Island Black Heritage Society.

Sea Girt House in Newport, Rhode Island, the largest Black-owned luxury hotel in the country. By 1842, Downing had launched his own restaurant and catering business, and he continued his father's habit of catering to a wealthy clientele.

Downing's pinnacle came when he opened the Sea Girt House luxury hotel in Newport, Rhode Island, in 1854. The luxurious five-story hotel served a white clientele and included large stores, a restaurant, and a confectionary. Famed Black intellectual Martin R. Delany spoke highly of Downing's establishment, praising it as "among the best-conducted places in the country, the proprietor among the most gentlemanly."[19]

As Downing's business success grew, so did his commitment to civil rights, and he battled to abolish the segregation of Rhode Island public schools for more than ten years.

Downing Family Portrait. From the Rhode Island Black Heritage Society.

> I would have been a millionaire today if I had bent to prejudice.
> —George Thomas Downing

Downing's commitment to the abolitionist movement led him to become involved in the Underground Railroad as well, and his hotel became a stop for runaway slaves. He also participated in groups including the American League of Colored Laborers (ALCL), a union for freedmen in New York City, and the American Colored Union Labor League, of which Downing was a founding member.[20]

Arsonists destroyed the Sea Girt ten days before Christmas in 1860, just six years after it opened. It's commonly believed that the crime was committed in retaliation for Downing's work to support the civil rights movement, but the perpetrators were never found.[21] Downing responded by using the $40,000 from his loss to build a new structure on Downing Block, the upper floor of which was rented to the U.S. government and used as a hospital for the Naval Academy.[22]

Following the Civil War, Downing moved to Washington, D.C., where he managed the Members' Dining Room for the U.S. House of Representatives for twelve years. Here, Downing built close political ties with influential policymakers and advocated for civil rights. He maintained especially strong friendships with Massachusetts Senator Charles Sumner and the Black abolitionist and orator Frederick Douglass. Although Downing did not hold office in Washington, his political network helped advance racial equality.

Downing died in 1903 at the age of eighty-three. Upon his passing, the *Boston Globe* wrote, "The foremost colored man in this country expired in the person of George T. Downing."[23] The Downing Block that bears his name still exists and is located on Bellevue Avenue, bordered by Liberty and Downing Streets.

Downing Block, ca. 1890. Reproduced by permission from the Newport Historical Society Library & Collections.

HOSPITALITY TRAILBLAZERS OF THE WEST

THE INTER-OCEAN HOTEL

Denver, Colorado, and Cheyenne, Wyoming
Proprietor: Barney Lancelot Ford

Barney Lancelot Ford rode the currents of empire and westward expansion that fueled so many American fortunes. Born into slavery on January 22, 1822, in Stafford, Virginia, Ford's parents were an enslaved African American woman and her white plantation owner. He spent most of his childhood in South Carolina, where another slave taught him how to read and write. Ford worked as a slave himself until the age of twenty-six when he escaped slavery by simply walking off the riverboat his master had hired him out to work on. Once he found his freedom, Ford made his way to Chicago, where he ran a successful barbershop and became friends with abolitionists such as Henry O. Wagoner, John Jones, and others active in the Underground Railroad. He also met and married his wife, Julia A. Lyoni, there in 1849.[1]

The Fords didn't stay in Chicago long. In 1851, the couple decided to travel west, hoping to join in on the California Gold Rush. Their travels took Ford and his wife through Central America by ship—it was too dangerous for an escaped slave to travel across land—where they passed through the port of Greytown, Nicaragua. Recognizing the opportunity of living in a port town, Ford ultimately decided to settle in Greytown rather than moving ahead to California.[2]

Before long Ford opened the United States Hotel in Greytown catering to other transient Americans like himself. Just three years later, however, the hotel and most of the city was destroyed by an attack from an American naval ship over a dispute with Great Britain. Undeterred, Ford resettled in Virgin Bay, where he operated first the Hotel William Walker—named for the notorious American filibuster—and then the California Hotel.[3] Ford's own expansionist entrepreneurialism continued to mirror his country's.

By 1860, Ford once again decided to follow the Gold Rush west to Colorado. He established himself several times in Denver, Breckenridge, Cheyenne, and San Francisco, building successful enterprises—barbershops, restaurants, banks, hotels—all of which eventually succumbed either to nature or the boom-bust economy.[4]

In Denver, Ford's lucrative barbershop on Blake Street was destroyed in the Great

Illustration of Barney L. Ford.
Reproduced by permission of the Denver Public Library, Western History Collection.

Fire of April 1863, along with much of Denver's business district. Yet this misfortune became Ford's catalyst to success. With a $9,000 loan he was able to purchase additional land on Blake Street that would become the site of a much larger two-story brick building.

In August 1863, he opened the People's Restaurant in this spot, and it was so profitable that Ford paid off his entire loan in just three months. He also operated a restaurant in Cheyenne for three years, until it too was destroyed by fire.

As one of the most influential African American businessmen in Denver, Ford became increasingly active in political affairs throughout the 1870s, and he even traveled to Washington, D.C., to lobby for Black suffrage. He additionally served in many county conventions, and he was the first Black man in Colorado to be on a federal grand jury and the Colorado Territorial Legislature.[5]

In 1872, Ford decided to sell the People's Restaurant and venture into the hotel business. Buying several lots at the corner of Blake and Sixteenth Street in downtown Denver, Ford acquired the four-story Sargent Hotel and renamed it Ford's Hotel. He then spent another $53,000 (a value approximating $1.2 million today) to build the elegant Inter-Ocean Hotel, a grand four-story building in the Second Empire style. Taking its name from the hotel's location between the Atlantic and Pacific Oceans, the Inter-Ocean became the finest hotel in Denver upon its grand opening in 1873. It was also the largest building in Denver's fledgling Lower Downtown district.

The Inter-Ocean Hotel.
From the Denver Public Library's Western History Collection.

At the request of the Cheyenne Chamber of Commerce, Ford opened a second Inter-Ocean Hotel in Cheyenne in 1875. It was a popular center of nightlife for the community and a delightful destination for travelers making the journey west. Advertisements for the hotel were published regularly in the local newspapers and boasted that it was "the largest and finest hotel between Omaha and San Francisco."[6] Ford billed it as the first hotel in the United States to sport electric lights, generating a lucrative buzz among the traveling public.

Over the years, the Inter-Ocean Hotel in Cheyenne would host many traveling dignitaries, including U.S. presidents Ulysses S. Grant and (America's most fervent imperialist) Theodore Roosevelt, who stayed there on several occasions. It was also home to the most popular bar in town, frequented by infamous gunslinger Tom Horn among many other regulars.[7]

The Inter-Ocean Hotel at the corner of Sixteenth Street and Capitol Avenue, Cheyenne, Wyoming.
From the Meyers Collection, Wyoming State Archives.

On a subzero night on December 17, 1916, after a forty-one-year run for the Inter-Ocean, an electric line shorted on its third floor. The subsequent fire killed a family of six and destroyed the hotel. It was never rebuilt.

Despite the success of his second Inter-Ocean Hotel, Ford incurred a number of losses during the Panic of 1873 and followed the silver boom back to Breckenridge in 1880. Here he opened the popular Ford's Restaurant and Chop House and became the first African American business owner in the city.[8]

In 1890, Ford returned to Denver, where he maintained several real estate investments until his death in 1902 at the age of eighty.[9] While Ford lost several fortunes over his lifetime, he died a man of considerable wealth, leaving behind an estate estimated at $500,000, over $16 million today.[10]

The Pacific House Hotel.
Reproduced by permission of the Washington State Historical Society, Tacoma, Washington.

Ford's legacy continues to survive in the buildings and landmarks named in his honor. A stained-glass portrait of Ford inside the Colorado State Capitol recognizes his commitment to ending racial discrimination and gaining civil rights for African Americans in the state. Schools and high-rises have been named in his honor, and in 1992 he was inducted into the Colorado Business Hall of Fame. The Ford family home, which was built in 1872 in Breckenridge's wealthy residential area, was restored by the Breckenridge Heritage Alliance and now operates as the Barney Ford Museum.[11]

While the majority of Ford's properties have been torn down, his beloved People's Restaurant, Ford's first successful restaurant in Colorado, still resides at 1514 Blake Street in Denver. The building was listed on the National Register of Historic Places in 1976.[12]

THE PACIFIC HOUSE

Olympia, Washington
Proprietor: Rebecca Groundage Howard

The hospitality industry continued to offer African American women opportunities denied to them in other industries, especially out West. Such was the case for Rebecca Groundage Howard, a pioneering woman who went on to break both race and gender barriers of the time. While little is known of Howard's early life, records indicate that she was born in Philadelphia in 1827 or 1829, yet whether or not she was born into slavery is unclear. In 1843, she married a cooper, or barrel maker, named Alexander Howard in New Bedford, Massachusetts. By 1859, the couple had moved West in search of opportunity and settled in Olympia, which was then part of the Washington Territory. The African American population of the territory was very small at this time, and so the Howards were one of only a few Black families in Olympia.[13]

The Howards began leasing the Pacific House in 1860, taking over the hotel and restaurant's operation from William Cock, who had overseen the establishment since its opening six years prior. After assuming ownership of the business, the Howards renamed their enterprise Pacific Restaurant. While the hotel was originally advertised under Alexander's name, later advertisements featured Rebecca's, indicating that she had taken over management of the hotel and restaurant.

The Pacific Restaurant became a popular destination for travelers and territory politicians, and before long it was Olympia's leading hotel. Rebecca was especially esteemed for her cooking skills and, according to biographer George E. Blankenship, she gained a reputation for "catering to the none-too-fastidious travelers whose appetites had been sharpened by an ever-jolting ride."[14]

By 1862, responding to the accommodation needs of an ever-growing clientele, Rebecca decided to expand her enterprise to include both a hotel and restaurant. Rebecca continued to be the star attraction, "the capital feature of the Capital—a permanent and indispensable [part] of Olympian society—a walking index of kitchen comforts and the art of cuisine," according to the local newspaper. Asked the rhetorically inclined editorialist: "Were we to meet an Olympian in Greece or Turkey at dinner, the third most natural question we should expect to be asked would be: 'Does Becky still survive?'"[15]

PACIFIC HOTEL AND RESTAURANT,
OLYMPIA, W. T.

The above well known and popular House, having been thoroughly renovated and newly furnished, is now prepared to entertain Guests in greater comfort, and in a more accommodating manner, than can be done by any other House in the place. The House will be conducted on the

Restaurant Principle.

Meals after 8 o'clock, EXTRA. An adjoining Cottage has been leased and refitted, where a large number can be accommodated with lodging, good clean beds, and well-ventilated rooms.

☞ CALL AND ASSURE YOURSELVES OF THE TRUTH OF THE ABOVE.

Mrs. REBECCA HOWARD, Proprietress.

Advertisement for the Pacific House Hotel,
reprinted from the *Pacific Coast Business Directory* (1867).

According to legend, many patrons would try to call her "Aunt Becky," which Rebecca found racially condescending. Only close friends were allowed the intimacy, with everyone else obliged to the more formal "Mrs. Howard." Not even the newly installed Governor William Pickering escaped her demand for respect. When he tried to refer to her as "Aunt Becky," she insisted that, to the best of her knowledge, she was not a sister of either his father or mother.[16] Under Howard's management, the Pacific House became one of the most prominent hotels in the territory, and the Howards were among the wealthiest people in Olympia. As the leading hotel in town, the property often served as a meeting place for lawmakers, lobbyists, and

traveling dignitaries, including President Rutherford Hayes and his wife Lucy.

Upon Howard's death in 1881 at the age of fifty-four, her property was valued at over $6,200 (nearly $200,000 today), and twenty-six pages were needed to list her holdings. Her husband died nine years later.[17]

After being sold to Captain Hambright, who managed a saloon in the building, the Pacific House fell into ruin and was eventually demolished in September 1902. The empty lot served as the pole yard for the Olympia Telephone Company for a number of years and is now a parking lot for the Bread Peddler, a local artisanal bakery.[18]

OUR HOUSE
Seattle, Washington
Proprietor: William Grose

The American West, if never free of the racial prejudices of the East, at least offered an outlet to escape white supremacy's most ardent limitations through expansion and empire.

Despite being born to a free Black restaurant worker, Washington, D.C. offered very little opportunity for William Grose. Indeed, he left for the Navy in 1850 at the young age of fifteen, where, according to historian Esther Mumford, he likely served as a cook.[19] He reported to his first assignment in 1853 on the USS *Vincennes*, which brought him around the globe as it visited ports of call everywhere from South Africa and China to the Arctic.[20]

After an honorable discharge in San Francisco following a shipboard injury,

William Grose: Hotelier, businessman, and wealthiest nineteenth-century member of Seattle's Black community.

Grose began work in the gold-mining camps of California. Here he became an influential abolitionist, helping create a western branch of the Underground Railroad and even traveling to Panama, where he put his Spanish-language skills to use convincing officials not to return escaped slaves. Grose also played an integral role in creating an African American settlement in British Columbia on the Fraser River in 1858.[21]

Grose had an imposing presence, standing six feet two inches tall and weighing more than four hundred pounds. But those who knew him reported he was an honest,

generous, kind, and gentle man. While working as a steward on the steamer *Constitution*, Grose forged an unlikely friendship with Washington governor Isaac Stevens after Grose found and returned the governor's lost watch.[22]

At the urging of Governor Stevens, who was so impressed by Grose's character that he encouraged him to reside in Washington Territory, Grose settled in Seattle with his wife and two children around 1860. His wife, Sarah, and their daughter, Rebecca, were Seattle's first African American female residents.[23]

Cooking and barbering were two of the rare occupations open to African Americans in early Seattle, as the more lucrative jobs, such as lumbering, mining, and shipping, were off-limits. Grose quickly found work as a cook and became a familiar sight in his large white apron, with people commonly calling him "Big Bill the Cook."[24]

In August 1876, Grose took his savings from the rented lunch counter at Rube Low's Saloon in Pioneer Square and opened a restaurant called Our House on what is now Yesler Way, named after Seattle's primary employer at the time, Henry Yesler's sawmill. Although Grose could not write, he was a good businessman. By 1883, he had accumulated enough money to convert his establishment into a hotel by the same name, erecting a three-story hotel near Yesler's Wharf, which was popular with Seattle's largely white population. Twenty-five cents could get you a meal or a bed, but Grose was well-known for extending credit to those in need.[25] He even provided for a penniless young man named Robert Moran, who went on to become Seattle's mayor.[26]

Our House prospered and Grose became a wealthy man, provided lodging for many of Seattle's earliest African American residents who arrived as transient laborers in the latter part of the nineteenth century. According to news articles from around 1891, Grose held over a quarter-million dollars in assets, and he was one of the city's most "extensive taxpayers."[27]

Grose purchased twelve acres of land in Madison Valley from Henry Yesler for $1,000 in gold a decade earlier, making him the first African American to purchase property in East Madison.[28] He gradually sold off parcels to other enterprising African Americans as increased housing discrimination forced other Black newcomers to live in the area. This community continued to grow and became the northern anchor of what would be known as Seattle's Central District.[29] Grose remained highly active in the community that cropped up around him, founding the Cornerstone Grand

Lodge of the York Masons—Seattle's first Black Masonic chapter[30]—and the First African Methodist Episcopal (AME) Church.[31] He was also a member of the Washington Pioneer Association. Because of his wealth and influence, he often served as an intermediary between Seattle's civic and political elite and the emerging African American community.

Our House was destroyed by the Great Seattle Fire of 1889. Oral tradition has it that the hotel was sold shortly before the fire, and that Grose returned the purchase money to the buyer following its destruction. Grose retired to his ranch on the outskirts of Seattle where he remained until his death, mourned by the Seattle community and those who traveled throughout the state to pay homage to the Seattle pioneer and entrepreneur.

In September 1983, a half-acre park in Madison Valley was dedicated to Grose. The City of Seattle paid yet another homage to Grose when they transferred the lease on a vacant fire station to nonprofit Africatown Community Land Trust, and the space is now home to the William Grose Center for Enterprise and Cultural Innovation.[32] Grose's home still stands at its original location today, albeit with some modifications. He is buried in Lake View Cemetery on Capitol Hill.[33]

THE MOUNTAIN VIEW HOTEL
Oracle, Arizona
Proprietors: Annie Box and William "Curly" Neal

Unlike the South and Northeast, where some African American entrepreneurs were obligated to find success on the periphery of society, much economic activity in the West was already marginal—mining, ranching, saloon-keeping, and the like—meaning that African American hoteliers could more readily operate at the center of their local community's social order.

Annie Box and her husband, William "Curly" Neal, operated the Mountain View Hotel in Oracle, Arizona. The hidden resort, in a western mining town in the Catalina Mountains, became recognized as the "epitome of western opulence" and welcomed distinguished guests from around the globe.[34]

Born in 1870 in the Cherokee Nation, which was then in the Oklahoma Territory, Annie Magdalena Box came from a mixed heritage. On the side of her mother, Hannah, was both Cherokee and African American heritage, while her father, Wiley, possessed an English lineage—though his mother

Mountain View Hotel.
Reproduced by permission from the Arizona Historical Society.

was an African American woman from New Orleans.[35]

Standing at six feet tall, Annie was an especially striking figure, and according to historian Jan Cleere "she held herself as regally as the most noble of queens."[36] Her father even called her his "Cherokee Princess."[37]

Curly Neal also hailed from the Cherokee Nation, coming from a mixed heritage of Cherokee, African American, and white backgrounds. After running away from home following the death of his parents, a nineteen-year-old Curly met Buffalo Bill Cody, who enlisted the young man as a military scout in the Indian Wars. William left

the army in 1878 but remained friends with Cody for the remainder of his life.[38]

Working as a cook in Tucson, Curly joined a tight-knit community of African Americans in Tucson.[39] According to records, there were only about one hundred fifty African Americans in the entire Arizona territory at the time.[40]

Curly grew into a successful business-man, rancher, and entrepreneur. Driving freight on the stage line between Tucson and Fort Lowell, he transported ore, wood, and water to the mines in Mammoth and Oracle.[41] Annie, an excellent sharpshooter, ran with him on his most dangerous hauls, delivering gold bullion from Mammoth to

Annie Box Neal.
From the Arizona Historical Society.

Portrait of Annie.
From the Arizona Historical Society.

Tucson. Before long, Curly became one of the wealthiest men in Tucson.[42]

As a prominent member of the African American community in Tucson, Curly met and became close friends with Wiley and Hannah Box. Despite their twenty-one-year age difference, he became romantically involved with their daughter, and the pair married in 1892.[43] After their marriage the couple moved to Oracle, where Annie's mother deeded them a number of acres that would later become the site of the Mountain View Hotel.[44] The hotel was born out of Curly's efforts to bring his wife out of her depression following her mother's death in 1894.[45]

The Mountain View Hotel was a year-round hotel and health resort on the couple's isolated, 160-acre ranch, nearly five thousand feet above sea level. The mild climate of the oasis offered guests relief from the Arizona desert heat, alongside breathtaking mountain views. Financed by the couple's joint business ventures, Annie was solely responsible for designing and decorating the two-story, $90,000 (near $3 million in value today) resort.[46]

On February 1, 1895, the Mountain View Hotel opened its doors to guests of all backgrounds. Located in the foothills of the Santa Catalina Mountains and surrounded by verandas and porches, patrons could

stay and escape the desert heat for $2.50 a day, or $12.50 a week.[47] The resort consisted of a nine-hole golf course, a croquet court, and an outdoor dance pavilion, attracting a variety of visitors, including celebrities, dignitaries, and those seeking the adventure of the "wild west."[48] Annie loved hosting picnics, card games, dances, and shooting competitions. An excellent shot, she even claimed that frequent guest Buffalo Bill Cody was the only person to ever best her in a shooting match.[49]

William "Curly" Neal.
From the Arizona Historical Society.

Annie with a group of visitors outside the Mountain View Hotel. From the Arizona Historical Society.

Aerial view of the Mountain View Hotel. From the Arizona Historical Society.

The Mountain View Hotel doubled as a health sanatorium for those suffering from tuberculosis. Physicians would even send patients to the resort, knowing that the dry mountain air alongside Annie's home-cooked meals would help them recover from the debilitating illness.[50]

The *Los Angeles Herald* praised Annie as "one of the most charming, genial and appreciative of landladies, who understands how to perform the difficult art of providing the best accommodations including a bill of fare, to make all feel pleased, at home and perfectly at ease." According to the *Tucson Citizen*, she was "the queen of hostesses."[51]

The Mountain View Hotel became an entertainment mecca for Oracle, Mammoth, Florence, and Tucson, and hosted visitors from countries as far as Russia, China, and Australia.[52]

Yet racism soon found a foothold in the West, and the Mountain View fell into disrepair as guests began frequenting the nearby Biltmore, El Conquistador, and other luxury resorts.[53] Curly died in 1936 at age eighty-seven in a freak car accident at the Mountain View. Several Catalina Mountains residents remembered him as honest and unpretentious, a "quintessential frontier figure."[54] Annie sold the property shortly after Curly's death, yet she lived in the hotel's boardinghouse until she passed away in 1950, at eighty years old.[55]

THE HOTEL ROBINSON

Julian, California
Proprietors: Albert Robinson and
Margaret Tull Robinson

The American West continued to be a place of social mobility for Black proprietors who could combine entrepreneurship with opportunity on the frontier. Located fifty miles northeast of San Diego, the Hotel Robinson was one of the first businesses in San Diego County to be owned and operated by African Americans. Albert and Margaret Tull Robinson combined comfortable lodgings, hearty meals, and warm hospitality to make a historic impact on the small town of Julian.

Albert Robinson was born into slavery in 1845 in Missouri. After the Civil War, Albert made his way west to San Diego, and by 1886 he had settled down in the mining town of Julian and worked as a ranch cook.[56]

Later that year Albert met and married Margaret Tull, a San Diego native whose father was the first African American juror in the county. The Robinsons soon entered the hospitality industry with the Robinson Restaurant and Bakery, built on a piece of land in nearby Julian that was gifted to the couple by Margaret's mother. Margaret served a chicken dinner every night of the week, and the restaurant quickly became a staple of their local community over the next decade.

The Hotel Robinson. Reproduced by permission from the San Diego History Center.

Margaret Robinson and others in front of the Hotel Robinson, ca. 1910. From the San Diego History Center.

Recognizing a business opportunity with the rapid growth and development of the mining town, Robinson decided to venture into the hotel business, demolishing his restaurant to make way for the Hotel Robinson.[57] Margaret's mother, Susan, was likely involved in financing the construction of the hotel.

Offering fourteen guest rooms and a full kitchen, dining room, and parlor, the Hotel Robinson became a social center for the wealthiest and most influential people in San Diego, including visiting senators and congressmen. Many settlers frequented the hotel for its hospitality and good food—Margaret even prepared a midnight feast for patrons of a monthly dance for community residents at the Julian town hall, located just across the street from the hotel.[58]

Hotel Robinson, 1914. From the San Diego History Center.

Margaret and Albert's success paved the way for the growth of an African American community within San Diego County. The space the Robinsons created not only for themselves but also for Black and white miners and other Julian residents was remarkable for its time.

Robinson died of an unknown illness in 1915. Margaret continued managing the hotel by herself until 1921, when she sold the property to Martin Jacobs for $1,500 (approximately $24,000 today). The Jacobs family managed the hotel for forty-seven years, though they did change its name to the Julian Hotel in honor of the original that burned down in 1900.[59]

As of 2024, the Julian Hotel is still in operation and stands as the oldest continuously operated hotel in Southern California.[60] The historically restored sixteen-room property is furnished in an early twentieth-century style and is now a part of the National Register of Historic Places, as well as a Point of Historic Interest for the state of California. The cedar and locust trees Albert planted during the hotel's construction in 1897 still stand today.

THE GOLDEN WEST HOTEL

Portland, Oregon
Proprietor: William D. Allen

Many African American hoteliers in the West found success by serving an underserved clientele, and in so doing established their enterprises as cornerstones of thriving Black communities. Hailing from Nashville, William Duncan Allen built the Golden West Hotel in Portland, Oregon—the first and only hotel in the city open to African American residents and travelers in 1906.[61]

The arrival of railroads in the early 1880s brought Black workers to the Portland area. Indeed, while there were only 1,105 African Americans in Oregon at the turn of the century, 70 percent of this population lived in Portland.[62] Most Black Portlanders at this time resided on the west side of the Willamette River, and this neighborhood subsequently became a hub for African American culture as businesses catering to Black customers opened up.

Portrait of William D. Allen. Reproduced by permission from the Oregon Historical Society.

However, none of the city's white-owned hotels allowed African American patrons, so Allen opened the five-story Golden West Hotel in 1906 to serve the African American community.[63] Located at the corner of Northwest Broadway and Everett Streets, the property comprised one hundred hotel rooms and housed several other Black-owned businesses, including the Golden West Hotel barbershop, owned by Waldo Bogle; A. G. Green's candy shop, named the "finest ice cream parlor and candy shop west of Chicago" by the *Portland Times*; and George Moore's Golden West Athletic Club, which offered amenities such as Turkish baths and a gymnasium.[64] The hotel also operated a gambling den in its basement, whose operations remain a mystery still today.

At the time, the Golden West was the largest Black-owned hotel in the United States.[65] The hotel employed seventy-five African Americans and primarily catered to Black railroad porters, cooks, and waiters—the

The Golden West Hotel. From the Oregon Historical Society.

primary occupations for Black men in Portland—who weren't permitted to lodge elsewhere in the city.[66]

While segregation continued to prevail in Portland, the small Black community that grew around the Golden West flourished with the growth of other Black-owned businesses on nearby streets, including two of the most important Black churches in the region, the Mount Olivet Baptist Church and Bethel A.M.E. Church.

As a focal point of African American culture in Portland, the Golden West hosted a number of prominent Black entertainers, politicians, and musicians over the years. Notable guests included civil rights activist A. Philip Randolph and Freddie Keppard's Original Creole Orchestra, who performed at the hotel in 1914. The hotel was also a popular after-church destination for local community members. As Kathryn Hall Bogle, the daughter of the Golden West Hotel Barbershop's owner, recounts, the hotel was "swamped with customers all of a sudden every Sunday" and "there was a great swapping of . . . laughter, plans for the coming week, just a general get-together, socializing."[67]

The Golden West operated until 1931, when the Great Depression and a shortage of traveling Black railroad workers forced Allen to close his doors. Catherine Byrd purchased the property in 1933 and reopened it as the New Golden West Hotel, yet the establishment lacked its earlier panache. In 1935, she sold the building, and it passed between several owners before becoming the Broadmoor Hotel, a low-income housing development, in 1943.

Today, the building still provides low-income housing but is again called the Golden West. In 2009, the owners installed a series of historical panels outside the building that detail the rich history of the Golden West Hotel.[68]

Soda fountain at the Golden West Hotel.
From the Oregon Historical Society.

BLACK HOTELIERS OF THE LATE NINETEENTH CENTURY

THE WORMLEY HOTEL

Washington, D.C.
Proprietor: James Wormley

As the hospitality industry continued to evolve, so did the sophistication of Black hoteliers who found success catering to a decidedly upper-crust society. James Wormley built an internationally renowned hospitality business during the nineteenth century, accommodating the richest and most prominent visitors and residents of Washington, D.C. The *Evening Star* claimed that James Wormley was "one of the most widely known stewards and hotel proprietors in the country," while the *Boston Herald* wrote that his hotel, "while not the largest, was the most strictly aristocratic of any in the city, its quiet elegance and high prices attracting a very select circle of patronage."[1]

Born a free man in 1819, Wormley started his business career at a young age.

While he was growing up, he honed his people skills by helping with his family's hackney carriage business, driving government officials around Washington and learning the value of confidentiality.[2] Likely from this experience, Wormley gained an unusual ability to seamlessly navigate between the isolated spheres of white and Black America that were exceedingly common at the time.[3]

James Wormley.
Reproduced by permission from the DC History Center, General Portrait Collection.

Wormley's first business venture was a wildly successful catering company opened in the 1850s. As he built his reputation in the local culinary scene, he earned a position as head steward of the Metropolitan Club on nearby Lafayette Square. Here, Wormley met the wealthy statesman Reverdy Johnson, who chose Wormley as his personal chef upon being appointed minister to England in 1868. According to local historian John DeFerrari, Wormley even brought live turtles on his trip across the Atlantic, and his terrapin stew was a favorite among British dignitaries.[4]

The Wormley Hotel. Reproduced by permission from the DC History Center, Junior League Photograph Collection.

Upon returning to Washington, D.C., Wormley began exploring ways to expand his business, and in 1871 he opened a five-story hotel and restaurant on the corner of Fifteenth and H Streets. The Wormley Hotel (or the Wormley House, as he called his flagship establishment) became a popular destination for the wealthy and politically prominent in the nation's capital. Wormley's culinary expertise combined with his keen eye for detail ensured that his hotel was among the top destinations for travelers to the district. Indeed, the hotel was well-known for its neat and well-managed rooms, its early adoption of telephone service, and its dining room where Wormley served European-style dishes, likely inspired by his time abroad.[5]

As a prominent member of Washington, D.C.'s local community, Wormley became actively involved in the political scene. He was particularly close with Massachusetts senator Charles Sumner, whose steadfast support for the rights of African Americans both before and after emancipation made him an ally of the racial equality movement. One of Wormley's most significant achievements was leading a successful campaign to persuade Congress to allocate funds for the district's first public school for African American students in 1871, though local politics delayed the school's opening until 1885.

The Wormley Hotel became one of Washington's cornerstones for politics, diplomacy, and social elegance. The hotel was famous for hosting the so-called "Wormley Conference," an informal, secret meeting among Democratic and Republican representatives to resolve the stalemated 1876 presidential election. The agreement essentially ended Reconstruction in the South (a fervent demand of the Democrats) in exchange for semipermanent Republican dominance of national politics for the next generation.[6] It is unclear if Wormley knew about the secret deliberations taking place in his hotel, which would enshrine Jim Crow politics in the country for much of the next century.

Wormley died in 1884 after undergoing an operation to remove kidney stones. Among the pallbearers were T. E. Roessle, manager of the Arlington Hotel, C. C. Willard of the Ebbitt House, and O. G. Staples, long-time proprietor of the Riggs House, all of whom were white. Wormley left an estate in excess of $100,000; his children and grandchildren remained among Washington's Black elite.[7]

For a few years after his death, the Wormley Hotel continued to be recognized for its excellent menus and high standards, yet the establishment began to falter under the management of Wormley's son, James T. Wormley. The hotel was sold in December of 1893 along with all of its furnishings, and in 1906 the structure was razed and replaced by the Union Trust Building.[8]

A new elementary school for Black children in Georgetown at Thirty-Fourth and Prospect Streets was named after James Wormley in 1885. Sadly, Wormley did not live long enough to see the opening of the school that he'd so ardently supported.

THE KENMORE HOTEL

Albany, New York

Proprietors: Adam and Catherine Blake Jr.

One of the most extraordinary entrepreneurial success stories of nineteenth century Albany is that of Adam Blake Jr., who built and ran the highly successful Kenmore Hotel. While there are no remaining portraits or photographs of Blake, a mysterious stained-glass window above the entrance to Israel AME Church on Hamilton Street commemorates him with the words "He loved liberty and abhorred slavery. He believed in the equality of all."[9]

As the adopted son of Adam Blake Sr., manager of the Van Rensselaer Manor staff, Blake Jr. was raised at the manor and received his education alongside the Van Rensselaer children. Adam Blake Sr. was a trusted confidant of General Stephen Van Rensselaer III, and this position gave him a social prominence throughout Albany, regardless of his race.[10] He was a sophisticated, intelligent, and charismatic man, active in abolitionist activities, and noted master of ceremonies for Pinkster, an annual celebration by Albany's African American community.[11]

Blake Jr. benefitted from his father's connections, natural charm, and business savvy. As a young man, he began working as a waiter at the famous Delavan House on Broadway, and he was soon recognized for his hard work and promoted to the head position, solidifying his own connections to Albany's aristocracy. It turned out that Blake had a knack for the service industry,

and he went on to open several of his own restaurants before taking up the hotel business in 1865 with the Congress Hall Hotel.[12]

Blake's establishment quickly became a local landmark, and it was the preferred location of many top legislators for lodging and meals, as well as its illustrious receptions and meetings. According to local historian Julie O'Connor, the hotel's restaurant employed French chefs alongside a wide array of fine wines, and the hotel even accommodated Charles Dickens on his second American lecture tour.[13] Blake's hospitality was so well-known that the Congress Hotel became a training ground for young African Americans in the service industry.

In 1878, New York State offered Blake $190,000 (approximately $5.3 million today) in compensation for the land that the Congress Hotel sat on to build a new Capitol. With this money he built the Kenmore Hotel.

As O'Connor writes, "the Kenmore was a marvel of modern technology and comfort . . . the most elegant structure on the finest street in Albany."[14] The hotel enjoyed immense success for both its extraordinary service and hospitality. Designed by leading Albany architects, the Kenmore was one of the first of its kind, featuring state-of-the-art amenities such as hot and cold running water, an elevator, in-room telephones, and a luxurious dining room.

As one of the finest hotels in the city, the Kenmore was a welcome respite for wearied African American travelers facing discrimination. The influential travel guide Seneca

The Kenmore Hotel.
Image courtesy of the Library of Congress, Detroit Publishing Company photograph collection.

Ray Stoddard even listed Blake's hotel as the only option for visitors in Albany, calling it "first class in every particular."[15]

Like his father, Blake Jr. was active in civil rights. He became treasurer, for example, of the New York State Equal Rights League, and he worked alongside Judge James Matthews, the first elected Black judge in the country, in the fight to desegregate Albany's public schools.[16]

Blake Jr. died prematurely in 1881 at just fifty-one years old. According to the notes taken on his funeral, the service was attended by a wide variety of people and featured pallbearers of both races. The Kenmore's main competitor, the Delavan Hotel on Broadway, even lowered its flag to half-mast in honor of the late hotelier. Other attendees of note included fellow Black hoteliers and restaurateurs James Wormley and George Downing, as well as many known members of the Underground Railroad.

By the time of his death, Blake had amassed a fortune of more than $100,000, equivalent to $3 million in today's value—an astonishing accomplishment for the son of a former slave. His wife Catherine was just thirty-nine years old, and while she received many offers to purchase the hotel, she continued managing the property for a number of years after her husband's death. The Kenmore enjoyed almost another decade of success, and Catherine became well-known in her own right, venturing into real estate development in the surrounding Albany area to much success. Before long she was one of the wealthiest women in the city, yet she gave back to her community as a founding member of the Women's Exchange, a marketplace for talented women of all races to sell their wares.

WOODLAND PARK HOTEL
Newton, Massachusetts
Proprietor: Joseph Lee

SQUANTUM INN
Quincy, Massachusetts
Proprietor: Joseph Lee

Adam Blake Jr. was not the only African American entrepreneur whose ingenuity brought success in the hospitality industry. During the late 1890s, Joseph Lee rose to prosperity as hotelier, restaurateur, caterer, inventor, and philanthropist. Lee owned and operated the exclusive Woodland Park Hotel in Newton, Massachusetts, alongside a summer resort called Squantum Inn in nearby Quincy. Lee owed much of his success to his automated bread-dough-kneading and bread-crumb-making machine, both of which he received U.S. patents for.[17]

Little is known about Lee's childhood other than his birth to Charleston slaves Henry Lee, a blacksmith, and his wife Susan. As a cook who worked in a local bakery, Lee's mother likely passed her culinary skills down to her son, who went on to follow in her footsteps as a member of the United States Coast Survey. Lee served here for the next decade, preparing meals for the crews to develop his culinary knowledge.

Joseph Lee: Restaurateur, hotelier and inventor.

Lee made his way to Massachusetts with his new wife Christiana in 1877, at which point the couple opened the Hillside House at Weston. The 1880 United States Census records place the Lees in Needham, managing a boarding house with five Black servants and seven white boarders.[18]

In 1882, Lee leased the Woodland Park Hotel, and one year later he purchased the property.[19] Over the next several years Lee enhanced the landscaping and added over seventy new rooms, including a billiards room and a bowling alley. The Woodland Hotel was well-known for its lavish suppers and dinner parties, which Lee would personally cater with ice creams and fancy cakes. Yet his services were not limited to his hotel, as he delivered delicacies throughout the Newton area and regularly catered parties and weddings.

By 1886, Lee had become one of "Newton's rich men," or one of the town's large taxpayers, according to the *Boston Daily Advertiser.*[20] Upon the hotel's grand opening, the *Advertiser* wrote that his establishment was "a picturesque structure, with gables and towers, dormer windows, high chimneys and wide, shady verandas . . . surrounded by seven acres of well-kept grounds, provided with tennis courts and laid out in pretty drives and walks."[21]

The Woodland Park catered to many distinguished guests, including President Benjamin Harrison and his family, President Chester A. Arthur, and President Grover Cleveland. Other prominent guests included Walbridge Abner Field, chief justice of the Supreme Judicial Court of Massachusetts; the Earl and Countess of Aberdeen; Lady Marjorie Gordon; and Lady Henry Somerset, British philanthropist and champion of women's rights.

By 1891, Lee's expanded ventures included the Italian Renaissance–styled Hotel Abbotsford in Boston. The *Boston Post* wrote of the hotelier that "Joseph Lee has supplied a location where the want has long been felt with a most desirable residence hotel. As evidence of its future success, one half of the suites which range over the five stories of the hotel have already been secured to tenants."[22] Lee was now one of the most successful hoteliers in New England.

Both Lee and Christiana became prominent members of Massachusetts society. He sat on the executive committee of the Massachusetts Hotel Association and became a member of the Hotel Men's Mutual Benefit Association. He also joined the battle for civil rights as a Massachusetts delegate to the 1890 Convention of Colored Men

in Washington, D.C., where the American Equal Rights Association formed to advocate for the full rights of African American men.[23]

Lee's enterprises faced severe hardship during the depression of 1893. Several newspapers reported that Lee possessed only $75,000 in assets and was over $100,000 in debt.[24] He was forced to relinquish his ownership of the Woodland Park Hotel and Hotel Abbotsford in 1896.[25]

However, Lee quickly returned to the hospitality business when in July 1897 he opened his elegant 250-seat Pavilion Restaurant, which overlooked the Charles River and Norumbega Park. Lee operated the Pavilion Restaurant for only one season as opportunities beckoned elsewhere.[26]

Indeed, Lee set his sights on a new venture—the Lee Catering Company—and moved his family to Boston. Lee soon became a recognized name in the Boston culinary scene, managing not only his own catering service but the Trinity Court Café, as well. That endeavor was short-lived, however, as he left the café in less than a year to dedicate more time to his catering business.[27]

Given the demands that breadmaking placed on his catering enterprises, Lee became interested in automating the process of making bread. He wanted to reduce the time and effort it took to knead the dough while maintaining consistent quality, and in 1894 he acquired a patent for a bread-kneading machine.[28] The innovation was far more efficient and ensured uniform quality of the bread, allowing his company to bake hundreds of loaves a day. Yet Lee soon realized he had another problem on his hands: the machine was producing too much bread. So, in June 1895, he secured another patent for

Lee's Squantum Inn.
Reproduced by permission from the Quincy Historical Society, Joseph Lee Collection.

his bread-crumbing machine, which transformed day-old bread that would have been discarded into a useful ingredient.

In 1898, Lee opened a summer resort in Squantum, which he and his wife would manage for the next eighteen years. The hotel was an upscale, sixteen-room facility he called Squantum Inn, located on five acres overlooking Dorchester Bay on Boston Harbor. Its opening ceremony that summer featured a "who's who" of local politicians and business elites.[29]

The Squantum Inn lodged numerous dignitaries, including Boston's mayor Thomas N. Hart and its governor John L. Bates. A special feature of Lee's establishment was that diners could personally select from a variety of fish and game on view and have it prepared to order. Lee additionally used the breadcrumbs from his bread-crumbing machine to coat and fry his fish, much to the delight of his guests who found this method superior to the use of crumbled crackers by most chefs at the time.

Before long, Lee sold the rights to his bread-crumbing machine to Boston's Royal Worcester Bread Crumb Company,

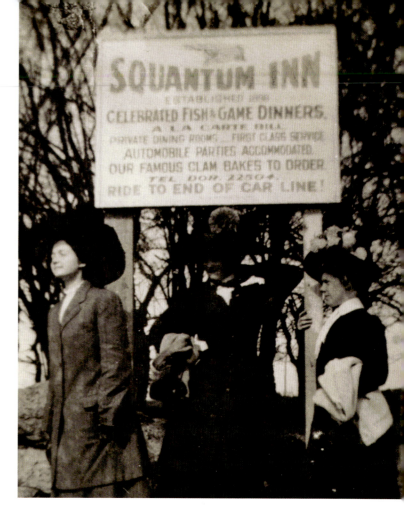

Squantum Inn patrons under signage.
From the Quincy Historical Society's
Joseph Lee Collection.

who mass-produced the machines and marketed them to hotels and restaurants nationwide.[30] By the turn of the century, Lee's bread machines could be found at top hotels and catering establishments across America.

> The manager, Joseph Lee, is known by almost every epicure. His bountiful table, bright with linen and silver, and overloaded with good things, has made an enviable reputation among all hotel men.
> —*Boston Herald*, September 11, 1899

After Lee's death from pulmonary tuberculosis in 1908, his wife Christiana took over operations of the Squantum Inn, and a year later she purchased the Pratt estate, just around the corner. Here she opened a restaurant—with the help of her daughter Genevieve—which she called Lee's Inn in memory of her husband.[31]

Christiana managed Lee's Inn alongside her daughter until she passed away in 1916. The *Boston Globe* wrote of her that "Mrs. Lee was a woman of executive ability and enjoyed a great degree of popularity."[32]

In 2019 Lee was inducted into the American National Inventors Hall of Fame, more than a century after he received the patent for his revolutionary bread-kneading machine.[33]

CHURCH'S HOTEL

Memphis, Tennessee
Proprietor: Robert Reed Church Sr.

Black commercial inroads into Southern society were difficult, but not impossible. Robert Reed Church Sr. was an entrepreneur, business leader, philanthropist, and landowner in Memphis, Tennessee. Reputedly the first African American millionaire in the South, Church was born in Holly Springs, Mississippi, in 1839 to Charles B. Church, a wealthy white steamboat captain, and Emmeline, an enslaved seamstress who died when Robert was only twelve years old.[34]

Church's father never legally recognized him as his son, nor did he educate

him. However, he did train him as a cabin boy, dishwasher, cook, and steward aboard his steamboats. Such positions were the pinnacle of Black achievement for decades under Jim Crow, but like a select few, Church leveraged such positions for his own purposes.[35]

Robert Reed Church Sr.

Church and his father were among the few survivors of the sinking of the luxury steamer *Bulletin No. 2* in 1855.[36] Robert was later captured by Union troops while working as a steward aboard the steamer *Victoria* soon after the start of the Civil War.[37] His captors left twenty-three-year-old Church in Memphis, and from there he embarked on a career that would establish

him as one of the most successful Black businessmen in the South.

The knowledge that Church gained as a steamboat steward prepared him well for the responsibility of meeting customer expectations. While real estate was his primary business venture, he was engaged in other interests as well, owning a restaurant, saloon, and hotel.

Church's Hotel, advertised as the only "first-class colored" hotel in the city, opened in downtown Memphis on the southwest corner of South Second and Gayoso Streets.[38] The hotel had large and spacious rooms including a dining room, and it was furnished with the most up-to-date amenities. Unfortunately, no photos of the hotel remain.

Church was shot and left for dead during the Memphis massacre of 1866 when race rioters attacked his saloon.[39] He recovered but vowed to stay in Memphis, despite the increasing anti-Black violence. He also stayed during the yellow fever epidemic of 1878 and increased his property holdings throughout the city while values were depressed.

Before long Church's holdings included undeveloped land, commercial buildings, residential housing, and bars in the red-light district of Beale Street, and he reportedly collected around $6,000 a month in rent.

In 1899, Church purchased a tract of land on Beale Street and opened the Church Park and Auditorium, a property valued at $100,000 (approximately $3.4 million today) when built.[40] The auditorium seated two thousand people and, as the first major urban recreational center in the nation owned by an African American, soon became the cultural center for the region's African American community. Local Black Republicans held large rallies and meetings there, and even President Theodore Roosevelt spoke to a 10,000-person audience at the location. Another famous Memphis citizen, "Father of the Blues" W. C. Handy, served as orchestra leader at the auditorium. Other notable speakers and performers included Booker T. Washington, James Weldon Johnson, and the Fisk Jubilee Singers.

Church later founded Solvent Savings Bank and Trust, the first Black-owned bank in the city since the Memphis branch of the Freedman's Savings and Trust Company bank closed in 1874. Solvent Savings extended credit to African Americans so they could buy homes and develop businesses; the bank even once saved the Beale Street Baptist Church from foreclosure.

Church gave liberally to local school, social, and civic organizations, becoming one of the most prominent philanthropists in Memphis.

Church died in Memphis in 1912. In 1984, the Memphis Chamber of Commerce honored him by naming him one of Memphis's pioneer businessmen, more than a half century after his death. Following many years of neglect, Church's auditorium was razed. The city subsequently acquired the park property and added it to the Beale Street Historic District, listed in the National Register of Historic Places in 1993.[41]

THE HOTEL BERRY

Athens, Ohio
Proprietor: Edwin Cornelius Berry

African Americans continued to make their mark in the hospitality industry and in some instances made an even deeper foray into accommodating a white clientele. Edwin Cornelius Berry spent his entire life perfecting the art of hospitality and became one of the most celebrated African American restaurateurs and hoteliers in the nation. Indeed, Berry seemed to have an innate skill for hotel management and food service. Booker T. Washington even praised his achievements in *The Negro in Business*: "Mr. Berry is one of those pioneers of our race who has conquered race prejudice by achieving a business success."[42]

Born in Oberlin, Ohio, in 1854, Berry moved to Albany with his family at two years old. He attended Albany Enterprise Academy, one of the first educational institutions in the United States conceived, owned, and operated by African Americans.[43] When his father died in 1870, however, he left high school to provide for his mother and eight siblings.

At age sixteen, Berry walked ten miles to Athens in search of work and secured a job in a brickyard, where he earned fifty cents a day. He was quickly recognized for his aptitude and was promoted to make $1.25 a day. Berry later became employed as an errand boy at a dry goods store in Parkersburg, West Virginia, where he earned ten dollars a month, sending eight dollars back to his mother.[44] He also worked in an ice cream parlor where he served as a waiter, a pivotal moment in his life.

Berry later took a job in a restaurant where he worked as a dishwasher and cook apprentice, learning how to prepare and serve food.[45] When he saved enough money, he moved back to Athens to work as a caterer in a restaurant. As Berry became highly proficient, demand for his services grew.

In 1878, Berry married his childhood schoolmate, Ms. Mattie Madry. After five years of working in the restaurant business, he opened his first business, a small restaurant called Berry Brothers, alongside his elder brother with just forty dollars that he had saved.[46] He soon bought out his brother and ran the restaurant himself.

Expansion quickly followed. In 1880, Berry bought a lot located at Eighteenth North Court Street to build another small restaurant that would become part of the Hotel Berry.

A decade later Berry purchased an old building on East Court Street and erected the Hotel Berry, a twenty-room hotel on the property adjoining his restaurant.[47] During this time, he was the only African American Court Street businessman.[48] However, the purchase placed Berry in debt to the amount of $8,000 (approximately $249,000 in value today) at seven percent interest, and Berry struggled to meet his mortgage notes. Nearly one year after opening, he closed up for the night with just one guest at his hotel. Denied loans from both banks in Athens, he walked past a friend who noticed his anguish and loaned him five hundred dollars on the spot. He told

Berry he could use it without interest until he was able to repay it. According to Berry, this was the only time in his career that anyone offered encouragement beyond empty words.[49]

For Berry, food service and hospitality were always two sides of the same coin. Although he specialized in the culinary side of business, he paid special attention to all aspects of hotel management.[50] He began many practices that were copied by hotel owners around the world. For example, Berry is reputed to be the first hotelkeeper in the United States to have closet hangers, Gideon Bibles in each room, and sewing kits, ideas that likely came from Berry's wife, Mattie. The Hotel Berry was modern and up-to-date in every aspect, each room equipped with electric call bells, electric lights, hot water, a closet, and private bath. The hotel also had a barber shop on the first level and a ballroom used for dances and other special events.

While Berry never refused service to African Americans, his customers were predominantly white, making him one of the only African Americans in the nation who operated a first-class hotel patronized by whites. Indeed, Booker T. Washington commended Berry for having a deep sense of loyalty to his race, writing that "he would rather lose customers than . . . be guilty of that sort of disloyalty."[51] Newspapers across the nation reported on the unusual story of a Black freeman running and operating a successful hotel in Ohio.[52] Travelers sought to stay in Athens for the sheer pleasure of dining at the Hotel Berry.

Berry was a natural hotelier. He regularly gathered the clothes of his guests after they had fallen asleep at night and brought them to his wife, who would replace buttons, repair rents, and press the garments, after which he returned them to the guests' rooms.[53] He always returned their tips, often by way of their guestroom mailboxes.[54]

After twenty-eight years in operation, Berry decided against expanding his facilities to keep up with the roaring twenties, and he and Mattie sold the Hotel Berry in 1921. At the time of his retirement, the Hotel Berry had expanded to more than fifty-five rooms. The building was worth more than $50,000 (approximately $900,000 in today's value) and Berry reputedly earned $25,000 to $35,000 annually.[55]

Berry died in 1931 at the age of seventy-six. In an editorial written several weeks after his death, Harry C. Smith, editor of the *Cleveland Gazette*, eulogized him as "the leading and the best Afro-American businessman in the last quarter of a century."[56]

The Hotel Berry was bought in 1935 by Fred Beasley, who expanded it to eighty-five rooms and ran it until 1961, at which point it was purchased by Ohio University for use as a student dormitory.[57] For more than eighty-two years, the Hotel Berry stood at 18 North Court Street until it was razed in 1973.

The Hotel Berry. Reproduced by permission from the Southeast Ohio History Center.

The Hotel Berry. From the Southeast Ohio History Center.

THE MESSENGER, Athens, Ohio—Sun, April 7, 1974 — Page D-1

Hrea

social events. You heard it in Athens, on the Ohio University campus and in neighboring towns. Traveling salesmen exchanged the words as they parted company in other cities and headed for Athens. In the weeks preceding Ohio U.'s annual homecoming the call might be heard in New York, Cleveland or Chicago, or be jotted in a note written by former classmates planning reunions. The Berry Hotel was the social center for town, gown and countryside.

Today, only ghosts and a wrecking crew inhabit the Berry. Before long there won't even be a building to stir memories of a different day when Athens and Ohio University were smaller and the rambling hotel well served the needs of the community.

Since 1962 it has been Berry Hall, the property of The Ohio University Fund, Inc. The university first used the hotel as a dormitory to help ease the housing shortage. Later it was an office and classroom building.

Edward C. Berry

iversity, the building is being razed and before long the site where the Berry has stood for 82 years will be vacant.

Plans are to make a public parking lot of the site, but no firm details have been made.

The Berry was born in 1892, built by a black man who succeeded in a time when blacks were almost uniformly relegated to menial jobs. And it prospered.

Berry bought the Allen Building on N. Court Street and built a 20 room hotel. When it was time to open, Berry was $9,000 in debt. But customers soon changed the debt to profit. The Berry was popular with travelers and the dining room was "the" place to go for dinner. Berry was a thoughtful host. His rooms were not only neat and comfortable, and he thought of such things as putting a pin cushion, needles, thread and buttons in each room, something many a traveling salesman appreciated. Berry also supplied each room with a Bible in the days before this was common practice. He later enlarged the hotel to 55 rooms, and it subsequently grew to 90 rooms.

He sold the hotel in 1921 and died in 1931 at the age of 76. Berry's fame had spread, carried by satisfied customers and Ohio U. graduates. He served as a trustee of Wilberforce College.

A fire hit the Berry on Oct. 22, 1926, and tragedy was narrowly averted. One woman was injured when she leaped from a second floor window, but all other guests escaped with little more than smoke illness.

Fred Beasley, who had gained fame as an auto dealer, bought the hotel in 1935 from a chain operator and did extensive remodeling. He sold it to The O.U. Fund in 1961.

The original structure was along the Victorian lines, with bay windows overlooking N. Court. Later, Beasley remodeled the exterior. The bay windows

The Berry As It Appeared In 1961

during the period when the Ku Klux Klan marched in Southeastern Ohio. No doubt some of the men who hid under sheets to practice their bigotry still took part of Ed Berry's fine meals and rented his rooms.

Edward Cornelius Berry was no ordinary man. When he decided to open a hotel he had already gained a wide reputation for his excellent food. He had worked in Potter's Restaurant and then started a small restaurant on W. State Street, near N. Court. Berry next had an eating establishment on Court Street. By 1892 he was known for his industry — he and his wife worked from dawn until long past dark — and his honesty and most of all his ability in the kitchen.

were removed and the front covered with metal panels.

Through the years and different owners the Berry became close to public property. Political parties held their banquets there, and did a lot of their closed door candidate choosing in the upstairs rooms. Fraternities, business groups and service clubs used the facilities for banquets and dances.

But it was in the dining room and coffee shop, the cozy bar and the ballroom where the atmosphere was found and where the seeds for memories were planted.

The Berry food was not only good, but there was a sense of formality. It was the place to go for that special dinner. Uniformed waiters and waitresses served customers seated at tables covered with white linen, and for a time there was an organist who entertained.

In the days when folks spent more time "going out" and less time before the radio, the Berry usually boasted a band. Often it was composed of Ohio U. students, some of whom went on to fame in the music field.

There was a basement barber shop where traveler and townsman became acquainted,

Phi Delta Theta Banquet At The Berry About 1900

and the lobby was often occupied by an Athenian looking for someone to talk to.

Sometimes the lobby visitors were there to get a glimpse of or shake hands with a famous guest. Most of Ohio U.'s famous visitors stayed at the Berry. Men and women of the worlds of art, music, literature or science, as well as governors, senators and other politicians signed the register book and rode the creaky elevator to their rooms.

The Berry had its oddities, too, especially the bell on the elevator. It was designed to alert the clerk who often doubled as bell boy and sounded as if it might have once been used in a fire station.

The ballroom — called the Ivory Room — was also used for dining during the week and for banquets, sometimes with an ensemble providing music.

But when it came time for the formal dances, the tables and chairs were removed, the bandstand erected and the Berry really bounced. There was a rotating ball covered with hundreds of small mirrors that reflected spotlights in a pattern of bubbles on the walls and ceilings, something of a predecessor to the more recent psychedelic lighting. The ballroom echoed with the strains of the waltz, ragtime, jazz and the big band

sound, and the dancers did the Charleston, Big Apple and the fox trot as each generation took turn on the floor. More than romance flowered in the Berry ballroom, and more than a fraternity pin was surrendered after a night of nearness and music.

All that is history now. Some events are held in any of numerous places afforded Athens and nearby, and the dancing — to music that probably would have shattered the revolving mirrored ball — done in Baker Center, dormitories and bars.

Soon the only thing left of the Berry will be a memory.

A Traveling Designer Examines Frescoes By Marjorie Beasley Mathews

TWO

HOSPITALITY ACROSS
THE COLOR LINE

SUNSHINE AND JIM CROW

The concept of the "vacation" was novel for Americans at the dawn of the twentieth century. To a growing white middle class, learning how to make time for recreation, budgeting, planning, and finding amenable accommodations made any vacation a challenging experience. For Black America, these challenges were compounded by racial discrimination. Travel for African Americans inside the borders of the United States became an experience so fraught with humiliation and unpleasantness that most Black people simply never thought of a vacation in the same terms as the rest of America.

Many African American families were reluctant to plan vacations in the absence of reliable accommodations. Legal and extralegal discrimination barred African Americans of all classes from fashionable places of rest and amusement frequented by whites. Farther west, certain facilities in Denver and Colorado Springs offered accommodations for African Americans, but nearly all white resorts were closed to them.

White supremacy could bar the ocean itself from Black tourists in the form of segregated beaches in New Orleans, Texas, Virginia, and elsewhere. According to author and civil rights activist W. E. B. Du Bois, dark skin stood out even more prominently against white sands.[1] As senior *Vox* editor Lavanya Ramanathan writes, "segregationists masquerading as public officials drew literal lines in the sand, parceling less desirable beaches to people of color."[2] Black children were barred from public pools and amusement parks. Well-to-do Black travelers could find accommodations on the Jersey Coast, some hotels in the far North, or boarding houses in Harpers Ferry and in the Virginia and West Virginia mountains.[3] There was a hotel and a number of boarding houses at Oak Bluffs in Martha's Vineyard that drew a considerable crowd of African Americans.

Often absent from the Oak Bluffs' historical narrative as a popular destination for African American elite, as well as musicians and politicians, is the inn at Shearer Cottage, the oldest Black-owned inn on the island. In 1912, married couple Charles and Henrietta Shearer expanded their home and opened a twelve-room seasonal inn. Shearer Cottage catered to African Americans who, at the time, were not permitted to stay at other island establishments. The Shearers provided lodging, meals, and catered events. The dining room was frequently filled with

guests who socialized and enjoyed meals prepared by the Shearer family. Prominent African American entertainers, political figures, and luminaries stayed at Shearer Cottage throughout the decades.[4]

In 1912, after moving to California from New Mexico, Willa and Charles Bruce, a Black couple just one generation removed from slavery, bought a parcel of sparsely populated land along what would later be known as Manhattan Beach. The ambitious couple opened a seaside resort that would later become fondly known as Bruce's Beach. For more than a decade, the rare recreational seaside enclave welcomed Black beachgoers from all over Los Angeles and beyond.

Newport, Rhode Island, and Berkshire Hills both had Black boarding houses, and Black travelers could usually find good accommodations along the beaches of Massachusetts and Connecticut. Hotels in the Adirondacks and the Catskills did not always discriminate, and there were also a few Black boarding houses. African Americans in Maryland often vacationed on Chesapeake Bay, staying in boarding houses on the hills.

On the Gulf Coast, there was Gulfside Assembly, located at Waveland in southern Mississippi.[5] The summer resort was the spiritual child of Bishop Robert E. Jones, who was a resident of New Orleans. There was not a single organized resort other than Gulfside where Black people were allowed to take a sea bath south of Virginia on the Atlantic seaboard and as far as Mexico on the Gulf Coast.

From Virginia to Florida, there was practically no place for African Americans to find summer recreation, except for one secluded hotel in Ashville, North Carolina. Kentucky, Tennessee, Arkansas, Oklahoma, and Missouri offered no summer resorts for African Americans, although there were two hotels and bath houses at Hot Springs open to Black people for the winter and spring tourist seasons in Arkansas.

Economic means offered some chance of respite from segregation's persistent pressures in the area of travel as much as elsewhere. The economic status of upper-class African Americans made it possible for them to vacation with those of comparable social and economic backgrounds from other places. Yet, as historian Willard B. Gatewood writes, discrimination posed serious problems for the Black elite because they found most Black-owned establishments "socially unacceptable," and so many members of the Black upper class vacationed where they could stay with acquaintances and friends, rather than in Black hotels or boarding houses.[6] Since they were generally barred from public accommodations in the South, and not infrequently in the North, the well-to-do often used letters of introduction to ensure their welcome into private homes rather than be exposed to the vagaries of segregation.[7]

In Washington, D.C., there was a beautiful cottage city at Arundel-on-the-Bay for African Americans to vacation.[8] A few of the district's African American upper class not only owned comfortable residences in the city but also owned what was known as

"country places," and several other families enjoyed summer homes in nearby Maryland and Virginia. Those who did not own such places escaped the summer heat by taking cottages in Harpers Ferry, Virginia, or other well-known resorts at Cape May and Saratoga.

Purpose-built hotels and resorts by Black entrepreneurs offered more dependable accommodations. In Atlantic City there was Fitzgerald's Hotel, "Mrs. Poole's cottage," and "Ridley's cottage," among others.[9] Here were African American–owned drugstores and bathing pavilions, and in the summer months Black families could be seen in droves on the famous Boardwalk. Down the Jersey coast, there was another resort at Sea Isle, and at Cape May was a large hotel owned and operated by African American hotelier E. W. Dale.

Despite what many white Americans might have believed about African Americans' propensity for travel, there was a large demand for vacation opportunities among the Black population. In response, African American hoteliers and entrepreneurs began offering vacation opportunities, operating hotels, and acquiring pleasant cottage sites. After the turn of the twentieth century, the development of resorts, beaches, and ranches designed exclusively for African Americans proliferated. Black travelers of all classes flocked to these resort communities scattered across the United States.

In 1920, one such establishment located at Port Monmouth, New Jersey, one mile from Keansburg, was Barrett Beach—a fifty-acre seashore resort that included the Barrett Beach Inn.[10] The resort was valued at $126,000, financed and controlled by African Americans through Barrett Beach Company, Inc. Resort amenities included a motion picture theater, an electric light plant, an artesian well equipped with a water system 321 feet deep, bungalows, a dance floor, bath houses, and a large pavilion.

Woodland Park was a small resort founded by Marion E. Auther, a Black businessman from Ohio and a leading salesman for the Idlewild Resort Company, along with his wife, Ella Auther. As Idlewild developed into a vibrant resort, the Authers dreamed of creating a smaller resort that catered to Black clientele seeking a more tranquil resort experience.

Woodland Park originated when the Brookings Lumber Company sold the remnants of its former lumbering village in Newaygo County. Marion and Ella utilized their earnings from commissions on the lots they sold at Idlewild to acquire the property. By 1921, the Authers had purchased all of the parcels from the Brookings Lumber Company to establish their new resort, renaming it Woodland Park.

In 1923, they opened the community's premier resort property, the Royal Breeze Hotel. Located near Woodland Lake, the hotel and clubhouse offered evening entertainment and summer fun for all. The Royal Breeze featured fifty guest suites, a parlor, a formal dining room, a game room, a wraparound screened porch, and three separate rental cottages.

Woodland Park attracted both a seasonal and year-round population, although the resort never achieved the same level of popularity as Idlewild.[11]

Another case in point is the Surf Club, a 200-acre playland only twenty-five miles from the center of Detroit.[12] Located on the shores of Canada's Lake St. Clair, Surf Club was the only resort of its kind for African Americans. The club was developed in 1949 when eight Black businessmen put up $10,000 each to form the Bell Shores Company, and it was an immediate success.

The Lee Haven Beach Club was another fashionable resort on a private island off the Connecticut coast, near Greenwich.[13] Founded by African American New York real estate developer James O. Hagans, the beach club attracted the cream of African American society along the Eastern seaboard from New York to Washington, D.C. Modern in every respect, the property had a main clubhouse featuring a bar and restaurant, four houses offering fifty to sixty rooms for rent, and a dock for members to bring their boats.[14] Sadly, the club was forced to close in 1952, just four summers after its opening, due to hurricane damage.

About a mile down from the popular Silver Springs attraction near Ocala, Florida, was one of the largest recreational attractions for African Americans in the South, Florida's Paradise Park.[15] Designated "for colored people only," they welcomed 100,000 African Americans each year, some from as far as New York or California.[16]

Woodland Park founder Marion Auther (*right*) beside W. E. B. Du Bois on a dock at Woodland Lake. From the W. E. B. Du Bois Library, UMass Amherst Department of Special Collections & University Archives.

By 1950, the country's fourteen million African Americans spent about $500 million each year on travel.[17] The pleasure trips, which constituted a large share of this total, were usually taken by African Americans traveling to visit friends or relatives in other cities. At that time, although the American resort business was a $12 million annual enterprise, there were only an estimated twenty Black resorts in the entire country; there were practically no white resorts that would accept people of color. Many African American citizens turned to vacations in foreign countries in response.

Yet Black Americans found the job of deciding where to spend their vacations a much tougher task than any time before, as each year saw the addition of more and more interracial resorts. Numerous new resorts opened, including Bembe Beach, Venice Beach, Oyster Harbor, and Arundel-on-the-Bay, alongside the dozens of others that grew into prominence during this time period. Some old resorts let down their barriers and others reorganized specifically as interracial vacation spots.[18] Spurred by anti-bias legislation as well as good business practices, these facilities started dropping racial barriers and opening vast new accommodations for African Americans setting out for vacationland.

Portrait of Major Charles R. Douglass

HIGHLAND BEACH

Anne Arundel County, Maryland
Proprietors: Major Charles and
Laura Douglass

The connection between hospitality and civil rights for African Americans was always clear. As the son of famed abolitionist writer and lecturer Frederick Douglass, Major Charles Douglass was no stranger to racism. When he and his wife Laura were barred from entering a restaurant at the Bay Ridge Resort on Chesapeake Bay in 1890, Douglass became motivated to venture into real estate, and he purchased forty-four acres of beachfront property along the Chesapeake Bay, just southwest of Annapolis, Maryland, to found the Highland Beach Resort.[19]

Douglass developed the land as a summer resort community—the first in the country to be African American owned and operated—and built cottages that he sold to

friends and family.[20] The initial purchasers included Blanche K. Bruce, the first African American U.S. senator from Mississippi; P. B. S. Pinchback, former Louisiana governor; James Wormley, owner of the famous Wormley Hotel in Washington, D.C.; and Judge Robert Terrell, the first African American judge in Washington, D.C.

Among these cottages, Douglass built a large summer house for his family, which he named Twin Oaks. While the cottage was primarily built as a place for his father to spend retirement, Twin Oaks became a hub for prominent members of the local African American community. Sadly, Frederick Douglass did not live to enjoy the house.

Highland Beach became a summer haven and a popular gathering place for many affluent African Americans. Over time visitors included Booker T. Washington, W. E. B. Du Bois, Paul Robeson, and Langston Hughes, to name a few.

Highland Beach, Maryland, YWCA camp for girls. Reproduced by permission from the Smithsonian National Museum of American History, Scurlock Studio Records.

In 1922, Highland Beach became the first African American incorporated municipality in Maryland, thanks to the efforts of Charles's son, Haley Douglass, who had assumed town leadership after his father's death just two years prior. Once incorporated, the younger Douglass and his allies led the town for the next three decades and succeeded in keeping their community small and exclusive.

Yet the Highland Beach community could not keep newcomers out of the area surrounding the resort. The 1940s saw the development of competing resort communities by both white and Black people that attracted newly affluent African Americans. By 1960, the formerly all-white resort community of Arundel-on-the-Bay was predominately African American.

Today, Highland Beach is a small community of around one hundred residents, many of them descendants of the original settlers. The resort guesthouse has since been transformed into a private residence, so you may drive around Highland Beach, but only invited guests can stay overnight. The famed former resort sits on a long, curving beach set against ample park ground that opens to the bay, yet it remains a private beach for residents only.[21] The Twin Oaks property, now the Frederick Douglass Museum and Cultural Center, remains a focal center for Highland Beach. The property is also listed on the National Register of Historic Places.[22]

THE BAY SHORE HOTEL

Hampton, Virginia
Proprietors: Frank D. Banks and John Mallory Phillips

The Bay Shore Hotel Corporation was founded in 1897 by a group of nine Hampton Institute administrators and Black entrepreneurs, including businessman Frank D. Banks and seafood magnate John Mallory Phillips.[23] The group purchased property on Buckroe Beach and opened a four-room cottage called the Bay Shore Hotel. Before long their operations expanded into a three-story, seventy-room resort whose fishing pier, dance hall, boardwalk, and amusement park offered one of the premier African American vacation spots in the nation.

By the 1930s Bay Shore Beach and Resort (as it was now called) rivaled the nearby all-white amusement park Buckroe Beach Park—the only thing separating the two properties being a fence extending from the beach and leading out into the sea.[24] Guests at the Bay Shore Hotel traveled from as far

The Bay Shore Hotel.
Reproduced by permission from the Hampton History Museum.

Bay Shore Hotel beachgoers. From the Hampton History Museum.

A north view of the Bay Shore Hotel. From the Hampton History Museum.

away as New York, while visitors from nearby Richmond regularly took the train to enjoy fun in the sun.[25] Bay Shore's biggest attraction was its nearly one hundred yards of beachfront property where African Americans could splash and play without racial discrimination.

In August 1933, the bustling waterfront hotel was severely damaged by a hurricane. Due to inadequate insurance and insufficient cash resources, the resort struggled to recover, and only the dance hall was saved. The Bay Shore Corporation defaulted on its loan in 1940, at which point operations were handed over to the New Bay Shore Corporation, headed by Charles H. Williams. While initial expansion was delayed by the onset of World War II, in 1947 construction began on a new hotel and amusement park, boasting a carousel, Ferris wheel, bumper cars, and gaming area for children.

The Bay Shore Hotel after the great "Storm King" of 1933. Although the
hotel was rebuilt after the devastating hurricane, it never fully recovered.
From the Hampton History Museum.

Bay Shore Beach and Resort continued to be a destination for African
American vacationers for several decades. Top-shelf entertainers such as
Count Duke Ellington, Ella Fitzgerald, and Louis Armstrong packed the
dance hall and drew tourists from several states away. Whites at Buckroe
Beach would often jump the fence separating the two resorts to hear the
vibrant music being played at Bay Shore.[26]

Ironically, the Bay Shore Beach and Resort began declining after the
passage of the Civil Rights Act in 1964, as African Americans suddenly had
access to a range of new entertainment options. The resort closed and was
razed to make room for a residential area in the 1970s.[27]

IDLEWILD RESORT

Lake County, Michigan
Idlewild Resort Company

Upper-class Black families in the Midwest began frequenting two exclusive African American summer resorts in Michigan during the early twentieth century: one was the West Michigan resort near Benton Harbor, which often hosted a "dignified and conservative" clientele.[28] The other was Idlewild, otherwise known as "The Black Eden," where African American writers, businessmen and women, physicians, and entertainers could relax and spend their summers in a racially segregated country.[29]

Located in the lake country north of Grand Rapids and advertised as the "Atlantic City of the Race," Idlewild was perhaps the most exclusive resort for African Americans in the Midwest.[30] W. E. B. Du Bois even wrote that "not for one moment in [the] fine joy of life, absolute freedom from the desperate cruelty of the color line and . . . for the wooing of the great silence which is Peace and deep Contentment—not for one little minute can they rival or catch the bounding pulse of Idlewild."[31]

W. E. B. Du Bois (*right*) at camp in Idlewild. From the W. E. B. Du Bois Library, UMass Amherst Department of Special Collections & University Archives.

On the beach at Idlewild Resort, Lake County, Michigan. Photo credit: The Abbott Sengstacke Family Papers / Robert Abbott Sengstacke / Getty Images.

W. E. B. Du Bois (*far left*) on vacation in Idlewild. From the W. E. B. Du Bois Library at UMass Amherst.

Idlewild's development comprises one of the more intriguing sagas in African American history. Homesteading the land for three years, a group of white business-men recognized the potential of the area and took shelter in tents to gain full legal rights to the property, living off the land and surviving on fish and berries.[32] After acquiring ownership from the government and forming the Idlewild Resort Company (IRC), the group advertised in African American newspapers across the country, capitalizing on the lack of resorts catering to the Black population to sell one hundred sixty acres of land in 25 × 100 foot lots for as little as four dollars down and one dollar per month.[33] The company promoted its first excursion to the resort in late 1915, inviting a select group of thirty African American professionals from nearby Chicago and Evanston to Idlewild.

While property sales at the Idlewild Resort initially lagged behind expectations, the purchase of land by Dr. Daniel Hale Williams, a prominent Black surgeon of the time, spurred interest among the African American community.[34] Madame C. J. Walker and W. E. B. Du Bois each purchased a lot, and their endorsements ensured the resort's success.

Before long, Idlewild's clientele were traveling from as far as St. Louis and New York City to enjoy the resort's amenities, which included bathing facilities and pri-vately owned cottages.[35] The resort became a cultural center for African Americans of the time, attracting popular musicians and lecturers from across the country.[36] Idlewild not only provided an opportunity for Black travelers to partake in activities such as swimming or horseback riding, but its club-house's great stone fireplaces also offered a

place for friends and neighbors to gather on rainy days.

Idlewild was at the height of its popularity from the 1920s until the early 1960s. During that time nearly twenty-five thousand vacationers visited the community, overwhelmingly the permanent population each season.[37] Idlewild was home to more than three hundred Black-owned businesses, including the Flamingo and Paradise Clubs, the latter of which was a top spot on the summer entertainment circuit for Black performers such as Della Reese and Sarah Vaughan, among many others.

Idlewild was the preeminent African American resort town until the passage of the Civil Rights Act in 1964, when the resort lost much of its appeal.[38] Many of the buildings were sold or torn down, but there are still many permanent residents who continue to welcome visitors.

MURRAY'S RANCH

Apple Valley, California
Proprietors: Nolie B. and Lela Murray

Murray's Ranch was advertised as the first Black-owned dude ranch.[39] Sometimes referred to as the "Overall Wearing Dude Ranch," it was one of the most unique of the western-themed dude ranches that were popularized in the first half of the twentieth century.[40] The forty-acre ranch was owned by Black businessman Nolie Murray and his wife Lela, both prominent members of the Los Angeles African American community.[41] The ranch was located in Apple Valley just outside the city limits of Victorville.

During the 1920s segregation limited Black Californians' access to most private and public recreational facilities. Resorts, hotels, nightclubs, and even public parks in many California communities were closed to African American patrons. For nearly half of the twentieth century, Black recreation took place in segregated facilities.

Before "experience-based tourism" swept across the nation, Apple Valley was once a popular destination for its many guest ranches that emerged between the end of World War I and the mid-1950s. While much of the country's more popular destinations were closed to African Americans in the first decades of the twentieth century, Black-owned resorts proliferated in California at this time, including Lake Elsinore and Val Verde in L.A.[42]

The remarkable story of Murray's Ranch began in 1922 when Arthur Cook, one of the most prominent men in the Apple Valley community, offered to sell forty acres of land to the Murrays for a nominal price. Nolie Murray was a local business owner, whose "honest and just methods of dealing with patrons" at his Los Angeles pool hall and cigar store earned him a large number of loyal friends, including Cook.[43] His wife Lela was a registered nurse who worked tirelessly to help those less fortunate, yet

Nolie and Lela Murray, owners of Murray's Dude Ranch. From the Miriam Matthews Photograph Collection, UCLA Library Special Collections.

she suffered from frequent colds and lung ailments that made life in the city difficult. Upon learning of the couple's difficulties, Cook sold the land to the Murrays for just one hundred dollars.

The Murrays' vision was to build a facility that helped underprivileged children, and so they worked hard to make their dreams a reality. The couple built bungalows to house children from a variety of different backgrounds and races, whether they were sent there by the courts or by desperate parents seeking help.[44] Murray's Ranch also welcomed children suffering from physical ailments, particularly those with respiratory illnesses. At any given time, there were a dozen or more children staying at the ranch, some of whom were there for up to seven years.[45]

Despite their relentless efforts, the Great Depression alongside the ranch's operational expenses depleted the Murrays' savings by the 1930s. Taking note from the proliferation of dude ranches around them, the couple converted their property to provide a first-class guest experience.

Murray's Ranch catered primarily to an African American clientele, and soon became a recreational favorite for vacationing celebrities and prominent members of L.A.'s African American community.[46] The Murrays received an unexpected windfall of free publicity when the world heavyweight boxing champion Joe Louis, the "Brown Bomber," visited the ranch. The mainstream media covered the visit extensively, taking care to note that Murray's Ranch was for "Negros only."[47]

The ranch boasted more than twenty buildings, and amenities included tennis courts, riding stables, a dining hall, a baseball field, and a swimming pool, among others. During its peak season from May to September, Murray's Ranch hosted nearly a hundred guests each week, and the ranch was open to anyone who could afford to come, regardless of race. It cost a couple just five dollars a night to stay at the ranch, while the rate was three dollars for a single person.

In the late 1930s Murray's Ranch became a popular movie set, with four of Herbert Jeffries's "all-colored cast" westerns shot on location.[48] The ranch was also frequented by other celebrity guests, including everyone from Bill "Bojangles" Robinson and Hattie McDaniel to Lena Horne, to name a few.

The Murrays insisted on having an integrated staff and hired cooks, pantrymen, yardmen, stable attendants, and service staff for their skills rather than their race.[49] Their team included white, African American, and Japanese employees. While white guests often frequented the ranch's restaurant, they did not spend the night until 1945, when a Workers Union newspaper ran

a story that popularized the ranch among its white audience. Thereafter Murray's Ranch was integrated, long before the rest of the nation.

After Lela's death in 1949 at the age of fifty-eight, Nolie remarried a schoolteacher from Los Angeles named Callie Armstrong.[50] Nolie continued running the ranch, but the fading interest in dude ranches, rising costs, and increasing recreational opportunities for African Americans made it difficult.[51]

In 1955, Nolie sold the ranch to entertainment legend Pearl Bailey and her husband, drummer Louie Bellson, for $65,000, and the couple called their new property the "Lazy B" (the B stood jokingly for "bastard"). Under her ownership, the ranch was renovated to include modern conveniences like telephones and updated lighting, and the property became a central hub for her family and Hollywood friends.

While Nolie sold most of the ranch, he kept five acres for his new venture, the Desert Heart Motel, which he managed until his death in 1958.[52] He was celebrated not only for putting Apple Valley on the map but for elevating African Americans' place in society.

Bailey and her husband continued to use the ranch as a private resort where they could relax and escape the demands of the film and entertainment industry for several years. Yet when work obligations became too much, she lost her passion for the property and sold the ranch in the mid-1960s.

The property changed hands several times over the next few decades, and by 1988 it was abandoned.[53] San Bernadino County eventually claimed the property and gave it to the Apple Valley Fire Department, which used the ranch and its many buildings for training. Today, the property sits vacant, offering only a few faint traces of Murray's Ranch.

SUMMER, SAND, AND SEGREGATION BY THE SEA

AMERICAN BEACH

Jacksonville, Florida
Proprietor: Abraham L. Lewis

American Beach was founded in 1935 by Abraham Lincoln Lewis, Florida's first Black millionaire and the founder of the Afro-American Life Insurance Company.[1] Lewis originally purchased the thirty-three acres of shorefront property on Amelia Island as a company retreat, selling parcels of land to company executives and shareholders, yet the destination soon became a popular vacation site for Black travelers from across the nation.[2]

While Jim Crow laws shut African Americans out of many beaches throughout Florida, American Beach was one of only a few beaches that welcomed Black people and provided quality accommodations during the segregation era. It was "a place for recreation and relaxation without humiliation," according to Lewis.[3]

For nearly three decades, the thirty-three-acre beachfront welcomed thousands of visitors, many of them traveling from across the country in search of sun and relaxation. During the summer, the beach filled with Black families and children as they enjoyed hotels, restaurants, and other amenities at the vacation spot.[4] As a top destination for African American vacationers, American Beach hosted several prominent Black celebrities such as Joe Louis and Zora Neale Hurston, among others.[5]

In 1964, American Beach was devasted by Hurricane Dora, destroying the many homes and buildings along the coastline.[6] The passage of the Civil Rights Act of 1964 further eroded American Beach's popularity as African Americans began exploring destinations newly available to them around the country.

Yet American Beach has managed to survive. Many descendants of the original property owners still have homes in the area, and the beach is currently being restored.[7] The American Beach Historic District was listed on the National Register of Historic Places in 2002, and the A.L. Lewis Museum at American Beach is located on the site to preserve the community's unique history.[8]

Four young women with radio personality Hoppy Adams at Carr's Beach. Reproduced by permission from the Smithsonian National Museum of American History's WANN Radio Station Collection.

CARR'S BEACH AND SPARROW'S BEACH

Annapolis, Maryland

Proprietors: Elizabeth Carr Smith and Florence Carr

Black resorts continued to shape American culture by cultivating some of the most vibrant Black entertainers and artists in mid-century America. At a time when Jim Crow laws placed strict limits on Black recreation, African American audiences and artists flocked to desegregated venues at the Carr's Beach and adjacent Sparrow's Beach resorts on Chesapeake Bay.[9] Fondly called "the Beach," the resort and concert venue at Carr's Beach hosted several prominent African American performers throughout the 1940s and 1950s.

The origins of Carr's Beach can be traced back to 1902, when former slave Frederick Carr and his wife Mary Wells Carr bought 180 acres of waterfront farmland on the Annapolis Neck, just south of Annapolis. While the couple predominantly used the land for farming, they also took in boarders, and in 1926 they founded Carr's Beach as a retreat for Black families. Their daughter, Elizabeth Carr Smith, operated the resort, and her younger sister, Florence Carr Sparrow, launched the adjoining Sparrow's Beach in 1931.

Beachgoers enjoy Carr's Beach, 1955.
From the NMAH's WANN Radio Station Collection.

After Elizabeth Carr Smith's death in 1948, her children partnered with local businessman William L. "Li'l Willie" Adams to expand the resort and create Carr's Beach Amusement Company. As a part of this expansion the company built a midway with slot machines and a nightclub called Club Bengazi, which held events for some of the biggest names in entertainment, from Etta James and the Temptations to Aretha Franklin.[10] Indeed, the resort community became a stop on what was known as the Chitlin' Circuit, a tour route traveled by African American musicians and entertainers throughout the Eastern and Southern United States. On July 21, 1956, the resort drew an estimated seventy thousand people for Chuck Berry's live performance, yet the venue could only hold eight thousand lucky fans.[11] An electrifying 1962 show by "Mr. Dynamite" himself, James Brown, drew eleven thousand concertgoers.

Over the years, hundreds of thousands of Black vacationers frequented both Carr's

Singer Sarah Vaughan performs at Carr's Beach, 1956.
From the NMAH's WANN Radio Station Collection.

and Sparrow's beaches to relax, swim, and bask on the sand. Each night visitors would fill the pavilion and nightclub for dances and concerts, many of which were hosted live via radio broadcast by Charles W. Adams Jr., or Hoppy Adams, a beloved disc jockey on the local African American station. White visitors would even sneak onto the grounds to attend the performances of leading Black artists.

Unfortunately, the resorts no longer exist as a venue or destination. Like most of the Black-owned hotels and resorts, the passage of the Civil Rights Act of 1964 diminished the popularity of Black-only beaches, but their legacies live on.

Radio personality Hoppy Adams broadcasts show from Carr's Beach.
From the NMAH's WANN Radio Station Collection.

THREE

BLACK HOTELIERS AT THE TURN OF THE CENTURY

MORE THAN A PLACE TO STAY

The Great Migration was a mass exodus of six million African Americans from the American South to northern, Midwest, and western cities like New York and Los Angeles beginning in the early twentieth century.[1] Between 1900 and 1910, Los Angeles's Black population more than tripled, rising from 2,131 to 7,599.[2] Although the 1910 census showed that 36.1 percent of the city's Black residents owned their homes, compared with 2.4 percent in New York City, segregation followed African American migration as discrimination and restrictive covenants became increasingly common due to the influx of white workers from the South.

Yet discriminatory responses to Black migration brought opportunity to enterprising African Americans. After realizing they could not stop the influx of African Americans moving into Harlem, white residents began to desert the neighborhood.[3] Soon, housing prices began to drop, and migrating African Americans were able to take advantage of the lower prices. Before long, droves of African American actors, musicians, scholars, writers, and other Black notables were arriving in Harlem, and a new cultural identity began emerging in the Black community.

This new sense of community gave birth to the Harlem Renaissance, an intellectual and cultural revival of African American art and philosophy during the early twentieth century.

Alain LeRoy Locke, a Harvard-educated writer, philosopher, and educator who was commonly known as the first Black Rhodes Scholar and named the "Dean of the Harlem Renaissance," described the movement as a "spiritual coming of age" in which African Americans emerged from "social disillusionment to race pride."[4] Locke celebrated the uniqueness and diversity of African American art and described the era as part of a broader cultural awakening, believing it was an expression of the modernist spirit and a form of intellectual liberation that would lead to social change. The Harlem Renaissance brought writers, musicians, and artists from across the country and the world to participate in this monumental celebration of Black culture.

Yet African Americans in Harlem were hardly free from discrimination. While there was no legal segregation, businesses and property owners practiced de facto segregation that was nevertheless equally oppressive, preventing Black and white patrons from

sleeping in the same hotel.[5] There was subsequently a shortage of quality establishments to accommodate the affluent African American intellectuals and cultural influencers contributing to the Harlem Renaissance. Hotels such as the Hotel Olga, the Marshall Hotel, and the Hotel Theresa emerged to host Black entertainers and the crowds who thronged to see them.[6] In Harlem, as in cities across America, Black-owned hotels became centers of vibrant cultural expression and innovation, nuclei for broader transformations in American culture by providing not only quality accommodations but also a vibrant nightlife of music and inclusivity for the Black community.

Black hostelries quickly became a favorite stop for visiting Black jazz musicians, singers, and performers, and white patrons were there ready to partake in the festivities—which, for some Black hoteliers, brought on a whole new set of challenges.

THE MARSHALL HOTEL
Manhattan, New York
Proprietor: James L. Marshall

The Marshall Hotel, located in the heart of Manhattan's Tenderloin District, was owned and operated by accomplished African American boniface James L. Marshall.[7] The Marshall Hotel revolutionized social life for Black New Yorkers and was the center of a growing African American middle-class neighborhood that attracted some of the most influential Black luminaries and intellectuals.

During the 1880s the Tenderloin was a blighted area infested with poverty, disease, and vice.[8] At this time the neighborhood had clear boundaries, situated in West Midtown between Twenty-Forth and Forty-Second Street, Fifth and Seventh Avenues. Twenty years later, however, these lines became more blurred with the influx of immigrants and African Americans fleeing the horrors of the Jim Crow South. These same years saw the center of the Theater District move north, from Union Square to Long Acre (now Times Square), bringing a newfound wealth and affluence to the area.

In 1900, James L. "Jimmie" Marshall opened the Marshall Hotel on West Fifty-Third, which would become a focal point for the local African American community. Having previously owned another establishment on West Thirty-First, Marshall's relocation brought him to a more upscale area of the district, with the first-class, Black-owned Maceo Hotel just down the street. While the Maceo was considered the "headquarters of clergy and businessmen," the Marshall was a haven for the more artistically inclined actors and musicians.[9] Nevertheless, both establishments offered dinner and live music that drew droves of fashionable African Americans to the neighborhood, becoming a cultural center for avant-garde Black New Yorkers.

The Marshall Hotel boasted nicely appointed rooms, a restaurant that never closed, and a ballroom.[10] Yet the hotel's success had more to do with its charismatic host James Marshall, whose gift for making celebrities feel welcome and appreciated

drew the most famous Black artistic and intellectual talent to his property, including actors, dancers, vaudevillians, composers, musicians, intellectuals, poets, and writers.

While Marshall owned several brownstones, the five-story Marshall Hotel was his pride and joy, consisting of two large brownstones that were gas-lit and furnished in the style of the day alongside an elegant boarding house that hosted regular visitors the likes of J. Rosamond and James Weldon Johnson, among others.[11]

The Marshall Hotel was a prominent gathering place for New York's Black and white cultural elite, and it was not uncommon for some of Broadway's biggest stars to spend an evening there.[12] Marshall's was the place to be seen in New York: as James Weldon Johnson himself wrote, "to be a visitor there, without at the same time being a rank outsider, was a distinction."[13] Indeed, musicians, singers, actors, and theater entrepreneurs of both races congregated at the Marshall, such as African American vaudeville stars Bert Williams and George Walker; songwriters and performers Bob Cole and Billy Johnson (who also operated an on-property "studio"); white singer and actress Lillian Russell; civil rights activist and noted Black scholar W. E. B. Du Bois; white Broadway impresario Florenz Ziegfeld; the first African American heavyweight boxing champion, Jack Johnson; musicians Will Marion Cook and Eubie Blake; opera impresario Theodore Drury; singer Abbie Mitchell and actress Ada Overton; and poet and lyricist Paul Laurence Dunbar.[14]

Prince Henry of Prussia himself even stayed at the hotel in 1902, and he rubbed elbows with members of New York's white high society known as the Four Hundred.[15]

In the early 1900s Ford Dabney and James Reese Europe arrived at the Marshall to arrange Black musicians into trained, organized bands for the first time. While it was not yet called jazz, James Weldon Johnson wrote that "the first modern jazz band ever heard on a New York stage, and probably on any other stage, was organized at the Marshall."[16]

Like most innovators, Marshall and his hotel attracted opposition. The hotel soon caught the attention of elite white New Yorkers, who were undeniably offended by an African American running a respectable establishment where both Black people and white people could gather in one place.[17] Enter the "Committee of Fourteen," a self-appointed group of white moralists who took it upon themselves to identify disorderly behavior. The committee would send private investigators into establishments like the Marshall to scout out liquor-law infractions, prostitution, or anything else deemed unseemly. These investigations would provide the Committee of Fourteen with evidence to intervene and attempt to reconstruct social conditions in New York City.

While the committee itself was not backed by the police or government, they had close ties with the national and state brewers' associations, liquor dealers' associations, and the insurance companies that covered any establishment holding

a liquor license. This partnership allowed them to regulate establishments such as the Marshall by going directly to the source that controlled their business.

The Marshall was a longtime target of the committee, and they kept the establishment under close surveillance due to its mixed-race culture.[18] For the committee, "race mixing" was a prominent threat, as any relationships across the color line could overthrow Manhattan's social order.[19] According to William S. Bennet, congressman and Committee of Fourteen member, "If it is a colored place in which white people were not admitted at all . . . there is no chance for trouble."[20]

As a result, the committee required business owners, particularly African American–owned establishments, to eliminate race mixing. After an undercover agent observed two separate instances of race mixing at the Marshall without any intervention from its proprietor, Marshall was coerced into signing a promissory note that he would segregate his facility, despite New York State's law to prohibit segregation in public accommodations.

Soon thereafter, New York authorities issued an ordinance that prohibited eating establishments from remaining open past one o'clock in the morning.[21] No longer able by law to cater to the theater trade (which remained open until at least 11 p.m.), the Marshall, along with many other businesses located in the theater district, was forced to shut down. After one last extravagant party, the hotel closed its doors on September 5, 1913.

The culture, vibrancy, and excitement of the Marshall, as well as that of the surrounding Black Tenderloin district, would soon migrate uptown to Harlem, in what would become known to history as the Harlem Renaissance.

No monument or historical marker celebrates the story of the Marshall Hotel.

THE DOUGLASS HOTEL & THEATRE

Macon, Georgia
Proprietor: Charles Henry Douglass

Black-owned hotels played a crucial role in cultivating Black performance culture, which, in turn, reshaped American thought. One such establishment was the Douglass Hotel and Theatre in Macon, Georgia, owned and operated by African American entrepreneur Charles Henry Douglass.

Born in 1870 to a former slave in Macon, Douglass grew up in poverty and worked to support his family's income by peddling wood and vegetables while attending public schools in the afternoon.[22] He also worked in cotton fields, and at the age of fourteen he left for the city where he obtained a job as a "buggy boy" for six dollars a month.[23] In 1901, Douglass entered the banking business as director of the Georgia Loan and Saving Company.

Recognizing an opportunity to provide entertainment for Macon's African American community, Douglass opened the Ocmulgee Park Theatre in 1904.[24] In 1906, he sold his lease and purchased

Portrait of Charles Henry Douglass. Reproduced by permission from the Georgia Archives, Vanishing Georgia Collection.

a building on Broadway Street, next to his already established Colonial Hotel, for $18,000 (a value of around $580,000 today).[25] These properties made Douglass the only African American to own property on Broadway.

In 1907, Douglass organized the Florida Blossom Minstrels and Comedy Company of about forty members that performed throughout fourteen states.[26] This venture earned him a favorable reputation, and he became quite successful. Yet just four years later, he sold his interest in the theatrical company and took the proceeds to build the Douglass Theatre, a nickelodeon and vaudeville hall that catered to African

Americans.[27] In 1921, he opened the New Douglass Theatre adjacent to the renamed Douglass Hotel.

The Douglass Hotel and Theatre hosted a number of dazzling stars over the years, including vaudeville greats, comedy stars, and early jazz and blues greats such as Ida Cox, Bessie Smith, Ma Rainey, and big band impresarios Cab Calloway and Duke Ellington.[28] Influenced by superstar Little Richard, local soul artist Otis Redding began his career at the Douglass, and other legends like James Brown made frequent appearances throughout their career.

Yet Douglass did not limit his establishment to African Americans only. According to Douglass Theatre board member George Fadil Muhammad, white people wanted to see shows at the Douglass Theater because they were the best in town.[29] However, Jim Crow laws made race-mixing in public spaces illegal. To circumvent the legislation, Douglass implemented dedicated nights for white patrons so that everyone could enjoy his establishment—despite the legal mandate to maintain separate bathroom and water-fountain facilities.

Not everyone appreciated Douglass's quasi-integration. August of 1922 saw perhaps the most violent moment in the theatre's history, when the badly mutilated body of John "Cockey" Glover was left at the Douglass as an act of clear racial enmity. Glover was a thirty-five-year-old African American man who was involved in the self-defense killing of Deputy Sheriff Walter Byrd at the nearby Hatfield's Pool Hall, also owned by Douglass.[30] Glover

Douglas Hotel
For Colored People Only

Centrally Located

25 Neatly Furnished Rooms with Hot and Cold Baths

EUROPEAN PLAN
Reasonable Rates
By Day or Week

One Block from New Terminal Depot

361-363 BROADWAY
PHONE 1620
MACON, GA.

DOUGLAS THEATRE
C. H. DOUGLAS, PROPRIETOR

Charles H. Douglass Hotel & Theatre advertisement.
From the Georgia Archives, Vanishing Georgia Collection.

was extracted from a train as he attempted to flee to Chicago. As news traveled of his arrest, a mob of three hundred white men intercepted the police on the road back to Macon. Glover was tied to a tree, riddled with bullets, and set on fire.

The mob paraded the mutilated body through the Black communities of Macon and was eventually discarded in the foyer of the Douglass Theatre. Thousands of Macon residents came to view the body, some even fighting to grab a souvenir from the corpse.

According to Muhammad, the mob that murdered Glover deposited his body at the theatre because they saw Douglass as a "refuge and symbol for the black community."[31] As a so-called "race man," Douglass stood proudly for his culture, never resorting to violence but rallying his fellow African Americans to build up their community. Dumping Glover's body at the Douglass was a clear statement.

Douglass managed the theatre with support from the Black community until his death in 1940.[32] His wife and sons ran the theatre until it closed in 1972, while the hotel was razed soon afterwards.

Charles H. Douglass Hotel & Theatre. From the Georgia Archives, Vanishing Georgia Collection.

After sitting dormant for years, the Douglass Theatre reopened in 1997 with new renovations, including a modernized lobby, refurbished seats, central air and heating, and a modern projection and sound system.[33] In 2016, a plaque was placed outside the theatre to commemorate Glover's death alongside over fifteen people who were lynched in Middle Georgia between 1886 and 1922, and by extension Charles Douglass's reputation for community empowerment.

THE GOLDFIELD HOTEL

Baltimore, Maryland
Proprietor: Joe Gans

Sometimes celebrity could incubate Black hospitality. Joe Gans was the world's first African American boxing champion, winning the lightweight title in 1902, but those in Baltimore would come to know Gans as the proprietor of the Goldfield Hotel, home to one of the city's hottest nightclubs.[34]

Born Joseph Saifuss Butts in 1874, Gans took his mother's last name, Gant, yet changed it to Gans after a local Baltimore reporter misspelled it. His professional boxing career began at just seventeen years old, when he first started competing in amateur fights.[35] He perfected his craft by studying other boxers' techniques and competing in the popular Battle Royal contests, which consisted of a dozen fighters boxing blindfold until only one competitor remained. These often long and grueling contests helped Joe learn exceptional boxing skills and strategic methods for enduring long bouts in the ring. Due to his scientific approach and famous left jab, he eventually became known as "The Old Master." In 1902, Gans captured his place in history when he became the first African American boxing champion with an astonishing one-round knockout of the defending champion, Frank Erne.[36] However, his most famous fight was still four years away.

In 1906, on Labor Day in Goldfield, Nevada, the champion took on his most famous bout, which became known as the

Baltimore's Joe Gans, the clever, young, Black lightweight who challenges for the title, ca. 1898. Image courtesy of the Library of Congress, Prints and Photographs Division.

"Fight of the Century."[37] The Old Master faced Oscar "Battling" Nelson, a fighter eight years older than Gans who had already racked up a number of significant wins. The match drew the largest gate in history, with a purse of $30,000 and a crowd of over eight thousand.[38]

The boxers battled a grueling forty-two rounds.[39] Gans occasionally helped Nelson get up during the fight and allowed him time to recover. Even after breaking his hand in the thirty-third round, Gans continued to fight. While Gans was victorious, he received only $11,000, while his defeated opponent claimed $20,000. However, Gans increased his winnings by betting on his own victory, a practice that was legal in Nevada at the time.[40]

As news of the epic spectacle spread, the champion's opportunities for more lucrative prize fights grew, and Gans capitalized on his fame by investing his winnings in various business opportunities.

Gans returned to Baltimore and opened the Goldfield Hotel—in recognition of his epic victory against Oscar Nelson—in 1907, with a grand opening ceremony and overflowing crowds to mark the occasion.[41]

The Goldfield's nightclub is known for being among the first integrated (then called "black-and-tan"[42]) entertainment clubs in the city, and both white and Black guests were welcome at a time when the color line was usually strictly enforced. The future jazz great Eubie Blake got his start as playing piano at the club, and he even wrote a tribute to the club called "The Goldfield Rag."[43]

The champ's entrepreneurial venture into hotel ownership inspired other professional boxers to follow suit, including African American heavyweight champion Jack Johnson, who established nightclubs in Chicago and New York.

Despite defending the lightweight championship title seventeen times, Gans lost it in a rematch to Oscar Nelson in 1908.[44] By the time Gans retired from the sport in 1910, he had racked up over one hundred fifty wins with at least one hundred knockouts, and fought in three different divisions as a featherweight, lightweight, and welterweight.[45]

Gans's retirement was due largely to symptoms from tuberculosis, which he began suffering from as early as 1907.[46] After being bedridden in Prescott, Arizona, for several months, the champ made his way home to Baltimore to visit his mother and two children in 1910.[47] Gans succumbed to tuberculosis and died later that year at the age of thirty-five. Upon his death, hundreds of friends and fans gathered to honor the late boxer. Joe Gans was buried at the historic Mount Auburn Cemetery in Baltimore, Maryland.[48]

The Goldfield Hotel, at Colvin and Lexington Streets, now owned by Robert J. Thomas and known as the Goldfield Market. Photo by Afro American Newspapers / Gado / Getty Images.

Joe Gans in an automobile. From the C. A. Earle Rinker Photograph Collection of Goldfield, Nevada; University of Nevada, Las Vegas, Special Collections and Archives.

The Goldfield Hotel was later used as a grocery store before it was razed in the 1960s.[49] The site is currently occupied by a post office complex, but there is a small marker that shares the story of Joe "The Old Master" Gans and the Goldfield Hotel. He was inducted into the International Boxing Hall of Fame in 1990.[50]

THE HOTEL METROPOLITAN

Paducah, Kentucky
Proprietress: Maggie Steed

During a period when women enjoyed few political rights, Maggie Steed opened the Hotel Metropolitan—the first hotel in Paducah, Kentucky, owned and operated by an African American woman.[51] The hotel is a testament to her grit, tenacity, and relentless pursuit to provide quality accommodations for African Americans traveling through Paducah.

Maggie Steed was born in 1877 in Tennessee and married Henry Steed, also a Tennessee native. She moved to Paducah in 1893.

Hotel Metropolitan, Paducah, Ky.

The Hotel Metropolitan, Paducah, Kentucky. Image courtesy of Betty Dobson.

Maggie had previously worked in hotels in Indiana and Kentucky and understood the rules of Jim Crow and what they meant for African Americans.[52] Although white-owned establishments were occasionally available to Black people, more often they were substandard and did not always protect Black travelers from racially motivated violence.[53] Steed envisioned owning and operating a safe, quality hotel that would accommodate Black people traveling to the Paducah area.

Henry Steed and Maggie Steed purchased a home in 1904 that would later become the site of Maggie's dream hotel.[54] The Steeds often rented out rooms to help make ends meet. When Maggie proposed converting their residence into a full-fledged hotel, Henry was against the idea. It would not be until after her husband's death that Maggie's hotel plan began to take shape.

Steed was refused a bank loan to finance her hotel because she was a woman.[55] The bank insisted that her husband sign the loan application. The twenty-four-year-old Steed took the form home and returned to the bank with her dead husband's signature. Maggie's dream to open a hotel for African Americans would now become a reality.

The Hotel Metropolitan in Paducah, Kentucky, which served as a welcome hostel for Black visitors to the city before, during, and after the U.S. Civil War, when slavery and then rigid racial segregation prevailed in many parts of the mid-South. Image courtesy of the Library of Congress, Carol M. Highsmith Archive. Photo credit: Carol M. Highsmith (2020).

Maggie Steed had her house demolished to make room for the Hotel Metropolitan, which was was completed by the spring of 1909. Five years later, Steed gained full rights to the property—which she had signed for with her late husband's name—after paying more than $1,250 in interest.[56]

The Hotel Metropolitan was listed in the *Green Book*, serving as a haven for African American travelers during the days of Jim Crow.[57] As jazz music rose in popularity during the roaring twenties, many Black musicians traveling on the Chitlin' Circuit stayed within the safe and comfortable confines of the Hotel Metropolitan, including Ella Fitzgerald, Billie Holiday, Ike and Tina Turner, B. B. King, Sam Cooke, Cab Calloway, and Louis Armstrong, among others.[58] The hotel also welcomed other prominent African American leaders such as Thurgood Marshall and Satchel Paige.

Maggie managed the Hotel Metropolitan until her death in 1925, passing on the hotel's maintenance to her son, Edward Wright.

After hotels began to desegregate in the 1950s and 1960s, the Metropolitan Hotel lost its eminence, and the building became a boarding house.[59] The hotel later fell into disrepair and was threatened with demolition in 1999. Local residents Betty Dobson and Sheryl Cooper formed the Upper Town Heritage Foundation to renovate and preserve the hotel, which operates as a museum today. It is one of the few African American historic sites standing in Paducah today.

THE WHITELAW HOTEL

Washington, D.C.
Proprietor: John Whitelaw Lewis

More than a few Black hoteliers saw their enterprises not as ancillary to the Black freedom struggle but as direct instruments in the fight for civil rights. John Whitelaw Lewis was a prominent African American laborer, entrepreneur, businessman, civic leader, and renowned hotelier.[60] Lewis owned and operated the upscale Whitelaw Hotel, aka "The Embassy," on Thirteenth and T Streets in Northwest Washington, D.C.[61] The Whitelaw, which was completely financed and built by Black entrepreneurs, investors, designers, and craftsmen, is an example of civic leaders attempting to counter the oppression of racial discrimination and economic adversity in the early twentieth century.[62]

The Whitelaw Hotel was nestled within the U Street corridor, nicknamed "Black Broadway," which was a vibrant Black community home to over two hundred Black-owned businesses patronized solely by African Americans.[63] The oldest Black-owned financial institution in Washington, D.C., Industrial Bank, also founded by Lewis, provided opportunities for African American home ownership and capital to launch businesses from within what was often considered a prosperous "city within a city."[64] The neighborhood's various businesses were frequented by several well-known African Americans, including everyone from intellectuals Zora Neale Hurston and Mary McLeod Bethune to performers such as Louis Armstrong and Billie Holiday.[65]

John Whitelaw Lewis was born in Bowling Green, Virginia, in 1867. Lewis's education was limited to three months in public school. Nonetheless, he learned the value of hard work and he developed a keen business sense. He also learned to be politically active along the way.[66]

John Whitelaw Lewis. Image courtesy of Erica Buddington.

In 1894, Lewis arrived in Washington marching with Coxey's Army of the Unemployed, a group of jobless men led and organized by Ohio businessman Jacob Coxey in response to the economic crash of the previous year and the conditions of economic equality that followed.[67] Lewis was eventually hired by developer Harry Wardman as a bricklayer's assistant.[68]

He went on to become president of the hod carriers' union (a hod carrier being a laborer who carries materials to bricklayers and stonemasons), where he boosted wages from $1.25 per day to $2.25 without a strike.[69] He also organized a building and loan association, which in 1913 became the Industrial Savings Bank, one of the oldest African American–owned financial institutions in the country.[70]

In 1919, Lewis opened the four-story Whitelaw Hotel, an upscale apartment-style hotel in the Italian Renaissance Revival style.[71] At the cost of $158,000 (approximately $3 million today), the hotel was built entirely by Black craftsmen under the leadership of Isaiah T. Hatton, one of the first African American architects in the country.[72]

The Whitelaw Apartment House, 1839 Thirteenth Street Northwest, Washington, D.C. Image courtesy of the Library of Congress, Historic American Buildings Survey. Photo credit: Dynecourt Mahon.

Lewis, a promoter of Black solidarity and economic self-sufficiency, sold twelve-dollar shares of stock to the African American community to finance its construction. According to the *Washington Bee*, he specifically wanted Black people and not white people to invest so that "they can see buildings towering skyward and say to the world, this is what we have gotten out of prosperity."[73]

The Whitelaw Hotel offered African American travelers an opportunity to stay in a first-class hotel, often for the first time, in the nation's segregated capital. The Whitelaw operated as a hotel and as an apartment building, featuring twenty-five one-bedroom apartments and twenty-two hotel rooms, along with an array of first-rate amenities. The U-shaped property featured facades of buff brick and limestone trim, an ornate lobby, and an intricate domed skylight made of yellow and green stained glass that dazzled a dining room.[74] The *Washington Bee* described the Whitelaw as the "first hotel apartment of its size built for the exclusive use of colored people in this country."[75]

The hotel served as a center for community functions and events during a time when even prominent African Americans were not allowed to stay in the city's white-only hotels.[76]

The Whitelaw Hotel dining room. Reproduced by permission from the DC History Center, Whitelaw Hotel Records, 1930–1948.

A guest room in the Whitelaw Hotel.
From the DC History Center, Whitelaw
Hotel Records, 1930–1948.

The lobby of the Whitelaw Hotel.
From the DC History Center, Whitelaw
Hotel Records, 1930–1948.

During its short heyday, many prominent Black entertainers, athletes, and political figures, such as Cab Calloway, Duke Ellington, Joe Louis, and Thurgood Marshall, stayed at the Whitelaw Hotel.[77] The Whitelaw was listed in *The Negro Motorist Green Book*, a travel guide for African American travelers during the Jim Crow era.[78]

Industrial Bank was forced to close its doors in 1932 due to the financial crisis caused by the Great Depression.[79] Two years later, however, the bank was reopened by Texas native Jesse Mitchell, an African American businessman with a Howard Law education, and it still operates to this day.[80]

The Whitelaw Hotel also went bankrupt and was purchased by millionaire banker Talley R. Holmes at a foreclosure sale in the late 1930s.[81] In a vain attempt to restore the property, Holmes significantly reduced rental rates, and low-income tenants flocked to the building. Holmes owned the property for the next several decades and eventually passed it on to his son, yet maintenance and upkeep was often overlooked.

The passing of the Civil Rights Act of 1964 and the rise of drug infestation in the once-bustling neighborhood led to the migration of wealthy Black patrons to other areas of the city.[82] Violent protests following the assassination of Martin Luther King Jr. in 1968 further destroyed homes and businesses, displacing residents from the neighborhood. Formerly prosperous businesses like the Whitelaw were deeply affected and unable to recover from the devastation.

Yet Lewis did not live to see the decline of his beloved hotel, suffering a stroke in 1928 that led to his death at Freedmen's Hospital in Washington, D.C. He was virtually penniless at the end of his life.[83]

The Whitelaw Hotel was abandoned in the 1970s and became a haven for drug dealers and prostitutes.[84] In 1977, the once-celebrated hotel was shut down by the city and slated for demolition, yet two years later the building was documented as a part of the Historic American Buildings Survey by the Library of Congress.[85] Unfortunately, the building fell victim to a disastrous fire in 1981.

Nearly a decade later the property was purchased by the District government, who sold it to Manna, Inc., a nonprofit organization that develops housing for low- to moderate-income residents.[86] The developer undertook extensive renovations on the property to restore the ballroom and exterior, costing upwards of $4.1 million. The property reopened in 1992 and was listed on the D.C. Inventory of Historic Sites that same year and the National Register of Historic Places a year later.[87]

Today, the Whitelaw Hotel once again houses residents. The building's lobby boasts a display of the property's former glory, including documents displaying the signatures of Duke Ellington and other famous guests of the once-distinguished hotel.[88]

The Industrial Savings Bank (now called Industrial Bank) remains in business today and has almost a half billion dollars in assets, more than one hundred forty employees, and nine branches nationwide.[89]

THE GURLEY HOTEL

Tulsa, Oklahoma
Proprietor: Ottawa W. Gurley

Often remembered as one of the wealthiest hoteliers and businessmen in Tulsa, Oklahoma, Ottawa "O. W." Gurley played a pivotal role in the economic prosperity of Tulsa's Black community.

Gurley was born in 1868 to freedmen in Huntsville, Alabama, and grew up in Pine Bluff. A man of many talents, he worked as a minister, educator, postal service employee, and political administrator.

Upon the opening of the Cherokee Outlet in 1893, the fourth and largest land run in the Oklahoma Territory, Gurley jumped at the opportunity to stake a claim in Noble County, Oklahoma.[90] While he unsuccessfully ran for treasurer of Noble County, he later became principal of the town's school and ran a general store.

When in 1905 oil was discovered in Red Fork, a small town south of Tulsa, Gurley and his wife packed up and moved eighty miles to Tulsa, joining thousands of other Americans racing to the oil boomtown.

Ottawa W. Gurley (*kneeling, front frow, second from left*),
member of the Colored Citizens' Relief Committee and East Welfare Board.
Reproduced by permission from the Tulsa Historical Society & Museum.

Gurley purchased roughly forty acres of land "only to be sold to colored" in North Tulsa and subdivided his parcel into residential and commercial lots. His first real estate venture, a boarding house on a deserted road that would later become Greenwood Avenue, was established on this lot to support a growing number of Black migrants. As the African American community in Tulsa continued to grow and prosper, the Greenwood neighborhood became a thriving center that Tuskegee educator Booker T. Washington dubbed as "Negro Wall Street." The census of 1920 reported 8,878 African Americans living in Tulsa. A year later, that number was almost eleven thousand.[91]

The boarding house would eventually become the Gurley Hotel. It rented out rooms and spaces to smaller businesses. Gurley also owned additional properties, including a two-story building that housed the Masonic Lodge and a Black employment agency. He was also one of the founders of Vernon AME Church, which itself helped to transform Negro Wall Street.[92]

As a Black middle-class community grew around him, Gurley prospered by offering loans to many of Greenwood's new businesses. When Gurley recognized a need, he worked to fulfill it. Out of the six hundred businesses in Tulsa, Gurley had a stake in at least one hundred.[93] The Greenwood District prospered, featuring African American–owned businesses, many financed by Gurley, from brickyards and theaters to a chartered airplane company.

Whatever community members needed could usually be purchased from within their own neighborhood. Although segregation kept many African Americans working on the white side of town, they would return to Greenwood and spend their hard-earned dollars in the community, further strengthening the district's economy. In addition to doctors, lawyers, and other professionals, a vibrant working-class population also emerged, testifying to the district's economic vitality.

On May 30, 1921, Gurley's prosperity came to an abrupt and tragic halt when racial tensions in Tulsa (which had been rising since the Red Summer of 1919) erupted in violence. Dick Rowland, a Black teenager, was accused of sexually assaulting Sarah Page, a white woman. When Black people in the community vowed to protect Rowland from lynching, a fight erupted between a white and Black man, sparking one of the most tragic massacres of Black people in the nation's history, known today as the Tulsa Massacre.

By the time the massacre came to an end on the morning of June 2, nearly three hundred African Americans were dead and Black Wall Street was burned to the ground.[94]

According to Gurley's testimony at legal proceedings following the devastation, white rioters had appeared at his hotel that morning, all wearing khaki suits: "They saw me standing there and they said, 'You better get out of that hotel because we are going to burn all of this God damn stuff, better get all your guests out.'"[95] The angry mob banged on the lower doors of the hotel's pool hall and restaurant, and people began to run for their lives, leaving their possessions behind.

The Tulsa Race Riot Report by the Oklahoma Commission says that prior to the massacre, Gurley was worth $157,783—the equivalent of almost $2.5 million today.[96]

Gurley was arrested for inciting the conflict but implicated two other Black leaders—fellow businessman J. B. Stradford and newspaper editor A. J. Smitherman—to secure his release. Gurley and his wife left Tulsa and resettled in Los Angeles where they ran a small hotel. Gurley died in 1935 at the age of sixty-seven.

For fifteen years, O. W. Gurley had helped build a town where Black families could own their own piece of the American dream. Despite sporadic efforts, Greenwood has not been able to rebound to its former heights. But Gurley's legacy has long outlasted his fortune.

THE STRADFORD HOTEL

Tulsa, Oklahoma
Proprietor: John B. Stradford

The Gurley Hotel was not the only pillar of Black Wall Street. John "the Baptist" Stradford was a prominent and prosperous African American hotelier and businessman in Tulsa. His luxurious Stradford Hotel would also help define the Greenwood District as one of Black America's most vibrant communities.

J. B. Stradford was born a free man in Versailles, Kentucky, in 1861.

Not much is known about Stradford's early life prior to his graduation from

Portrait of John B. Stradford. Image used with permission of John W. Rogers Jr. of Ariel Investments, Chicago, Illinois.

Oberlin College in 1896 and Indiana Law School in 1899. Stradford was an astute and talented entrepreneur. He operated pool halls, bathhouses, shoeshine parlors, and boarding houses in St. Louis and his hometown of Lawrenceburg, Kentucky.

In 1899, Stradford and his wife Augusta settled in Tulsa. There Stradford joined forces with O. W. Gurley, building fortunes in real estate and rental units in Tulsa's famed Greenwood District.

Stradford also became a civil rights activist. He filed a lawsuit against the St. Louis–San Francisco Railway Company for failing to provide adequate accommodations for Black travelers. He publicly fought against lynching and many of the new Jim Crow laws created when Oklahoma became a state in 1907.

According to a set of handwritten memoirs discovered by Stradford's descendants, by 1917 Stradford had amassed quite a fortune. He owned fifteen rental houses and a sixteen-room brick apartment building.[97] At that point in his career Stradford decided to build an opulent hotel in Tulsa, exclusively for African American patrons. The hotel would cater not only to Greenwood District residents but also to other African Americans visiting and staying in the area.

The luxurious fifty-four-room Stradford Hotel opened in June 1918 at 301 North Greenwood Avenue. At the time, the property was the largest African American–owned and operated hotel in Oklahoma, and one of the few African American–owned hotels in the United States. The Stradford Hotel offered all the features and amenities of a luxury hotel, including a dining hall, a gambling room, a saloon, and a large event hall. The hotel quickly prospered.

By 1920, Stradford had become the wealthiest African American in Tulsa.

Stradford's dream to expand his hotel business was quashed when on May 30, 1921, only three years after opening its doors, the Stradford Hotel was destroyed during the Tulsa Massacre.

When white rioters approached his hotel, the sixty-year-old Stradford planted himself in front of the property with a rifle. But he was overcome by the angry mobs that swarmed the area. Soon all the buildings along a thirty-four-block area on and near Greenwood Avenue were demolished and burned to the ground, including the opulent Stradford Hotel. Some six thousand residents of Greenwood were placed in detainment camps, including Stradford himself.[98]

Stradford escaped the detainment camp with the assistance of allies who maintained a great respect for him. He was obliged to remain in hiding and abandon much of the fortune he had worked so hard to amass.

The Stradford Hotel. Image used with permission of John W. Rogers Jr.

Smoke billowing over Tulsa, Oklahoma, during the 1921 race massacre. Image courtesy of the Library of Congress, Prints and Photographs Division. Photo credit: Alvin C. Krupnick Co.

Men sifting through the burned ruins of the Gurley Hotel.
Reproduced by permission from the Tulsa Historical Society & Museum.

Although the destruction of the Greenwood District was clearly carried out by white rioters, Stradford and twenty other African Americans were indicted for inciting a riot. Stradford's son, attorney C. F. Stradford, posted bail but his father, fearing for his life, jumped bail and escaped to Independence, Kansas. He later settled in Chicago. For the next few years, he and his son fought his extradition to Tulsa.

Burned businesses in the Greenwood District following the 1921 Tulsa race massacre. The large, three-story brick building center left is the Stradford Hotel. From the Tulsa Historical Society & Museum.

Stradford formed a group of investors in Chicago to erect a new luxury hotel, but the project ran out of funds and was never completed. Stradford later owned a candy store, barbershop, and pool hall. He never repeated the level of success he enjoyed in Tulsa.

John "the Baptist" Stradford died in Chicago on December 22, 1935. In 1996, a Tulsa jury acquitted Stradford of all charges relating to the Tulsa Race Riot.[99]

HOSPITALITY AND THE "HARLEM RENAISSANCE" ERA

"Harlem Renaissance" is actually a misnomer. The rich surge of African American arts and letters during the 1920s was not limited to activity a few blocks north of 125th Street in New York, or even to New York City. "Negro Renaissance" gave way to "Harlem Renaissance" as colored gave way to Negro, Negro to Black, Black to Afro-American, and, more recently, Afro-American to African American.[1]

THE HOTEL OLGA

Harlem, New York
Proprietor: Edward H. Wilson

In 1920, African American businessman Edward H. Wilson opened a first-class hostelry at the corner of West 145th Street and Lenox Avenue in Harlem, New York, called the Hotel Olga. Wilson conjured up his swank haven for "the Race" from an earlier mixed-race watering hole on the same site, the Dolphin Hotel.[2]

Edward H. Wilson was born in Arkansas in 1877, his father a farmer and cattleman. He made his way to Lincoln University, a historically Black college in Missouri, a significant achievement for someone of his generation. After graduation, he returned to the cattle. In 1904, the ambitious Wilson ventured into the drugstore business as well as the amusement and hospitality industries, eventually deciding to migrate north to New York.

When activist A. Philip Randolph asked Wilson in a January 1925 interview for *The Messenger* why he migrated to New York, Wilson self-assuredly answered, "Observing the trend of the exodus from the South, I decided to come North. I located in New York City because I regarded it as the Mecca for Negro Business."[3]

Quality accommodations in Harlem, other than a few boarding houses, were rare. The Hotel Theresa, also located in Harlem, catered to an all-white clientele at the time. The color line there wasn't broken until 1940 when the Hotel Theresa would finally admit Black guests.

Edward H. Wilson, owner of the Hotel Olga. Image courtesy of the Madam Walker Family Archives / A'Lelia Bundles.

In 1919, Wilson decided to purchase a rundown hotel at auction. The building had already seen three failed hotels come and go and shared a block with a vacant lot that had once been home to several pro and semi-pro baseball teams. Wilson financed the purchase with help from his sister-in-law, A'Lelia Walker, the heiress of Madam C. J. Walker. Wilson added the hotel to two other properties he owned, one a social club frequented by W. E. B. Du Bois and where Billie Holiday later performed.

Wilson reopened as the Hotel Olga in December 1920, providing accommodations for an exclusively African American clientele—the first of its kind in Harlem.[4] The three-story Olga featured mahogany furnishings, numerous reading rooms, and an extensive library.

The luxury hotel became a safe haven for African American travelers while visiting New York, and the property was listed in the renowned *Negro Motorist Green Book*.[5]

The Hotel Olga welcomed many prominent African American entertainers, athletes, writers, publishers, artists, doctors, lawyers, and businessmen. Dean of the Harlem Renaissance Alain LeRoy Locke notably stayed at the Olga in May 1924 when he visited his contemporaries in Harlem.

Although Joe Louis was one of the most famous athletes of the era, the Olga was the only luxury hotel that welcomed him and his party. Baseball Hall of Famer Satchel Paige stayed at the property. The Olga would serve as jazz trumpeter Louis Armstrong's temporary home for nearly a decade.

In October 1925, Rube Foster, one of the key catalysts behind professional Black baseball and founder of the National Negro League, stayed at the Olga. In 1932, James Herman Banning and Thomas C. Allen stayed at the hotel after being the first African American aviators to make a historic transcontinental flight.

Like many prominent businessmen in the community, Wilson was a member of the Masonic Order. He deeply cared about all civic movements that tended toward uplifting the Black race, opening the doors of the hotel to several organizations fighting for civil rights at the time, particularly the National Association for the Advancement of Colored People (NAACP).

The Hotel Olga closed in the early 1940s. For a quarter century—spanning the storied Harlem Renaissance, the Great Depression, and World War II—Wilson's little venture offered travelers of color a key waypoint into and through America's most renowned Black community.

Edward H. Wilson died in 1944.

In recent years Harlem historian Eric K. Washington and other activists attempted to save the landmark for adaptive reuse. However, the New York City Landmarks Preservation Commission demurred. The building was razed in 2019, eradicating any physical evidence of the Hotel Olga's existence.

E. Russell "Noodles" Smith in passenger seat. Reproduced by permission from the Black Heritage Society of Washington State.

THE GOLDEN WEST AND THE COAST HOTELS

Seattle, Washington

Proprietor: E. Russell "Noodles" Smith

Not all hoteliers of the "New Negro" era were as high-minded as E. Russell "Noodles" Smith. Smith was a well-known entrepreneur, hotelier, and night-club owner, gaining his nickname after a particular night of gambling—he always made sure he had enough cash left over for a bowl of noodles. "Noodles" Smith reveled in the lifestyle of a roaring twenties gangster. He was also a patron of the arts and became known as "the father—or perhaps the midwife—of Seattle jazz."[6]

 Smith was born in Missouri, yet the exact date and location are unknown. He arrived in Seattle during the Alaska–Yukon–Pacific Exposition in 1909, after reportedly parlaying five dollars into $17,000 during a three-night gambling spree in Goldfield, Nevada.

Smith was a hard-nosed, miserly man who amassed a fortune from nightclubs, bootlegging, gambling, and real estate. He dominated the nightclub scene that formed the backdrop for Seattle jazz from the 1920s to the 1940s.[7]

In 1917, Smith and Burr "Blackie" Williams opened the Dumas Club, a social club for African Americans. In 1920, he opened the Entertainers Club with another partner. Then, in 1922, in the basement of that establishment, he and "Blackie" reopened the Alhambra Cabaret (originally founded by a man named Harry Legg). Ten years later, the establishment was renamed the Black & Tan Club, suggestive of its mixed-race clientele. The Black & Tan operated for nearly five decades.

Smith also owned the Golden West and the Coast Hotels in Seattle's Chinatown/International District, a neighborhood that included Asian and African Americans and was the center of the city's night life. Smith's hotels welcomed Black travelers at a time when many white-owned establishments refused to accommodate them. It was at his hotels that he also built relationships with musicians visiting the area, which often meant after-hours jam sessions there.

The list of people who stayed and played in Smith's establishments include some of the greatest names in jazz: Duke Ellington, Louis Armstrong, Count Basie, Aretha Franklin, Charlie Parker, Louis Jordan, and Eubie Blake, to name a few.

Smith regularly invested in other people's ventures, usually taking a percentage of the profits and, if the venture faltered, taking ownership of the entire enterprise. At the height of his popularity in the late 1920s and early 1930s, Smith was part owner of several businesses in the city.

According to historian Ashley Harrison, Prohibition arose earlier and saw a longer lifespan in Washington than elsewhere in the country. In Seattle, however, a "tolerance policy" was upheld by the police and political establishment, whereas businesses could continue to serve alcohol discreetly as long as officials got their cut of the profits."[8]

In 1926, Seattle became the first major U.S. city to elect a woman mayor, reform candidate Bertha Knight Landes. Prior to the election, Smith had formed cordial relationships with the downtown establishment and operated gaming tables at the Golden West. In her drive to clean up what was known as one of the most corrupt cities on the West Coast, Mayor Landes began cracking down on such activities and repeatedly raided Smith's business. Smith had no choice but to shut down his tables.

In 1940, Smith retired from the nightclub business and spent the rest of his days as an elder statesman of the Seattle community working for the rehabilitation of young African American men who had been incarcerated, paying off jail fines for the less fortunate at Christmastime, and even financing amateur sports. A local newspaper in fact reported in his obituary that he had supported fifty families during the Great Depression.[9]

The Golden West Hotel and the Coast Hotel were eventually both demolished for the construction of the I-5 Freeway.

THE HOTEL DOUGLAS

San Diego, California
Co-Proprietor: George A. Ramsey

George Alvetta Ramsey was a prominent African American businessman, hotelier, and civic leader. Ramsey had a significant impact on the development of tourism, modern culture, and society in downtown San Diego. In 1924, he, along with white businessman Robert Rowe, erected the Hotel Douglas (named after Frederick Douglass) to provide quality lodging for African Americans during a period of harsh segregation. The Hotel Douglas was the only high-quality hostelry for Black residents and visitors to San Diego. Along with its adjacent nightclub the Creole Palace, the Hotel Douglas served as a cultural hub for African Americans in California.

George Alvetta Ramsey was born in Pasadena, California, in 1889. His father was a railroad porter.

Nightclub entertainers posing in front of the Hotel Douglas.
Reproduced by permission from the San Diego History Center.

When Ramsey arrived in San Diego in 1913, he was a valet for developer and business mogul Herbert Snow.[10] When not living as a "stowaway and hobo," Ramsey made due in the early 1900s by selling newspapers on the streets and was also known to have devoted his youthful energy to such jobs as "ranch hand, boxing manager, bootblack, and salesman."[11]

Settling in downtown San Diego by 1916, Ramsey developed his career operating bars, cafés, hotels, and boarding houses whose visitors were primarily African Americans. One of his earliest business ventures was the Hotel Yesmar (Ramsey spelled backwards), later known as the Hotel Anita, which he established in 1917 with African American businesswoman Anna Brown.[12]

In the early 1920s, Ramsey partnered with Rowe and his African American wife Mabel Rowe. The reality of Jim Crow in San Diego inspired Ramsey and Rowe to build a hotel to serve all patrons, regardless of race. For years, the Rowes successfully operated Ideal Rooms, a large Victorian lodging house at the corner of Market Street and Second Avenue. That structure was razed, and in 1924 Ramsey and Rowe built the Hotel Douglas in its place.

Robert Rowe died prior to the building's inauguration on Thanksgiving Day in 1924.[13] After the failure of his three-year marriage to his first wife, Rena, and the death of his business partner, Ramsey married Rowe's widow in 1927. Mabel was an integral part of the enterprise and co-managed the Douglas along with Ramsey. Miss Mabel, as the staff called her, was also a well-known madam who ran Leroy's Room, a bordello in the area which she operated separately from the Hotel Douglas. Mabel was one of the few successful female Black business owners in San Diego.

The two-story Hotel Douglas offered forty-five rooms and a spacious ballroom with a capacity for two hundred people. This ballroom would later serve as the Creole Palace nightclub. Also on premises was a café, bar, clothing store, laundry, card room, billiard hall, and barbershop.

While African Americans were not allowed to patronize other San Diego businesses, the Hotel Douglas served all guests, Black and white, and maintained a color-blind hiring policy. The Creole Palace was patterned after Harlem's Cotton Club, which was itself, however, a white-only establishment.

The Creole Palace would eventually become the focal point for which the Douglas was best known. It hosted a cabaret that featured a risqué black-and-tan chorus line, jazz and blues musicians, band performances, and singers who delighted the nightclub's racially mixed clientele.

The raciness of the club in conjunction with the flouting of prohibition brought controversy. But it was just such controversy, of course, that was the primary appeal of black-and-tan clubs for many patrons.[14]

Thursday, known as "Kitchen Mechanics' Night," was the busiest night of the week. Black housekeepers at the Douglas got the night off from work and could get in the Creole Palace for free.

In a city otherwise shut off to African Americans, the Douglas provided them a first-rate hotel and stylish nightspot. As its reputation as the premier Black entertainment venue on the Pacific coast grew, the hotel-nightclub became known as "Harlem of the West," or "Cotton Club West" to some; and Ramsey, considered by some the "most prominent and influential African American in the city," was informally named the "Black Mayor of San Diego."[15] Ramsey and his Hotel Douglas stood as a symbol of African American prosperity.

The Hotel Douglas saw itself frequented by celebrated Jazz Age entertainers, such as Bessie Smith, Billie Holiday, the Mills Brothers, the Ink Spots, Duke Ellington, Lionel Hampton, Count Basie, and many more who graced the Creole Palace's stage, in front of which patrons danced the Lindy Hop, the Black Bottom, the Shimmy, and the Susie Q.[16] These entertainers would also enjoy accommodations at the Douglas. Celebrities such as Joe Louis and congressmen Oscar Stanton DePriest frequented the Douglas as well, further illustrating its prominence and elevating tourism in the downtown San Diego community.[17]

The Douglas and Creole Palace was more than a hotel and nightclub. Both businesses provided employment to Black performers, service staff, shop workers, and community residents. It also opened the door for local Black musicians, singers, comedians, and dancers to develop their craft. During a period of intense discrimination and limited opportunities, the Douglas offered high wages, job security, and promotional opportunities. It also served as a conduit to advance independent Black- and Asian-owned businesses, including several within the building which were managed by Ramsey's brother, Alphonso "Al" Ramsey. In August 1935, Ramsey put out an advertisement in the *Chula Vista Star* that declared, "Everyone is welcome" to both the Creole Palace and the Hotel Douglas.[18]

In 1939, after twelve years of marriage, the Ramseys divorced, with Mabel continuing to manage the hotel. Ramsey eventually sold his half of the business to Mabel, and she remained the sole proprietor of the property.

The demise of the Hotel Douglas began in the late 1950s due to suburbanization and the expanding economy of post–World War II America. The civil rights movement opened once-restricted establishments to Black patrons, and the Hotel Douglas began to fade in popularity along with other Black-owned establishments. By the late 1950s, the Douglas's glory days had come to an end, affirmed by an article in the San Diego newspaper *Voice and Viewpoint* that reported "the Hotel Douglas [in its later years] had become a flophouse, with rented out rooms."[19] Mabel sold the property in 1956.

George A. Ramsey died in 1963. Ramsey's obituary in the *San Diego Union* called him the "Mayor of San Diego's Harlem."[20]

In a study approved by the city's Historic Sites Board in 1984, the Centre City Development Corporation (CCDC) evaluated the condition of the Douglas and declared in a report that the hotel was "not architecturally significant."[21] What was significant, apparently, was the old building's prime location, targeted by developers due to its proximity to the newly established Horton Plaza shopping mall. The hotel was razed in 1985 and replaced by residential apartments as part of the city's revitalization efforts.

Embedded in the sidewalk at the corner of Second Avenue and Market Street is a commemorative bronze plaque where the Hotel Douglas once stood.

George A. Ramsey at the Hotel Douglas (*front row far right*). From the San Diego History Center.

HENRY'S COLORED HOTEL

Ocean City, Maryland
Proprietors: Charles T. and Louisa Henry

Henry's Hotel, formerly known as "Henry's Colored Hotel," was owned and operated by African American mail carrier Charles T. Henry and his wife, Louisa. Built around 1895, the Cape Cod–style building stands today as one of the few nineteenth-century structures in downtown Ocean City. Henry's Hotel is one of the oldest hostelries that catered to Black tourists and entertainers during a time when they were restricted access to the Ocean City beach and boardwalk hotels.

Charles T. and Louisa Henry bought the hotel and lot from white investors in December 1926 and renamed it "Henry's Colored Hotel." The property was sold to Henry for just ten dollars.

Henry's Colored Hotel.
Reproduced by permission from the Ocean City Life-Saving Station Museum, Ocean City, Maryland.

During Jim Crow, the ocean-side beach as well as the boardwalk were off-limits to African Americans, who were otherwise allowed to use a dune and beach on Sinepuxent Bay (which the Coast Guard now oversees). Ocean City stores and shops opened the boardwalk to African Americans after the main summer season had passed for what was then called "Colored Excursion Days."[22]

Henry's Colored Hotel was a modest three-story, wood-shingled, twenty-room property about the size of a large single-family home. The Henrys offered its hotel guests more than just a room for the night. Also listed in *The Negro Motorist Green Book*, the full-service property was a haven for African Americans prohibited from staying in other hotels in Ocean City. The Henrys added a restaurant, a laundry facility, and a nightclub across the street.

World-renowned performers Cab Calloway, Duke Ellington, Louis Armstrong, Count Basie, Lionel Hampton, and a very young James Brown frequently came to Ocean City to perform for summer visitors at the nearby Pier Ballroom but weren't allowed to spend the night in the same downtown hotels that accommodated their white audiences. All were welcomed at Henry's Colored Hotel and mingled with less famous guests while staying there.[23]

The hotel stayed in the Henry family until 1964 when Pearl Bonner, a former teacher who had run another boarding house nearby, purchased it with a four-hundred-dollar investment and a rent-to-own deal. She renamed the building Henry's Hotel, and she and her daughters operated the facility with a firm innkeeper's hand.[24]

Rather than running the hotel as a vacation destination, Bonner ran the property as a rooming house for African American men who worked in Ocean City. Bonner and her family successfully ran the hotel for four decades until she died in 2003.

Today, the historic structure stands at its original location on the corner of Division and Baltimore Streets but hasn't had a visitor in decades. In 2007, "The Henry" was named one of four African American heritage landmarks on the Lower Eastern Shore.

In 2024, the Henry Hotel Foundation, an Ocean City nonprofit dedicated to the restoration of the historic hotel, was approved for a $250,000 grant to begin exterior rehabilitation projects at the site.[25]

THE HOTEL MATTHEWS

Akron, Ohio

Proprietor: George Washington Mathews

Hotel Matthews was centrally located on Howard Street, at the heart of the Black business and entertainment district in Akron, Ohio. Owned and operated by entrepreneur George Washington Mathews, the property was the first premier hotel for Black patrons in Akron. Mathews was one of many successful African American entrepreneurs along Howard Street from the 1930s to the 1960s.

Born in 1887, Mathews was the eldest of ten sons born on a cotton farm in rural Georgia. In 1908, he left home and headed to Alabama to find work. After saving enough money from working odd jobs, he traveled north and landed in Akron on his way home from a boxing match in Toledo, Ohio. In 1920, he decided to make Akron his home. Mathews purchased an old eleven-room boarding house where he opened his first barbershop. In 1925, using every penny he possessed, Mathews purchased a second rooming house at Seventy-Seven North Howard Street and opened Hotel Matthews.

Although Mathews spelled his name with one T, the sign on the hotel storefront read "Matthews" all the same. It is believed that it was an error of the sign makers—a discrepancy that was never rectified, though the advertisements in local newspapers always featured the proper spelling.

Within five years Mathews opened a barber shop and beauty parlor inside of the hotel. Hotel Matthews was one of the only three hotels in Akron providing service to Black patrons, and the property was listed in the *Green Book* from 1938 to 1967.

George Washington Mathews, owner of Hotel Matthews. From the Steward, Horace, and Evelyn Photograph Collection, University of Akron Archives and Special Collections, University Libraries.

Hotel Matthews. From the Steward, Horace, and Evelyn Photograph Collection.

The Matthews featured modern amenities, affordable room rates, and impeccable service. The property eventually expanded to sixty rooms. Mathews and his wife, Alberta, ran the business together. The Mathews liked to describe their establishment as a "Business with a Soul."

Mathews standing at the rear of his hotel's beauty salon.
From the Steward, Horace, and Evelyn Photograph Collection.

During the 1940s through the 1960s, Howard Street was the heart of Akron's African American and jazz culture. During its heyday, Hotel Matthews hosted many prominent Black entertainers such as Count Basie, Duke Ellington, Cab Calloway, and Ella Fitzgerald. By this time Mathews was recognized as one of the most successful Black businessmen in Akron, his Hotel Matthews having become an anchor and focal center within the Black community. Many organizations, in fact, held their meetings in Hotel Matthews. Mathews was active in his church and other civic organizations such as the Masons, the Colored Elks, and the NAACP. Although he hadn't graduated from high school, let alone attended college, in 1964 Mathews established a $25,000 endowment fund for student scholarships at the University of Akron.

By the mid-1960s, the Howard Street community began to decline, as did much of Akron amid the collapse of the booming rubber industry the city was built upon.

As Mathews neared retirement, he decided to hire employees to run the hotel while he maintained ownership of the property. Hotel Matthews, along with many other businesses on Howard Street, was deemed blighted with urban renewal projects beginning in the 1970s. In 1978, Hotel Matthews was forced to shut its doors permanently. In 1982, the property was demolished to make way for the Innerbelt. Mathews died the same year at ninety-five years old. The Innerbelt was never finished, and the former hotel location was abandoned in downtown Akron.

An Ohio Historical Marker was placed at the Hotel Matthews location in 2001. Today the only remnants of the historic Howard Street District can be seen at the Mathews Monument, located at the corner of Howard Street and Martin Luther King Boulevard in Akron. The monument was designed by local artist Miller Horns and features a brick facade with a green door and barbershop pole. Horns advocated for the monument sixteen years before it was completed in 2012. He died shortly after the monument was completed.[26]

The Hotel Matthews monument, Akron, Ohio. Photograph taken and used by permission from August Drabick.

THE RENDEZVOUS HOTEL

Anchorage, Alaska
Proprietress: Zula Swanson

The color line extended as far as American settlements did. Throughout the 1940s and 1950s, Zula Swanson built a real estate empire and became one of the largest land-owners in the state of Alaska, including the Rendezvous Hotel in Anchorage.

Swanson was born in Jackson's Gap, Alabama, in 1891. Though information about her early life is meager, it is known that she unhappily worked on a cotton plantation. In 1918, faced with Jim Crow and the lack of opportunities in general for African Americans, Swanson moved to Portland, Oregon, where she worked as a dressmaker. Shortly after arriving in Portland, she married John Lowe, a mechanic and chauffeur. The marriage did not last.

During the 1920s, Swanson survived through prostitution, yet she managed to accumulate a large savings. By the end of the decade, she fled to Anchorage to make a fresh start after narrowly escaping drunk-driving and bootlegging charges, which involved the death of a woman.

Zula Swanson, owner of the Rendezvous Hotel. Reproduced by permission from the Anchorage Museum.

Swanson settled in a small frontier town of only three thousand inhabitants populated mostly by white fishermen, loggers, laborers, and miners. She soon realized a profitable business opportunity, parlaying her savings into purchasing a burned-out building on a downtown corner lot for $2,000 dollars, where she erected a brothel camouflaged as a boarding house. It was here she also opened the Rendezvous Hotel, which included a lounge and served as a networking space for African Americans in the segregated town. The bar was often the first stop for the town's newcomers seeking employment and housing.[27]

Swanson formed partnerships with local white civic leaders, both personal and professional. In the 1930s, she began an affair with an "unnamed" prominent white businessman whose influence reportedly kept her out of trouble with law enforcement.

Throughout the 1940s and 1950s, Swanson added to her real estate empire, purchasing commercial and residential lots throughout the city. By the 1960s, she had made herself into one of the largest landowners in the state of Alaska, eventually selling one of her downtown lots to developers for an estimated $250,000. In 1969, she was named "Alaska's Richest Black" by *Ebony* magazine.[28]

In retirement, Swanson leased the Rendezvous Hotel to a white couple before building a large suburban home on Goose Lake, where she maintained active involvement in various community clubs and civic associations. She was a member of the Daughters of the Elks and the Northern Lights Civic and Social Club. In 1951, Swanson was also one of the founding members of the Anchorage chapter of the NAACP after a racially motivated arson attack burned down a Black home in Rogers Park in 1950.

Zula Swanson died in Anchorage in January 1973 at the age of eighty-two, her transition from cotton-picking to bourgeois respectability complete.

JACKSON HOUSE HOTEL
Harrisburg, Pennsylvania
Proprietor: German I. Jackson

Though German Jackson's contributions to the hospitality industry are largely unknown today, he became one of Harrisburg's most prosperous hoteliers and entrepreneurs during the twentieth century. When Black headliners and their bands performed at segregated clubs in the city, they stayed at the Jackson House, located in the lively Seventh Ward business district, home to many Black clubs and hotels.

The son of slaves, Jackson grew up one hundred miles south in Winchester, Virginia, near the site of a famous 1893 lynching in which a mob apprehended a Black teenaged male accused of assaulting a white woman on a train.[29]

Jackson was part of the Great Migration from the South. He traveled north to get an education but, ultimately, only completed the seventh grade. He was nevertheless a hard worker and earned the respect of those who knew him.

Jackson was an advocate for equality and dreamed of opening a hotel in Harrisburg to serve African American travelers. However, in 1925 a competing Black hotel proprietor, Morris Cowan, opened the forty-room Booker T. Washington Hotel in Harrisburg to cater to Black patrons.

Cowan, headwaiter at the segregated upscale Penn Harris Hotel, renovated a dated hotel called the Eagle and renamed it after the founder of the Tuskegee Institute. Cowan changed out the hotel furnishings and removed the bar, following Prohibition's strictures.

In 1927, two years later, Jackson followed in Cowan's footsteps and purchased a three-story Second Empire–style home at 1006 North Sixth Street for $9,000 (approximately $165,000 in value today). Built in 1884, the brick building was erected as a residence for dry goods merchant Frank Hess and his wife Eleanor. In 1910, a leatherer purchased the property and added an additional story for his shop.[30]

Jackson renovated the property to accommodate about ten guests and called it the Jackson House (sometimes referred to as Jackson Rooming House). The interior decor included elaborate woodwork, gaslight fixtures, and pocket doors inlaid with red glass. Jackson and his wife, Betty, lived on the property. He later opened a coffee shop next door.

> The Booker T. Washington … will appeal to these colored people who heretofore traveling through Harrisburg have been unable to secure adequate accommodations.
> —from the *Harrisburg Telegraph*, 1925.

German I. Jackson.
Photograph courtesy of Calobe Jackson Jr.

Both Cowan and Jackson had years to learn the hotel trade while working at the Penn Harris Hotel. Jackson, a Penn Harris bell captain, had worked at the property since it opened in 1918. Jackson would continue to serve there for several decades.

The upscale Penn Harris's four hundred rooms and four restaurants dwarfed both the Booker T. and the Jackson House. In its heyday, the Penn Harris Hotel was the favored meeting place of Pennsylvania's political elite.[31] It was, of course, segregated.

Black people weren't allowed to spend the night at the lavishly appointed hotels like the famed Penn Harris Hotel and other downtown hotels. They were only welcomed to stay at the few hotels and rooming houses that catered to African American travelers. Cowen's hotel, along with Jackson's, were two of only a few establishments that catered to African American travelers in Harrisburg.

Not everyone accepted Harrisburg's segregation. In 1937, a group of African American school teachers from Philadelphia visiting Harrisburg for a convention sued the Penn Harris for refusing them service.

Warrants were served on the property's management for violation of the state's Equal Rights Act of 1935.

The Penn Harris allowed both Cowan and Jackson to remain employed at the hotel despite their new hotel ventures. When Jackson opened another hotel in Atlantic City, Penn Harris's president Franklin Moore offered to sell him furnishings at a steep discount to appoint his new property.[32]

Harrisburg became a frequented "hot spot" for jazz musicians during the Jazz Age while traveling through the East Coast. The Jackson House was much adored and considered one of the best hostelries in the city free from segregation and discrimination. It became a favorite place for Black guests, performers, athletes, and celebrities. Among the legendary performers who stayed at the Jackson House were Duke Ellington, Ella Fitzgerald, Pearl Mae Bailey, Cab Calloway, Count Basie, and Louis Armstrong. Joe Louis stayed at the Jackson House while visiting Harrisburg as a guest referee for the Harrisburg Golden Gloves tournament in December 1940.

> To start out each morning with a smile and a kindly feeling toward everyone regardless of race or creed and with the privilege of working hard. This to me is America's precious freedom of opportunity.
> —German Jackson, 1952

Volunteers assist with the Jackson House Mural. Photo credit: Sean Simmers (PennLive / *Patriot News*).

The Jackson House Mural sat on the north wall. Photo credit: Joe Hermitt (PennLive / *Patriot News*).

During the late twentieth century, the economic and social environment of the Seventh Ward landscape began to shift. Over time, the Jackson House survived as the last remnant of a once-thriving African American business community. The Jackson Hotel and surrounding properties fell into disrepair, and preservation efforts to save the historic landmark failed to materialize.

German Jackson died in 1998. The building was razed in January 2021. Amongst the debris was an eye-catching mural of the hotel's founder alongside famous African American guests who stayed at the monumental landmark, painted on the north facade of the building in 2017 by Sprocket Mural Works artist Cesar Viveros and dozens of volunteers.[33]

Today, the Jackson House sandwich shop, which opened in 1982, sits on a tiny lot next to where the revered Jackson Hotel once stood.

THE HOTEL SOMERVILLE / DUNBAR HOTEL

Los Angeles, California
Proprietors: John and Vada Somerville

In the late 1920s, Dr. John Alexander Somerville and his wife Dr. Vada Somerville opened the first hotel in South Central Los Angeles for Black patrons. They remain among the most influential success stories of twentieth-century Black Los Angeles. Both hoteliers and tireless advocates for Black Angelenos, the Somervilles were pillars of the African American community. The Hotel Somerville (later named Dunbar Hotel) became the hub of Central Avenue's vibrant jazz scene from the late 1920s to the early 1950s. Located on Forty-First Street and South Central Avenue, the Hotel Somerville became the heart of Black culture in Los Angeles and a beacon for the South Central community.[34]

The Hotel Somerville, ca. 1928.
From the Miriam Matthews Photograph Collection, UCLA Library Special Collections.

Despite failing an exam for a university scholarship in his native Jamaica, Somerville was an exceptional student. He took a job as a bookkeeper with an export company and decided, after two years of saving, he would travel to the United States. In 1901, twenty-year-old Somerville took a boat to San Francisco. Having been raised in one of the most integrated cultures in the Caribbean, Somerville was stunned by the blatant racism he experienced in the Bay Area. He was shocked that he could not get a decent meal, employment, or lodging because of his skin color.[35]

Somerville initially planned to attend Howard University and then return to

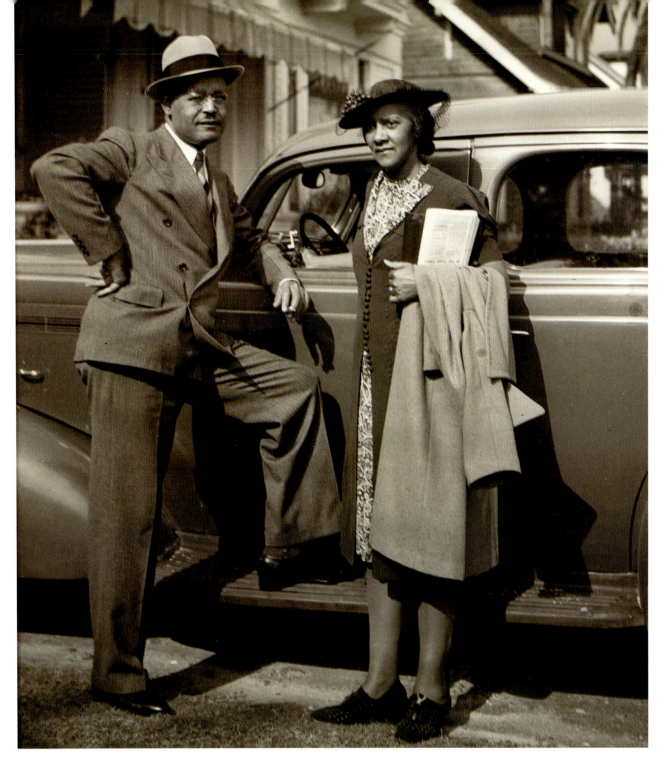

Drs. John and Vada Somerville. From the Miriam Matthews Photograph Collection.

practice dentistry in Jamaica. However, his disappointments in San Francisco led him to travel south to the Redlands in San Bernardino County. While there he resided with a Black family and worked in a bowling alley. Within two years, Somerville saved $250 for tuition and headed to Los Angeles to attend dental school at the University of Southern California. On his first day, his white classmates threatened to leave the program unless he was dismissed. But the school supported Somerville and the controversy waned.[36]

While at USC, John met Vada Watson, who was pursuing a liberal arts degree on a *Los Angeles Times* scholarship.

In 1907, Somerville graduated first in his class with honors, becoming the first African American to earn a DDS degree from USC. He established a practice at Broadway and Fourth Street, then the center of L.A.'s Black business district. Vada and John were married in 1912 and remained together for almost sixty years.

Like most professional Black intellectuals in their time, the Somervilles were prominent leaders in the fight against discrimination. They became close friends of activist and NAACP cofounder W. E. B. Du Bois. In 1914, the Somervilles founded the Los Angeles chapter of the NAACP, with John presiding as its first president, a position he held for a decade.

When World War I began, the couple grew concerned that John might be drafted, putting his dental practice in jeopardy. Vada decided to enroll in dental school and earn a degree in dentistry herself. In 1918, Vada became the first African American woman to earn a DDS degree from USC's School of Dentistry. The couple operated their practice from their home at San Pedro and Eighteenth Street.[37]

Throughout her fifteen years of practice, Vada engaged in club work and political activities in support of Black women. She was involved with the Los Angeles League of Women Voters, the Council on Public Affairs, and UCLA's YWCA; she also hosted a club for Black women dedicated to discussing art and moral philosophy.

In 1925, the Somervilles purchased a parcel of land at the northeast corner of San Pedro Street and Vernon Avenue and built the twenty-six-unit La Vada Apartments. It was the first modern apartment building constructed in Los Angeles specifically for Black tenants. The move was heralded as both an effort to address the housing shortage for African Americans and to promote Black business enterprise.[38]

Hotel Somerville lobby.
From the Miriam Matthews Photograph Collection.

Despite a growing middle- and upper-class Black population, there were still no first-rate hotels in Los Angeles that would accept African Americans. When traveling, most African Americans stayed with family or friends, or spent the night in unkept and poorly run Black boarding houses, which were often unsafe.

The Somervilles and other prominent civic leaders decided to change that. By the 1920s, L.A. had already been home to a few successful Black-owned hotels, including Ida B. Wells's Southern Hotel and the Clark Hotel, also on Central Ave.[39] But Somerville wanted his hotel to be something new in the city. He and Vada wanted the Hotel Somerville to be a center for culture and civil rights activism.

In late March 1928, to fund their dream hotel, the Somervilles partnered with prominent business leaders and launched the Somerville Finance and Investment Company, through which they raised $250,000 (equivalent to nearly $4.6 million today).[40] Twenty-seven years after Somerville had been denied access to San Francisco hotels, the Somervilles dedicated the four-story upscale hotel that bore their name—the Hotel Somerville.

The Hotel Sommerville was a pioneering enterprise, inarguably the first hotel in Los Angeles erected ground up by African Americans. Typically, Black hoteliers purchased and refurbished old properties vacated by whites. The Hotel Somerville was erected right in the heart of a burgeoning commercial and cultural district for Black Angelenos, built by all-Black laborers, contractors, and craftsman from the South Central community. The Somervilles held lease agreements for businesses within the hotel, including a barber, drugstore, and doctor's office; they also held a lucrative lease with the Fred Harvey Dining System, the nation's most successful railroad dining operation across the nation.[41]

The Hotel Somerville opened for business on June 23, 1928. An estimated five thousand people showed up to the hostelry's grand-opening gala, marveling at the stylish, four-story modern enterprise that included a hundred rooms, all appointed with custom furniture, sixty private baths, an art deco lobby complete with orchestra balcony, and a dining hall, café, restaurant, pharmacy, barbershop, beauty parlor, and other businesses (many run by Black women) on the ground floor.

That same year, not soon after its opening, the Somerville hosted the NAACP's first West Coast national convention.[42]

In the September 1928 issue of NAACP's magazine, *The Crisis*, W. E. B. Du Bois called the hotel "a beautiful inn with a soul," and "an extraordinary surprise to a people fed on ugliness—ugly schools, ugly churches, ugly streets, ugly insults. . . . It was so unexpected, so startling, so beautiful."

The Hotel Somerville was a shining symbol of excellence for a Black community often shut out of commercial and industrial opportunities in Los Angeles. With its upscale appointments, and the presence of Club Alabam next door (a prime location on a two-block strip of jazz venues), the Sommerville was the gathering place for African Americans. W. E. B. Du Bois and other Black professionals and intellectuals discussed civil rights and plans to improve the lives of African Americans every night of the week in the Somerville lobby.

The hotel hosted some of the most prominent Black intellectuals and celebrities of the day, including Langston Hughes, Thurgood Marshall, and entertainers Bill "Bojangles" Robinson, Josephine Baker, Herb Jeffries, Louis Armstrong, Duke Ellington, Count Basie, Jimmie Lunceford, and W. C. Handy.

Despite the property's initial success, the stock market crash in 1929 hit the Somervilles hard. Nine months after the hotel opened, they lost the property through foreclosure. As a result, they were ordered to vacate their managerial roles. Consequently, the hotel fell into the hands of a group of white investors.[43]

Over the next few years, ownership of the building traded hands. In 1930, the Sommerville was purchased by astute Black businessman Lucius Walter Lomax Sr., who renamed it the Dunbar Hotel, after the famous poet and playwright Paul Laurence Dunbar. In 1931, Lomax obtained a permit to operate a nightclub. During the early 1930s, the hotel continued to be the foremost Black-owned hotel in Los Angeles under Lomax's direction.[44]

In 1933, Lomax's success streak came to an end when the property faced another round of foreclosures. In 1935, the hotel was briefly owned by Father Divine, a prominent Black spiritual leader who founded the International Peace Mission Movement. The Dunbar was then converted into a hostel for members of the Peace Mission Movement and no longer operated as a traditional hotel.

In 1936, former Chicago businessman James "Jimmy" Nelson, an astute Black businessman in South Los Angeles, purchased the Dunbar. The property quickly regained its popularity as a hot spot in South Central and across the city of Los Angeles. The newly redesigned hotel lobby captured the attention of residents and visitors. Nelson was credited with reinvigorating the Dunbar after years of dormancy.

Nelson proved to be a highly competent hotelier and would become the face of the Dunbar during its most formidable years. With nearby venues featuring the biggest names in jazz, during the 1930s and 1940s Central Avenue became a nightlife destination. In 1937, after the sudden departure of the hotel's manager, Nelson asked his nephew Celestus "Celes" King Jr. to come to California and manage the hotel.[45]

Nelson was a sports fanatic. In the mid-1930s, former heavyweight boxing champion Jack Johnson, a friend of Nelson's, briefly operated his Showboat nightclub there with his accompanying orchestra named The Melody Champions.[46]

The Dunbar Hotel welcomed all the jazz greats including Ella Fitzgerald, Cab Calloway, Duke Ellington, Fats Waller, Nat King Cole, Lena Horne, Jimmy Lunceford, Billy Eckstein, Billie Holiday, Jelly Roll Morton, Ray Charles, and Count Basie. After entertaining audiences at the all-white venues across town, performers would stay at the Dunbar and sometimes occupy entire floors of the hotel. Those who couldn't afford to stay at the Dunbar congregated outside, "holding up the wall." The strip in front of the hotel became a cruising area, where locals showed up and showed off.[47]

After World War II, things began to shift on Central Avenue. While there were still gifted musicians playing at some of the venues, the demographics changed. In 1948, the Supreme Court ended the racial covenants that white landowners used to keep Black people and other minorities out of their neighborhoods. Soon after in 1952, Nelson passed away, and the property again went up for sale. In 1958, Celestus King Jr. bought the building, and renamed it King's Hotel. The property was never able to regain the vibrancy of its heyday. In the 1960s, the hotel fell on hard times as Black residents and businesses dispersed throughout the city.[48]

In 1968, African American Bernard Johnson purchased the property and dreamed of restoring the hotel to its former glory. But by this time the magic the Dunbar once had was gone. The hotel fell into disrepair and in 1974 shut its doors for good. That same year, the Dunbar was recognized as a Los Angeles Historic-Cultural Monument.

Despite the hotel's decline, there was still community support to save the historic building. In 1975, Johnson established the nonprofit Dunbar Hotel Cultural and Historical Museum Inc, and in 1976, the Dunbar was placed on the National Register of Historic Places. In 1983, the nonprofit group formed a taskforce to refurbish the hotel with a new facade, affordable housing, and a Black history museum. In April 1987, the nonprofit received a $2.9 million, thirty-year loan from L.A. City to refurbish the hotel.

In 1990, the Dunbar reopened as a seventy-three-unit apartment building for low-income senior citizens with a museum of African American history. However, the restoration was short-lived: nearly two decades later the property fell into dilapidation after L.A. City foreclosed it due to default on most of the $2.9 million loan.[49]

In 2011, Dunbar Village LP purchased the Dunbar Hotel, along with the nearby Somerville Apartments, as part of a massive $30 million renovation. The company converted the low-income senior housing into a mixed-use development called the Dunbar Village. Today, the Dunbar Hotel has a total of eighty-three units, with forty-one allotted for senior housing and forty-two units for affordable housing.[50] There's a restaurant on the lower floor, and the name "Hotel Somerville" is still there, emblazoned on the sidewalk on the Central Avenue side of the building.

In 2014, the L.A. Conservancy awarded the newly completed Dunbar Village a Conservancy Preservation Award.

Although the Somervilles' affiliation with the property was short-lived, they continued to play a prominent role within Black life in Los Angeles for many years to come. Vada would manage a newspaper and lead numerous charitable and cultural organizations. In 1936, John served as the second Black member of the Los Angeles Chamber of Commerce and California's first Black delegate to a Democratic convention. In 1949, he published the autobiography *Man of Color* and became the first African American appointed to the Los Angeles police commission, serving from 1949 to 1953. For his contributions to Anglo-American affairs, in 1954 Queen Elizabeth II declared him an Officer of the Order of the British Empire.

Shortly after the couple's sixtieth anniversary in October 1972, Vada died at age eighty-six. John passed a few months later at the age of ninety-one on February 11, 1973, at Good Samaritan Hospital in Los Angeles.[51]

THE DEW DROP INN

New Orleans, Louisiana
Proprietor: Frank Gerald Painia

New Orleans has long had a reputation for being a significant music and entertainment mecca. One iconic hotel to live up to its reputation was the well-known Dew Drop Inn in New Orleans. *The Louisiana Weekly* called the Dew Drop Inn "one of the swankiest places in town."[52]

The Dew Drop Inn's owner and operator Frank Gerald Painia offered his clientele much more than entertainment. From 1945 to 1970, the Dew Drop, located along the LaSalle Street corridor in the Central City neighborhood of New Orleans, offered the Black community access to a high-quality hotel, a restaurant, a bar, and a barbershop. The "Drop," as it was fondly called, became one of the most culturally significant venues in the U.S. and served as the hub of entertainment and civic activities for New Orleans residents and visitors, regardless of race or gender.

Frank G. Painia was born in the Iberville Parish town of Plaquemine in 1911. In 1934, he left Plaquemine to escape poverty-stricken rural Louisiana and moved to New Orleans with his wife Feddie and two young children.

Painia only had a seventh-grade education and was a barber by trade. He and his family moved in with his sister and became a partner in a barber shop on LaSalle Street. When the shop was demolished a couple of years later to make way for a housing project, Painia opened his own shop on the corner of LaSalle and Sixth.[53]

Frank G. Painia (*left*).
Image courtesy of Dew Drop Inn.

Painia soon purchased a building from a businessman who owned a bar and a grocery store just two doors down. He renovated the building to accommodate his barber shop and bar/restaurant. Painia's brothers Paul, a cook, and Easton, a bartender, relocated from Plaquemine to help him run the business. The establishment called the Dew Drop Inn opened its doors in April 1939.

Although the Dew Drop Inn had a difficult start, Painia was a savvy businessman. In 1945, he purchased a residential building next door to open a hotel for Black residents and travelers who needed a nice place to stay. Painia began experimenting with local entertainment in the lounge and found a great demand for live music. The "Groove Room" served as a training ground for many New Orleans musicians. By October 1945 the *Louisiana Weekly* began referring to the spot as "New Orleans' swankiest nightclub." The facility was featured in the *Green Book*, and the enterprise was a testament to Black entrepreneurs' creative and innovative spirit amid the Jim Crow segregation era.[54]

Reaching back to the vaudeville days, floorshows at the Dew Drop featured dancers, comedians, novelty acts, and a house band that backed a variety of artists that kept the place hopping. Emcees for these shows included Joseph "Mr. Google Eyes" August as well as Patsy Vidalia, an openly gay female impersonator.[55]

The 1950s was a phenomenal decade for the Dew Drop Inn. Many Black artists who performed at venues along the Chitlin' Circuit played there and later became household names in rock 'n' roll. The Drop was host to many iconic Black musicians of the 1950s and 1960s, including a young Ray Charles. Little Richard not only stayed at the Drop but also recorded and performed there as well. Other entertainers who performed at the Drop included "Soul Queen of New Orleans" Irma Thomas and Fats Domino.[56]

Dubbed "the Mayor of LaSalle Street," Painia was well-respected within the Black community. A pioneer as well in the civil rights movement, he consistently lobbied to eliminate segregation laws. In a much-publicized incident in November 1952, Painia, along with white screen actor Zachary Scott and people in his party, was arrested and charged with disturbing the peace and "race mixing." Scott was on location in New Orleans for a film and was visiting the club when the New Orleans Police Department received a complaint that "Negroes and whites were being served together." Painia decided to make a stand and went to jail with the club's patrons.[57]

The early 1960s continued to be favorable years for the Dew Drop as Painia varied his floor shows to meet his audience's tastes. When soul became the latest trend, the Dew Drop hosted the likes of James Brown, Etta James, Sam Cooke, the Ike & Tina Turner Revue, Joe Tex, and Otis Redding.

While the public's taste in music changed over the years, Painia adapted, continuing to offer the best entertainment in New Orleans. In fact, Little Richard would immortalize the club when he recorded the appropriately titled "Dew Drop Inn" years later.

Like many of the Black-owned establishments during the mid-1960s, the Civil

Dew Drop Inn. From the Ralston Crawford Collection of Jazz Photography, Tulane University Special Collections, New Orleans, Louisiana.

Rights Act of 1964 was the beginning of the end for the Dew Drop Inn. By the end of the decade, the Groove Room was closed, and the more profitable hotel portion of the facility was expanded.

The business, which was already declining, floundered after Painia died in 1972. After his death, the barbershop, restaurant, and bar were leased out to new occupants, while Painia's wife Feddie struggled to maintain the hotel. By the mid-1970s the building had fallen into disrepair and was listed for sale on several occasions. In 2005, the property was ravaged by the aftermath

of Hurricane Katrina. The dilapidated property sat vacant for years.

In 2010, the Dew Drop Inn was given Historic Landmark status and listed as an endangered New Orleans site by the Louisiana Landmarks Society.[58]

In 2017, The National Trust for Historic Preservation launched the African American Culture Heritage Action Fund to recognize more sites meaningful to Black experiences. In 2022, the Dew Drop Inn was added to the list.

Frank Painia's grandson Kenneth Jackson eventually sold the property to local Black

Dew Drop Inn, refurbished. Image courtesy of the Dew Drop Inn.

developer Curtis Doucette Jr. on the condition that he revitalized the property in a way that honored its legacy. The newly renovated $10 million project includes a 400-person music venue, bar, swimming pool, and seventeen hotel rooms, each themed after a Dew Drop Inn legend.[59]

The restoration of the Dew Drop Inn was part of a concentrated effort to revitalize Central City. The new Dew Drop opened in 2024 with a performance by Irma Thomas, sixty-three years after her last appearance there.[60]

Dew Drop Inn, refurbished lounge.
Image courtesy of the Dew Drop Inn.

Dew Drop Inn, refurbished
welcome area. Image courtesy
of the Dew Drop Inn.

FOUR

THE GROWTH OF
BLACK HOSPITALITY
IN MIAMI

AFRICAN AMERICAN HOSTELRIES
TURN UP THE HEAT IN MIAMI

African American entrepreneurs and hoteliers were not only instrumental in erecting fine individual accommodations. In some instances, they were responsible for laying the groundwork for an entire hospitality infrastructure that would later become a destination visited by millions. They did this not only in spite of segregation but also from the very segregated places that white supremacy had created. Such was the case in Miami.

When the city was first incorporated, Miami's original charter called for a separate area to be set aside for African Americans, who became concentrated in what was derogatorily termed "Colored Town" (present-day Overtown) on the northwest outskirts of downtown.

Although Colored Town's population sometimes contained at least 25 percent of Miami's population, it did not receive a fair proportion of city improvements. The area was burdened with poor roads, drainage, and sewage collection, and its inhabitants could not count on clean water. The community's general impoverishment compounded these deficits to the result of various health epidemics. Although the birth rate was high in Colored Town, its infant mortality rate was twice that of white Miami.

Once incorporated, Miami and South Florida quickly grew, its emerging potential attracting many Black people seeking economic opportunities. Between 1900 and 1920, ten to twelve thousand Black Bahamians, approximately 20 percent of that country's population, emigrated to Florida.[1]

By 1948, Black winter tourists, otherwise barred from the many exclusive Miami Beach hotels, did not have to worry anymore about hotel accommodations in this tropical resort.[2] There were several fine hostelries in the African American section of Miami.

Overtown eventually became one the hottest black entertainment meccas in the country during the 1950s and 1960s. Though normally forbidden lodging at the hotels at which they performed, legends like Dinah Washington, Lena Horne, Count Basie, Sammy Davis Jr., Mary Wells, Sam & Dave, James Brown, Aretha Franklin, Ella Fitzgerald, B. B. King, Nat King Cole, and Jackie Wilson stayed while performing there.

THE DORSEY HOTEL

Miami, Florida

Proprietor: Dana Albert "D. A." Dorsey

Named Miami's first Black millionaire hotelier, Dana Albert "D. A." Dorsey was also an influential African American businessman, banker, philanthropist, and real estate magnate. Dorsey owned and operated the Dorsey Hotel, the first Black-owned hotel in Miami, Florida. Along with his wife Rebecca, Dorsey was among the early founders of Miami and acquired extensive real estate holdings in the newly incorporated city. The Dorseys built, sold, and leased property to many of Miami's early Black residents. Dorsey was also the proprietor of the Negro Savings Bank, and once owned twenty-one acres of what is now Fisher Island near Miami Beach, now recognized as one of the most affluent zip codes in the nation.[3]

The son of former slaves, Dorsey was born in 1872 in Quitman, Georgia. A self-taught man, he only received a fourth-grade formal education. By 1892, Dorsey lived in Titusville, Florida, working for the Florida East Coast Railway run by Henry M. Flagler. Since there were no roads to Biscayne Bay at the time, Dorsey reportedly made the journey down the Florida coast alone on a raft he built himself. Dorsey's involvement in early Miami began around 1896.[4]

Black people from the Bahamas, Georgia, and other parts of the South helped build the railroad and the city of Miami. Black laborers were forced to live in tents near their worksites. Dorsey recognized the need to provide housing for these workers, so he began to invest in real estate. Dorsey purchased his first parcel of land for twenty-five dollars in Overtown's aforementioned northwest sector of Colored Town. He erected one small shotgun-style rental house per parcel, reinvesting the rental income to purchase additional parcels, and soon accumulated large blocks of real estate. Dorsey rented the houses, but never sold any.

At the time, Black residents in Miami were prohibited from participating in the real estate market, disallowed from owning or renting homes or commercial properties. This discriminatory practice was enforced by race-restrictive covenants in property deeds, prohibiting Black people from purchasing or leasing property in white communities.

Dana Albert "D. A." Dorsey, Miami's first Black millionaire hotelier.

In 1914, Dorsey was listed as the only African American real estate agent in Miami. He became one of the pioneer land owners in the Liberty City development. Through the constant reinvestment of his rental income into more rental properties, Dorsey was able to extend his holdings as far north as Fort Lauderdale. His wife Rebecca played a significant part in Dorsey's business ventures, serving as his business partner and record keeper.[5]

In 1917, during the height of Miami's segregation period, Dorsey and Rebecca sold land to the City of Miami for a park for African Americans (known today as Dorsey Park in Miami).

In 1918, Dorsey purchased Elliott Key and the twenty-one-acre barrier island now known as Fisher Island from Herman B. Walker so he could provide access for African American beachgoers. The *Miami Daily Metropolis* reported "Negro Buys 1/3 of the Keys to Erect a Colored Resort."[6] Dorsey wanted to establish a Black resort as during the Jim Crow era Black people were forbidden on Miami public beaches. The resort would have a hotel, cottages, and—because Fisher Island is only accessible by ferryboat or private yacht—boats to transport visitors between Florida's mainland and the island.[7]

Due to geographic obstacles, manpower challenges, and overt racism, Dorsey was unable to proceed with construction on Fisher Island. After nearly two years of ownership, he sold the island to automotive pioneer and land developer Carl G. Fisher, who was in the process of developing Miami Beach. In 1925, William Vanderbilt II traded a luxury yacht to Fisher for ownership of the island. Today, Fisher Island is consistently ranked as one of the most exclusive and wealthiest enclaves in the U.S.[8]

By 1920, Dorsey had amassed an extensive portfolio of real estate holdings, eventually becoming the first African American millionaire in Miami. Dorsey owned properties with Miami pioneers such as Julia Tuttle—the "Mother of Miami"—and Henry Flagler.

In 1920, Dorsey became the owner of the first Black-owned hotel in Miami when he built the Dorsey Hotel. Some of the white influentials who visited were awed by Dorsey's accomplishments, achieved under difficult circumstances. Some even went to Dorsey for financial support. During the Depression, Dorsey—who had also founded the Negro Savings Bank—loaned William Burdine, the white owner of the largest department store in downtown Miami, $30,000. Burdine agreed to make Dorsey part-owner of the store. After the Depression, however, Burdine repaid the loan with interest but informed Dorsey that he was no longer part-owner. According to Chapman, Dorsey never forgave Burdine for his actions.[9]

As a community leader, Dorsey served as chair of the Colored Advisory Committee to the Dade County School Board. He also financially supported Bethune–Cookman College (now University) and even donated large land tracts for African American schools, including land to the Dade County Public Schools on which Miami's first Black high school, Dorsey High School (now known as D. A. Dorsey Educational Center) was built in 1936.[10]

On February 14, 1940, just fifteen days before his death, Dorsey donated the land on which a library for African Americans was to be constructed. Dorsey's donation came with an eighteen-month timeline. The Washington Heights Neighborhood Association and the Friendship Garden Club worked to raise funds, and the City of Miami also donated $7,000 to meet the deadline. On August 13, 1941, the Dorsey Memorial Library opened its doors in Overtown.

On the day of Dorsey's passing, flags were flown at half-staff all over Miami. He was buried in Lincoln Memorial Park, Miami's African American cemetery. Some two thousand mourners attended.

In 2003, the Dorsey Memorial Library was deemed a historical place by the city of Miami. On January 17, 2018, Miami city leaders held a ceremonial groundbreaking to launch a $1.3 million renovation project for the historic preservation of the library. The D. A. Dorsey home has been restored and is now a museum, sitting on the National Register of Historic Places.

The remnants of the Dorsey Hotel were ultimately lost in a fire in January 1981.

By today's standards, Dorsey would have been a billionaire at the time of his death. He owned real estate not only in Dade and Broward counties but in Cuba and the Bahamas as well. His extensive real estate holdings are considered to be the largest-ever held by an African American man in Miami–Dade County.

THE MARY ELIZABETH HOTEL

Miami, Florida

Proprietor: William B. Sawyer

Dr. William B. Sawyer was an African American physician, civic leader, hotelier, and owner of the Mary Elizabeth Hotel, located in the spirited Miami Black business and entertainment district of Colored Town. Dynamic husband-and-wife entrepreneurial teams remained a common feature of

Black hospitality, and William and his wife Alberta were no exception. A savvy businesswoman during a time when such high-profile roles for women were extraordinary, Alberta Sawyer proudly operated the Mary Elizabeth. The hotel was located on a northwest sector of Second Avenue known as "The Strip," or "Little Broadway," and became a focal center of Colored Town's vibrant night life. Sawyer also founded Miami's first hospital for African Americans, Christian Hospital.[11]

William B. Sawyer, owner of the Mary Elizabeth Hotel.

Sawyer was born in 1886, in Waldo, Florida, a small community near Gainesville; little is known about his parents. Sawyer worked as a water boy at a train depot in Waldo. After an altercation with a white youth, Sawyer was sent on the next train out of town by his parents, who feared for his life. Information about his life dries up until his enrollment at Edward Waters College in Jacksonville. He later transferred to Atlanta University, where he earned money to finance his education by cooking breakfast and firing the furnace for W. E. B. Du Bois. Du Bois became Sawyer's mentor and inspired his extraordinary ambition.

Taking heed of Du Bois's advice, after graduation Sawyer enrolled in the top African American medical school in the U.S., Nashville's Meharry Medical College, paying for his tuition by firing the furnaces of the wealthy white students at Vanderbilt. In 1908, Dr. Sawyer, the youngest student in a class of 107, graduated with honors. After graduation, Sawyer relocated to Miami, settled in Colored Town, and established his practice there.[12]

Sawyer was a welcome addition to Colored Town, being one of the first Black physicians in the area. He earned post-graduate accreditations from Frederick Douglass Hospital in Philadelphia and Providence Hospital in Chicago, and his reputation as a surgeon grew apace.

In 1910, Sawyer married Alberta Preston. They had two children, Gwen and William Jr.

Sawyer and S. M. Frazier, the only other Black surgeon in Colored Town at the time, were frequently forced to transport patients in need of major surgery to Meharry College. Sawyer realized the desperate need for an all-Black hospital in Miami. In 1920, a significant contribution from a white donor financed the purchase of the lots to erect the facility, and construction of Christian Hospital ensued. Sawyer was elected chair of the board, a position which he held for almost three decades. In addition to his private practice and his work with Christian Hospital, Sawyer also served as a Dade County Public Health physician.

Christian Hospital faced trouble in its early years. In 1924, it was destroyed by fire, but a new facility was erected that contained eighteen more beds than the original hospital.

Throughout this period, Sawyer was also making significant contributions to the entertainment and social scene of Colored Town. In 1921, he and Alberta established

The Mary Elizabeth Hotel. Reproduced by permission from the State Archives of Florida.

the Mary Elizabeth Hotel, which Alberta managed. The hotel was named after their first child, who had died in infancy. Alberta's business acumen became evident.

At the time it opened, the ninety-room hotel was the tallest building in Colored Town. The property was well-appointed and equipped with elevator service and an intercom system that connected rooms to the front desk. The hotel featured private bathroom facilities for 40 percent of the rooms, a penthouse, and a beautiful rooftop garden. The hotel also boasted two lounges, the Flamingo Room and the Zebra Lounge, both of which were among the favorite stops of entertainers visiting the area. Once again, in one of the endless ironies of Jim Crow, segregation contributed to the economic

and cultural vitality of what was becoming known as Colored Town's Little Broadway.[13]

The Mary Elizabeth served as a favorite hostelry for many of the era's leading Black personalities. W. E. B. Du Bois frequented the hotel on his way to and from conferences in the West Indies. Educator, philanthropist, and humanitarian Mary McLeod Bethune, a close friend of the Sawyers, visited the hotel often. Bethune's son, Burt, managed the on-property drugstore for many years. Other political luminaries who stayed at the Mary Elizabeth included A. Philip Randolph, Thurgood Marshall, and Adam Clayton Powell Jr. Many renowned Black performers, such as Marian Anderson and Bessie Smith, stayed at the hotel.

The Mary Elizabeth also welcomed many Latin American visitors. In July 1950, the property hosted the Miss Latin American beauty pageant, when Monica Major of Puerto Rico was crowned Miss Latin America.[14]

Sawyer's influence within the community inevitably resulted in his becoming a spokesperson for Colored Town. In 1932, the NAACP reached out to him to solicit his input on strategies to combat the exclusivity of the white primary, one of the key tools of political disenfranchisement in the South. Sawyer also played a role in a peaceful campaign to secure a portion of Virginia Key in Biscayne Bay for an African American beach in 1945.

In 1947, the Orange Blossom Classic, a championship football game for historically Black colleges and universities, headed south to Miami and brought a festive atmosphere to an already lively Colored Town. The Classic was lucrative for the business entities of Colored Town, including the Sawyers. Soon, the Mary Elizabeth added a large dormitory room to accommodate the visiting teams.[15]

Sawyer continued his community development activities for the remainder of his life. In November 1949, he launched a half-million-dollar housing project, Alberta Heights, in northwest Miami. The project consisted of eighty units, including sixty-four single-bedroom and sixteen two-bedroom apartments, in the Brown subdivision, later renamed Brownsville by residents.[16]

On July 29, 1950, Dr. Sawyer died at the age of sixty-three. Prior to the funeral, hundreds of area residents viewed Dr. Sawyer's body in the upstairs lobby of the hotel. The Bethel A.M.E. Church struggled to accommodate the overflow of mourners who came to pay their last respects to the business and civic leader who had worked tirelessly to improve the lives of African Americans in and around Miami.

In the not-too-distant past, African Americans in Miami suffered deplorable treatment and limited civil rights, as they were severely limited in their choices of places to live, socialize, recreate, and educate. They were denied equal housing, business opportunities, voting rights, and the use of the area beaches. More than half a century later, on May 3, 1948, in the landmark case of *Shelley v. Kraemer*, the U.S. Supreme Court ruled unanimously that such racial covenants in housing were unconstitutional.[17]

THE LORD CALVERT HOTEL AND THE HAMPTON HOUSE MOTEL

Miami, Florida

Manager: Rudolph Perguson

In May 1951, Miami paused to commemorate the million-dollar Lord Calvert Hotel (later renamed the Sir John Hotel). Although white-owned, the fabulous resort was managed by Rudolph Perguson, an African American man. A first-class, modern hotel featuring 113 apartment-unit suites, complete with telephone and refrigerator-equipped kitchens, Lord Calvert's rooms were decorated in modern blond or ebony furniture, with chairs, walls, and drapery color schemes in the finest taste. Unique even in fabulous Miami was the hotel's 70' × 228' center recreational court in addition to its 30' × 60' saltwater swimming pool.[18] Built to give African American tourists a reason for coming to Miami, it was hoped that the property would force white hotels to compete for Black business.

While it stood, the property was home to the popular nightclub Knight Beat. The Knight Beat was a hot stop on the Chitlin' Circuit, its vibrant pool a popular hangout for artists and prominent African American leaders. It was also the scene of one of the most striking photos ever taken, that of heavyweight boxing champion Muhammad Ali, his fists raised while training underwater at the Sir John.[19]

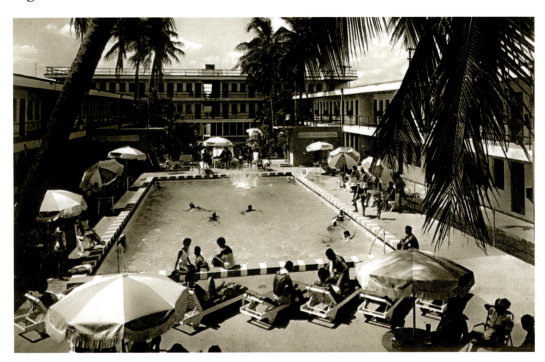

The Sir John Hotel (formerly the Lord Calvert). From from the State Archives of Florida.

In July 1954, the Booker Terrace Motel, a white-owned luxury motel catering to African American travelers, opened its doors in the heart of Brownsville, a vibrant, predominately African American middle-class subdivision of Miami. Promotional packages advertised luxury at low cost, with special rates for couples along with its air-conditioned rooms, swimming pool, dining room, and cocktail lounge. The motel quickly became a popular Black social center. In January 1961, a contest was held to rename the motel and apartments. The Booker Terrace underwent a complete renovation, remodeling, and refurbishing. A Coconut Grove schoolteacher won the contest and the property became known as the Hampton House.

Dubbed the "Jewel of Black Miami," the Hampton House Motel, also listed in the *Green Book*, was an oasis for African American leaders, activists, performers, and professional athletes. Frequent visitors included Joe Louis, Jackie Robinson, Roy Campanella, Ray Charles, Patti LaBelle, Stevie Wonder, Lena Horne, Milton Berle, Sam Cooke, Frank Sinatra, Flip Wilson, James Brown, Jackie Wilson, Nat King Cole, Nina Simone, and many others.[20]

Among the historic events occurring there were the repeated visits and press conferences by the Reverend Martin Luther King Jr. The property became a hub for civil rights activism, especially for groups such as the Congress of Racial Equality (CORE). Film footage exists of Dr. King giving at least two press conferences at the Hampton House. On February 25, 1964, Malcolm X and Muhammad Ali celebrated Ali's first championship victory over Sonny Liston there. Ali routinely visited the Hampton House Motel during his visits to Miami. Following the passage of the Civil Rights Act of 1964, the Hampton House Motel lost much of its core clientele and closed in 1976.

The Hampton House remained shuttered and continued to deteriorate until the early 2000s. At the start of the twenty-first century, a group led by Dr. Enid Pinkney began a more than fifteen-year journey to raise funds, make plans, and oversee the restoration of the property, which has now been designated a historic site called the Historic Hampton House.[21]

In February 2023, the Hampton House Motel was notified by the state of Florida and federal government that it had been added to the National Register of Historic Places.

> During the days of Jim Crow, most African American performers would use the "Chitlin' Circuit" when traveling to perform. This collection of performance venues, mostly in the South, was a modern-day Underground Railroad that welcomed African American entertainers in the 1940s and 1950s.

James "Bud" Ward, the first African American to graduate from Cornell University's hotel administration program (1952), welcomes guests at the Booker Terrace Motel (later named the Hampton House). Image courtesy of Sterling Ward.

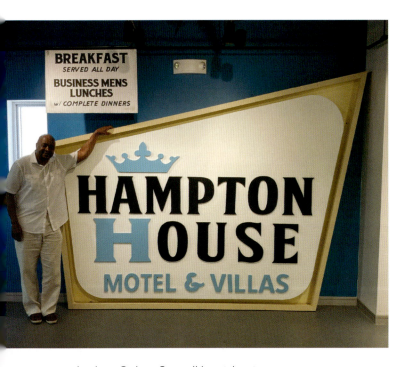

Author Calvin Stovall beside signage for the Hampton House Motel. Image courtesy of Calvin Stovall.

The Hampton House room heavyweight boxing champion Muhammad Ali stayed in when visiting Miami. Image courtesy of Calvin Stovall.

TRAVELERS'

GREEN BOOK

HOTELS · MOTELS
RESTAURANTS
TOURIST HOMES
VACATION RESORTS

TED STATES · CANADA · MEXICO
CARIBBEAN

GUIDE FOR TRAVEL & VACATIONS

FIVE

THE GREEN BOOK ERA

VACATION AND RECREATION WITHOUT HUMILIATION

The first and second Great Migrations witnessed as many as six million African Americans migrate from the South to the North and West between 1910 and 1970. Living in northern cities provided both an escape from the Jim Crow South and better employment opportunities. Higher incomes led to more African Americans purchasing automobiles and thereby avoiding the injustices that came along with bus and train travel. African Americans who migrated to the North and West obviously left family members behind. They naturally desired to reconnect, which often meant long road trips through unfriendly or even hostile areas.

During the Jim Crow era, white-owned businesses could legally refuse to serve or accommodate African American travelers seeking a meal, a hotel room, or even a restroom. Random violence was a haunting possibility for travelers in the South.

Jim Crow was primarily associated with Southern states, but African American travelers could also encounter other dangers scattered across Northern states in the form of what were known as "sundown towns." Sundown towns were white communities that approved city ordinances requiring Black travelers to depart before sundown, often under threat of violence. Some communities even posted warning signs for Black travelers to be gone by sundown. According to *Green Book* scholar Candacy Taylor, "the 1930 census listed 44 of the 89 counties along Route 66 as 'sundown towns'—all-white communities that posted signs stating that Black people had to leave by sundown."[1]

Black motorists traveling across America could face uncomfortable circumstances under the best of conditions, dreadful and dangerous under the worst. African American motorists packed their automobiles with extra food and water in the likely event they could not find a restaurant that would serve them, blankets and pillows as most motels along the highway refused to let them stay the night, and coffee cans for roadside bathroom breaks if service stations did not allow them to use their facilities.

It was in response to these hardships that several innovative publishers began to produce guides, directories, and resources for African American travelers to help them locate friendly services along their route. Most of these publications, like the businesses listed in their pages, were modest in scope if not in ambition—many of the accommodations were guest houses, tourist

homes, or other informal lodgings rather than hotels.[2]

Over the years, Black travelers found new business establishments opening to them and vying for their patronage. Road-trip-oriented motels began to spring up around the country to cater to an African American community on the move. Although discriminatory practices had not disappeared altogether, some measurable strides had been made.

THE NEGRO MOTORIST GREEN BOOK
Publisher: Victor Hugo Green

> The White traveler has had no difficulty in getting accommodations, but with the Negro, it has been different.
> —from *The Negro Motorist Green Book*

The *Green Book*, as it is most often called, was an invaluable segregation-era guide for African Americans traveling across the country from the 1940s to the 1960s. The guide included listings of Black-owned restaurants, hotels, vacation destinations, barbershops, gas stations, and much more around the country. The *Green Book* was more than a travel resource—it was an indispensable guide for keeping Black people safe while traveling from one destination to the next in segregated America.

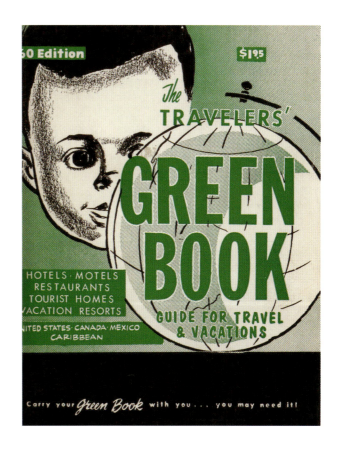

The Travelers' Green Book, 1960 Edition. Reproduced by permission from the The New York Public Library's Schomburg Center for Research in Black Culture; Manuscripts, Archives and Rare Books Division.

The *Green Book* was the brainchild of Victor Hugo Green, a postal worker and entrepreneur. Green was born in 1892 in New York City and was reputedly named after Victor Hugo, the French author of *Les Misérables*. He was the eldest of three children of William H. and Alice A. Green. The family lived in suburban Hackensack, New Jersey. Green's schooling extended only through seventh grade. In 1913, at the age of twenty-one, he began working as a mail carrier. In 1918, Green married Alma Duke of Richmond, who arrived with her family in New York as part of the Great Migration from the South. In the late 1920s, the couple relocated to Harlem when the Renaissance was in full swing.

Many who knew Green described him as an affable man of "tremendous drive and energy." He was tall, well-built, well-groomed, and always fashionably dressed when he was out in public; he would change into his postal uniform only once he arrived at work.[3]

By 1933, while still employed at the post office, Green was managing his brother-in-law, Robert Duke, who was a musician. Duke toured as a musician and experienced firsthand the indignities and difficulties Black people endured from white establishments while traveling. Confirmed by similar stories from his traveling friends, Green decided to develop his famous travel guide.

For inspiration, he looked to other travel guides including those published for Jewish people who often faced discrimination from non-Jews. The idea of the publication soon crystallized. Named after its creator, the first edition of the guide was published in 1936, although there's no known copy of that edition.[4]

Green Book creator Victor Hugo Green in 1956.

The 1937 edition of *The Negro Motorist Green Book* featured sixteen pages and focused on hotels and restaurants in New York City. Not surprisingly, musicians saw the guide as an invaluable resource as they traveled from gig to gig.

Demand grew rapidly for a more geographically expansive travel guide, so the following year Green expanded it to twenty-four pages covering twenty-one states and greater Washington, D.C. Green worked on the guide nights and weekends

while delivering mail during the day, a schedule he kept until he retired in 1952.

The Negro Motorist Green Book grew into a pocket-sized publication, about five by seven inches, and cost twenty-five cents. Green solicited help from fellow postal workers and Black motorists to locate Black-friendly businesses for him to include in the guide. By 1939, the guide doubled in size to forty-eight pages, covering forty-four states across the U.S.

The *Green Book*'s listings were organized by city and state, with the most bountiful listings in major metropolises where there were thriving populations of African Americans, such as New York, Detroit, Chicago, and Washington, D.C. The travel guides were perhaps more valuable for their listings outside of these cities, where businesses welcoming Black people were increasingly scarce. But even in cities with no Black-friendly hotels, the book often listed the addresses of homeowners who were willing to rent rooms to weary travelers.

The *Green Book* listed establishments in segregationist strongholds such as Alabama and Mississippi, but its reach also extended from Connecticut to California—any place where its readers might face prejudice or danger because of their skin color.[5]

In 1947, Green established a Vacation Reservation Service, a travel agency to book reservations at Black-owned establishments.[6]

> There will be a day sometime in the near future when this guide will not have to be published. That is when we as a race will have equal opportunities and privileges in the United States. It will be a great day for us to suspend this publication for then we can go wherever we please, and without embarrassment.
> —1948 edition of
> *The Negro Motorist Green Book*

Green regularly improved the guide, changing its title in 1952 to *The Negro Travelers' Green Book*, with guidance on train, bus, and airplane travel.

By the early 1940s, the *Green Book* included thousands of Black-owned or Black-friendly establishments across the country. The guides could be purchased at churches, other Black businesses, and at Esso (now Exxon) gas stations, the only major retailer to offer them. Esso gas stations were not just known for welcoming Black customers; during the 1940s, more than a third of its operators were Black. While it's not known how many *Green Books* were actually published, sources estimate it eventually sold upwards of fifteen thousand copies annually and was widely used by Black business travelers and vacationers alike.[7] Some sources estimate that two million copies were sold in 1962 alone.

By the early 1960s, the *Green Book* was known as *The Travelers' Green Book* and had reached about two million people. Each issue now contained around a hundred pages filled with hotels, restaurants, attractions, and homes that African American travelers could safely patronize. In offering travel advice to its readers, the book adopted a pleasant and encouraging tone, usually avoiding addressing racism in explicit terms.

As time went on, the guide and its entries grew in sophistication, later including even airline and cruise ship journeys to international destinations such as Canada, Mexico, the Caribbean, Africa, and Europe. The guide also offered travel tips and featured articles on select destinations. Although other guides for Black travelers now competed in the market, none enjoyed the credibility or legacy of the *Green Book*.

Victor Hugo Green died on October 16, 1960, at the age of sixty-seven, after more than two decades of publishing his travel guide. Four years later the Civil Rights Act of 1964 prohibited racial segregation in restaurants, theaters, hotels, parks, and other public places.

> The "Green Book" was the bible of every Negro highway traveler in the 1950s and early 1960s. You literally didn't dare leave home without it.
> —Earl Hutchinson Sr., from his memoir
> *A Colored Man's Journey Through 20th Century Segregated America*

After Green's death, his wife Alma took over as editor and she, along with an all-female staff, continued to release the *Green Book* for several more years. However, the march of progress eventually pushed the guide to its inevitable obsolescence. The last issue was published in 1966 as *The Travelers' Green Book: 1966-67 International Edition.*

Original versions of the *Green Book* are virtually impossible to locate, though reproductions are available. The Schomburg Center for Research in Black Culture hosts digital collections of the guides. Additionally, the center offers a mapping program that illustrates paths Black motorists could have taken in 1947 and 1956.

TRAVELGUIDE

Publisher: William "Billy" Butler

The nexus between Black entertainment and Black hospitality remained generative well into the era of mass highway travel. *Travelguide* was founded in 1946 by African American musician, travel editor, and entrepreneur William Henson "Billy" Butler, whose many years touring as a musician with theatrical troupes convinced him that a travel directory for African Americans was needed. Butler became an important pioneer in the development of Black travel during the segregation era. *Travelguide* provided Black travelers and vacationers the latest information on hotels, resorts, restaurants, motels, and other accommodations of interest.

Travelguide cover. From The New York Public Library's Schomburg Center for Research in Black Culture, Jean Blackwell Hutson Research and Reference Division.

Travelguide creator William H. "Billy" Butler.

Butler began playing music as a teenager and studied at the Chicago Musical College. He built a reputation for himself in the early days of Broadway in shows such as *Shuffle Along* with famous jazz pianist Eubie Blake, touring with several bands of note throughout the 1920s and 1930s. Stories of Black performers overnighting in train stations or even inveigling accommodations in the local jail were widely circulated. Black performers forced to travel around the country always exchanged information with each other, and the nucleus for Butler's first issue of *Travelguide* was built up from these private files.[8]

In 1947, the first edition of Butler's *Travelguide* came off the press. It was published annually and was designed to attract the upwardly mobile African American traveler. The publication looked and felt different than the *Green Book* and its predecessors, slim and neat at nine by four inches.

Stylish, bold, and sophisticated, *Travelguide* reflected the personality of its creator. It was based in New York City's theater district, a cultural landscape with which Butler was very familiar and which reflected the guide's target market. The publication included well-dressed models playing golf, driving fancy cars, or relaxing on the deck of a pleasure craft, all joyful and exuberant. It was still uncommon in these days to see photographs of fashionably dressed, middle-class Black women living their best lives and indulging like their white peers in America's prosperous and luxuriant postwar leisure market. By 1949, *Travelguide* enjoyed a circulation of fifty thousand.

Unlike the *Green Book*, which relied on Black travelers themselves for its updates, *Travelguide* relied on Butler's network of entertainment professionals. The listings in *Travelguide* correspondingly focused on larger towns and cities and included nightclubs and bars as well as advertisements for entertainment venues.

Butler's years in the entertainment industry helped him become a savvy marketer. In addition to paying for advertisements in prominent Black

newspapers, he also managed frequent mentions in newspapers including the *New York Amsterdam News*, the *Chicago Defender*, the *Baltimore Afro-American*, and the *Pittsburgh Courier*.[9] Articles about *Travelguide* often mentioned Butler's musical achievements and highlighted his years as a touring musician to increase his credibility as a travel expert.

Butler took a different approach to navigating the landscape of racial segregation than did the *Green Book*. Where the *Green Book* was primarily targeted to the Black middle class, was wide-ranging and aimed to list all business establishments open to African American travelers, *Travelguide* was more avowedly political, contextualizing the politics of segregated travel in a more determined support for civil rights and equality. Alongside the listings of hotels and restaurants, for example, *Travelguide* also advertised the NAACP's *The Crisis* magazine, the United Negro College Fund, and the Urban League. *Travelguide* even took pains to list a brief description of each state's civil rights laws and other traveler tips.

There is also a subtle but notable degree of militancy in *Travelguide*'s motto "Vacation and Recreation without Humiliation," distinct from the more modest tagline of the *Green Book*, which aimed to provide "the Negro traveler information that will keep him from running into difficulties, embarrassments, and to make his trips more enjoyable."[10]

Although free listings were offered to all desirable hotels and resorts, *Travelguide* often found refusals even in states having penalties for infractions of civil rights. Some of them stated that, while they had no personal prejudice against African Americans, their customers might object. Others contended that too few Black people possessed the necessary culture and refinement to mix well with whites at hotels and resorts. Still others said that refined and cultured persons of any race were welcomed at their establishments, but they were reluctant to publicize the fact.[11]

One mean of combatting such widespread prejudices among the white traveling public was the formation of the *Travelguide* Travel Club for Black travelers, which entitled members to free auto rentals, hotel and resort reservations, airline and steamship bookings, and identification stickers. Members sent in regular reports of their experiences while traveling. These reports often identified hotels and restaurants which had indicated a desire to have a larger Black clientele.[12] *Travelguide* exercised extreme care in sending guests to new establishments "taking the plunge" to accept Black guests. These travelers had to lean backwards to create a good impression. They almost always were successful and thus made it possible for others to

follow in their footsteps.[13] In all these ways Butler's efforts helped break down barriers for Black travelers.

During the 1950s, Butler solidified his position as a travel expert by authoring a travel column that appeared in the *Pittsburgh Courier* called "The Courier's Guide for Travelers." Butler answered readers' inquiries about where to stay and new travel services, and it shared commentary about changing racial attitudes in various parts of the country. In his columns and interviews, Butler reinforced the concept that *Travelguide* was a direct rejoinder to segregation and racial discrimination. It was Butler's hope that his guide would eventually cease to be a specialized publication and take its place among directories utilized by all people regardless of color.

Travelguide's growth in the domestic arena paralleled increasing interest on the part of its customers in foreign travel. This led Butler to establish a travel agency: King Travel Organization, an affiliate of *Travelguide*. King Travel took care of foreign tours and bookings and individual trips all over the world. It was truly cosmopolitan in character, as 65 percent of its customers were not Black.[14]

In 1955, the Moulin Rouge casino and resort opened in a historically Black neighborhood in Las Vegas. Touted as the first interracial casino resort, the Moulin Rouge captured enormous publicity in the Black press. Butler successfully positioned King Travel as the resort's booking agent, which allowed *Travelguide* to ride the enormous publicity wave the casino garnered.

Butler's partnership with the Moulin Rouge casino and resort was significant, reflecting *Travelguide*'s objective to promote interracial accommodations. Unfortunately, the partnership was short-lived. Despite the opening fanfare, the Moulin Rouge closed after a few months.

The final issue of *Travelguide* was published in 1957 (although another guide of unknown origin with the same title was also published in 1962–63).

Butler died in Roosevelt Hospital in New York on March 19, 1981, at the age of seventy-seven.

The Nationwide Hotel Association, Incorporated

During the mid-1950s, African American tourists traveling long distances were often confronted with dismal, inferior hostelries operated by people whose general attitude seemed to be: "They won't accept you, so you have to accept what we offer." In 1953, someone decided to do something about it. The Nationwide Hotel Association (formerly the National Hotel Association) sounded a warning that if "hotels catering to black patrons didn't improve soon, competition arising from changing customs and laws will wipe them out."[15]

The NHA called for a rise in standards of management, maintenance, facilities, and services for hotels and other places catering to the Black public. The organization soon attracted almost a hundred hotels and motels as members in its clean-up drive. Founders of the NHA were African American William H. Brown, then manager of New York City's Hotel Theresa, and Andrew F. Jackson, D.C. public relations counsel. These two studied the Black travel market for six months before organizing the NHA. The organization believed these problems, among others, should be solved on an economic rather than racial basis.

NHA's campaign was to improve the quality of hotel service and offer modern accommodations at sensible prices so the traveling public would be enticed to stay at hotels and motels rather than with friends and relatives. Travelers were reluctant to stay at lodging facilities where service was poor, rooms were unattractive, and the atmosphere squalid.

NHA's membership emblem was the symbol of NHA hostelries across the United States. Its red, white, and blue symbol was a travelers' assurance of quality accommodations. Carrying the slogan "Hospitality Plus Service," it was prominently displayed in every member hotel.

NHA members included the thirty-two-unit, ultra-modern, $250,000 A. G. Gaston Motel in Birmingham, Alabama, billed as "The Nation's Newest and Finest Motel"; the Liberty Hotel in Atlantic City; the Booker Terrace Hotel and Apartments in Miami; the 200-room Carlton Plaza and the 200-room Hotel Gotham, both in Detroit; and the 152-room Wedgewood Towers Hotel located in Chicago.

The organization also recognized the lack of trained personnel in the industry. To help stimulate interest among Black college students to pursue the hospitality industry, NHA began offering scholarships to three colleges: Michigan State, Cornell University, and Tuskegee Institute.

The Nationwide Hotel Association held its first annual convention in Miami. From October 17 to October 19, 1955, more than 150 delegates from across the nation attended the second annual National Hotel Association Convention at Detroit's Gotham Hotel, whose African American owner, John J. White, was named "Hotelman of the Year." Forty-five member hotels were represented at the convention. Other awards were made to the Lord Calvert Hotel, as "Hotel of the Year"; A. G. Gaston's Motel as "Motel of the Year"; and the Raleigh, North Carolina, Starksville Guest House as "Guest House of the Year." Other winners were the Plaza Hotel in Norfolk, Virginia; Washington, D.C.'s, Dunbar Hotel; Chicago's Evans Hotel; and the Stewart's Hotel in Anniston, Alabama. Dykes A. Brookins, owner of the Rio Plaza Hotel in Newark, New Jersey, was president of the organization.

THE EGGLESTON HOTEL

Richmond, Virginia
Proprietor: Neverett A. Eggleston

Neverett Alexander Eggleston was an African American hotelier, restaurateur, and political activist in the vibrant Jackson Ward community. Eggleston was the owner and operator of the thirty-room Eggleston Hotel. Located across the street from the Hippodrome Theater, the Eggleston was a favorite gathering place and first-class hostelry to a slew of African American travelers and celebrities.[16]

Eggleston left his home state of Virginia as a young man and headed to New York City. In 1918, he worked as a waiter in a hotel and witnessed the emergence of the Harlem Renaissance era, which most likely fueled his passion for the hospitality industry. Eggleston returned to Virginia in the early 1920s and began working as a cook at the Lakeside Country Club. In October 1925, he married Richmond native Sallie Juanita Robertson.[17]

In 1928, Eggleston launched his first venture, a restaurant called the Lafayette in Richmond's spirited African American business district Jackson Ward, which is often referred to as the "Cradle of Black Capitalism."[18] In addition to philanthropic societies and organizations, African Americans developed their own financial institutions and businesses, and other residents prospered in medicine, law, and similar professions.

Eggleston's restaurant business was short-lived, but that didn't stop him from setting his sights on loftier goals. In the late 1930s, William "Buck" Miller, owner of Miller's Hotel, asked if Eggleston would be interested in taking over his business. Miller's Hotel was a three-story property originally opened in 1904. Eggleston agreed and managed the hotel and restaurant and the adjacent pool parlor at the corner of Second and Leigh Streets. Around 1942, Eggleston obtained an interest-free loan of $25,000 to purchase the building, which he renamed the Eggleston Hotel.

During World War II and the Korean War in the 1940s and 1950s, several military bases opened or expanded in central Virginia. As a result, Jackson Ward swelled with African American soldiers in need of quality lodging and searching for entertainment. The wartime mobilization was a tremendous godsend for Eggleston and Richmond's African American business community.

Eggleston worked tirelessly to make his establishment one of the finest hotels in Richmond. The hotel and its restaurant, Neverett's Place, would become a favorite travel destination and dining spot. The Eggleston was the hub of a lively strip that, during its heyday, locals called "the Deuce." This was Second Street, the heart of the action in Jackson Ward.[19]

For decades, the Eggleston was one of only three hotels in the city that permitted Black guests.[20] Duke Ellington, Ella Fitzgerald, Count Basie, Louis Armstrong, Redd Foxx, Moms Mabley, Joe Louis, Muhammad Ali, Jackie Robinson, Willie Mays, Satchel Paige, Booker T. Washington, and Thurgood Marshall were among the Black luminaries who spent the night there.

Eggleston was also a political activist in the Richmond community. He joined the Richmond Democratic League to register African American voters. Behind the scenes, he contributed to African American political campaigns and became involved in anti-segregation efforts in Richmond during the 1960s.

Following the Civil Rights Act of 1964, Jackson Ward banks, shops, theaters, and restaurants lost customers or had to close altogether. The Eggleston Hotel was no exception. In the late 1960s, the hotel began to see its once-guaranteed African American clientele slowly dwindle.

By the end of the 1970s, the decline of the business district was undeniable. The Eggleston began renting its thirty-room hotel by the week. By the 1980s, the restaurant had become a deli and the hotel practically was a boarding house. A decade later the hotel closed, and the building fell into disrepair.

Eggleston died at a Richmond hospital in 1996. His funeral featured a horse-drawn hearse and a procession of antique cars.[21] Then-governor of Virginia George Allen shared a statement of condolence for the renowned hotelier.

In April 2009, the site was razed by the city after the hotel partially collapsed.

Today, the four-story Eggleston Plaza, which includes thirty-one income-based apartments, sits on the former hotel site. A historical marker recognizes "the entrepreneurial and professional efforts of the residents of Jackson Ward."[22]

The 1940 edition of the *Green Book* introduced one Utah listing: the "New Hotel J. H." in Salt Lake City. James H. Hampton, a Black man who previously worked as a chauffeur for a taxicab company, owned and managed the property. In 1946, the city directories began to list Ida M. Hampton, his widow, as hotel manager. The New Hotel J. H. continued to be the lone listing for Utah in the *Green Book* until the late 1940s.

THE MAJESTIC HOTEL

Cleveland, Ohio
Proprietor: Alonzo G. Wright

Throughout the postwar U.S., African American driving enthusiasts spurred business. Alonzo G. Wright was a prominent businessman, entrepreneur, and hotelier who directly saw the advantages of this trend in the nearly dozen Sohio gas and service stations that he owned. Considered the first African American millionaire in the city of Cleveland, Ohio, Wright owned numerous other businesses within the city, including the Majestic Hotel, Carnegie Hotel, and Ritzwood Hotel. The Majestic was the largest hotel in Cleveland that catered to African Americans. During its last twenty-three years, the property was the largest Black-owned hotel in the state of Ohio.

Wright was born in 1898 in a one-room house in Fayetteville, Tennessee. His father was a telephone lineman who was killed on the job when Alonzo was just six years old.

To help his family make ends meet, Wright earned money as a shoeshine boy and a messenger before moving with his mother to Cleveland in the early 1910s. There he earned his high school diploma at night while holding down odd jobs. Wright also worked for eight years as a garage attendant at the Auditorium Hotel, where he met Sohio executive Wallace T. Holliday.

Impressed by Wright's work ethic, Holliday offered Wright a desk job, but Wright turned it down and asked to run a gas station instead; with Holliday's help, Wright became the first African American to lease a Sohio station, in a predominantly Black neighborhood. Wright enhanced his business offerings by providing extra services, such as frequent windshield cleanings and complimentary tire and radiator checks. His motto was "A Business Built with a Rag." By 1937, Wright operated six Sohio stations. By the mid-1940s, he was operating eleven.[23]

Alonzo G. Wright pictured with award-winning cow. Reproduced by permission from the Cleveland Memory Project, Cleveland State University, Michael Schwartz Library Special Collections.

By 1940, Wright was credited with having hired more Black youths than any other businessman in the U.S. He would also help found the Cleveland Development Fund, which strived to eliminate slum housing. Wright's ongoing passion for helping others was recognized by the National Negro Business League, who presented him the C. C. Spaulding Business Achievement Award.[24]

Wright left the service-station business when gas rationing for World War II slowed sales. In 1943, he set his sights on real estate and established the investment firm Wright's Enterprises. In 1944, along with investors Lawrence O. Payne and William O. Walker, Wright purchased the Majestic Hotel from Josef Weiss, bringing the five-story, 250-unit brick-structure hotel under Black ownership for the first time.[25]

Although the property continued to operate as a residential hotel, Wright sought traveling customers. The Majestic Hotel became one of a few reputable hostelries for Black travelers coming into the city.

Although Wright was a successful entrepreneur, he did not escape the stings of racial prejudice. When he decided to move into an all-white section of Cleveland Heights in 1930, white supremacists firebombed his house. Such intimidation tactics failed. Wright remained there until 1947.

During a period when Black people could not always obtain fair treatment at the city's leading downtown hotels such as the Cleveland and Hollander, the Majestic provided first-class accommodations without subjecting Black patrons to embarrassment.

Not only did the Majestic offer a safe place for African Americans to stay, but the property also provided a hospitable place to eat, relax, and bask in musical entertainment absent racial discrimination.

Several businesses operated inside the Majestic, including a pharmacy, tailor, beauty salon, barber shop, and dentist office. As early as 1931, the property included a jazz club originally named the Furnace Room, later renamed the Heat Wave and then the Ubangi Club. In 1934, "Mammy" Louise Brooks served New Orleans Creole fare in the Majestic Grill, until it changed hands in 1936 and became Sadie's, where patrons were served "Home Cooked Food."[26]

When Wright purchased the property, the jazz club reopened as the Rose Room, and the Majestic became the premier entertainment hub in Cleveland for popular jazz performances and cabaret-style shows. Between 1952 and 1957, pianist Duke Jenkins led the Rose Room's house band, which hosted "Blue Monday Party" jam sessions on Monday nights. These sessions featured nationally known jazz performers and made the Rose Room a preeminent venue through the 1950s.

While the Majestic served a predominately Black clientele and was in a largely Black section of Cleveland, audiences coming to enjoy the music in the Rose Room were racially mixed. The Majestic became a fixture in the black-and-tan scene in what residents called "Cleveland's Harlem," in the heart of the Cedar-Central neighborhood.[27]

In 1947, Wright purchased the Carnegie Hotel, which he planned to make the "finest

Black hotel in the county," but he sold the property in 1960. He also purchased the Ritzwood Hotel, which was lost in a devastating fire in 1959.

In 1947, Wright moved to a 200-acre farm in Chesterland, Ohio, far from the racial insecurities of Cleveland's suburbs.

The Majestic Hotel was one of only five Cleveland hotels listed in the 1956 *Green Book*. Although Wright was dedicated to operating a first-rate modern and fashionable hotel and invested hundreds of thousands of dollars into renovations—which he personally oversaw—along with the many other Black-owned hotels across the nation, the Majestic gradually lost its appeal with the passing of the Civil Rights Act of 1964.

When Cleveland's leading Black newspaper, the *Call & Post*, reported in 1967 about the hotel's pending demolition to erect the Goodwill Industries Rehabilitation Center, its tone was sentimental. Recognizing the "tremendous community development in a slum area," it also concluded, "With the Majestic goes the sounds of music, the voices of the great, and a bright era of Negro community life."[28] The property was demolished in 1972.

The five-story, 150-room California Hotel, located in Oakland, California, opened in the early days of the Great Depression. From its opening through World War II, the property was for whites only. After the war, new ownership came in and ended its discriminatory policies, accepting African Americans as hotel guests. It was the first, and only, East Bay hotel to do so during the time.

The California Hotel became an important cultural focal point for African Americans of East Bay during the 1950s and 1960s. During World War II, it was known for blues, jazz, and similar music played in its ground-level bars and ballrooms. The hotel welcomed prominent African American celebrities, including B. B. King, Lou Rawls, Big Mama Thornton, Fats Domino, Ike and Tina Turner, James Brown, Sam Cooke, Ray Charles, and Richard Pryor, among others.

On June 30, 1988, the California Hotel was placed on the National Register of Historic Places.[29]

THE BARKSDALE HOTEL

Washington, D.C.
Proprietor: Wallace A. Barksdale

Many of the successful Black hotel and hospitality proprietors of the twentieth century got their start in jobs traditionally reserved for African Americans: stewards, cooks, waiters, porters, and the like. Wallace A. Barksdale was no exception, getting his start as a railroad chef during World War I. Though born in 1886 in Louisville, Kentucky, he grew up in South Carolina and later moved to Richmond, Virginia, where he met his first wife. He would make himself into an American success story.[30]

Wallace Barksdale opened his first restaurant on D Street, which he operated from 1917 to 1918 while still serving as a railroad chef. After leaving the railroad in 1933, he acquired ownership of another restaurant from Albert I. Cassell, who was working as a campus architect for Howard University. The Barksdale's Restaurant remained in operation for more than two decades. In 1942, Barksdale purchased the Hamburger Grill adjacent to Griffith Stadium (currently the site of Howard University Hospital).[31]

In 1946, Barksdale purchased a thirty-three-room property near Dupont Circle in the heart of the capital's diplomatic and chancellery buildings. The Barksdale Hotel welcomed notable guests such as singer and songwriter Ruth Brown, former First Lady Eleanor Roosevelt, and labor unionist and civil rights activist A. Philip Randolph. The hotel accepted both Black and white guests,

Wallace A. Barksdale, owner of the Barksdale Hotel. Image courtesy of Mark G. Barksdale.

Wallace A. Barksdale, owner of the Barksdale Hotel. Image courtesy of Mark G. Barksdale.

unlike other downtown hotels that had strict racial segregation policies prohibiting renting rooms to Black patrons.

Barksdale died in 1953 at Freedmen's Hospital in Washington, D.C. At the time of his death, his estate was estimated to be worth $250,000 (valued at approximately $3 million today). Barksdale's widow, April Shine Barksdale, continued to operate the family businesses.

An obituary published by the *Washington Afro-American* newspaper described Barksdale as a "self-made man, having pulled himself up on sheer grit, determination and personal discipline."[32]

THE HOTEL CARVER

Pasadena, California
Proprietor: Percy Carter Family

Community investments by Black hospitality entrepreneurs could continue to pay off long after their hotels' glory days are over. Pasadena, California, has a reputation as a town of predominately white suburban affluence. However, the Hotel Carver was a focal point for the Pasadena African American community during the mid-twentieth century. The three-story Victorian property located at 107 South Fair Oaks Avenue was purchased in the 1940s by Black entrepreneur and hotelier Percy Carter and his family.[33]

The original structure was built in the late 1880s as part of the "Doty Block" in the Old Pasadena District and served as a showroom for a stagecoach and carriage company. In later years it was a freight depot for the Pasadena and Los Angeles Railroad, which became part of the Pacific Electric Railway. In the early twentieth century the building was converted to the Hotel Mikado, catering to a Japanese American clientele.[34]

Percy Carter purchased the property in the 1940s. He changed the name to the Hotel Carver in honor of prominent Black

Percy Carter, owner of Hotel Carver. Reproduced by permission from the Pasadena Museum of History, Black History Collection.

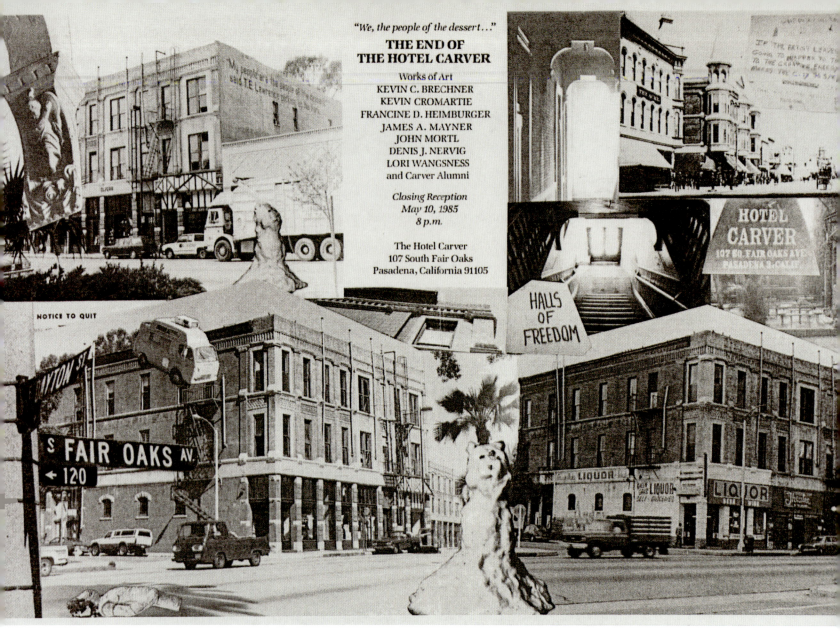

Hotel Carver in memoriam collage, April 10, 1985.
From the Pasadena Museum of History, Black History Collection.

inventor and scientist George Washington Carver. Directly across the street from the Hotel Carver sat the Hotel Green, a property which catered to a white clientele, physically enacting the color line that kept the races so close, yet so far apart.

The Hotel Carver's Blue Room dining hall was located on the second floor, and in the basement was a nightclub, originally called the Onyx Club and later the Club Cobra, where up-and-coming jazz musicians performed.[35]

During the 1970s and 1980s, a controversial mural painted by Paul Waszink adorned the north facade of the building with a simple quote, in tall, dark-green letters on a cool gray background. Fashioned like a line of dialogue from a book, it read: "'My people are the people of the dessert,' said T. E. Lawrence picking up his fork." In 1970, Percy Carter's descendants sold the property to artist-director Duane Waddell, who converted the ground level to the Pasadena Repertory Theater and developed

art studios on the upper floors, which housed over a hundred artists, writers, musicians, directors, dancers, filmmakers, and other creatives. Artists such as Paul McCarthy, Gill Dennis, Betty Dore, and Herbie Lewis rented studios there.[36]

Over the next decade, the building changed hands twice. In mid-April 1985, all the hotel tenants found thirty-day eviction notices nailed to their front doors. The remaining tenants organized an art exhibit titled "The End of the Hotel Carver." The ballroom, the old Blue Room, and most of the empty spaces in the building were filled to the brim with works by over forty artists. By June 1985, the Hotel Carver was empty.

In 1987, the Hotel Carver was partially destroyed during the Whittier Narrows earthquake. The building was then gutted, remodeled, and retrofitted, and the Paul Waszink mural was painted over.

In 1996, a group of former tenants from the Hotel Carver came together as part of a large art festival in Old Pasadena for a reunion art show called "A Brief Re-birth of the Hotel Carver," which took place on the sidewalk in front of the building.[37]

Today, the building is a mixed-use retail and office space.

BOOKER T. WASHINGTON HOTEL

San Francisco, California
Proprietor: Charles Sullivan

Charles Sullivan, owner of the six-story Booker T. Washington Hotel, played a significant role in San Francisco's Black cultural life during the mid-1960s. He was one of the most influential, and controversial, entrepreneurs in the bustling Fillmore District, which became renowned as one of the hottest entertainment locales in the world—and Sullivan was a significant reason why.

Sullivan was tall, handsome, and imposing. He was a classy dresser and wore finely tailored suits every day. From the late 1940s until his death, the entertainment mogul paved the way for some of the most prominent music events in California history. Likely the wealthiest Black man in the Fillmore, he was crowned "The Mayor of the Fillmore" by a local merchants' group and provided an oversized key to the city.[38]

Sullivan was born in 1909 on a farm in Monroe County, Alabama.[39] He ran away from home at age thirteen. In 1928 he arrived in Los Angeles and washed cars while attending night school to become a machinist, eventually

Charles Sullivan (*far left*) and others in the Fillmore, ca. early 1960s. Reproduced by permission from Thomas Reynolds, "Harlem of the West" / Wesley Johnson Jr. Collection.

working his way up to the status of journeyman. Yet he was denied admission to local—and segregated—machinist unions, and in 1934, at the height of the Great Depression, he decided to relocate to San Francisco.[40]

He began working as a chauffeur and mechanic for Hollywood film editor and director George Nicholls Jr., who was living in Hillsborough. Sullivan only had a sixth-grade education, but he was an astute individual who knew how to build relationships and make connections.

In 1939, Sullivan opened a barbeque restaurant in San Mateo named Sullivan's Café. He also purchased a bar in Pacifica for $7,000, primarily for its liquor license and to expand his café. In June 1944, he was issued a permit to put a "dark room" in his establishment. He would also expand Sullivan's Café to include a card room, making him the first Black businessman on the peninsula to operate a gambling establishment.[41]

Sullivan also worked as a machinist in the shipyards throughout World War II.

Initially, the union refused to hire Black people. A determined Sullivan persuaded fifty white machinists to testify on his behalf, but it took the personal intervention of President Roosevelt to get the union to hire him. Sullivan became the first African American in the Bay Area to become a member of the International Association of Machinists, thus integrating West Coast shipbuilding.

Charles Sullivan next parlayed his machinist skills and love of music into a jukebox and vending machine business, which he named Sullivan's Music Company. He began booking live entertainment and by the mid-1940s had become one of the most successful music promoters on the West Coast.[42]

Sullivan moved into the Fillmore, where he met "Fats" Corlett, who was currently the owner of the Edison Hotel at 1540 Ellis Street. The hotel had a shady reputation, but Corlett began to rehabilitate it, first by renaming it the Booker T. Washington. Corlett's felony conviction, however, precluded him from running the bar. Here Sullivan identified an opportunity. He purchased the hotel, as well as the nearby Post Street Liquor Store. The Post Street building was renting rooms on the second floor, and it was this space that became the Sullivan Hotel.[43]

The "Booker T" would become a mainstay during the days of segregation both for African American celebrities and jazz musicians coming to the city to perform and others visiting the vibrant Fillmore community. The hotel attracted standing-room-only crowds every night with live entertainment.

The Booker T. Washington Hotel. Reproduced by permission from the San Francisco Public Library's San Francisco History Center.

The Booker T had six floors and 125 rooms, with suites in the front of the top floor. There were free radios in every room and television sets in each suite. Chartreuse drapes laced the windows and maroon carpets embellished with silver scrollwork covered the floors. Mirrors decorated in peach and silver lined the serving counter.[44]

The hotel employed a full-time staff of housekeepers, bartenders, and front desk staff. The mother of renowned author Maya Angelou, Vivian Baxter, was a desk clerk at the hotel.

Sullivan booked some of the hottest Black entertainers of the era at the Fillmore or other Bay Area venues, including Louis Armstrong, Lionel Hampton, Ruth Brown, Billie Holiday, Slim Gaillard, James Brown, Charlie Parker, and Ike and Tina Turner, whose band included a young guitarist named Jimmy James, better known today as Jimi Hendrix.

Among the other Black luminaries and sports figures who stayed or even played at the Booker T were Duke Ellington, Louis Jordan, Nat King Cole, Archie Moore, Dinah Washington, Joe Louis, the Harlem Globetrotters, Little Richard, Jackie Wilson, Arthur Prysock, Josephine Baker, W. E. B. Du Bois, Paul Robeson, and Langston Hughes.[45]

By the 1960s, the Fillmore District's physical and cultural landscape began to shift as the city launched an aggressive redevelopment plan. Once redevelopment started, area clubs that were once buzzing with patrons were destroyed or evicted, and adjacent buildings were tagged for demolition.

On August 1, 1966, Sullivan flew back to San Francisco from Los Angeles where he had promoted a James Brown concert at the War Memorial Opera House with $6,000 in receipts. In the early morning hours of August 2, Sullivan was found shot to death in the industrial district south of Market. According to the police report, he was sprawled on the street next to the open door of his rental car. The car headlights were still on, his empty valise and keys in the open trunk. He had been shot once at close range in the chest. A revolver was found by his right hand. Police reported that it was a suicide. Sullivan was fifty-seven years old.

The San Francisco coroner dismissed the idea of suicide, declaring the death of "unknown circumstances."[46] To this day, the case remains unsolved.

In 1966, the San Francisco Redevelopment Authority purchased the Booker T for $300,000 with plans to use it as a temporary relocation center for displaced residents. The hotel was razed in 1970. Like many razed lots in the Fillmore, the parcel sat vacant until 1983, when ground broke for a Safeway.

Today no trace of the Booker T. Washington Hotel survives. The city assessor's office claims the hotel's address, 1540 Ellis Street, never existed.[47]

THE HOTEL THERESA

Harlem, New York

The Waldorf of Harlem

One of the most famous Black hotels in America was the Hotel Theresa in Harlem, New York, located at Seventh Avenue and 125th Street. Opened in 1913, the Hotel Theresa was built by German-born cigar manufacturer and stockbroker Gustavus Sidenberg and named after his deceased wife.

The 300-room, thirteen-story, full-blockfront all-white Theresa Hotel was designed by architects George and Edward Blum, who were trained at the famous École des Beaux-Arts in Paris. The hotel "exemplifies the Blums' inventive use of terracotta for ornamentation, and has been called 'one of the most visually striking structures in northern Manhattan.'"[48]

The Hotel Theresa was primarily planned as an apartment hotel. Such hotels, often referred to as "family hotels," offered suites and catered primarily to long-term guests, many of whom maintained their permanent residences in the building. *Harlem Magazine* commented on the inviting atmosphere of the Hotel Theresa, noting that it would possess "the varied comforts and conveniences of an up-to-date hostelry, with all the seclusion of home life."[49]

Like its exterior, the Hotel Theresa had an all-white clientele and staff. Its luxurious Skyline Room kept its dinner service strictly segregated.

Shortly after opening, however, the neighborhood in which the Hotel Theresa sat changed dramatically. The increasing African American population of Harlem meant the steady loss of white dinner patrons and guests and put the hotel's survival at stake. In 1940, after vain attempts by the management to maintain the Hotel Theresa's policy of strict segregation despite the changing character of the neighborhood, the hotel finally dropped its policy of discrimination, already an anachronism in the predominantly Black community.[50] The announcement of the new policy was accompanied by extensive renovations and enhanced services and facilities at the hotel.

Immediately, the Theresa began to serve an almost exclusively Black clientele. Gresham Management Company, operators of the Theresa, hired an additional eighty employees and installed Walter M. Scott, a debonair African American, as the hotel's resident manager. Scott was a NYU graduate, World War I veteran, and had worked as a business manager at the Harlem YMCA. Scott also worked as a bellman and waiter on the Hudson River Dayline boats.[51]

The Hotel Theresa, New York.
Reproduced by permission from the
Office for Metropolitan History.

The Theresa was integrated when most mid-Manhattan hotels wouldn't accept African Americans. Black people were allowed to perform at the white clubs, hotels, and theaters but couldn't sleep in the hotel rooms or eat in the restaurants. Since the Hotel Theresa was the largest hotel in Harlem and one of the few hotels in New York (other than the Olga, also in Harlem) that welcomed Black patrons, it soon became a major social center for Harlem and became fondly known as the "Waldorf of Harlem."[52] *Ebony* magazine didn't quite accept the comparison, noting that with its dimly lit hallways, drab, colorless bedrooms, dingy, ancient furnishing, and limited room service, the Theresa was anything but a first-rate hotel. It was the best that Harlem had, however.[53]

Despite all the faults of the Hotel Theresa, the largest Black hotel in the nation was a popular, much-patronized Harlem center. It had little competition in New York and was widely considered the best Black hotel in the country.[54] *Hospitality*, the official magazine of the Nationwide Hotel Association, an organization of hotels and resorts that catered to African Americans, wrote that "the Theresa has become the outstanding hotel for minorities in the country."[55]

The Theresa welcomed many of America's most prominent social, political, entertainment, and sports figures of color at its registration desk. Most of the acts that played at the nearby Apollo Theater signed the guest register. Among those who frequented the hotel was Joe Louis. In 1941, Louis attracted ten thousand fans when he stayed there after a victory at the Polo Grounds. Other notable guests included Duke Ellington, Nat King Cole, Josephine Baker, Ray Charles, James Brown, Jimi Hendrix, Louis Armstrong, Dorothy Dandridge, Lena Horne, and Count Basie. Entrepreneur John H. Johnson conceived the ideas for both *Jet* and *Ebony* magazines while at the Theresa and frequently published articles about the famous hotel.[56]

By 1946, the prosperous hotel was still owned by the Gustavus Sidenberg estate and managed by a white realtor.

In 1948, resident manager Walter Scott resigned due to illness. Gresham Management hired Howard University graduate William Harmon Brown. Former President Bill Clinton's commerce secretary, Ron Brown, son of William Brown, grew up in the hotel.

Besides serving as a cultural hub, the Theresa also incubated key political moments. The March on Washington Movement, founded by African American labor unionist and civil rights activist A. Philip Randolph, was organized at the Theresa. The hotel later served as headquarters for the Organization of Afro-American Unity, founded by Malcolm X.[57]

In September 1960, the Theresa entered the national limelight when Cuban Premier Fidel Castro and his staff visited New York to address the United Nations General Assembly. They first attempted to check into the Shelburne Hotel after being refused admittance to other downtown hotels. The Shelburne demanded an advance payment of $10,000, which an infuriated Castro

refused to pay. Castro and his entourage decided to stay at the Hotel Theresa. The large group occupied forty suites on three floors of the hotel, with Castro housed on the ninth floor.[58] The ten-day visit resulted in a $15,000 bill. According to the *New York Times*, Castro decided to stay in Harlem because of "the belief that Negroes would be more sympathetic to the Cuban revolutionaries."[59] While staying at the hotel, Castro was visited by Nikita Khrushchev, the premier of the Soviet Union; General Abdel Nasser, president of Egypt; Jawaharlal Nehru, the prime minister of India; poet Langston Hughes; and Malcom X.[60]

At the end of 1960, John F. Kennedy made a presidential campaign stop at the hotel, along with Jacqueline Kennedy and Eleanor Roosevelt.

The Gustavus Sidenberg estate retained ownership until 1948. From that date until its sale in 1966 and conversion into an office building, the hotel has had a series of corporate owners, most of whose principals were white.[61]

In the mid-1950s, however, Black businessman Love B. Woods decided to sell one of his cash cows, the Woodside Hotel, for $80,000 to purchase the Hotel Theresa. Woods had been in the hotel business for a long time, but he was now old and feebleminded. He bought the Hotel Theresa despite those who knew of his declining condition thinking it was a bad idea.

By the mid-1960s, the Theresa had begun to deteriorate after only minimal investment had been made to modernize and upgrade the property. In late 1960, Woods announced that the Hotel Theresa would undergo a $100,000 renovation. His hotel enhancements included replacing the telephones in all three hundred guest rooms, adding additional private baths, and expanding dining room service. He also planned to reopen the hotel's famous bar and add a gold lounge.

But by 1965, his dream turned to dust. Woods had poured all his money into the purchase of the property nearly ten years earlier; basic maintenance had eaten up much of the remainder of his capital. According to businessmen in the area, Woods spent most of the money he would have used for the mortgage paying for building code violations and was never able to get ahead. Friends say he died "broken hearted and a pauper."[62] In his resolve to manage a luxurious hotel for his people, he lost it all, including a luxurious office building on 125th Street as well as the hotel.[63]

In 1971, the building was converted into a modern office building called Theresa Towers. The building was declared a landmark in 1993 by New York's Landmark Preservation Commission and was added to the National Register of Historic Places in 2005.

Black Bottom and Paradise Valley, Detroit, Michigan

During the height of Jim Crow, there was one destination in Detroit, Michigan, where people from around the globe, regardless of skin color or culture, came for a jubilant time. That was Paradise Valley, which was located within an area known as Black Bottom (originally named after its fertile topsoil) in Detroit, a neighborhood Jelly Roll Morton would make nationally renowned in the 1920s with his classic jazz hit the "Black Bottom Stomp." Black Bottom was a predominantly Black neighborhood on Detroit's near east side and personified self-sufficiency in every aspect of life.[64]

Paradise Valley was a district which Black migration transformed into a cultural and commercial mecca. Tens of thousands of African Americans thrived and owned more than three hundred businesses. Some businesses were in Black Bottom, but most were in Paradise Valley along Hastings Street and Saint Antoine Street. Paradise Valley encompassed Black-owned hotels (including the Gotham Hotel), barber shops, salons, restaurants, grocers, theaters, banks, churches, pharmacies, bowling alleys, apartment buildings, funeral parlors, nightclubs, and numerous other business establishments.

Through the middle part of the century, Paradise Valley was nationally recognized for its music scene and nightlife. The nightlife there not only brought all cultures and races together, but it was also the place to go for the best the entertainment and music industry had to offer, drawing people from around the world.[65]

The jubilation would be short-lived.

The National Housing Act of 1949, followed by the 1956 National Highway Act, provided the city funds to begin building new development in the area, ultimately displacing Black Bottom residents and Paradise Valley Black business owners to make room for the Chrysler Freeway and Lafayette Park. The east side neighborhood was demolished by 1954; Paradise Valley hung on for a few more years.[66]

Paradise Valley has been referred to as one of the most prominent and dynamic African American neighborhoods in U.S. history.

THE GOTHAM HOTEL

Detroit, Michigan
Proprietor: John J. White

Some Black-owned hotels came to enjoy success despite their origins in the disreputable worlds of prostitution, vice, and the sometimes-sordid entertainment scene. Very few others experienced the opposite trajectory. The Gotham Hotel in Detroit was one of the nation's finest Black-owned hotels. Located at John R. Street and Orchestra Place, the nine-story, 200-room property was owned by John J. White. Besides being the nation's largest Black-owned property, the Gotham built a reputation as the best-operated hotel of its kind. It was also a further example of "the intersection between legitimate business and illicit enterprise" that characterized some Black hotels in the Jim Crow era.[67]

John J. White, owner of the Gotham Hotel. Reproduced by permission from the Walter P. Reuther Library, Wayne State University, Archives of Labor & Urban Affairs.

Detroit's African American population grew rapidly as a result of the massive migration into its automotive industries, especially during the two World Wars when those factories became centers of national defense production. In its heyday during the 1920s, Detroit was the fourth-largest city in the United States, becoming a tourist and convention center. Like other major cities across the U.S., African Americans faced discrimination and were barred from staying in Detroit's downtown hotels.

Even as late as the 1940s, there were only seven or eight hotels serving Black people in Detroit.[68] But those hotels were usually subpar and often nothing more than run-down boarding houses. Detroit needed better hotel accommodations for its multiplying African American residents and their visitors.

Two local entrepreneurs, John White and Irving Roane, believed that the Black community deserved more. In November 1943 (about four months after the 1943 Detroit race riot), White and Roane purchased a nine-story, 200-room hotel from Danish businessman Albert B. Hartz. The original structure was built for Hartz in 1924 and started its life as the Hotel Martinique, catering to the city's white majority—but all that was about to change.

For the next two decades, the twin-towered Gotham Hotel became the social center of Detroit's Black community. Ads in Black publications deemed the Gotham "a monument to our race" and noted its location in a "refined neighborhood."[69] Each hotel room had an attached bath, which was virtually unheard of in Black hotels during this era. Rooms cost three to five dollars a day and suites, which featured solid mahogany furniture, cost seven to eight dollars a day.[70] In addition to its first-class amenities and decor, the Gotham provided a level of service that rivaled the nation's finest hotels. It also featured a drugstore, barbershop, and permanent apartments for wealthy residents.

At its peak, the Gotham registered a thousand guests a week, and welcomed a Who's Who of African Americans in entertainment, sports, business, and politics, including Jackie Robinson, Langston Hughes, B. B. King, Thurgood Marshall, Adam Clayton Powell Jr., Jesse Owens, Ella Fitzgerald, Sammy Davis Jr., Count Basie, and Billie Holiday.[71] Joe Louis would often enjoy breakfast in the hotel's fancy Ebony Room restaurant.

African Americans were particularly proud of the Gotham because it gave them the opportunity to patronize a lavish, clean, and comfortable facility of their own. During its reign, it was deemed one of the "Nation's Finest Hotels," garnering owner John White a "Hotel Man of the Year" award in 1955 by the Hotel Association.[72] The Gotham seemed to exemplify the progress that Black people were making in Detroit and across the nation.

The Gotham was no exception in suffering the tragic ironies that afflicted so many paragons of Black culture as the civil rights movement progressed, resulting in Black-owned businesses seeing their clients and customers flock to white-owned establishments. The hotel began losing business to once-forbidden downtown hotels such as the Statler, Fort Shelby, and Book-Cadillac. The Gotham was no longer able to compete in an integrated hotel marketplace and was eventually forced to shut its doors in September 1962.[73]

The Hotel Gotham. Reproduced by permission from the Detroit Public Library, Burton Historical Collection.

But that's not where the Gotham story ends.

Not only did the Gotham accommodate hotel guests, but the hotel also specialized in corruption. In November 1962, 112 officers from the Detroit Police Department, the federal IRS, and the Michigan state police raided the vacant Gotham Hotel.

Gotham hotel owner John White was among the forty-one people arrested during the raid.

The search took twenty-four hours to complete, the officers ultimately seizing 160,000 betting slips, $60,000 in cash, thirty-three adding machines, miscellaneous equipment, marked cards, and loaded dice.

There was a numbers office located on each floor of the hotel, with the largest room consisting of felt-covered tables, along with adding and calculating machines. The hotel's switchboard operator alerted occupants of incoming police officers, followed by an alarm system that would peal on every floor including the penthouse. The Gotham was known as the "fortress of the numbers racket in Detroit," according to the *Detroit Free Press*.[74]

Although the hotel was known as a gambling house, many notable Black and white politicians and Detroit policemen who frequented it turned a blind eye to the illegal activities taking place there. In the meantime, the FBI and Detroit Police Commissioner George Edwards were determined to end the hotel's illegal activities.

The authorities said that organized crime was involved in the scheme and that White had ties to bosses Anthony Giacalone and Pete Licavoli.[75] Computations based on tapes and account books of the houses operating in the Gotham indicated a gross business of over $21 million a year—the equivalent of a whopping nearly $222 million today.[76]

The Gotham was razed in July 1963 as part of "urban renewal" in the area. John White died in 1964 while awaiting trial on federal gambling charges.

Today the hotel's former site at John R and Orchestra Place is a surface parking lot.

THE MARSALIS MANSION MOTEL

Jefferson Parish, Louisiana
Proprietor: Ellis Louis Marsalis Sr.

The Marsalis Mansion Motel offered quality lodging for African Americans in New Orleans during the Jim Crow era. The property's owner and operator, Ellis Louis Marsalis Sr. was the first African American owner of a motel in Jefferson Parish. Ellis Sr. was also father to internationally renowned jazz musician Ellis Marsalis Jr., and grandfather of equally renowned musicians Wynton, Branford, Delfeayo, and Jason.[77]

Ellis L. Marsalis Sr. was born in Summit, Mississippi, in 1908. He witnessed quite a bit of racial violence and injustice during his upbringing. As a result, from a very young age, he was determined to become a landowner and a self-made man running his own business. Marsalis's early dream was to become a farmer.

Marsalis Mansion Motel. Reproduced by permission from the Amistad Research Center (New Orleans, LA), Ellis Marsalis, Sr. papers.

By 1936, Marsalis was the first Black owner of an Esso filling station in Uptown New Orleans. He worked multiple odd jobs to save money and become independent. He eventually saved $5,000 toward a down payment on a lot that included a house and a barn. The lot had been owned by the Arnoult family since 1719, and once made up the slave-holding Rosedale Plantation.

When Marsalis's family moved to the address on River Road in 1943, he originally purchased the land to be a home for his family and hoped to lead a quiet life as a chicken farmer. However, he later realized the land wasn't suitable for this, and as he pondered what to do with the space, other Black business owners asked if they could use his old barn for meetings. Marsalis decided to clear out a loft in the barn to make a few extra rooms to accommodate their requests. When members of the National Urban League came to New Orleans, Marsalis allowed them to use it, though he shied away from controversy and asked his guests not to be in the yard shaking hands and taking pictures. As the eventual hotelier expanded the barn into a motel, however, controversy undoubtedly reared its head.

From its opening in 1944, the Marsalis Mansion Motel offered quality accommodations for Black travelers during the Jim Crow era. The property's brick-and-concrete wings eventually encompassed the old barn and became the epitome of 1960s excellence. As it grew in popularity among Black travelers, the motel sometimes took on the nicknames of the Marsalis Tourist Home, the Marsalis Motel, or the Marsalis Inn. The green and white matchbooks available in its lounge read the Marsalis Mansion.[78]

The Marsalis Mansion Motel offered luxury amenities and accommodations for its time. The motel housed more than forty guestrooms, as well as honeymoon suites, and featured a covered pool proudly advertised as having "no bugs." The motel advertised its telephones, air conditioning, and free color television sets. Each guestroom was adorned with carpeting and a built-in sound system that allowed guests to select their favorite songs. The restaurant called the River Room hosted elegant parties and card games. In the 1950s, the property was home to the popular nightclub called the Music Haven.[79]

Ellis L. Marsalis Sr. Reproduced by permission from the Amistad Research Center (New Orleans, LA), Ellis Marsalis, Sr. papers.

The Marsalis Mansion accommodated some of the most prominent Black figures and musicians, including Martin Luther King Jr., Dinah Washington, Thurgood Marshall, Ray Charles, and Etta James, to name a few.

According to a 1988 interview, Marsalis paid a Jefferson Parish deputy sheriff five dollars a week for extra protection. However, it did not prevent an attack in the late 1940s when someone threw a smoke bomb onto the motel grounds. When deputies threatened Marsalis that they would find a way to shut down his business if he didn't increase his payments to twenty dollars a week, Marsalis went to the bank and asked the teller to set up a weekly withdrawal to pay the bribe. The bank teller told him it was illegal and that he had to report it. After that, Marsalis said he never saw another extortion attempt.[80]

Although the Marsalis Mansion thrived during the segregation era, Marsalis fought feverishly to dismantle the segregationist policies that made him successful. He formed the Boosters Club, an organization to encourage Black residents to register to vote. The club also helped raise money for Black students to attend college, including Ernest Nathan "Dutch" Morial, the future mayor of New Orleans.

By the mid-1960s, Marsalis had earned a reputation as a respected business leader and political activist, and in 1964 he was elected president of the National Hotel Association. A lifelong Republican, he was named a delegate to the Republican Presidential Convention in the same year.[81]

Following the Civil Rights Act of 1964, and as racial integration became more widespread throughout the region, the motel's clientele began to take a drastic shift. The Marsalis Mansion began to lose its luster and inevitably fell into disrepair. In 1986, the motel closed its doors for good. Marsalis, however, was still living at the family's home on the property.

In 1993, the old motel building was deemed a fire hazard and razed.

In 2004, Marsalis died in the old home where he raised his family. He was survived by his son, the famous jazz pianist Ellis Marsalis Jr., and his daughter, Yvette Washington, who helped run the motel for its final thirty years. In 2007, demolition equipment returned to demolish the home.

On Jan. 9, 2015, the Jefferson Parish Historical Commission unveiled a historic marker to commemorate Marsalis and the Marsalis Mansion Motel which stands in the former location of the motel.

During his later years, Marsalis was often seen wearing a straw cowboy hat—fitting headgear for a political pioneer, civil rights advocate, and first-rate hotelier.[82]

SIX

THE BLACK HISTORY OF ATLANTIC CITY AND LAS VEGAS

BLACK HOSPITALITY IN THE WORLD'S FAMOUS PLAYGROUNDS

Like elsewhere in America, Black entrepreneurial genius helped to develop both Atlantic City and Las Vegas into the thriving midcentury resort areas that they became. In so doing, Black entrepreneurs also created vital nodes of cultural and political influence that radiated throughout the rest of the country.

Most African Americans who resided in Atlantic City worked as laborers or in the service industry at white-owned hotels. Ninety-five percent of jobs at resorts and in tourism in Atlantic City during the Victorian era, in fact, were made up of Black workers.[1] Though Black migrants did not encounter segregation laws in Atlantic City, they did encounter discriminatory practices such as redlining (where lenders forbid access of potential homeowners to certain neighborhoods based on race) which cloistered Black people in the Northside neighborhood. It was from this Northside neighborhood where much of the Black entrepreneurial energy flourished.

In Northside one could find some of the most enterprising Black merchants in the world. They owned hotels, tourist homes, restaurants, nightclubs, and numerous other businesses which placed them in a position to claim a large piece of the millions of tourist dollars spent each day. These African American businessmen, like most of Atlantic City's seasonal entrepreneurs, had to make their biggest financial gains between May and September of each year.

Atlantic City had attracted African American vacationers in appreciable numbers since the beginning of the twentieth century. Many of them discovered its glamour and appeal while employed in the resort's large hotels or as servants of wealthy tourists.[2] The beaches and hotels were not segregated until 1900, when white tourists visiting the area from the Jim Crow South began sharing their discontent about integration. Only then did the city council officially segregate Atlantic City.

Many of the nearby restaurants refused to serve African American customers, so families would pack their picnic lunches to the only beach open to them—Missouri Avenue Beach. Leftover chicken bones gave the beach its popular name: Chicken Bone Beach.[3]

Entertainer Sammy Davis Jr. with beachgoers on Chicken Bone Beach, ca. 1952.
From the John W. Mosley Photograph Collection and the Charles L. Blockson Afro-American Collection,
Temple University Libraries, Philadelphia, Pennsylvania.

African American family on Chicken Bone Beach. From the John W. Mosley Photograph Collection and the Charles L. Blockson Afro-American Collection.

Mother and daughter smile for the camera on Chicken Bone Beach. From the John W. Mosley Photograph Collection and the Charles L. Blockson Afro-American Collection.

In response to the demand of Black travelers, Northside would come to claim some four thousand hotel and boarding-house rooms. Black vacationers came to Atlantic City to indulge, often excessively, in its wondrous, wide-open brand of summer fun, and their schedules seemed to seldom include sleep. People would drive into Atlantic City from Philadelphia, New York, Washington, D.C., and even Boston to relish in a fun-filled weekend of entertainment.

According to listings in the *Green Book*, somewhere between twenty and fifty cottages in the Northside were open to African Americans in the mid-twentieth century. Some residences were owned by families, and travelers were welcome to stay in a single room.[4]

Upscale Black-owned hotels began to open in Atlantic City. One was the six-story, 141-room Liberty Hotel located at 1519 Baltic Avenue. Opened in the 1930s, the property became a hub of activity for Black vacationers visiting the famous resort city. The Randall Hotel and Wright's Hotel also made names for themselves among Black tourists.

None of the 500,000-plus African Americans who visited Atlantic City annually would ever leave without making a pilgrimage to "The Curb." One of the most famous nightclubs was Club Harlem, located near the Liberty Hotel. Club Harlem attracted stars like Ella Fitzgerald, Nat King Cole, Lena Horne, Billie Holiday, Cab Calloway, Dinah Washington, Louis Armstrong, Sammy Davis Jr., and Aretha Franklin.

By the late 1960s, Missouri Avenue Beach, along with the many other Black-owned businesses on the Northside, became obsolete and faded out of existence. During the 1970s and 1980s, when Atlantic City built its famous casinos, most of the Northside neighborhood's historic buildings were either razed, repurposed beyond recognition, or converted into public housing.

Whereas Atlantic City segregated itself over time, Las Vegas plunged directly into Jim Crow practices. Rigidly segregated casinos and hotels were the standard in Las Vegas. Black people were barred from practically every place white people went for entertainment or services. The common motto in Las Vegas was: "A Black man can entertain on the Strip but cannot be entertained there."[5]

When African American entertainers were booked there, they were either forced to seek lodging in hotels outside of where they worked or were restricted from the dining and gaming rooms. Except for a favored few who were friends of the entertainers, African American patrons were barred from most of the leading clubs and casinos. On the west side of town, the Brown Derby Club, Cotton Club, and El Morocco were the only clubs that catered to African Americans. In downtown Las Vegas, only two restaurants would serve Black patrons. If a Black person tried to enter the small or large clubs, he or she was generally blocked at the door by an armed guard and turned away.[6]

Black people were also restricted to the most menial jobs. While over two-thirds of the maid, janitorial, and menial kitchen help in the city were held by African Americans, few got the higher-paying jobs as bellhops, bartenders, or cooks. The "tipping" professions were almost completely white.[7]

To avoid humiliation or segregation, most African Americans in Las Vegas sat in their cars to see a movie, the drive-in theater being the only place where they could be certain of admittance. Though the names of Lena Home, Billy Eckstine, or the Mills Brothers blazed regularly on the marquees of the casinos and hotels, members of their race were neither welcome nor admitted as guests.

The same "whites only" policy applied in the motels and smaller hotels.[8] Due to its severe segregation practices, Vegas came to be widely known as the "Mississippi of the West."[9]

In mid-March 1960, a clever campaign to open Las Vegas resorts, clubs, and casinos to African Americans was staged. Led by the city's only Black dentist, Dr. James B. McMillan—then serving as NAACP local chapter president—the NAACP, other civic leaders, and the publisher of the liberal daily *Las Vegas Sun* promised "a blow to the purse strings of southern Nevada if, in the end, it becomes necessary."

The threat followed an NAACP letter to Mayor Oran K. Gragson, which demanded an interracial mass meeting to break Las Vegas's discrimination practices. Opposition in some quarters was resolute. Yet no one seemed anxious to have the spotlight of national and world attention focused on this rollicking, frolicsome city because of mass Black demonstrations and, possibly, sit-downs. On March 25, 1960, one day before the planned "peaceful, but firm" demonstration was scheduled to occur, a meeting was quickly arranged by Governor Grant Sawyer, as well as the mayor, hotel owners, city and state officials, local Black leaders, and Dr. McMillan. The meeting was held at the shuttered Moulin Rouge, and it resulted in the Moulin Rouge Agreement: to lift all Jim Crow restrictions and desegregate all Strip casinos, hotels and restaurants, and other previously restricted areas. *Las Vegas Sun* editor Hank Greenspun mediated the agreement.[10]

The scheduled March 26 mass demonstration was canceled.

THE BRIGANTINE HOTEL

Brigantine Island, New Jersey
Proprietress: Sara Spencer Washington

Sara Spencer Washington was a prominent Black businesswoman, entrepreneur, hotelier, philanthropist, civil rights activist, and one of America's first Black millionaires. "Madame Washington," as she was widely known, was the owner of Apex Enterprises, a hair products empire based in Atlantic City, New Jersey. Madame Washington owned the Brigantine Hotel on Brigantine Island, New Jersey. The stylish and elegant business tycoon successfully built a dynasty of beauty products, schools, publishing houses, and pharmaceuticals that survived both the Great Depression and racial segregation in Atlantic City.[11]

Washington was born in 1889 in Beckley, West Virginia, to Joshua and Ellen Douglass Phillips. She attended public school in the Beckley area before going to the Lincoln Preparatory School in Philadelphia and then to Norfolk Mission College in Norfolk, Virginia. Washington earned a BS degree in business administration from Northwestern University. She also studied advanced chemistry at Columbia University in New York City.[12]

In 1905, at sixteen years old, Washington began her profession as a dressmaker. In 1911, she settled briefly in York, Pennsylvania, where she studied hair care. Due to her mother's poor health the family relocated to the Jersey Shore, the ocean air believed to possess healing properties for the sick.

Sara Spencer Washington.
Image courtesy of the Atlantic City Free Public Library.

In 1913, Washington established a one-room beauty salon in the Northside, Atlantic City's Black business and cultural district. Her parents were displeased with this decision because they wanted her to become a schoolteacher. But her reputation as a hairstylist within the community grew rapidly.

Frustrated with the lack of beauty products for African American women, Washington took on the challenge. In 1919, at the age of thirty, she founded the Apex News and Hair Company in Atlantic City and began her career as a cosmetics entrepreneur.[13] Washington did not pioneer the beauty industry; she launched her business the same year that famed cosmetics entrepreneur Madam C. J. Walker died.

Washington ran her one-room beauty salon by day and walked door-to-door at night selling her beauty products. She would go on to build a business empire that included Apex News and Hair Company, Apex Publishing Company, Apex Laboratories, and Apex Drug Company. Her Apex Beauty Colleges stretched across twelve cities in the U.S., the Caribbean, and Johannesburg, South Africa; they graduated as many as four thousand students annually.[14]

It is estimated that Washington's company employed nearly five hundred people in her stores across the nation, in addition to the estimated forty-five thousand sales agents who canvassed Apex beauty products door-to-door as Washington had in her early days. In 1939, Washington was honored at the New York World's Fair as one of the "Most Distinguished Businesswomen."[15] By the mid-1940s, her beauty empire was estimated to be worth roughly $500,000.[16] Despite her success Washington was still barred from "whites only" establishments and beaches.

The beauty tycoon never turned her back on the Black community. Besides providing African Americans skills, jobs, and confidence through Apex, she devoted her time to helping those less fortunate. She used her influence and wealth to break through racial bans and push for equal rights.

Washington donated twenty acres of farmland as a campsite for Black youth and endowed a girls' home to the National Youth Administration that focused on providing work and education for young people between the ages of sixteen and twenty-five.

When golf courses would not accept African Americans, she opened the racially inclusive Apex Golf Course in Galloway Township, New Jersey, one of the first Black-owned golf courses in the nation, now home to Pomona Golf & Country Club. She later founded Apex Rest, a nursing home for the elderly in Atlantic City.[17]

In 1944, Washington purchased the Brigantine Hotel from religious leader Father Devine and established the first integrated beachfront in the Atlantic City area. Previously, Black beachgoers, including luminaries like Martin Luther King Jr. and Sammy Davis Jr., were relegated to two blocks of beachfront between Missouri and Mississippi Avenues, the aforementioned Chicken Bone Beach.

Washington was engaged in the political and civic affairs of both Atlantic City and national civil rights organizations. She was

The Brigantine Hotel. Image courtesy of the Library of Congress, Historic American Buildings Survey / Historic American Engineering Record / Historic American Landscapes Survey.

an active member of the NAACP, the New Jersey State Federation of Colored Women's Clubs, the National Association of Negro Business and Professional Women's Clubs, and the National Council of Negro Women.[18] She was also delegate to the Republican National Convention and an active member of the Atlantic City Board of Trade.

Although she suffered a stroke in 1947 which left her paralyzed, Washington continued to provide for Atlantic City's Black community and operate her empire until her death in 1953. Her adopted daughter, Joan Cross Washington, became the president of the Apex company until it was sold.

Muralist BKFoxx's tribute to Sara Spencer Washington. Image courtesy of BKFoxx.

Washington was posthumously inducted into the Atlantic County Women's Hall of Fame in 1997. Nearly seventy years after her death in October 2021, she was inducted into the New Jersey Hall of Fame. The Atlantic City Arts Foundation partnered with Avanzar, formerly The Women's Center, to create a mural of "The Madame" by muralist and photorealist BK Foxx on a building facade on the southeast corner of Atlantic Avenue and Dr. Martin Luther King Jr. Boulevard.[19]

The Brigantine Hotel, now known as Legacy Vacation Resorts Brigantine, is the only building associated with Madame Washington's empire still standing today.

DEMOCRACY HITS LAS VEGAS

THE MOULIN ROUGE HOTEL AND CASINO

Las Vegas, Nevada
Co-proprietor: Joe Louis

On May 24, 1955, in typical extravagant Las Vegas fashion, democracy arrived in grand style in the form of the Moulin Rouge Hotel and Casino. Built near Berkeley Square, the Moulin Rouge, was named after the famed Paris cabaret. The multimillion-dollar luxury property publicized itself as the first interracial hotel casino in the United States. The fabulous property, built to accommodate four hundred guests, began its operation with a $50,000 three-day press party attended by topflight newsmen and theatrical stars who were flown in from all over the country. Despite the fanfare, the glory of the Moulin Rouge was short-lived, demonstrating the ongoing commercial perils that Black businesses faced even as Jim Crow was being slowly dismantled.

The Moulin Rouge was a very short ride from the Las Vegas Strip and the segregated Black neighborhood of West Las Vegas. Imposing and regal, with its pretty green lawn and $35,000 Eiffel Tower neon sign, its decor and architecture were modern with a tropical accent.[1]

Interracially owned, with Joe Louis as 2 percent part-owner and official host, the establishment's staff was integrated with more than 550 persons and served an interracial clientele. Whites flocked to the Moulin Rouge and constituted about 80 percent of its customer base.

The property cost an estimated $3.5 million and featured 110 rooms and seven suites. The casino/hotel offered the Café Rouge, the Pierre Bar, the Deauville Dining Room, an Olympic- sized swimming pool, and a barber shop, beauty salon, gift shop, and 24-hour gambling casino with eighty slot machines. The hotel and casino also included stylistic features designed to transform the romance of Paris into the glitz of Las Vegas. The hotel sign featured a sixty-foot-high neon Eiffel Tower, a design that was also featured on the casino's chips. For dining, patrons had a French chef at their disposal.

The most popular attraction at the Moulin Rouge was its marquee African-themed late-night showcase featuring Vegas's only all-Black chorus line, the Tropi Can Can. The Moulin Rouge showgirls

The Moulin Rouge Hotel & Casino. Reproduced by permission from Nevada State Museum, Las Vegas.

The Moulin Rouge bar, which included a motif of cancan dancers and other depictions evoking Paris's Moulin Rouge. From Nevada State Museum, Las Vegas.

The Moulin Rouge lobby. From Nevada State Museum, Las Vegas.

> In Vegas for twenty minutes, our skin had no color. Then the second we stepped off the stage, we were colored again. The other acts could gamble or sit in the lounge and have a drink, but we had to leave through the kitchen with the garbage.
> —Sammy Davis Jr.

were featured on the June 1955 cover of *Life* magazine.

People criticized the hotel as "just giving the Negro the dubious right of losing his money with other white suckers," forgetting other facets of the hotel.[2] It provided African American vacationers and especially entertainers with comfortable accommodations at reasonable rates. More importantly, it had opened good-wage positions to African Americans. Every department was set up on an interracial basis: the chefs, waiters, clerks, card dealers, security guards, and even the contractors who built the hotel.

Renowned Black performers Nat King Cole, Lena Horne, Sammy Davis Jr., Louis Armstrong, Sarah Vaughan, Duke Ellington, Dorothy Dandridge, Ella Fitzgerald, Harry Belafonte, Pearl Bailey, and Lionel Hampton, as well as white celebrities Frank Sinatra, George Burns, Bob Hope, Judy Garland, Zsa Zsa Gabor, and Jack Benny all stopped by the luxurious Moulin Rouge.[3]

Boxing champion Joe Louis at the Moulin Rouge before the Helldorado parade. From Nevada State Museum, Las Vegas.

Theodora "Dolcinia" Boyd at the Moulin Rouge pool. From Nevada State Museum, Las Vegas.

LIFE

LAS VEGAS—IS BOOM OVEREXTENDED?

THE WAR ON VIRUS DISEASES

ROBERT COUGHLAN TELLS OF SALK'S NEW GOALS

NEWEST IN LAS VEGAS:
GIRLS AT THE MOULIN ROUGE

20 CENTS

JUNE 20, 1955

Life magazine Moulin Rouge feature cover. From Nevada State Museum, Las Vegas.

Predictions of failure and rumors of financial tragedy spread from the moment the Moulin Rouge opened its doors. With bad financing decisions and an overhead of $18,000 a day, the hotel casino operated in the red almost before the first croupier yelled "place your bets." The Moulin Rouge failed to pay $371,929 worth of notes as they came due and had $90,000 in liens filed against it in Las Vegas for unpaid bills by merchants; the hotel owed its bartenders and culinary workers $21,500 in back pay.[4]

Despite its popularity, in October 1955, after just 137 days of round-the-clock operation, law officers walked into the Moulin Rouge and stopped its one-square-inch red dice from rolling, stilled the clatter of its battery of 80 one-armed bandit slot machines, and padlocked its doors shut. Over 275 Black and white employees alike, including a dozen of the world's most beautiful African American chorus girls, were suddenly out of work. Hotel guests were asked to pack up and vacate the premises.

By December 1955, the hotel had filed for bankruptcy.[5]

The Moulin Rouge reemerged on March 25, 1960, when it served as the site of a meeting between the local chapter of the NAACP and city officials. That meeting would eventually lead to the demise of segregation in Las Vegas.

The Moulin Rouge remained shuttered for decades, amidst many failed plans to reopen the cultural landmark and restore the property to its former glory. On May 29, 2003, the property was severely damaged when a fire ripped through the famous hotel casino and burned it to the ground, leaving only the historic sign, tower, and facade.[6]

Over the years, the facility fell victim to several more fires. Despite the building being listed on the National Register of Historic Places, in July 2010 the City of Las Vegas and the Las Vegas Historic Preservation Commission approved the demolition of the remaining portion of the building because of public safety concerns.

Despite the failure of the hotel, the Moulin Rouge did become a catalyst for change in Las Vegas and remained a symbol of racial integration and Las Vegas's civil rights struggle.

In November 2020, the parcel was sold to BBC Capital, a private equity investment firm based in Australia for $3.1 million. As of 2022, the lot remains undeveloped.[7]

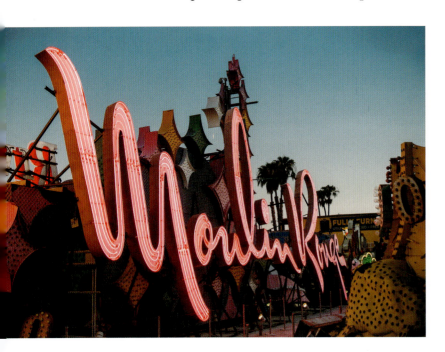

The sign for the Moulin Rouge sitting in the Neon Boneyard of Las Vegas's Neon Museum. Reproduced by permission from the Neon Museum.

HATTIE CANTY

President, Las Vegas Hotel and Culinary Workers Union Local 226

Hattie Canty (June 10, 1933–July 12, 2012) was one of the greatest union leaders in United States history. In 1990, Canty was elected president of the Las Vegas Hotel and Culinary Workers Union Local 226, enabling her to improve the lives of tens of thousands of service employees in Las Vegas's booming hotel and casino industry.[8]

Canty, a widowed mother of ten and former hotel maid at the Maxim Hotel and Casino on the Strip, brought an unprecedented level of determination and doggedness to her role as union president. With Canty at the reins, the union evolved into a powerful bargaining agent for the city's increasingly multiracial workforce. She mobilized the rapidly growing union membership to exert significant pressure on uncooperative Las Vegas hotel and casino employers.

Canty's dedication and leadership skills helped secure higher wages and respectable benefits for workers in Las Vegas's thriving gaming and tourism industry. She led a series of highly publicized strikes in Las Vegas. From the early to late nineties, the union mounted one of the longest strikes in American history, which cost Margaret Elardi, the owner of the New Frontier Hotel and Casino, nearly a billion dollars when she eventually sold the property.

By the mid-1990s, housekeepers and other hotel employees in Las Vegas earned more than double the average wage of service employees in other cities. Due in large part to Canty's efforts, unionized hotel workers in Las Vegas could be homeowners, could raise college-educated children, and could sustain a lifestyle within the middle class.[9]

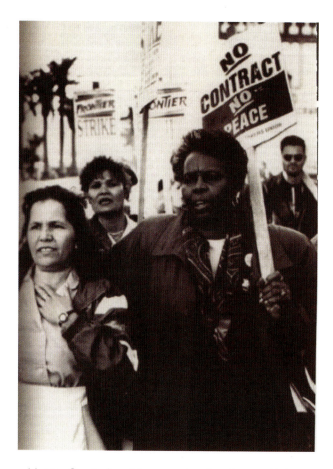

Hattie Canty, Las Vegas union leader and labor activist. From Special Collections and Archives, University of Nevada, Las Vegas.

SEVEN

HOSPITALITY DURING
THE CIVIL RIGHTS ERA

JIM CROW ALONG THE HIGHWAYS

Until the end of World War II, few white motel operators were willing to accept African American patronage. By the early 1960s, however, discrimination against Black travelers had declined noticeably along the highways. Some said this was proof that America was becoming more liberal. Others claimed, perhaps cynically, that it was simply the loud voice of the Black dollar belatedly asserting its power. The fact remained, however, that many white motels in the North and West began voluntarily opening their doors to African Americans.

In the far West where motor courts were plentiful, African American motorists were likely to find the going easiest. If they had reservations, the chances that they would be turned away were slight. In off-seasons, even if they lacked reservations, they were sometimes greeted like lost children. Many experienced tourists reported that when they were in "strange territory" they would always try the best motels first, having learned that the less attractive ones were most likely to snub them.[1]

Some intrepid Black travelers had even been accorded stealthy welcomes by white tourist court managers in Southern and border states. In Kansas, for example, an African American couple was admitted to a white-operated tourist court on condition that they disappear before daylight. "We wouldn't want to offend anyone," the owner explained timidly. And in Oklahoma, an African American family was lodged at a white motel for two days after they agreed to "pass" as Mexicans during their stay.[2] In some states, the law permitted African American motels to accept whites, but only if they did not share rooms with them.

Encouraging as the motel picture was, travel accommodations for African Americans were still sparse and scattered. In 1955, for example, 3,500 white motels would put up dogs, but fewer than fifty admitted they would house African Americans. Many motels in the South boldly designated the race of clientele they would accommodate. Then, African Americans owned a negligible percentage of the fifty-three thousand U.S. motels that grossed $1.5 billion in 1954.[3]

The Elfra Court Motel, owned and operated by Ella and Frank Foster, was the first Black-owned motel in Wildwood, New Jersey. The 36-unit property opened in the early 1950s and hosted famous Black entertainers Chuck Berry, Sammy Davis Jr., and the Supremes, to name a few.

In Springfield, Missouri, in the early 1950s, Alberta Northcutt Ellis opened her hotel to provide African Americans traveling along Route 66 a safe place to stay. The three-story Victorian-house hotel was staffed by family members and was located just three blocks north of the historic highway.[4]

These hotels on the highway got a taste of democracy in mid-June 1955 when the Ohio Turnpike Commission announced that it would not permit hotels, motels, inns, and other places of overnight accommodations to advertise along the 240-mile toll road if they practiced racial discrimination.

Other places resisted. Route 40, a forty-nine-mile highway stretching from the city limits of Baltimore to the state line of Delaware, dotted with garish motels and saturated with restaurants bathed in the multicolored glare of neon lights, was Jim Crowed all the way.[5] Discrimination along Route 40 had existed since the highway's inception. At the time, discrimination was so indoctrinated that the highway could have been picked up, placed down in Mississippi, and felt "at home." No one seemed too excited about it in the past—except perhaps the African American travelers who were humiliated by being turned away from motels and restaurants.[6]

Despite slowly improving conditions along the nation's roads, resistance to hospitality desegregation continued in many quarters. A 1964 editorial in the Santa Fe *New Mexican* pointed out an obvious contradiction: "There is no discrimination in public accommodations, we say, although there may be certain hostelries in the immediate area which suddenly find they have no vacancies when a Negro family shows up and asks for a room."[7] The 1963–64 edition of the *Green Book* contained an introductory page entitled "Your Rights, Briefly Speaking!" that included a list of states and their specific laws regarding discrimination, as well as the office in those states to whom travelers could complain.[8]

Several Black-owned hotels and motels played pivotal roles during the civil rights movement of the 1950s and 1960s. Paschal's Motor Hotel, the first Black-owned hotel in Atlanta (proprietors James and Robert Paschal) became an epicenter at the height of the civil rights movement. Martin Luther King Jr. kept a suite at the property that he used as a planning space.[9]

Another base of civil rights operations was a motel located eight miles north of Columbia on US-1 (present-day Two Notch). Opened in 1955, Motel Simbeth was co-owned by Modjeska Monteith Simkins, one of the state's most visible civil rights activists. The property quickly became a landmark business for the ongoing civil rights movement in South Carolina.[10]

Opened in 1951, the Ben Moore Hotel was a beacon for the Centennial Hill neighborhood in Montgomery, Alabama. Matthew Franklin Moore opened the first licensed hotel to serve African Americans in Montgomery. The property would become the site of historic meetings between representatives of the Black and white populations of Montgomery during the dawn of the Civil Rights era.[11]

The *Green Book* ceased publication in the mid-1960s, not long after the passing of civil rights legislation. However, many tourist destinations and businesses still did not accommodate people of color. While some state and local governments tried to maintain the status quo of systemic racism and oppression, including racial segregation of public accommodations, civil rights groups and their advocates organized to address racial injustice and promote equality.

THE TOOKES HOTEL

Tallahassee, Florida
Proprietors: Dorothy and James Tookes

The Tookes Hotel welcomed Black guests to Tallahassee at a time when other hotels in town turned them away.

Dorothy Tookes and her husband, James, owned and operated the Tookes Hotel in Tallahassee, Florida, for more than forty years. The eleven-bedroom, one-story rooming house and hotel in Frenchtown offered the only lodging for African American visitors to Tallahassee during the era of racial segregation.

Dorothy Ethel Nash Tookes was born in 1904 in Tallahassee, Florida. She attended Talladega College in Talladega, Alabama, and Florida A&M University. She graduated with a Bachelor of Science in Education, followed by a degree in Nursing Education.

In 1930, two years after graduating from Florida A&M, she married James Tookes, a chef at the Governor's Mansion. The young couple made their home in Tallahassee's Frenchtown neighborhood at 412 West Virginia Street.

In 1935, Tookes, at the age of thirty-one, became the founder and first principal of Bond Elementary School. In addition to her work for Bond Elementary, she worked as a nurse at the Florida A&M Hospital. In 1940, she took the position of a public school teacher in Gadsden County, where she taught until her retirement in 1971.

Dorothy Tookes, owner of the Tookes Hotel. Image courtesy of grandson Ronald McCoy of the Tookes family.

Tookes was an equal rights advocate, but she had no idea how her servant-ship and entrepreneurial spirit would lead to a business venture that would cement her name in history. During the mid-1940s, she saw an opportunity (and necessity) for a hotel within the African American community. In 1948, she and James turned their home into a rooming house and hotel.[12]

Tookes added a bathroom and three bedrooms to their Frenchtown home and began taking in guests. She added numerous interior features, such as oak flooring and chandeliers in the living and dining rooms. By the 1950s, they were marketing the home as the Tookes Hotel. In the early 1950s, Tookes added two rooms to the hotel. The property would soon become a vibrant hub for the Black community. The Tookes Hotel was listed in the city directory and marked outside with one of the first neon signs in Tallahassee.

At the time, the Tookes Hotel was the only lodging establishment in Leon County to offer rooms to Black people when visiting segregated Tallahassee. The hotel hosted several famous Black entertainers and luminaries including Lou Rawls, Ray Charles, Duke Ellington, and American writer and civil rights activist James Baldwin.[13]

Dorothy Tookes greeting guests in front of her hotel after her son's wedding. From the Florida Memory project, reproduced by permission from the Florida State Library and Archives.

Even after segregation ended, the hotel was still so popular that more rooms were added in 1971. The Tookes Hotel remained in operation until the early 1980s.

Dorothy Tookes ran the hotel until her death at age eighty-four in 1988.

In 1992, the City of Tallahassee recognized Tookes for her outstanding service to the Tallahassee community during and after the turbulent segregation era for nearly five decades.

In 1993, the home was leased to the State Department of Corrections and converted into a halfway house and operated until the early 2000s.

On January 26, 2001, the property was named to the National Register of Historic Places.

In summer 2024, Dorothy Tookes's grandson, property owner Ron McCoy, announced that Frenchtown's Historic Tookes Hotel would welcome guests for the first time since the early 1980s after completing its renovation. The newly refurbished bed-and-breakfast, venue, and museum will be bookable as an Airbnb in 2025.[14]

THE A .G. GASTON MOTEL

Birmingham, Alabama
Proprietor: A. G. Gaston

One of the hallmarks of the Civil Rights era in the 1950s and 1960s was the fact that battles of a national and historic character often took place in the most ordinary, even mundane, places. Such was the case with the A. G. Gaston Motel in Birmingham. Arthur George "A. G." Gaston was a successful Black businessman, entrepreneur, hotelier, and civil rights activist. During his lifetime, Gaston overcame poverty and racial discrimination to build a multimillion-dollar business empire in the South. In 1954, Gaston built and operated his motel in Birmingham, which provided first-class lodging and dining for African American travelers. In 1963, the property also served as the headquarters of the Birmingham campaign to end racial segregation in public accommodations in the city and across the nation.[15]

Gaston was born in a log cabin in 1892, in Demopolis, Alabama. His father was a railroad worker who died soon after Gaston's birth. He was raised by his grandparents, Joseph and Idella Gaston—former slaves—when his mother left to work as a cook for a wealthy businessman in Greensboro, Alabama.[16]

Arthur George "A. G." Gaston, owner of A. G. Gaston Motel. Reproduced by permission from the Birmingham, Alabama, Public Library Archives.

Gaston's grandparents' home was the only one in the neighborhood with a big, beautiful swing in the backyard. It is reported that the young Gaston charged the neighborhood children buttons to ride the swing. Gaston later pointed out this taught him that people would be willing to pay for something they wanted or needed.[17]

Gaston's mother enrolled him in the Tuggle Institute, a privately run charitable school for African Americans that focused on developing trade skills and business acumen, where he rose to the top rank of the students. Booker T. Washington was a prominent supporter of the Tuggle Institute. Gaston admired Washington, who believed in Black self-reliance and lifting oneself up by one's bootstraps.

At the age of eighteen, after completing the tenth grade, Gaston left the school and began selling The *Birmingham Reporter*, a Black-owned newspaper. He also spent time as a bellman at the fine Battle House Hotel in Mobile, Alabama.[18]

In 1913, Gaston enlisted in the U.S. Army and was assigned to the all-Black Ninety-Second Infantry Division, which was deployed in World War I combat in 1917. A big part of the reason was the twenty-dollar monthly military pay.[19] He spent three years at Fort Riley, Kansas, where like other Black people he did kitchen and latrine duty. For extra money, he polished the boots of the white officers.

When he returned to Birmingham following the war, Gaston drove a delivery truck for a local dry-cleaning company for one dollar a day. Desperate to support himself and his mother, Gaston had no other alternative but to accept a job in the mines of the Tennessee Coal, Iron and Railroad Company in Fairfield, Alabama. Although the job paid quite well, working in the mines was brutal and unsafe. Gaston undoubtedly saw many early deaths from the harmful work conditions.[20]

When Gaston's fellow miners admired the great box lunches his mother had prepared for him, he began selling them. He also sold peanuts and popcorn, sometimes earning as much as twenty dollars a day. He then began loaning money to the other workers, charging 25 percent interest. Gaston was soon profiting as much as one hundred dollars a month.[21]

Gaston recognized the need for poor African Americans to have affordable funeral burial services, so he created the Booker T. Washington Burial Society. He traveled door-to-door, collecting twenty-five cents per week for the head of the household and ten cents for additional family members, guaranteeing a respectable burial. Gaston advertised his services to Black

churches throughout the state, often relying on local gospel singers, concerts, and radio programs targeted to Black people.

By 1932, Gaston established the Booker T. Washington Insurance Company, which not only offered burial services, but also life insurance, health insurance, and accident insurance. He later added the Booker T. Washington Business School serving both Black and white students.[22]

By 1941, the Booker T. Washington Insurance Company insured thirty-three thousand Black people in Alabama, collected $155,000 in premiums, and held $6 million in insurance policies. By 1946, the insurance company had sixteen branches across Alabama. Premiums reached a half million dollars annually. As expected, all burials took place at the Smith & Gaston Funeral Home.[23] Before the close of the decade, Gaston employed the largest number of African Americans in the state of Alabama and had become one of the richest Black men in the nation.

In 1947, Gaston became president of the National Negro Business League. He also served on numerous boards and was a major financial contributor to church groups, the YMCA, and other organizations. Gaston was committed to education and improving the lives of his race. He was especially supportive of Black colleges, including Washington's Tuskegee Institute.

In 1951, he and his second wife Minnie represented the A.M.E. Church at the World Methodist Council in Oxford, England.[24] While there, A. G. learned that the National Baptist Sunday School organization was considering Birmingham for its 1954 conference. Gaston realized that Black people would be challenged to find quality lodging in the city. He immersed himself in the intricacies of owning and operating a motel, using the successful Holiday Inn chain as an inspiration for his property.

The A. G. Gaston Motel opened just in time to host the National Baptist Convention. The property was designed by Stanley Echols of the Brooke Burnham architectural firm. The Gaston was a brick midcentury building composed of a two-story L-shaped corridor. The property boasted thirty-two guest rooms,

A. G. Gaston's Booker T. Washington Insurance Company became the catalyst of a business empire worth more than $30 million, and which included the Smith & Gaston Funeral Home; Citizens Federal Savings and Loan, the first Black-owned financial institution in Birmingham in more than forty years; the Vulcan Realty and Investment Company; the New Grace Hill and Mason City Cemeteries; and other profitable businesses in Birmingham.

some of which were "master suites" that could accommodate up to seven guests. All rooms were heated and air-conditioned with private baths, in-room telephones, jukeboxes, and high-end furnishings, including custom-made drapes and bedspreads. The enclosed parking court led into a shaded patio. Located off the lobby was a spacious dining room complete with a cocktail lounge. A Z-shaped motel sign was attached to the top of the west end of the front facade.[25]

The Gaston became a safe haven for Black people traveling through the South during the 1950s and was met with fervent support in a region where few white-owned hostelries welcomed Black people.[26]

The lounge regularly booked nationally renowned entertainers such as Stevie Wonder, the Temptations, and Little Richard. Other notable guests included Duke Ellington, Count Basie, Harry Belafonte, Johnny Mathis, Nat King Cole, Aretha Franklin, and Jackie Robinson. In 1962, future Secretary of State Colin Powell spent his wedding night there with his bride, Alma, a Birmingham native.

The A. G. Gaston Motel in Birmingham, Alabama.
From the Birmingham, Alabama, Public Library Archives.

A. G. Gaston Restaurant

A. G. Gaston Motel Master Suite

A. G. Gaston Motel . . . Birmingham's Most Popular Convention Host . . .

Postcard for the A. G. Gaston Motel. Reproduced by permission from the Alabama Department of Archives and History.

Dr. Martin Luther King Jr. outside the A. G. Gaston Motel in 1963. From the Birmingham, Alabama, Public Library Archives.

Gaston provided lodging accommodations for Martin Luther King Jr. and other civil rights leaders when they visited Birmingham. The Gaston Motel would soon become the epicenter of several significant chapters of the civil rights movement.

Gaston supported the civil rights movement financially but attempted to stay out of the political spotlight. Among other activities, he provided financial assistance to residents of Tuskegee who faced foreclosure because of their participation in boycotts of white-owned businesses.

In 1962, Reverend Fred Shuttlesworth, a civil rights leader in Birmingham and founder of the Alabama Christian Movement for Human Rights, joined forces with King and members of the Southern Christian Leadership Conference to devise a protest campaign to desegregate the city of Birmingham. The Birmingham campaign, known as Project C (for "confrontation"), consisted of small-scale sit-ins, an organized boycott of the downtown business district, and several mass marches.[27]

The Gaston Motel served as a command post for Project C from April through May 1963. Although Gaston favored nonconfrontational methods of civil rights reform, and initially opposed Dr. King's push for protest, he nevertheless supported the activists' efforts with money, printing presses, office space, and other facilities. The campaign's strategizing took place in room 30, the "War Room" as it was called, located on the second floor above the office and lobby. Press conferences associated with the protest campaign were regularly conducted within the property's courtyard.

After the young demonstrators at Kelly Ingram Park were met with violence and aggression by Birmingham authorities, national outrage was triggered when horrific images of the protestors being sprayed by fire hoses,

> I never went into anything with the idea of making money. I thought of doing something, and it would come up and make money. I never thought of trying to get rich.
> —A. G. Gaston

clubbed by police, and attacked by police dogs was broadcast widely. As local jails became crowded with hundreds of young protestors, Gaston bailed Dr. King and other activists out of Birmingham jail when they were arrested. Because of his role as a mediator, Gaston often faced pressure by proponents from both sides of the civil rights struggle.[28]

In May, the A. G. Gaston Motel hosted negotiations between local white business owners, city officials, and civil rights leaders. The meetings were met by a series of violent attacks, and on May 11, 1963, the Gaston was bombed below room 30 by white supremacists. A. G.'s home was also bombed in September of that year, just prior to the Sixteenth Street Baptist Church bombing that took the lives of four little girls.[29] The violence in Birmingham, in which the Gaston Motel was so directly involved, is credited by most historians with galvanizing support for the Civil Rights Act passed by Congress the next year. The next several years were quiet for Gaston. In 1968, he modernized and expanded the motel, adding a supper club and other amenities. That same year, he published his autobiography, *Green Power: The Successful Way of A. G. Gaston*. But old age would not protect him from violence.[30]

Bomb-damaged trailers at the Gaston Motel, Birmingham, Alabama, 1963.
Image courtesy of the Library of Congress, Prints and Photographs Division.
Photo credit: Marion S. Trikosko.

On the night of January 24, 1976, Gaston and his wife were assaulted by an intruder. Gaston was struck on the head with a hammer, handcuffed, and forced into the back seat of his Cadillac El Dorado. Authorities found him there two hours later, still bound and under a blanket. Later the same day, his abductor was captured by authorities.

In 1987, doctors amputated one of Gaston's legs and he lost sight in one eye because of diabetes—yet he continued to go into the office every day and direct all of his businesses. In 1987, in a most unusual move—and one not loved by his many relatives—A. G. sold the insurance company, probably worth about $35 million, to 350 of his Black employees for $3.5 million, giving up 90 percent of its value.[31]

Gaston's empire began to decline in the 1970s. In 1982, he converted the Gaston Motel into housing for the elderly, which operated until 1996. The Business College closed in 1988.

Gaston continued to be an active member of the Birmingham business community until his death from stroke complications on January 19, 1996, at the age of 103. Minnie died four years later.

Gaston left the Booker T. Washington Insurance Company, the A. G. Gaston Construction Company, the Smith & Gaston Funeral Home, and CFS Bancshares, the nation's second largest Black-owned bank, in addition to numerous charitable and philanthropic organizations. Gaston's net worth was estimated to be more than $130 million at the time of his death.[32]

The Gaston Motel fell into disrepair after sitting vacant for more than twenty years. The City of Birmingham acquired the former motel in 2015 with the plan to incorporate it into the larger Birmingham Civil Rights National Register Historic District. Today, the A. G. Gaston Motel is jointly owned by the National Park Service and the City of Birmingham and is a part of the Birmingham Civil Rights National Monument established by President Barack Obama in 2017. A multiphase restoration of the motel's 1954 wing began in 2019.

In March 2021, Birmingham Mayor Randall Woodfin and representatives from the city and the National Park Service flipped the switch, illuminating the iconic A. G. Gaston Motel sign. The early-evening ceremony in Birmingham's Civil Rights District marked the completion of the Phase 1 restoration of the historic site which encompassed the exterior restoration of the 1954 wing.[33] Phase 2 on the exterior of the 1968 wing and courtyard of the motel was achieved in the summer of 2022.[34]

Sit-In Protests across the South

The "sit-in" protests that catalyzed the civil rights movement in the early 1960s were not limited to lunch counters. The Andrew Jackson Hotel in downtown Nashville was one of the largest and most modern hotels of its kind in the South. The twelve-story property had four hundred rooms and private baths. On February 1, 1962, twenty-four Black male students, including civil rights activist John Lewis, attempted to register at the hotel and, when they were refused service, sat down in the hotel lobby for the night.

Many peaceful protests and demonstrations were met with violence, which led to more complicated protests. On June 11, 1964, Martin Luther King Jr. was arrested for trespassing at the Monson Motor Lodge after being asked to leave its segregated restaurant. This spurred a group of protesters, both Black and white, to leap into the "whites only" pool. Whites who paid for motel rooms invited African Americans to join them in the motel pool as their guests. The motel manager, Jimmy Brock, poured a bottle of muriatic acid into the pool, hoping the swimmers would feel threatened and exit the pool.[35]

In March of 1964, hundreds of people went to jail after huge demonstrations at the swanky Sheraton-Palace Hotel in San Francisco, resulting in 135 arrests of predominantly white protestors. An army of approximately a thousand young demonstrators, mostly college students, participated inside and outside the hotel. They picketed, chanted, sat down, and refused to move until the hotel finally agreed to hire more Black people and other minorities in positions other than bellhops or housekeepers. After a night-long demonstration, a two-year agreement was signed among leaders of minority groups and representatives of the Hotel Employers Association representing the city's thirty-three largest hotels.[36]

THE LORRAINE MOTEL

Memphis, Tennessee
Proprietors: Walter and Loree Bailey

Walter Lane Bailey and his wife Loree Catherine Bailey owned and operated the Lorraine Motel in Memphis, Tennessee. The Lorraine bears its role in the civil rights struggle in a different way. It was on one of the Lorraine's balconies in April 1968 where Dr. Martin Luther King Jr. lost his life. Prior to that awful day the Lorraine reflected the monumental changes experienced by Black people in postwar America.

The building originally opened as the sixteen-room Windsor Hotel around 1925. It later became the Marquette Hotel. Both the Windsor and Marquette properties were all-white establishments. In 1945, the hotel was purchased by African American hoteliers Walter and Loree Bailey. Bailey renamed the establishment the Lorraine Motel after his wife and the popular 1920s song "Sweet Lorraine," which was later recorded by Nat King Cole.[37]

During the Jim Crow era, Bailey operated the Lorraine as an upscale facility that catered primarily to a Black clientele. Over the next two decades, the Lorraine became a much larger and more prominent property under Bailey's tutelage. Bailey added a second floor, additional guest rooms, and a swimming pool, and he expanded the courtyard to accommodate drive-up access and parking.

Dr. Martin Luther King, Jr. (*far right*) arriving at the Lorraine Motel, April 3, 1968.
Reproduced by permission from the University of Memphis Libraries,
Special Collections Department.

The motel's signature turquoise-framed sign became a symbol of quality lodging for African American travelers visiting the city of Memphis. With its stylish exterior, exceptional café, and superior customer service the hotel attracted prominent business meetings and social gatherings.

During its heyday, it was not uncommon to see entertainers, athletes, and politicians at the motel. Although Bailey enjoyed hosting notables there, he wanted to ensure that all guests felt welcomed. Although recognized as a Black motel, the Baileys welcomed both Black and white guests. As the motel's popularity increased, it became the preferred place to stay among prominent figures in the African American business and political communities.

The Lorraine Motel, Memphis, Tennessee.
Image courtesy of the National Civil Rights Museum, Memphis, Tennessee.

Among its notable guests through the 1940s to the 1960s were entertainers Louis Armstrong, Cab Calloway, Nat King Cole, Ray Charles, Lionel Hampton, Sarah Vaughan, Ethel Waters, Sam Cooke, Count Basie, B. B. King, Aretha Franklin, the Staple Singers, and Otis Redding. Two famous songs, Wilson Pickett's "In the Midnight Hour" and Eddie Floyd's "Knock on Wood," were both composed at the Lorraine Motel. Negro League baseball greats like Satchel Paige, Josh Gibson, and Jackie Robinson, as well as the Harlem Globetrotters, also stayed there.[38]

Dr. King stayed at the Lorraine numerous times when visiting Memphis. On April 4, 1968, while there to support the Sanitation Workers' strike and just a day after delivering his prophetic "I've Been to the Mountaintop" speech at the Mason Temple Church of God in Christ, Dr. King was assassinated while standing on the balcony outside room 306. That was not the only tragedy that struck down the Lorraine that day: Bailey's wife, Loree, suffered a stroke a few hours after Dr. King was slain, dying five days later on April 9, the same day as King's funeral.

Bailey continued to run the motel, but he never rented room 306 again. He set aside that room, and the adjoining room 307, as a memorial. The room was preserved to capture exactly what it looked like on that tragic night. A large white wreath continues to hang on the balcony outside room 306 to memorialize the spot where Dr. King fell.

Bailey tried valiantly to keep the property open and Dr. King's memory alive.

He declared bankruptcy in 1982, and the building was scheduled to be auctioned off and faced demolition until circuit court judge D'Army Bailey (no relation to Walter Bailey) organized Memphis philanthropists to "Save the Lorraine."[39]

In 1984, the group changed the name of their organization to the Lorraine Civil Rights Museum Foundation. In 1988, in preparation for an $8.8 million conversion to a civil rights museum, the Lorraine closed as a motel. Sheriff's deputies were brought in to evict the last holdout tenant, Jacqueline Smith, who had resided there since 1973 while working for the motel as a housekeeper. Smith and many others claim that the museum, as well as other components of urban redevelopment and the growth of the historical tourism industry, contributed to the gentrification of the South Main Street area. Smith has continued her protest for more than three decades.

Walter Bailey died in 1988. He did not live to see the dedication ceremony of the National Civil Rights Museum on July 4, 1991. The museum officially opened to the public on September 28 that same year, and D'Army Bailey served as its founding president.

In 1999, the foundation acquired the Young and Morrow Building and its associated vacant lot on the West side of Mulberry as part of the museum complex. To accommodate public demand for further educational opportunities, the main museum closed in November 2012 for a $27.5 million renovation. The renovated museum opened to the public on April 5, 2014.[40]

The National Civil Rights Museum is now a complex of museums and historic buildings that boasts about 260 artifacts and offers films, oral histories, and interactive media to help guide guests through five centuries of Black history. It's among the top 5 percent of institutions to be accredited by the American Alliance of Museums, one of seventeen accredited International Coalition of Museum sites worldwide, and one of six coalition sites in North America.[41]

The Lorraine Motel is currently owned by the State of Tennessee and operated by the Lorraine Civil Rights Museum Foundation. The building is under a long-term lease to operate as part of the complex with the Tennessee State Museum in Nashville. In 2016, the property was honored by becoming a Smithsonian Affiliate Museum. It is also a contributing museum to the South Main Street Historic District of the National Register of Historic Places.[42]

THE ROBERTS MOTEL

Chicago, Illinois
Proprietor: Herman Roberts

Committed as most Black hoteliers were to the cause of civil rights, it cannot be denied that segregation gave some of them their opportunities, and the end of segregation cost many their business empires. Herman Roberts, a prominent Black entrepreneur, businessman, and pioneering hotelier in Chicago, was one such example. During the Great Migration, Roberts came to Chicago with nothing but became a hospitality tycoon. He built his legacy as the first Black motel/hotel developer in the Midwest, breaking racial color barriers in Chicago's hotel industry. Roberts offered African Americans the dignity they were denied elsewhere, providing them accommodations, entertainment, and housing when they had nowhere else to stay in Chicago during the 1950s and 1960s.

Born in 1924 in Beggs, Oklahoma, Herman Roberts was the youngest of six children. His family left Oklahoma when he was twelve and moved to Chicago. He did not let his humble beginnings hold him back.

Herman Roberts: Businessman, entrepreneur and hotelier. Image courtesy of Rod Roberts.

Roberts began delivering newspapers, making just two cents per paper. Then he wiped down cabs and made a dime from each customer. At fifteen, he began driving cabs, then had others drive his cab in the evenings until he saved enough money to start purchasing cab licenses. In 1944 he launched Roberts Cab Company.[43]

Roberts was drafted into the military during World War II, returning to Chicago in 1947. In 1952, he opened the Lucky Spot Club on the south side of Chicago. Two years later, in 1954, he launched the Roberts Show Club (often called the Roberts Show Lounge) in a garage that once housed cabs. In 1960 Roberts opened his first fifty-unit Roberts Motel, also on the south side of Chicago. It was the first new motel ever built in the city by a Black person.

The Roberts Show Club was the place to see and be seen, a popular venue that was a nightlife mecca for Black Chicagoans. Between 1957 and 1961, Roberts booked entertainment greats such as Sam Cooke, Lionel Hampton, Jackie Wilson, Dinah Washington, Sammy Davis Jr., Redd Foxx, Della Reese, Count Basie, Nat King Cole, Dick Gregory, Billy Eckstine, Smokey Robinson, Ramsey Lewis, and Sarah Vaughan, to name a few.[44]

Unlike downtown venues where Black people were not welcomed, Roberts opened his Show Club to African American and white patrons alike. It was not unusual to see white celebrities there such as Hugh Hefner, Gene Krupa, or singer Tony Bennett.

Roberts also broke gender barriers by hiring women. "Business is business" was his motto, and he did not tolerate any form of discrimination. He was described as a "first-class act" by those who knew him. He made a significant contribution during Jim Crow and the Civil Rights Movement by providing Black people accommodation and entertainment options at a crucial period in American history.[45]

Roberts built other properties, one in Gary, Indiana, and another in Oklahoma. In 1970, he built his sixth Roberts Motel in Chicago, which featured the famous 500 Room, where then-Chicago Mayor Harold Washington and other politicians often met (in ads he called the property "the Big One"). The motel was furnished with 250 rooms, twelve suites, two penthouse suites, and a restaurant, lounge, ballroom, bar, travel agency, convenience store, and beauty parlor. The chandeliered ballroom and winding staircase provided the perfect ambiance for parties and events attended by notable Chicago politicians and city elites.[46]

Located on Chicago's southside, Roberts Motel featured a coffee shop and lounge. Image courtesy of Rod Roberts.

Over his lifetime, Roberts owned thirty-five taxi cabs, eight motels, a nightclub graced by some of the world's most famous entertainers, a bowling alley, a skating rink, and oil wells on a 2,000-acre ranch in Oklahoma.[47]

Perhaps the biggest hurdle for Roberts's businesses was the passage of the Civil Rights Act of 1964. The law opened access to commercial establishments by African American patrons, ultimately hurting Roberts's businesses.

The Roberts Motel chain continued into the early 1990s. Roberts retired in 1992, when he was in his late sixties. Today, not much architectural evidence of Roberts's entertainment and lodging empire still exists. He died on January 31, 2021, in Las Vegas at the age of ninety-seven. The damage to African American enterprise by the formal ending of segregation, laudable as that goal was, is a story that still has not been adequately reckoned with today.

Herman Roberts transformed a motel courtyard into a venue for African Americans to enjoy live music and host some of the best parties of the era. Image courtesy of Rod Roberts.

Herman Roberts with Chicago's first African American mayor, Harold Washington. Image courtesy of Rod Roberts.

EIGHT

BEGINNING OF
A NEW ERA

GONE BUT NOT FORGOTTEN

Historically, hotel, motel, and resort ownership was a significant part of Black culture, but gradually these once-flourishing and celebrated businesses fell from the grasp of African Americans. As the restrictions of segregation lifted and federal equal accommodations laws were enforced with the Civil Rights Act of 1964, African Americans were able to travel and vacation to places they never had access to, resulting in many Black-owned hotels and resorts falling on hard times.

As Victor Hugo Green predicted, the end of segregation meant the decline of businesses, like Black hospitality, that existed as an answer to segregation. Now, in many cases, the only thing that remains are historical markers and archives in public libraries and historical societies across the nation.

In addition, lack of some definite form of organization for self-help, financial support, and economic planning on the part of these hospitality pioneers contributed substantially to their demise, as well as the inroads white competitors have made in this respect. In some instances, perhaps it was the failure of descendants to change with the times.

Candacy Taylor, award-winning author of *Overground Railroad: The Green Book and the Roots of Black Travel in America*, traveled across the U.S. to visit the properties listed in the historic travel guide. She found that of the thousands of *Green Book* sites on record, only 5 percent are still in operation.[1]

Over the years, the majority of Black hostelries were demolished as a result of neglect, urban renewal projects, neighborhood revitalization, or gentrification of Black communities. Some activists and preservation advocates have mobilized to save these landmarks and collect the stories surrounding them. Too often the places and spaces where significant Black history occurred are blindly demolished without care to identify their significance to American history.

In 2017, the African American Cultural Heritage Action Fund was formed to assist stewards of Black cultural sites throughout the U.S. in preserving physical landmarks, their material collections, and associated narratives. The initiative was organized under the sponsorship of the National Trust for Historic Preservation and awards grants to select applicants and advocates of Black

history. It is the largest program in America to preserve places associated with Black history.

Since launching the program, the fund has raised more than $80 million and supported more than two hundred preservation projects nationwide. In particular, the fund's grants have supported one hundred sixty places with a total investment of $12.4 million.[2]

One of the grant recipients is the Black-owned Hotel Metropolitan "Purple Room." Maggie Steed was the owner of the property. The hotel opened in 1909 in Paducah, Kentucky, serving Black travelers during the Jim Crow era and was later listed in the *Green Book*. Restoration of the Purple Room (which was used as an after-hours gathering space for Black musicians) will allow it to be used as a gathering space once again.[3]

Twenty individual listed properties in the National Register of Historic Places have been identified as being in the *Green Book*.[4] Below is a brief list of these establishments.

- **The Hotel Theresa | Harlem, New York:**
 In 1971, the property was converted into a modern office building called Theresa Tower. The building was declared a landmark in 1993 by New York's Landmark Preservation Commission and was added to the National Register of Historic Places in 2005.

- **The Hotel Berry | Athens, Ohio:**
 The property was razed in 1974 and sat as an empty lot until 1997. Now the HangOverEasy restaurant sits on its former location. The hotel's history is honored in a mural painted on the backside of the restaurant.

- **Inter-Ocean Hotel | Cheyenne, Wyoming:**
 The Historic Hynds Building sits on the former site of Barney Ford's hotel on Capitol Avenue.

- **The Mountain View Hotel | Oracle, Arizona:**
 The building where the hotel once stood, minus its porches and verandas, is now part of the Oracle Union Church on American Avenue.

- **The Hotel Carver | Pasadena, California:**
 The property is now a mixed-use retail and office space.

- **The Eggleston Hotel | Richmond, Virginia:**
The former hotel site is now the Eggleston Plaza. The four-story building includes thirty-one income-based apartments. A historical marker sits at the site recognizing "the entrepreneurial and professional efforts of the residents of Jackson Ward."

- **The Dunbar Hotel | Los Angeles, California:**
The former Somerville Hotel is no longer operating as a hotel; the Dunbar was renovated and is now part of a larger residential community named Dunbar Village. The property is a Los Angeles Historic Cultural Landmark and in the National Register of Historic Places. In 1974, entertainer Rudy Ray Moore used the run-down Dunbar Hotel building as a soundstage for his blaxploitation flick *Dolemite*.

- **Oak Bluffs Inn | Martha's Vineyard, Massachusetts:**
The historic and award-winning ten-room Victorian inn, owned for twenty-one years by Rhonda and Erik Albert, continues to be a vacationing haven for an elite African American community.

- **Shearer Cottage | Martha's Vineyard, Massachusetts:**
The Shearer family who ran the inn for over one hundred years planned to renovate the property. However, in July 2023, the owners abandoned the project, and the inn closed permanently. The Smithsonian National Museum of African American History and Culture in Washington, D.C., celebrates the Shearer Cottage's significance by featuring its story in a permanent exhibit called "The Power of Place." Henrietta and Charles Shearer are also featured in the Martha's Vineyard Museum for their entrepreneurism and impact on the African American community.

- **The Hotel Robinson | San Diego, California:**
As of 2022, the Hotel Robinson is still in operation and stands as the oldest continuously operated hotel in Southern California. The historically restored sixteen-room property is furnished in an early twentieth-century style and is currently known as the Julian Gold Rush Hotel.

- **The Hotel Metropolitan | Paducah, Kentucky &
 The Lorraine Motel | Memphis, Tennessee:**
 Both former hotels now operate as museums. The Lorraine is a contributing museum to the South Main Street Historic District of the National Register of Historic Places. The "Purple Room" is being renovated by the African American Cultural Heritage Action Fund.

- **The Kenmore Hotel | Albany, New York:**
 The Kenmore was renovated in 1986 into an office building. The building now features ninety-three apartments, along with retail space on the ground floor. In 2019, developers renovated the historic Rain-Bo Room, restoring the historic staircase and opening up twenty-five-foot ceilings and an upper-level mezzanine. The rechristened Kenmore Ballroom is available for weddings, events, and receptions.

- **The Hampton House | Miami, Florida:**
 The Historic Hampton House has undergone extensive renovations and is now open to the public.

- **The Brigantine Hotel | Brigantine, New Jersey:**
 This hotel once owned by Madame Sara Spencer Washington is now Legacy Vacation Resorts.

- **The A. G. Gaston Motel | Birmingham, Alabama:**
 The A.G. Gaston Motel is now a part of the Birmingham Civil Rights National Monument. The city of Birmingham and the National Park Service have preserved not only the historic motel but also highlighted A.G. Gaston's contributions to empowering Birmingham's African American community. The A. G. Gaston Motel has undergone extensive renovations and is now open to the public.

STEWARDS OF THE LEGACY

The last two decades of the twentieth century witnessed a proliferation of racial-discrimination suits filed against numerous hotel companies across the United States. As in the past, racism had a severe impact on African American participation in hotel ownership.

In June 1990, local politicians snubbed the newly freed Nelson Mandela during his visit to Miami on a seven-city tour of the United States. Cuban American and Jewish leaders were offended by Mandela's support of Fidel Castro and Yasser Arafat.

The incident outraged local Black activists and sparked a national Black tourism boycott of greater Miami that would last nearly three years. In May 1993, civic activists and lodging executives presented a plan to resolve the boycott which included development of an African American majority-owned convention hotel in Miami Beach. As part of the boycott settlement, the mayor and city commission of Miami Beach approved the purchase of the dilapidated Royal Palm Hotel.[1]

> The phrase "Stewards of the Legacy" serves as a rallying cry for the resurgence of Black hotel/resort owners today. Such entities harness the spirit of resilience and strive to set a positive standard of economic growth and sustainability in their respective communities.
> —Davonne Reaves,
> CEO and Founder, The Vonne Group

This project would become real estate developer, author, and political activist R. Donahue Peebles's foray into the hotel business. His undertaking was rife with symbolism and great anticipation well before the first shovel hit the dirt.

Peebles is president and chief executive officer of the Miami-based Peebles Corporation. He built his business developing commercial office space. When developers were asked to bid on building an oceanfront hotel—for which the city would underwrite with a $10 million loan—Peebles approached Hyatt heir Nick Pritzker, his biggest competitor for the project, with an offer to work together to build a Hyatt-flagged hotel on the site. Pritzker rejected the offer. Peebles recalled how another local developer said, "There was no way a black guy from Washington, D.C., who hasn't done anything here was going to win the site."[2] That motivated Peebles even more.

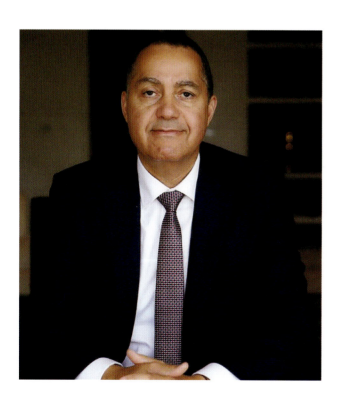

R. Donahue "Don" Peebles, Founder, Chairman, CEO, Peebles Corporation. Image courtesy of Peebles Corporation.

Along with world-renowned Miami-based design firm Arquitectonica, Peebles won the bid.[3] He also won a second municipal bid to purchase the run-down adjacent Shorecrest Hotel.

The Royal Palm combined the architectural assets of two existing hotels, the original Royal Palm and the Shorecrest properties. Arquitectonica designed two new seventeen-story towers and a three-story row of lanai suites. The result was an impressive integration of historic preservation and new construction.[4]

In 2001, a Days Inn property located in Memphis, Tennessee, became one of the first examples of a modern-day Black-owned franchise property.

The high-profile venture placed Peebles as the nation's first African American to develop and own a major convention resort hotel in the U.S. After a two-year delay, the 422-room, $84 million Royal Palm Crowne Plaza Resort opened in May 2002. The property was among the first nationally branded properties on South Beach and was awarded "Company of the Year" within its brand franchise.[5]

African Americans began realizing there were fewer Black-owned properties in the United States than before. This brought about a spark of interest among Black investors to purchase hotels. In 2001, the National Association of Black Hotel Owners, Operators, & Developers (NABHOOD) was formed by Andy Ingraham to help African Americans gain entry into hotel ownership.[6]

The Black capital stake in the U.S. travel economy is far from flourishing. According to NABHOOD, a mere 2 percent of U.S. hotels are under Black ownership. This means that travel dollars, regardless of their source, rarely end up in the hands of African Americans.[7]

Today, meanwhile, fewer than 1 percent of all hotels in the United States are owned by African American women. But many of them have realized how lucrative hotel ownership can be and have begun to forge their own path in the world of hospitality.

In 2007, Thomas A. Moorehead, founder and president of Moorehead Properties, Inc., became the first African American owner of the Marriott Residence Inn at the National Harbor Resort and Convention Center in Maryland.[8]

Kristin Kitchen is a serial hotelier and founder and CEO of Sojourn Heritage Accommodations. Her path to hotel ownership began with the opening of her first bed-and-breakfast, the historic Six Acres B&B, in a two-story, nine-bedroom house that once served as a freedom station on the Underground Railroad in the 1800s.[9]

Kristin Kitchen, Founder and CEO, Sojourn Heritage Accommodations. Image courtesy of Kristin Kitchen.

Set along Mill Creek, the property sits on six acres of land in College Hill, outside Cincinnati, where Kitchen was raised. The historic, sprawling 6,000-square-foot home underwent major renovations when Kitchen opened the B&B over fifteen years ago. Kitchen has been an advocate for utilizing local vendors, from soaps to linens to the breakfast table.

In December 2019 in Miami's historic Overtown neighborhood, Kitchen opened her second property, named the Dunns–Josephine Hotel as a nod to the Harlem Renaissance. The fifteen-room boutique hotel pays tribute to African American literary and entertainment legends including Josephine Baker, Langston Hughes, Zora Neale Hurston, Cab Calloway, Marcus Garvey, Duke Ellington, and Billie Holiday.[10]

Lobby area of the boutique Dunns–Josephine Hotel.
Image courtesy of Kristin Kitchen.

> You can't be in the community and not be a part of the community. Our mission with Sojourn Heritage is community tourism. Our tagline is: "When we thrive, our community thrives."
> —Kristen Kitchen, CEO, Sojourn Heritage Accommodations

Kitchen's third location is an 8,000-square-foot beautifully restored mansion recently opened in Rocky Mount, North Carolina. The Avent on Falls is marketed as an all-Black experience: sleep, dine, and shop from Black-owned businesses. The 1901 home turned B&B features soap, toothbrushes, towels, and linens created by Black-owned companies.

> If you want to change the physical appearance of your community or elevate the profile of your community, it can be easy to do that through an iconic place—through placemaking. Each place does have a story to tell; there are buildings that just feel right. There are businesses that feel right in a place, that feel natural. I try to do that in my real estate and hospitality development.
> —Moniqua Lane, Former Owner of The Downtown Clifton

Another African American woman making her mark is former Black Entertainment Television (BET) cofounder Sheila Johnson. America's first Black female billionaire, Johnson has expanded Salamander Hotels and Resorts' footprint to include seven ultra-luxe properties across the U.S. and the Caribbean, including its newest property, the Salamander Washington DC, formerly the five-star Mandarin Oriental. When Forbes Travel Guide announced its sixty-first list of Star-Rated hotels, restaurants, and spas, Johnson's 340-acre resort/ spa paradise Salamander Middleburg, in Middleburg, Virginia, shone brightly with a Five-Star distinction.[11]

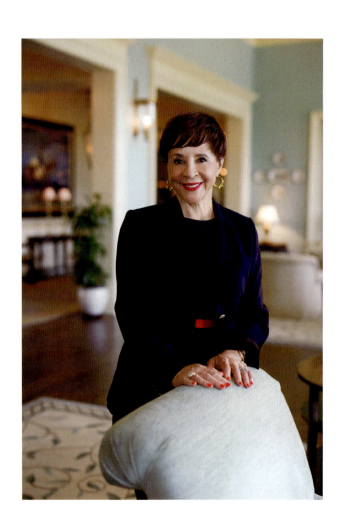

Sheila Johnson, Cofounder of BET, CEO of Salamander Collection. Photo credit: Drew Xeron.

After leaving Black Entertainment Television, I carved out a new life for myself, both personally and professionally. As a result, I became the founder and CEO of Salamander Hotels & Resorts, where I remain dedicated to bringing a touch of luxury into the lives of countless men, women, and children of all creeds, colors, and income levels.
—Sheila Johnson, Owner, Salamander Middleburg

Salamander Resort & Spa, Middleburg, Virginia. Photo credit: Justin Kriel.

Salamander Resort & Spa, Middleburg, Virginia. Photo credit: Justin Kriel.

Since launching Salamander Hotels & Resorts in 2005, and in addition to Innisbrook Resort in Palm Harbor, Florida, the company's portfolio also includes Half Moon in Montego Bay, Jamaica; Aspen Meadows Resort in Aspen, Colorado; Aurora Anguilla Resort in Rendezvous Bay, Anguilla; the Hotel Bennett in Charleston, South Carolina; and Salamander Washington DC.

African American celebrities and influencers are also getting bitten by the hotel/resort-ownership bug. The thirteen-time Grammy-winning rapper, songwriter, and music producer Pharrell Williams is officially in the hotel business. In collaboration with entrepreneur David Grutman (Groot Hospitality) the duo opened The Goodtime Hotel in Miami Beach in April 2021.

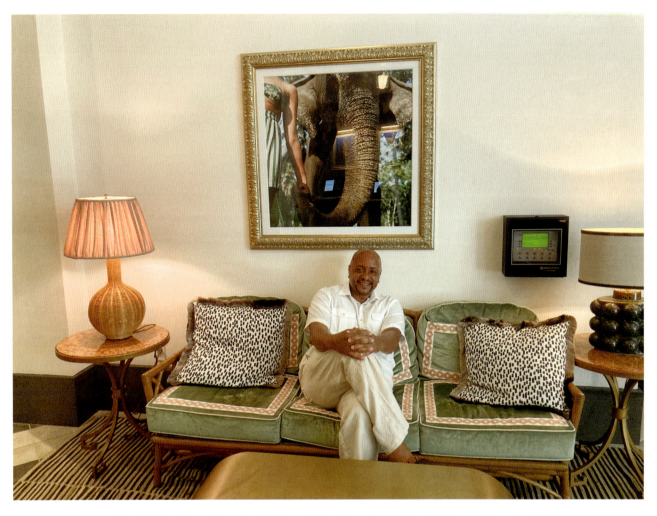

Author Calvin Stovall in the lobby of the Goodtime Hotel, Miami, Florida, 2021.
Image courtesy of Calvin Stovall.

The 266-room Art Deco–style property in trendy South Beach features Atlantic Ocean and Biscayne Bay views. Rooms come with blackout drapes, bright leopard prints, and pink rotary phones. The property takes up an entire city block and includes the sprawling Strawberry Moon pool club, which welcomes guests with two spacious pools, in addition to two open-air bars, a DJ booth, and private cabanas. The hotel is close to the beach and a short distance from fashion designer Gianni Versace's former mansion in a district recognized for its nightlife, restaurants, and eye-popping architecture.[12]

Williams and Grutman announced they have teamed up once again to open a new lifestyle hotel. Slated to be the duo's largest hospitality venture, Somewhere Else will be located on Atlantis Paradise Island in the Bahamas. The 400-room hotel will feature multiple food and beverage outlets and bungalows with recording studios.[13]

Actor, humanitarian, and author Hill Harper has been at the forefront of helping African American families learn how to build intergenerational wealth. Harper's passion for business, financial literacy, and social and economic justice continues to keep him

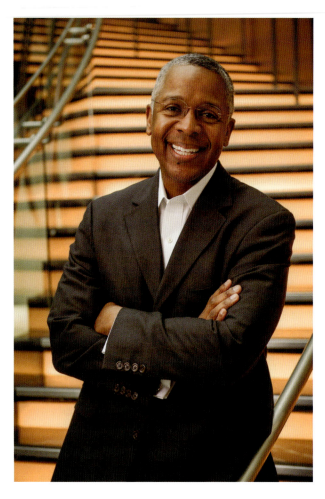

Norman Jenkins, President, Capstone Development. Image courtesy of Capstone Development.

in high demand. He is the founder and chairman of Black Wall Street Holdings Inc. and now co-owner of International House Hotel, an award-winning New Orleans hotel.[14]

Robert L. Johnson is the founder of RLJ Lodging Trust, a publicly traded real estate investment company focused on acquiring select-service hotels from premium brands. Johnson is also the founder and former CEO of BET. RLJ's portfolio consists of nearly one hundred hotels with approximately 21,200 rooms located in twenty-three states and the D.C. area. Brands in the portfolio include Courtyard by Marriott, Residence Inn by Marriott, AC Hotels, Moxy Hotels, Hilton Garden Inn, Embassy Suites, Hyatt Place, and Wyndham.[15]

After sixteen years at Marriott International, Norman Jenkins stepped away from a corporate job and is now the founder and president of Capstone Development, a privately held real estate development company he founded in 2009, based in Washington, D.C. The company owns more than twenty hotels across the nation, including hotels from Marriott and Hilton brands. Jenkins played a substantial role in Marriott's efforts to create opportunities for women and minorities to become hotel owners. He also helped put together deals including a minority-held hotel at National Harbor, a $42 million Residence Inn owned by California real estate businessman Kenneth H. Fearn, and a diverse group of Washington-area investors.[16]

FINANCING CHALLENGES
FOR BLACK ENTREPRENEURS

Hotel ownership doesn't come without its complexities, particularly for the African American entrepreneur. These include finding capital and the isolation many people describe when they find themselves the only one in the room.

In 2018, Deidre Mathis became the first Black woman to own a hostel in the United States when she opened Wanderstay in Houston, Texas. Mathis's tactics to raise capital included getting a small business loan, running an Indiegogo fundraising campaign that raised $5,000 from the Houston community, and winning over $85,000 in business-pitching competitions including the Bank of America/Mastercard Grow Your Biz Pitch Competition in 2019.[1]

Deidre Mathis, Owner, Wanderstay Boutique Hotel. Image courtesy of Deidre Mathis.

The Wanderstay Boutique Hotel, Houston, Texas. Image courtesy of Deidre Mathis.

The Wanderstay Boutique Hotel lobby. Image courtesy of Deidre Mathis.

In a recent article, African American female owner of Arizona's first adult-only resort in Arizona, Jenesis LaForcarde, took note that "I am always the only woman of color . . . I would go to these wellness resorts and would be the only Black woman there."[2] Despite recent advances in Black hotel and resort ownership, LaForcarde finds herself in a small pool of Black women aspiring to be independent hotel owners.

> I feel that there is a void that prohibits a lot of people from experiencing a place that exudes tranquility and style. I want to fill that void.
> —Jenesis LaForcarde, Owner, Jenesis House

This lack of representation in the wellness space became the catalyst for the twenty-eight-year-old entrepreneur to develop the Jenesis House, located in Prescott, Arizona. The thirteen-room destination retreat is designed for travelers who seek to discover the true luxury of self-care and wellness experience.

LaForcarde's overarching goal is to bring awareness to the importance of mental and physical well-being to women of color. The facility offers an expansive spa, along with healing arts and complete wellness immersion. Resort guests have the opportunity to engage in healing sessions, access to Pilates and yoga instructors, in-room soaking baths and meditation, plus a Nordic Spa, farm-to-table menu offerings, and on-site therapeutic gardens.

The self-funded project is compensating for startup costs via its luxury candle collection. LaForcarde also launched a crowdfunding campaign on iFundWomen.com, which allowed supporters to prebook their stay at the resort at a discounted rate through February 2022. The Jenesis House is scheduled to make its debut in 2030.[3]

When you couple the natural challenges of entrepreneurship with the lasting effects of systemic racism, the result is that Black hotel entrepreneurs are woefully underrepresented. One of the biggest barriers for Black people when it comes to hotel ownership is access to capital.

African American investors and developers have made economic gains over the years, and the climate has improved. However, African Americans still face institutional discrimination and are locked out of funding sources and access to capital. But the hotel ownership landscape is beginning slowly to shift.

Recognizing that access to capital constitutes a critical barrier to market entry, several major hotel brands, including Choice, Wyndham, Hilton, and Marriott, have created programs to offer financial and other incentives to qualified historically underrepresented owners and franchisees who will have a controlling equity interest in select branded products. Additionally, other African American advocates such as Davonne Reaves and Tracy Prigmore are offering support through educational programs and funding sources to help Black entrepreneurs realize their dream of hotel ownership.

Most recently, Choice Hotels International finalized an agreement with the Brittano Group to develop a member of the Ascend Hotel Collection in South Boston, Virginia: the Rook Hotels. Actor, hotelier, and activist Julian Brittano and his wife Karie Brittano signed an upscale franchise agreement with the industry's largest soft brand, Ascend Hotel Collection. This agreement marks the first Ascend hotel awarded through Choice's emerging markets franchise development program in 2022.[4]

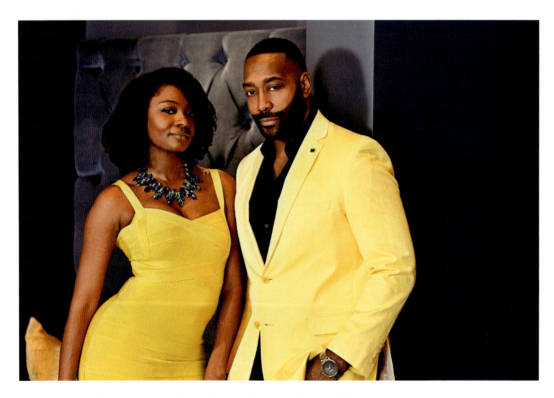

Hoteliers Julian and Karie Brittano.
Photo credit: Nikon Don Harris, Hardpress Studios.

Vaughn Irons, Principal of Stonecrest Resorts, is the inaugural member of Black Owners and Lodging Developers, otherwise known as BOLD, by Wyndham. Irons was recently awarded a new-construction 110-room TRYP by Wyndham franchise in the Atlanta suburb of Stonecrest, Georgia. The hotel will be a long-awaited improvement to Stonecrest Resorts' multimillion adaptive reuse project Priví, which is "transforming The Mall at Stonecrest into a family entertainment and lifestyle destination." The property broke ground in spring 2022, with Phase 2 renovations completed in spring 2023.[5]

Hospitality strategist, hotel investor, and founder of the Atlanta-based Vonne Group, Davonne Reaves is an award-winning, fourteen-year veteran of the hospitality industry. She has leveraged her experience gained as an asset manager and consultant to assist other people of color in breaking into the world of hospitality investment.

In 2020, Reaves's Epiq Collective—cofounded with a team of investors, including her former college roommate Jessica Myers, along with Acquania Escarne—partnered with Cincinnati-based Nassau Investments to broker a historic $8.3 million deal to acquire a Home2Suites by Hilton in El Reno, Oklahoma.[6]

That hotel venture made Reaves and Myers two of the youngest Black women to ever co-own a hotel with a major brand. Since then, Reaves has added two more properties to her growing portfolio. To assist new investors in overcoming the barriers she faced, Reaves launched a crowdfunding platform, Vesterr, as an additional marketing service for aspiring hoteliers to raise capital. At the age of thirty-eight, Reaves is one of the youngest African Americans to own three hotels.[7]

> I predict that within five to seven years we'll see a significant growth in Black hotel ownership at the $10-15 million deal level and beyond as today's first-time owners scale their portfolios.
> —Davonne Reaves, CEO and Founder, The Vonne Group

Davonne Reaves, Founder and President, The Vonne Group. Image courtesy of Davonne Reaves

African American founder and CCO of Bay Street Capital Holdings, William Huston, has set his sights on investing in the hospitality industry. The California-based wealth-management firm that invests in the stock market along with a portfolio of small, minority-owned businesses has been focusing on a neglected segment of the U.S. economy: Black-owned travel holdings. He notes that "Black travelers in America spend $109 billion on leisure travel annually, and only $1 billion goes to Black-owned hotels."[8]

> We're never going to compete with Marriott, but in five years people will know about us. And they will know the names of some of the other hotels that we don't own but we support, and that's just as impactful.
> —William Huston, CCO, Bay Street Capital Holdings

With its recent establishment of Resthaven Properties, composed of members-only boutique hotels, Bay Street is hoping to support minority owners and investors. Huston, a small-town Alabama native, is counting on socially conscientious, modern-minded travelers to book at his Black-owned properties.[9]

Recent initiatives such as AvroKO's Hospitable Bridge aim to amplify diverse voices in hospitality. Launched last year, the program from the New York–based design firm is dedicated to supporting female founders of color who are working toward positive change in hospitality.[10]

A trio of African American business leaders—CEO Velma Trayham, COO Toshia Posey, and CFO Jacques Posey—has formed the U.S. Diversity Group, a real estate owner, development, and management firm that is now offering investment opportunities through its hotel fund for the acquisition and management of properties. It is the first SEC-registered hotel-investment fund owned by African Americans.[11]

S. Lovey Parker is a trailblazing force in the hospitality industry, reimagining Black ownership and investment in independent and boutique hotels and resorts. As the founder of the Black Hoteliers & Investors Association (BH&IA), she is leading a movement to dismantle systemic barriers and create pathways to generational wealth through hospitality-driven investments. Her work is not merely about access—it is about ownership, influence, and the economic independence of Black entrepreneurs in a historically exclusive industry.[12]

With a bold mission to increase Black ownership of independent and boutique hotels and resorts by 650 over the next three decades, BH&IA is laying the foundation for an $8 billion economic shift that will redefine the landscape of hospitality.

In 2023, Maryland couple Dr. Amina Gilyard James and Norland James purchased the seventy-room Quality Inn on Old Austin Peay Highway and Raleigh LaGrange Road for $3.85 million, making the property the only Black-owned hotel in Memphis.

Hoteliers Dr. Amina Gilyard James and Norland James. Image courtesy of Dr. Amina Gilyard James.

S. Lovey Parker, Executive Director, Founder, Black Hoteliers & Investors Association (BH&IA). Image courtesy of S. Lovey Parker.

TLTsolutions founder Tracy L. Prigmore pursued commercial real estate while working as a healthcare executive. Prigmore's first hospitality property, a Comfort Inn & Suites, went under contract in 2008. But when she was denied a Small Business Administration loan, she was uncertain of what to do next. Now she does her part to support African American women as the founder of She Has a Deal (SHaD), an organization that empowers clients with a roadmap to becoming hotel owners through education, networking, and mentorship. SHaD's signature program is an annual hotel investment-pitch competition (SHaDPitch). Participants complete a multi-module education series that prepares them to lead hotel investment projects by providing insight into the process of sourcing, evaluating, financing, and pitching a hotel investment deal.[13]

> Providing access to capital is a big step in knocking down the highest barrier to entry underrepresented groups face when attempting to build or acquire a hotel.
> —Tracy Prigmore,
> CEO and Founder, TLTsolutions

Today, more than 60 percent of hotels in the U.S. are owned by members of the Asian American Hotel Owners Association (AAHOA), which raises questions about why Black Americans still find themselves underrepresented in an industry where other minorities have thrived.

NABHOOD has partnered with travel, tourism, and hospitality research company MMGY Global to conduct a study on Black travelers in the U.S., which revealed Black Americans spent $109.4 billion on domestic travel in 2019, and nearly $20 billion more on travel abroad. That's over 13 percent of the overall U.S. leisure travel market, roughly the same percentage of Black people in the United States and accounting for over 458.2 million traveler stays each year. Moreover, Black organizations spent an average of $900,000 on meetings, conferences, and conventions pre–COVID pandemic.[14]

A WAY FORWARD

While hotel ownership and Black capital investment have not kept pace with broader movements in American society since the passing of the Civil Rights Act of 1964, our outlined examples show that significant efforts are being made to close the gap.

For a people valued among whites exclusively for their labor and ostracized as an inferior race, African Americans have become an integral part of American society. But there's still a lot of work to be done, particularly when it comes to hotel and resort ownership and closing the multigenerational wealth gap for African Americans.

In October 2022, I visited the Historic Magnolia House located in Greensboro, South Carolina. Natalie Miller, its owner-operator, grew up around the corner from the house. In 1949, Louise and Arthur Gist became the first African American couple to own the house. The Gists opened their small hotel not long after acquiring the property. The Magnolia House soon became a popular place to stay for famous Black entertainers such as Ray Charles, Ike and Tina Turner, Louis Armstrong, James Brown, and other luminaries during the 1950s and 1960s.[1]

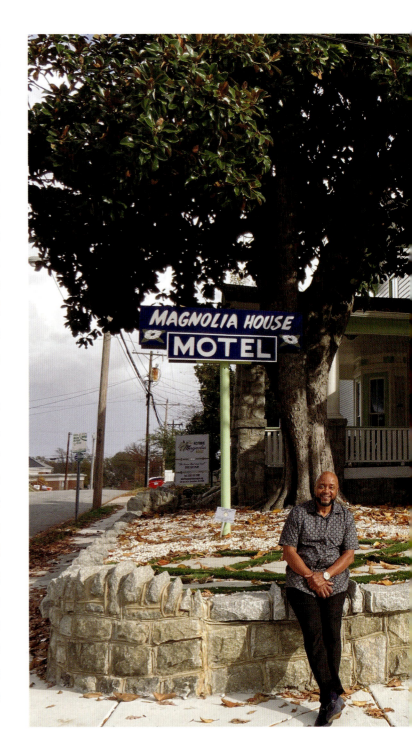

Miller shared her journey to restore the historic home with me. In fall 2022, the Historic Magnolia House was inducted as one of more than three hundred hotels and resorts throughout the country that is recognized by Historic Hotels of America.

Today, guests can visit the Historic Magnolia House for a pleasant night's stay in one of its well-appointed rooms, host a special event or wedding, or partake in a weekend brunch of catfish, shrimp and grits, or fried chicken and French toast.

The Magnolia House Historic Hotels of America designation.

Author Calvin Stovall in front of the Magnolia House, Greensboro, North Carolina. Image courtesy of Calvin Stovall.

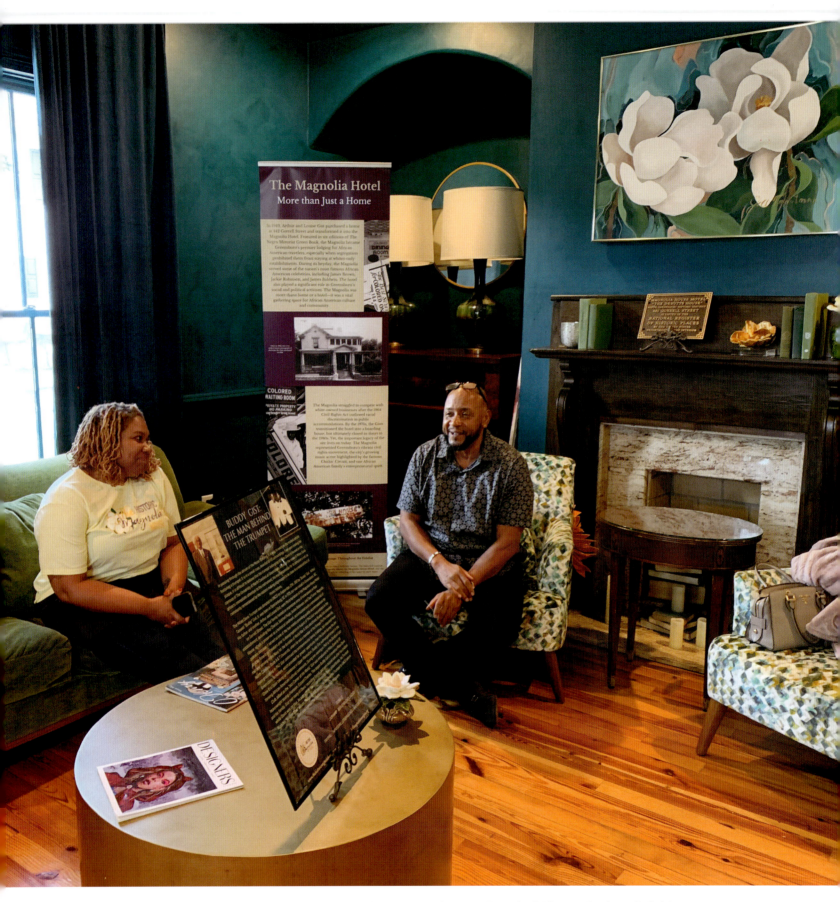

Calvin Stovall with Magnolia House founder and owner Natalie Miller in the hotel's lobby.
Image courtesy of Natalie Miller.

In a recent article, Natalie Miller shared, "There are these deep roots when you think about these safe Black spaces. These houses helped contribute to the roots of our history and our civil rights in so many different ways."[2]

Black hotel ownership is a critical step toward addressing the underrepresentation and lack of economic opportunities for African Americans in the hospitality industry—and it is growing every year. African Americans are continually seeking ways to support communities and businesses run by people of color.

Today, there's an array of fine Black-owned establishments across America, including Akwaaba Mansion (Brooklyn, New York), owned by the husband-and-wife team of Glenn Pogue and Monique Greenwood; La Maison in Midtown (Houston, Texas), owned since 2010 by Sharon Owens and Genora Boykins; the Clevedale Historic Inn and Gardens (Spartanburg, South Carolina) built in 1913 by the Cleveland family; and The Ivy Hotel (Baltimore, Maryland), considered one of the most renowned properties co-owned by African Americans Eddie and C. Sylvia Brown.

Kamau Coleman and Michael Clinton are cofounders of the new Redline Venice Apart Hotel in Venice, California. The Redline stands out as the only Black-owned boutique hotel on the strip, welcoming guests seeking short- or long-term stays just a few hundred yards from the beach.

The name "Redline" has a dual meaning, symbolizing the aforementioned racially discriminative policy in housing called "redlining," which disenfranchised Black communities, while also referencing the iconic "Red Cars" trolley line that carried workers and residents from downtown Los Angeles to Venice Beach between the 1920s and 1960s.

The property features five types of guest accommodations: a two-person studio, bedrooms accommodating one to three people, and a four-person suite, all of which offer a unique story to share with guests. For example, Beat By The Sea, a studio unit for two, immerses guests into the 1950s beatnik culture of poetry and jazz; its walls are decorated with records from artists like Billie Harris. The Escape suite pays homage to the surfers and skaters of the 1960s.[3]

As these and other entrepreneurs show, bold operators and owners are cultivating anew those historical roots of which Natalie Miller spoke.

Michael Clinton (*left*) and Kamau Coleman, Redline Venice Apart Hotels co-founders and owners. Image courtesy of the Redline Hotel Group.

In February 2024, during a Black History Month Special, *CBS Mornings* cohost Nate Burleson featured a story about an emotional journey he and his wife, Atoya, took to learn more about how her family's ancestry connected with the horrific Tulsa race massacre of 1921.

This voyage led them to the Greenwood neighborhood of Tulsa, Oklahoma, once known as Black Wall Street. Despite Atoya being born in Oklahoma City, she'd never visited Tulsa. During the feature, we learn that Atoya's family lost three businesses during the massacre—one being the Lafayette Hotel owned by her great-grandfather Lafayette Wilson.

It was evident that Atoya was overwhelmed and filled with mixed emotions. The bittersweet moment of the journey took place during their stop at the Black Wall Street Memorial, where she found the names of her ancestors' businesses, including the Lafayette Hotel.[4]

For Nate Burleson, the journey was rewarding because it allowed him to help tell an untold story that meant so much to his family.

A testament to the realization that American history is Black history.

Redline Venice Apart Hotel guest room.
Image courtesy of the Redline Hotel Group.

APPENDIX

Hotels, Motels, Resorts, and Other Places Featured in *Hidden Hospitality*

ONE
Black Pioneers of Hospitality

In the Beginning

The Royal Navy Hotel | Bridgetown, Barbados

The Jones Hotel | Charleston, South Carolina

The City Hotel | San Francisco, California

The Sea Girt Hotel | Newport, Rhode Island

Hospitality Trailblazers of the West

The Inter-Ocean Hotel | Denver, Colorado; Cheyenne, Wyoming

The Pacific House | Olympia, Washington

Our House | Seattle, Washington

The Mountain View Hotel | Oracle, Arizona

The Hotel Robinson | Julian, California

The Golden West Hotel | Portland, Oregon

Black Hoteliers of the Late Nineteenth Century

The Wormley Hotel | Washington, D.C.

The Kenmore Hotel | Albany, New York

Woodland Park Hotel | Newton, Massachusetts

Squantum Inn | Quincy, Massachusetts

Church's Hotel | Memphis, Tennessee

The Hotel Berry | Athens, Ohio

TWO
Hospitality across the Color Line

Sunshine and Jim Crow

Highland Beach | Anne Arundel County, Maryland

The Bay Shore Hotel | Hampton, Virginia

Idlewild Resort | Lake County, Michigan

Murray's Ranch | Apple Valley, California

Summer, Sand, and Segregation by the Sea

American Beach | Jacksonville, Florida

Carr's Beach & Sparrow's Beach | Annapolis, Maryland

THREE
Black Hoteliers at the Turn of the Century

More Than a Place to Stay

The Marshall Hotel | Manhattan, New York

The Douglass Hotel & Theatre | Macon, Georgia

The Goldfield Hotel | Baltimore, Maryland

The Hotel Metropolitan | Paducah, Kentucky

The Whitelaw Hotel | Washington, D.C.

The Gurley Hotel | Tulsa, Oklahoma

The Stradford Hotel | Tulsa, Oklahoma

Hospitality and the "Harlem Renaissance" Era

The Hotel Olga | Harlem, New York

The Golden West & The Coast Hotels | Seattle, Washington

The Hotel Douglas | San Diego, California

Henry's Colored Hotel | Ocean City, Maryland

The Hotel Matthews | Akron, Ohio

The Rendezvous Hotel | Anchorage, Alaska

Jackson House Hotel | Harrisburg, Pennsylvania

The Hotel Somerville / Dunbar Hotel | Los Angeles, California

The Dew Drop Inn | New Orleans, Louisiana

EIGHT
Beginning of a New Era

Gone but Not Forgotten
(Additional Properties Listed in the National Register of Historic Places)

Oak Bluffs Inn | Martha's Vineyard, Massachusetts

Shearer Cottage | Martha's Vineyard, Massachusetts

Stewards of the Legacy

The Royal Palm Crowne Plaza Resort | Miami, Florida

Six Acres Bed & Breakfast | Cincinnati, Ohio

Dunns–Josephine Hotel | Miami, Florida

The Avent on Falls | Rocky Mount, North Carolina

The Downtown Clifton | Tucson, Arizona

The Salamander Washington DC | Washington, D.C

Innisbrook Resort | Palm Harbor, Florida

Half Moon | Montego Bay, Jamaica

Aspen Meadows Resort | Aspen, Colorado

Aurora Anguilla Resort | Rendezvous Bay, Anguilla

The Hotel Bennett | Charleston, South Carolina

The Goodtime Hotel | Miami Beach, Florida

Somewhere Else (under construction)| Atlantic Paradise Island, Bahamas

International House Hotel | New Orleans, Louisiana

Wanderstay Boutique Hotel | Houston, Texas

The Jenesis House | Prescott, Arizona

The Rook Hotels (Ascend Hotel Collection) | South Boston, Virginia

The Magnolia House | Greensboro, South Carolina

Akwaaba Mansion | Brooklyn, New York

La Maison in Midtown | Houston, Texas

Clevedale Historic Inn and Gardens | Spartanburg, South Carolina

The Ivy Hotel | Baltimore, Maryland

Redline Venice Apart Hotel | Venice, California

NOTES

Preface

1. George Cantor, *Historic Landmarks of Black America* (Detroit, MI: Gale Research, Inc., 1991), xv.

2. Peter Farrelly, *Green Book* (Hollywood: DreamWorks Pictures, 2018).

Chapter 1: Black Pioneers of Hospitality

In the Beginning

1. Kelly Sharp, "Eliza Seymour Lee (1800–c. 1874), Black Past, August 25, 2020, https://www.blackpast.org/african-american-history/eliza-seymour-lee-1800-c-1874/.

2. Willard B. Gatewood, *Aristocrats of Color: The Black Elite*, 1880–1920 (Bloomington, IN: Indiana University Press, 1990), 300.

3. Elizabeth O. Johnson, "From Afro-Barbadian Slave to Wealthy Brothel Owner in 1700s, How Rachael Pringle Polgreen Rose to Prominence," Face 2 Face Africa, July 23, 2019, https://face2faceafrica.com/article/from-afro-barbadian-slave-to-wealthy-brothel-owner-in-1700s-how-rachael-pringle-polgreen-rose-to-prominence.

4. E. Nielsen, "Rachel Pringle Polgreen (1753–1791)," Black Past, August 2, 2017, https://www.blackpast.org/global-african-history/polgreen-rachel-pringle-1753-1791/.

5. Ibid.

6. M. Fate, "Jehu Jones Sr. (1769–1833)," Black Past, April 16, 2014, https://www.blackpast.org/african-american-history/jones-jehu-sr-1769-1833/.

7. Ibid.

8. Ibid.

9. G. Washington, "William Alexander Leidesdorff (1810–1848)," Black Past, January 26, 2007, https://www.blackpast.org/african-american-history/leidesdorff-william-alexander-1810-1848/.

10. "William Leidesdorff, Explorer, and Businessman born," African American Registry, accessed September 3, 2024, https://aaregistry.org/story/william-leidesdorff-a-san-francisco-landmark/.

11. G. Washington, "William Alexander Leidesdorff (1810–1848)."

12. "William Leidesdorff, Explorer, and Businessman born," African American Registry, accessed September 3, 2024, https://aaregistry.org/story/william-leidesdorff-a-san-francisco-landmark/.

13. G. Washington, "William Alexander Leidesdorff (1810–1848)."

14. Gary Mitchell Palgon, "William Alexander Leidesdorff: First Black Millionaire, American Consul and California Pioneer," (Atlanta, GA: Gary Palgon, 2005), 81.

15. Benjamin Schneider, "The incredible story of William Leidesdorff, San Francisco's Black founding father," *San Francisco Examiner*, September 13, 2022, https://www.sfexaminer.com/news/the-city/the-incredible-story-of-william-leidesdorff-san-francisco-s-black-founding-father/article_10a7cbbd-b999-5e69-af0c-73bbd8777266.html.

16. W. Smither, "Tunis Gulic Campbell (1812–1891)," Black Past, April 28, 2015, https://www.blackpast.org/african-american-history/campbell-tunis-gulic-1812-1891/.

17. Russell Duncan, "Tunis Campbell," New Georgia Encyclopedia, last modified July 15, 2020. https://www.georgiaencyclopedia.org/articles/arts-culture/tunis-campbell-1812-1891/.

18. Ibid.

19. May Wijaya, "The World Was His Oyster: George T. Downing," Rhode Tour, accessed February 19, 2022, https://rhodetour.org/items/show/41.

20. "Meet the Founder of One of the First 5-Story, Black-Owned Luxury Hotels," Black History, accessed September 4, 2024, https://www.blackhistory.com/2019/12/george-thomas-downing-founder-first-black-owned-luxury-hotel.html.

21. May Wijaya, "The World Was His Oyster: George T. Downing."

22. Jessie Carney Smith, "Downing, George T.," Encyclopedia.com, accessed September 4, 2024, https://www.encyclopedia.com/african-american-focus/news-wires-white-papers-and-books/downing-george-t.

23. Gloria de Paola, "Foodways to Freedom Through the Kitchen," *Edible Rhody*, September 6, 2017, https://ediblerhody.ediblecommunities.com/food-thought/foodways-freedom-through-kitchen.

Hospitality Trailblazers of the West

1. M. Hansen, "Barney L. Ford (1822–1902)," Black Past, January 18, 2007, https://www.blackpast.org/african-american-history/ford-barney-l-1822-1902/.

2. Kalyani Fernando, "Barney Ford: African American Pioneer," History Colorado, February 8, 2017, https://www.historycolorado.org/story/collections-library/2017/02/08/barney-ford-african-american-pioneer.

3. Randall K. Burkett, Nancy Hall Burkett, and Henry Louis Gates Jr, *Black Biography, 1790–1950, A Cumulative Index* (Alexandria, VA: Chadwyck-Healy, 1991), 229.

4. M. Hansen, "Barney L. Ford (1822–1902)," Black Past, January 18, 2007, https://www.blackpast.org/african-american-history/ford-barney-l-1822-1902/.

5. Colorado Encyclopedia Staff, "Barney Ford," Colorado Encyclopedia, accessed August 19, 2024, https://coloradoencyclopedia.org/article/barney-ford#Author.

6. Randall K. Burkett, Nancy Hall Burkett, and Henry Louis Gates Jr, *Black Biography*.

7. Rick Roddam, "Cheyenne History: 1916, Fire destroys Legendary Inter-Ocean Hotel," *KGAB*, December 13, 2016, https://kgab.com/100-years-ago-fire-destroys-cheyennes-legendary-inter-ocean-hotel/.

8. Colorado Encyclopedia Staff, "Barney Ford."

9. Maria Davies McGrath, "*The Real Pioneers of Colorado*," vol. I (Denver: The Denver Museum, 1934), 139–140.

10. Ibid.

11. Colorado Encyclopedia Staff, "Barney Ford."

12. Colorado Encyclopedia Staff, "Barney Ford's People's Restaurant," Colorado Encyclopedia, accessed September 5, 2024, https://coloradoencyclopedia.org/article/barney-fords-peoples-restaurant.

13. Jennifer Crooks, "Rebecca Howard: An African-American Businesswoman in Early Olympia," *Thurston Talk*, January 15, 2015, https://www.thurstontalk.com/2015/01/15/olympia-history/.

14. George E. Blankenship, *Lights and Shades of Pioneer Life on Puget Sound* (Shorey's Bookstore, 1987), 13.

15. Jennifer Crooks, "Rebecca Howard: An African-American Businesswoman in Early Olympia."

16. Ibid.

17. Shanna Stevenson, "Rebecca Groundage Howard, (1827–1881)," Black Past, February 12, 2007, https://www.blackpast.org/african-american-history/howard-rebecca-groundage-1827-1881/.

18. Jennifer Crooks, "Rebecca Howard: An African-American Businesswoman in Early Olympia."

19. Isolde Raftery, "This pioneer worked the Underground Railroad—and founded Seattle's Black Central District," *KUOW*, February 5, 2021, https://www.kuow.org/stories/this-seattle-pioneer-worked-the-underground-railroad-and-settled-the-central-district.

20. George Tamblyn, "William Grose (1835–1898)," Black Past, January 26, 2007, https://www.blackpast.org/african-american-history/grose-william-1835-1898/.

21. Mary T. Henry, "Grose, William (1835–1898)," History Link, November 27, 1998, https://www.historylink.org/file/393.

22. Ibid.

23. "Black History Month 2022—William Grose," Bellwether Housing, February 9, 2022, https://www.bellwetherhousing.org/post/black-history-month-2022-william-grose.

24. Esther Hall Mumford, *Seattle's Black Victorians, 1852–1901* (Seattle: Ananse Press, 1980), 43.

25. Isolde Raftery, "This pioneer worked the Underground Railroad—and founded Seattle's Black Central District."

26. Feliks Banel, "All Over The Map: The story of William Grose, one of Seattle's earliest black entrepreneurs," My Northwest, June 19, 2020, https://mynorthwest.com/1965450/all-over-the-map-william-gross-seattle-black-entrepreneur/.

27. Ibid.

28. Mary T. Henry, "Grose, William (1835–1898)."

29. Terry McDermott, "Life on East Madison—Giving Ground," *The Seattle Times*, December 13, 1992, https://archive.seattletimes.com/archive/?date=19921213&slug=1529833.

30. Jae Jones, "William Grose: One of the Wealthiest Black Businessmen in Seattle During the 19th Century," Black Then, October 22, 2022, https://blackthen.com/william-grose-one-wealthiest-black-businessmen-seattle-19th-century/.

31. Mary T. Henry, "Grose, William (1835–1898)."

32. Justin Carder, "William Grose Center for Cultural Innovation and Enterprise, Africatown's center for 'economic empowerment and community-driven development,' opens in the Central District," Capitol Hill Seattle Blog, September 12, 2022, https://www.capitolhillseattle.com/2022/09/william-grose-center-for-cultural-innovation-and-enterprise-africatowns-center-for-economic-empowerment-and-community-driven-development-opens-in-the-central-district/.

33. Mary T. Henry, "Grose, William (1835–1898)."

34. Tricia Martineau Wagner, "Annie Box Neal (1870–1950)," Black Past, July 9, 2007, https://www.blackpast.org/african-american-history/neal-annie-box-1870-1950/.

35. Jan Cleere, "Western Women: Oracle's 'queen' of the hostesses," *Arizona Daily Star*, May 8, 2015, https://tucson.com/news/local/western-women-oracles-queen-of-the-hostesses/article_da085543-38e7-5566-a8fe-0ccf27406d77.html.

36. Ibid.

37. Ibid.

38. Tricia Martineau Wagner, "William 'Curly' Neal (1849–1936)," Black Past, June 29, 2007, https://www.blackpast.org/african-american-history/neal-william-curly-1849-1936/.

39. Teri Colmar, "Meet William (Curly) and Annie Neal," Oro Valley Historical Society, February 26, 2021, https://ovhistory.org/meet-william-curly-and-annie-neal/.

40. Ibid.

41. Tricia Martineau Wagner, "William 'Curly' Neal (1849–1936)."

42. Jan Cleere, "Western Women: Oracle's 'queen' of the hostesses."

43. Tricia Martineau Wagner, "William 'Curly' Neal (1849–1936)."

44. Teri Colmar, "Meet William (Curly) and Annie Neal."

45. Tricia Martineau Wagner, "Annie Box Neal (1870–1950)."

46. Ibid.

47. Jan Cleere, "Western Women: Oracle's 'queen' of the hostesses."

48. Mountain View staff, "Our History," The Mountain View Hotel (website), About Us entry, accessed March 30, 2025, site last updated 2019, https://themountainviewhotel.com/hotel-history.

49. Tricia Martineau Wagner, "Annie Box Neal (1870–1950)."

50. Jan Cleere, "Western Women: Oracle's 'queen' of the hostesses."

51. Ibid.

52. Tricia Martineau Wagner, "Annie Box Neal (1870–1950)."

53. Jan Cleere, "Western Women: Oracle's 'queen' of the hostesses."

54. Tricia Martineau Wagner, "William 'Curly' Neal (1849–1936)."

55. Jan Cleere, "Western Women: Oracle's 'queen' of the hostesses."

56. David Cortes, "Hotel Robinson (1897–1921)," Black Past, July 15, 2017, https://www.blackpast.org/african-american-history/institutions-african-american-history/hotel-robinson-1897-1921/.

57. Alexander Nguyen, "Beloved hotel in Julian has deep roots in Black history," *KPBS*, February 16, 2023, https://www.kpbs.org/news/living/2023/02/16/julian-hotel-san-diego-deep-roots-black-history.

58. David Cortes, "Hotel Robinson (1897–1921)."

59. Ibid.

60. "A Julian California Historical Hotel," Julian Hotel, History page, accessed September 17, 2024, https://www.julianhotel.com/history.

61. Stan Fonseca, "Golden West Hotel," Oregon Encyclopedia, updated July 5, 2023, https://www.oregonencyclopedia.org/articles/golden_west_hotel/#.YNj-gehKg2w.

62. Ibid.

63. Adam Rozen-Wheeler, "Golden West Hotel Portland (1906–1931)," Black Past, March 26, 2017, https://www.blackpast.org/african-american-history/golden-west-hotel-portland-1906-1931/.

64. Ibid.

65. Douglas Perry, "Golden West Hotel, Portland's 'Black cultural hub' before falling into disrepair, makes case for national recognition," *The Oregonian,* February 3, 2022, https://www.oregonlive.com/history/2022/02/golden-west-hotel-portlands-black-cultural-hub-before-falling-into-disrepair-makes-case-for-national-recognition.html.

66. Stan Fonseca, "Golden West Hotel."

67. Ibid.

68. Adam Rozen-Wheeler, "Golden West Hotel Portland (1906–1931)."

Black Hoteliers of the Late Nineteenth Century

1. John DeFerrari, "The Talented Mr. James Wormley," Streets of Washington, September 10, 2012, http://www.streetsofwashington.com/2012/09/the-talented-mr-james-wormley.html.
2. Allison Espiritu, "James Wormley (1819–1884)," Black Past, February 25, 2007, https://www.blackpast.org/african-american-history/wormley-james-1819-1884/.
3. John DeFerrari, "The Talented Mr. James Wormley," Streets of Washington, September 10, 2012, http://www.streetsofwashington.com/2012/09/the-talented-mr-james-wormley.html.
4. Ibid.
5. Allison Espiritu, "James Wormley (1819–1884)," Black Past, February 25, 2007, https://www.blackpast.org/african-american-history/wormley-james-1819-1884/.
6. John DeFerrari, "The Talented Mr. James Wormley," Streets of Washington, September 10, 2012, http://www.streetsofwashington.com/2012/09/the-talented-mr-james-wormley.html.
7. Randall K. Burkett, Nancy Hall Burkett, and Henry Louis Gates Jr, *Black Biography, 1790-1950, A Cumulative Index* (Alexandria, VA: Chadwyck-Healy, 1991), 669.
8. John DeFerrari, "The Talented Mr. James Wormley," Streets of Washington, September 10, 2012, http://www.streetsofwashington.com/2012/09/the-talented-mr-james-wormley.html.
9. Paul Grondahl, "Grondahl: Albany's dashing, pioneering Black entrepreneur," *Times Union,* February 23, 2021, https://www.timesunion.com/news/article/Grondahl-Albany-s-dashing-pioneering-Black-15972563.php.
10. Julie O'Connor, "The Real Story of Albany's Kenmore Hotel; Adam Blake Jr.—Albany's African-American Horatio Alger and his wife Catherine Blake," Friends of Albany History, October 20, 2019, https://friendsofalbanyhistory.wordpress.com/tag/catherine-blake/.
11. Carl Johnson, "Adam Blake, hotelier," Hoxsie, March 1, 2012, https://hoxsie.org/2012/03/01/adam_blake_hotelier/.
12. Julie O'Connor, "The Real Story of Albany's Kenmore Hotel; Adam Blake Jr.—Albany's African-American Horatio Alger and his wife Catherine Blake."
13. Ibid.
14. Ibid.
15. Carl Johnson, "Adam Blake, hotelier."
16. Julie O'Connor, "The Real Story of Albany's Kenmore Hotel; Adam Blake Jr.—Albany's African-American Horatio Alger and his wife Catherine Blake."
17. Wayne Miller, "Joseph Lee: Restauranteur, Caterer, Hotelier, Inventor," Quincy History (blog), February 19, 2021, https://quincyhistory.org/blog/?p=594.
18. Ibid.
19. Anthony W. Neal, "Joseph Lee: famed hotelier, restaurateur, inventor," *The Bay State Banner,* February 27, 2014, https://www.baystatebanner.com/2014/02/27/joseph-lee-famed-hotelier-restaurateur-inventor/.
20. Ibid.
21. Ibid.
22. Wayne Miller, "Joseph Lee: Restauranteur, Caterer, Hotelier, Inventor," Quincy History (blog), February 19, 2021, https://quincyhistory.org/blog/?p=594.
23. Anthony W Neal, "Joseph Lee: famed hotelier, restaurateur, inventor."
24. Wayne Miller, "Joseph Lee: Restauranteur, Caterer, Hotelier, Inventor."
25. Anthony W Neal, "Joseph Lee: famed hotelier, restaurateur, inventor."
26. Wayne Miller, "Joseph Lee: Restauranteur, Caterer, Hotelier, Inventor."
27. Anthony W Neal, "Joseph Lee: famed hotelier, restaurateur, inventor."
28. Wayne Miller, "Joseph Lee: Restauranteur, Caterer, Hotelier, Inventor."
29. Ibid.
30. National Inventors Hall of Fame, "Joseph Lee: Bread Machines," Invent.org, accessed August 30, 2024, https://www.invent.org/inductees/joseph-lee.
31. Anthony W Neal, "Joseph Lee: famed hotelier, restaurateur, inventor."
32. Ibid.
33. Wayne Miller, "Joseph Lee: Restauranteur, Caterer, Hotelier, Inventor."
34. Reavis L. Mitchell, Jr., "Robert Reed Church, Sr. (1839–1912)," Tennessee State University Library Digital Archives, https://ww2.tnstate.edu/library/digital/churchrs.htm.
35. Historic-Memphis, "Robert Reed Church . . . The first black Millionaire," Historic-Memphis, accessed August 20, 2024, https://historic-memphis.com/biographies/robert-church/robert-church.html.
36. Reavis L. Mitchell, Jr., "Robert Reed Church, Sr. (1839–1912)," Tennessee State University Library Digital Archives, https://ww2.tnstate.edu/library/digital/churchrs.htm.
37. Historic-Memphis, "Robert Reed Church . . . The first black Millionaire."
38. Reavis L. Mitchell, Jr., "Robert Reed Church, Sr. (1839–1912)."

39. Historic-Memphis, "Robert Reed Church . . . The first black Millionaire."
40. Reavis L. Mitchell, Jr., "Robert Reed Church, Sr. (1839–1912)."
41. Historic-Memphis, "Robert Reed Church . . . The first black Millionaire."
42. Booker T. Washington, *The Negro in Business* (Hertel, Jenkins & Co., 1907), 62.
43. Ibid.
44. Ibid., 64.
45. W. Vincent Rakestraw, "Famous Hotel Now College Dorm," *Negro History Bulletin,* 27, no. 6 (March 1964): 140–42, http://www.jstor.org/stable/44175000.
46. Ashton Nichols, "A History of Athens' Famed Berry Hotel," *The Post Athens,* accessed August 20, 2024, https://projects.thepostathens.com/SpecialProjects/berrys-business-history/index.html.
47. W. Vincent Rakestraw, "Famous Hotel Now College Dorm."
48. Ashton Nichols, "A History of Athens' Famed Berry Hotel."
49. Ibid.
50. W. Vincent Rakestraw, "Famous Hotel Now College Dorm."
51. Booker T. Washington, *The Negro in Business* (Hertel, Jenkins & Co., 1907), 67.
52. Ibid.
53. Ashton Nichols, "A History of Athens' Famed Berry Hotel."
54. W. Vincent Rakestraw, "Famous Hotel Now College Dorm."
55. Ashton Nichols, "A History of Athens' Famed Berry Hotel."
56. Henry Louis Gates Jr. and Julie Wolf, "Why White Guests Clamored to Check In to Edwin Berry's Hotel," The Root, March 23, 2015, https://www.theroot.com/why-white-guests-clamored-to-check-in-to-edwin-berrys-h-1790859199.
57. Ashton Nichols, "A History of Athens' Famed Berry Hotel."

Chapter 2: Hospitality Across the Color Line

Sunshine and Jim Crow

1. W. E. B. Du Bois, "The Color Problem of Summer," *The Crisis*, vol. 36, no. 7 (July 1929): 235, 250.
2. Lavanya Ramanthan, "How Martha's Vineyard became a Black summertime sanctuary," *Vox*, updated August 24, 2021, https://www.vox.com/the-highlight/22627047/marthas-vineyard-black-tourism-oak-bluffs-inkwell.
3. Nicholas Som, "Shearer Cottage and the Rich African American Heritage of Martha's Vineyard," Saving Places, Green Book Sites entry, January 29, 2019, https://savingplaces.org/stories/shearer-cottage-and-the-rich-african-american-heritage-of-marthas-vineyard; Shelley Christiansen, "The Shearer Family, Keepers of the Inn," *Martha's Vineyard Magazine*, June 22, 2012, https://mvmagazine.com/news/2012/06/22/shearer-family-keepers-inn; "The Story of Shearer Cottage," Shearer Cottage (website), accessed February 7, 2025, https://www.shearercottage.com/history and https://www.shearercottage.com/press.
4. W. E. B. Du Bois, "The Color Problem of Summer."
5. "A Southern Seaside Resort." *The Crisis* 37 (July 1930): 228–229.
6. Willard B. Gatewood, *Aristocrats of Color: The Black Elite, 1880–1920* (Fayetville, AK: University of Arkansas Press, 2000), 193.
7. Carroll Greene Jr., "Summertime in the Highland Beach Tradition," *American Visions* (May/June 1986): 48.
8. Willard B. Gatewood, *Aristocrats of Color: The Black Elite, 1880–1920* (Fayetville, AK: University of Arkansas Press, 2000), 45.
9. "Vacation Days," *The Crisis,* vol. 4 (August 1912): 186–188.
10. "Barrett Beach," *The Crisis,* vol. 30 (July 1925): 119–120.
11. Ronald J. Stephens, "Woodland Park, Michigan (1921-)," Black Past, February 4, 2014, https://www.blackpast.org/african-american-history/woodland-park-michigan-1921/.
12. "Detroit's Glamour Playland," *Our World* 9 (July 1954): 9–11.
13. Robert Marchant, "Pre-civil rights, most clubs were white-only. One Greenwich spot for CT Black professionals defied the norm," *Greenwich Time*, updated February 5, 2022, https://www.greenwichtime.com/news/article/Pre-civil-rights-most-clubs-were-white-only-One-16833182.php.
14. Friends of the Greenwich Library, "Lee Haven Beach Club, Recreational and Revolutionary Space," The Oral History Project, February 9, 2017, https://glohistory.blogspot.com/2017/02/lee-haven-beach-club-recreational-and.html.

15. Marian Rizzo, "Paradise Park was a haven for black community," *Ocala Star Banner,* updated August 21, 2013, https://www.ocala.com/story/news/local/2013/08/22/paradise-park-was-a-haven-for-black-community/31925144007/.

16. Ibid.

17. Horace Sutton, "Negro Vacations: A Billion Dollar Business," *Negro Digest* (July 1950): 25–27.

18. "Summer Resorts: Many Formerly White Vacation Spots Open Facilities to Interracial Clientele." *Ebony* (July 1953): 104–106.

19. "Highland Beach, MD," Soul of America, accessed August 21, 2024, https://www.soulofamerica.com/black-towns/highland-beach-md/.

20. Elliot Partin, "Highland Beach, Maryland (1893–)," Black Past, January 5, 2011, https://www.blackpast.org/african-american-history/highland-beach-maryland-1893/.

21. "Highland Beach, MD," Soul of America, accessed August 21, 2024, https://www.soulofamerica.com/black-towns/highland-beach-md/.

22. "The House," Frederick Douglass Museum and Cultural Center website, "Our Stories" page, accessed September 23, 2024, https://www.fdmcc.org/the-house.

23. "Historic Black Beaches: Bay Shore and Other Memorable Sands," Hampton History Museum website, "Exhibits" page, accessed September 23, 2024, https://hampton.gov/3923/Historic-Black-Beaches.

24. University of Virginia, "Bay Shore Hotel," The Architecture of The Negro Travelers': Green Book, last updated October 30, 2023, https://community.village.virginia.edu/greenbooks/content/bay-shore-hotel-0.

25. "Historic Black Beaches: Bay Shore and Other Memorable Sands."

26. Mark St. John Erickson, "Hampton's Bay Shore Hotel was vacation spot for African Americans during Jim Crow era," *Daily Press,* February 10, 2020, https://www.dailypress.com/2015/09/23/hamptons-bay-shore-hotel-was-vacation-spot-for-african-americans-during-jim-crow-era/.

27. "Historic Black Beaches: Bay Shore and Other Memorable Sands."

28. Willard B. Gatewood Jr., *Aristocrats of Color: the Black Elite, 1880–1920* (Bloomington, IN: Indiana University Press, 1993), 201.

29. Patrick Dunn, "Michigan's 'Black Eden': A short history of Idlewild," Second Wave Michigan, *Second Wave Media,* October 10, 2020, https://www.secondwavemedia.com/features/Idlewild-mnrtf-series-14.aspx

30. Willard B. Gatewood Jr., *Aristocrats of Color: the Black Elite, 1880–1920* (Bloomington, IN: Indiana University Press, 1993), 201.

31. W. E. B. Du Bois, "Hopkinsville, Chicago and Idlewild," *The Crisis,* vol. 22, no. 4 (August 1921): 160.

32. "Summer Resorts: Michigan's Idlewild is nation's oldest summer playground owned by Negroes," *Ebony,* vol. 7 (June 1952): 107.

33. Ronald J. Stephens, *Idlewild: The Rise, Decline, and Rebirth of a Unique African American Resort Town"* (Ann Arbor, MI: University of Michigan Press, 2013), 16–19.

34. Ronald J. Stephens, "Idlewild Michigan (1912–)," Black Past, January 5, 2011, https://www.blackpast.org/african-american-history/idlewild-michigan-1912/.

35. Tom Nugent, "Idlewild, 'The Resort That Segregation Built,'" *The Washington Post,* December 31, 2002, https://www.washingtonpost.com/archive/politics/2003/01/01/idlewild-the-resort-that-segregation-built/029ffa03-5ac0-4820-a25d-2f02c2e85819/.

36. Willard B. Gatewood Jr., *Aristocrats of Color: the Black Elite, 1880–1920* (Bloomington, IN: Indiana University Press, 1993), 201–02.

37. Ronald J. Stephens, "Idlewild Michigan (1912–)."

38. George Cantor, *Historic Landmarks of Black America.*

39. Hadley Meares, "The 1930s California Dude Ranch That Broke Racial Barriers," *Curbed Los Angeles*, May 27, 2015, https://la.curbed.com/2015/5/27/9956904/murrays-dude-ranch.

40. Mark Landis, "How 'Murray's Overall Wearing Dude Ranch' came to be in the High Desert," *The Sun,* March 12, 2018, https://www.sbsun.com/2018/03/12/how-murrays-overall-wearing-dude-ranch-came-to-be-in-the-high-desert/.

41. Hadley Meares, "The 1930s California Dude Ranch That Broke Racial Barriers."

42. California African American Museum, "California dreamin': scenes of Black joy and leisure in the Jim Crow era—in pictures," *The Guardian*, August 12, 2023, https://www.theguardian.com/world/gallery/2023/aug/12/california-african-american-museum-black-joy-beach-photo-exhibit-los-angeles.

43. Hadley Meares, "The 1930s California Dude Ranch That Broke Racial Barriers."

44. Mark Landis, "How 'Murray's Overall Wearing Dude Ranch' came to be in the High Desert."

45. Hadley Meares, "The 1930s California Dude Ranch That Broke Racial Barriers."

46. Mark Landis, "How 'Murray's Overall Wearing Dude Ranch' came to be in the High Desert."

47. Hadley Meares, "The 1930s California Dude Ranch That Broke Racial Barriers."

48. Ronald J. Stephens, "Murray's Dude Ranch, Apple Valley, California (1922–1960)," Black Past, March 14, 2014, https://www.blackpast.org/african-american-

history/murray-s-dude-ranch-apple-valley-california-1922-1960/.

49. Hadley Meares, "The 1930s California Dude Ranch That Broke Racial Barriers."

50. Mark Landis, "How 'Murray's Overall Wearing Dude Ranch' came to be in the High Desert."

51. Hadley Meares, "The 1930s California Dude Ranch That Broke Racial Barriers."

52. Mark Landis, "How 'Murray's Overall Wearing Dude Ranch' came to be in the High Desert."

53. Ronald J. Stephens, "Murray's Dude Ranch, Apple Valley, California (1922–1960)."

Summer, Sand, and Segregation by the Sea

1. Chadd Scott, "'A Place for Recreation and Relaxation Without Humiliation,' American Beach on Amelia Island, Florida," *Forbes,* February 4, 2021, https://www.forbes.com/sites/chaddscott/2021/02/03/a-place-for-recreation-and-relaxation-without-humiliation-american-beach-on-amelia-island-florida/.

2. "American Beach Timeline," A.L. Lewis Museum at American Beach, The Origins & History of American Beach (webpage), accessed September 25, 2024, https://allewismuseum.org/origins-and-history/.

3. Chadd Scott, "'A Place for Recreation and Relaxation Without Humiliation,' American Beach on Amelia Island, Florida."

4. Larry Chase, "American Beach—A Minority at its Leisure," National Park Service, History of American Beach, last updated April 16, 2024, https://www.nps.gov/timu/learn/historyculture/ambch_history.htm.

5. Chadd Scott, "'A Place for Recreation and Relaxation Without Humiliation,' American Beach on Amelia Island, Florida."

6. Larry Chase, "American Beach—Beginning of the End."

7. Larry Chase, "American Beach—A Community in Transition," National Park Service, History of American Beach (webpage), last updated Jan 6, 2016, https://www.nps.gov/timu/learn/historyculture/ambch_communityintransition.htm.

8. "American Beach Timeline," A.L. Lewis Museum at American Beach.

9. Ann Powell, "Remembering Carr's Beach: The Most Popular African American Beach and Music Venue on the Chesapeake," Visit Annapolis, February 1, 2024, https://www.visitannapolis.org/blog/stories/post/remembering-carrs-beach-the-most-popular-african-american-beach-and-music-venue-on-the-chesapeake/.

10. "Carr's and Sparrow's Beaches," Leisure as Resistance, University of Maryland, Baltimore County: Interdisciplinary CoLab, accessed September 26, 2024, https://leisureasresistance.org/carrs-and-sparrows-beaches/.

11. Ann Powell, "Remembering Carr's Beach: The Most Popular African American Beach and Music Venue on the Chesapeake."

Chapter 3: Black Hoteliers at the Turn of the Century

More Than a Place to Stay

1. "The Great Migration," National Archives, African American Heritage (webpage), last reviewed June 28, 2021, https://www.archives.gov/research/african-americans/migrations/great-migration.

2. Cecilia Rasmussen, "A Pioneer of Black Los Angeles," *Los Angeles Times*, December 23, 1996, https://www.latimes.com/archives/la-xpm-1996-12-23-me-12005-story.html.

3. Erin Blakemore, "How the Harlem Renaissance helped forge a new sense of Black identity," *National Geographic*, February 24, 2022, https://www.nationalgeographic.com/history/article/how-the-harlem-renaissance-helped-forge-a-new-sense-of-black-identity.

4. "A New African American Identity: The Harlem Renaissance," The Smithsonian: National Museum of African American History & Culture, accessed September 26, 2024, https://nmaahc.si.edu/explore/stories/new-african-american-identity-harlem-renaissance.

5. "The Great Migration and the Harlem Renaissance," in *His115—US History Since 1870*, The American Women's College, Open Education at Bay Path University, https://open.baypath.edu/his115/chapter/the-great-migration-and-the-harlem-renaissance/.

6. Renato Grussu, "Harlem's 'Waldorf' and Other New York 'Black Hotels,'" *La Voce di New York*, April 11, 2021, https://lavocedinewyork.com/en/new-york/2021/04/11/harlems-waldorf-and-other-new-york-black-hotels/.

7. Jennifer Fronc, "The Marshall Hotel," The Gotham Center for New York City History (blog), June 5,

2010, https://www.gothamcenter.org/blog/the-marshall-hotel.

8. Marc Kirkeby, "The Brightest Days of the Marshall," NYC Department of Records & Information Services (blog), April 20, 2017, https://www.archives.nyc/blog/2017/4/20/the-brightest-days-of-the-marshall.

9. Jervis Anderson, "Harlem—I: The story of a refuge," *The New Yorker*, June 21, 1981, https://www.newyorker.com/magazine/1981/06/29/harlem-i-the-journey-uptown.

10. Marc Kirkeby, "The Brightest Days of the Marshall."

11. David Levering Lewis, *When Harlem Was in Vogue* (New York: Penguin Books, 1997), 29.

12. James Weldon Johnson, *Black Manhattan* (New York: Alfred A. Knopf, 1930), 119.

13. Ibid.

14. Jennifer Fronc, "The Marshall Hotel"; Marc Kirkeby, "The Brightest Days of the Marshall"; Sondra Kathryn Wilson, *Meet Me at the Theresa: The Story of Harlem's Most Famous Hotel* (New York: Atria Books, 2004), 53.

15. Marc Kirkeby, "The Brightest Days of the Marshall."

16. James Weldon Johnson, *Black Manhattan* (New York: Alfred A. Knopf, 1930), 120.

17. Marc Kirkeby, "The Brightest Days of the Marshall."

18. Jennifer Fronc, "The Marshall Hotel."

19. Ibid.

20. Ibid.

21. Marc Kirkeby, "The Brightest Days of the Marshall."

22. "Douglass' Vision and the Theatre," Douglass Theatre, History (webpage), accessed October 1, 2024, https://www.douglasstheatre.org/history/.

23. Jae Jones, "Charles Henry Douglass: Opened the "Douglass Theatre" for Entertainment for the Black Community," September 11, 2011, https://blackthen.com/charles-henry-douglass-opened-the-douglass-theatre-for-entertainment-for-the-black-community/.

24. Edward A. Johnson, "Introduction to the Douglass Theatre in Macon," Digital Library of Georgia, Collection: The Blues, Black Vaudeville, and the Silver Screen, 1912–1930s: Selections from the Records of Macon's Douglass Theatre, accessed October 1, 2024, https://dlg.usg.edu/collections/dlg_dtrm/essay.

25. Ibid.

26. Jae Jones, "Charles Henry Douglass: Opened the 'Douglass Theatre' for Entertainment for the Black Community."

27. Edward A. Johnson, "Introduction to the Douglass Theatre in Macon."

28. Michael W. Pannell, "Douglass Theatre legends and lore all tie back to the man who founded it," *Macon Magazine*, June/July 2020, https://maconmagazine.com/amazing-douglass/.

29. Ibid.

30. Thomas Aiello, "'The Three Deaths of John Glover, 1922," Georgia Historical Quarterly, 2021, 99–105, https://www.academia.edu/69669656/The_Three_Deaths_of_John_Glover_1922.

31. Michael W. Pannell, "Douglass Theatre legends and lore all tie back to the man who founded it."

32. Jae Jones, "Charles Henry Douglass: Opened the 'Douglass Theatre' for Entertainment for the Black Community."

33. Michael W. Pannell, "Douglass Theatre legends and lore all tie back to the man who founded it."

34. Daphne Fruchtman, Jessica Young, and Clio Admin, "Joe Gans and the Goldfield Hotel Historical Marker," Clio: Your Guide to History, last updated July 28, 2019, https://theclio.com/entry/12840.

35. Demetrice P. Dalton, "Joe 'Gans' Gant (1874–1910)," Black Past, January 16, 2016, https://www.blackpast.org/african-american-history/gant-joe-gans-1874–1910/.

36. Daphne Fruchtman, Jessica Young, and Clio Admin, "Joe Gans and the Goldfield Hotel Historical Marker."

37. Demetrice P. Dalton, "Joe 'Gans' Gant (1874–1910)."

38. Colleen Aycock and Mark Scott, "Joe Gans (Joseph Saifus Butts) The Old Master November 25, 1874–August 10, 1910," Goldfield Historical Society, Featured Stories (webpage), accessed October 8, 2024, http://www.goldfieldhistoricalsociety.com/joe-gans/.

39. John L. Smith, "1906 Gans-Nelson fight was one for the ages," *Las Vegas Review-Journal*, September 20, 2014, https://www.reviewjournal.com/news/1906-gans-nelson-fight-was-one-for-the-ages/.

40. Demetrice P. Dalton, "Joe 'Gans' Gant (1874–1910)."

41. Daphne Fruchtman, Jessica Young, and Clio Admin, "Joe Gans and the Goldfield Hotel Historical Marker."

42. Colleen Aycock and Mark Scott, "Joe Gans (Joseph Saifus Butts) The Old Master November 25, 1874–August 10, 1910."

43. Colleen Aycock and Mark Scott, *Joe Gans: A Biography of the First African American World Boxing Champion* (Jefferson, NC: McFarland & Co., 2008), 229.

44. Ibid., 217; 229.

45. Demetrice P. Dalton, "Joe 'Gans' Gant (1874–1910)."

46. Colleen Aycock and Mark Scott, "Joe Gans (Joseph Saifus Butts) The Old Master November 25, 1874–August 10, 1910."

47. Demetrice P. Dalton, "Joe 'Gans' Gant (1874–1910)."

48. "Immense Throng Pay Their Last Respect To The Ex-Champion With Impressive Ceremonies," sourced from *AfroAmerican Ledger* (Baltimore) 20 August 1910, Mount Auburn Cemetery, "City of the Dead," accessed October 8, 2024, https://mountauburn.msa.maryland.gov/details.aspx?PID=433.

49. Daphne Fruchtman, Jessica Young, and Clio Admin, "Joe Gans and the Goldfield Hotel Historical Marker."

50. "Joe Gans," International Boxing Hall of Fame, Inductees: Old Timers, accessed October 8, 2024, http://www.ibhof.com/pages/about/inductees/oldtimer/gans.html.

51. "Steed, Maggie M," Notable Kentucky African Americans Database, University of Kentucky Libraries, accessed October 8, 2024, https://nkaa.uky.edu/nkaa/items/show/273.

52. Constance Alexander, "Main Street: Maggie Steed/Betty Dobson: Women of substance," *Murray Ledger & Times*, March 23, 2020, https://www.murrayledger.com/opinion/columns/main_street/main-street-maggie-steed-betty-dobson-women-of-substance/article_a2be8020-6ca5-11ea-8863-0b77eeece874.html.

53. KFW Team, "KFW Features Maggie Steed for Women's History Month," Kentucky Foundation for Women (blog), August 3, 2018, https://www.kfw.org/feminist-blog/kfw-features-maggie-steed-womens-history-month/.

54. Alex Wemm and Mortimer R, "The Hotel Metropolitan Museum." Clio: Your Guide to History, January 27, 2019, Accessed April 13, 2022, https://theclio.com/entry/281.

55. Constance Alexander, "Main Street: Maggie Steed/Betty Dobson: Women of substance," KFW Team, "KFW Features Maggie Steed for Women's History Month."

56. "Betty Dobson & Ms. Maggie's Memories at Hotel Metropolitan," Paducah Travel (blog), July 29, 2020, https://www.paducah.travel/blog/stories/post/betty-dobson-shares-ms-maggies-memories-at-hotel-metropolitan-in-paducah/.

57. KFW Team, "An interview with Betty Dobson/Hotel Metropolitan," Kentucky Foundation for Women (blog), February 28, 2018, https://www.kfw.org/feminist-blog/interview-betty-dobson-hotel-metropolitan/.

58. Joyce West, "Paducah's Hotel Metropolitan," *KET*, February 15, 2015, https://ket.org/paducahs-hotel-metropolitan/.

59. KFW Team, "KFW Features Maggie Steed for Women's History Month."

60. "Whitelaw Hotel," DC Historic Sites, accessed October 9, 2024, https://historicsites.dcpreservation.org/items/show/59?tour=6&index=3.

61. "The Whitelaw Hotel," Virtual Tour of Shaw: Other Landmarks (webpage) in "Duke Ellington's Washington," *PBS*, accessed October 9, 2024, https://www.pbs.org/ellingtonsdc/vtOtherLandMarks.htm.

62. "Whitelaw Hotel," DC Historic Sites.

63. Briana Thomas, "The Forgotten History of U Street," *Washingtonian*, February 12, 2017, https://www.washingtonian.com/2017/02/12/forgotten-history-u-street-black-broadway/.

64. Devry Becker Jones, "U Street Corridor in Northwest Washington, District of Columbia—*The American Northeast (Mid-Atlantic)*," The Historical Marker Database, last revised January 30, 2023, https://www.hmdb.org/m.asp?m=173377.

65. "Explore Washington, D.C.'s Historic Black Broadway on U Street," National Trust for Historic Preservation, accessed October 9, 2024, https://savingplaces.org/guides/explore-washington-dc-black-broadway.

66. "Explore Washington, D.C.'s Historic Black Broadway on U Street," National Trust for Historic Preservation

67. Joe Grinspan, "How a Ragtag Band of Reformers Organized the First Protest March on Washington, D.C.," *Smithsonian Magazine*, May 1, 2014, https://www.smithsonianmag.com/smithsonian-institution/how-ragtag-band-reformers-organized-first-protest-march-washington-dc-180951270/.

68. "Recalling the Heyday of a Grand Hotel: When the Bright Lights of Black Society Shone at the Whitelaw," *Washington Post,* February 29, 1992, https://www.washingtonpost.com/archive/lifestyle/1992/03/01/recalling-the-heyday-of-a-grand-hotel/540b94f7-ef9a-4c56-a98b-e412cbfa6db6/.

69. United States Department of the Interior, National Park Service, "National Register of Historic Places Registration Form: Greater U Street Historic District," by Laura V. Trieschmann, Anne Selin, Stephen Callcot, NP Gallery Digital Asset Management System, December, 1998, 24, https://npgallery.nps.gov/SearchResults/434dee61-5338-4283-8f94-a545342bcf94?view=grid.

70. Devry Becker Jones, "U Street Corridor in Northwest Washington, District of Columbia—*The American Northeast (Mid-Atlantic).*"

71. "Whitelaw Hotel," DC Historic Sites.

72. "Recalling the Heyday of a Grand Hotel: When the Bright Lights of Black Society Shone at the Whitelaw."

73. Ibid.

74. "Whitelaw Hotel," DC Historic Sites; "History of the Whitelaw Hotel & Apartments at 13th and T Streets, NW," The House History Man (blog), August 10, 2014, http://househistoryman.blogspot.com/2014/08/.

75. "Whitelaw Apartment House, 1839 Thirteenth Street Northwest, Washington, District of Columbia, DC," Isaiah T. Hatton (architect), John W. Lewis (owner), Dynecourt Mahon (photographer), Harrison M. Ethridge (historian), Alison K. Hoagland (transmitter), part of Historic American Building Survey (Library of Congress), accessed October 10, 2024, https://www.loc.gov/item/dc0299/.

76. Briana Thomas, "The Forgotten History of U Street."

77. "The Whitelaw Hotel," Virtual Tour of Shaw: Other Landmarks in "Duke Ellington's Washington";

"Recalling the Heyday of a Grand Hotel: When the Bright Lights of Black Society Shone at the Whitelaw."

78. *The Negro Motorist Green Book: An International Travel Guide* (New York: Victor H. Green & Co., Publishers, 1949), Texas Historical Commission, from the collections of Henry Ford, 15, https://www.thc.texas.gov/public/upload/preserve/survey/highway/Negro%20Motorist%20Green%20Book%201949.pdf.

79. "Explore Washington, D.C.'s Historic Black Broadway on U Street."

80. "The Industrial Bank of Washington," Virtual Tour of Shaw: Other Landmarks (webpage) in "Duke Ellington's Washington," *PBS*, accessed October 9, 2024, https://www.pbs.org/ellingtonsdc/vtOtherLandMarks.htm.

81. Joseph D. Whitaker, "Whitelaw Hotel Is Closing After Checkered History: Once Elite Whitelaw Is Closing After Long Decline," *Washington Post,* July 4, 1977, https://www.washingtonpost.com/archive/politics/1977/07/04/whitelaw-hotel-is-closing-after-checkered-historyonce-elite-whitelaw-is-closing-after-long-decline/cf410a9f-8327-4a7c-bca0-c9540593aba9/.

82. Jane F. Levey, "Rebirth of the Whitelaw Hotel," DC History Center, February 9, 2021, https://dchistory.org/rebirth-of-the-whitelaw-hotel/.

83. James Louis Bacon, *Until I am Dust: John Whitehall Lewis and the Story of the Industrial Savings Bank and Whitehall Hotel* (Georgia: Benil Publishing, 2020).

84. Jane F. Levey, "Rebirth of the Whitelaw Hotel."

85. "Whitelaw Hotel," DC Historic Sites; "History of the Whitelaw Hotel & Apartments at 13th and T Streets, NW."

86. Jane F. Levey, "Rebirth of the Whitelaw Hotel."

87. "Whitelaw Hotel," DC Historic Sites.

88. "The Industrial Bank of Washington," Virtual Tour of Shaw: Other Landmarks in "Duke Ellington's Washington."

89. DeNeen L. Brown, "A black bank witnessed devastation after the 1968 riots. Now 'the future is bright,'" *Washington Post*, March 26, 2018, https://www.washingtonpost.com/local/a-black-bank-witnessed-devastation-after-the-1968-riots-now-the-future-is-bright/2018/03/22/069fde30-1cf9-11e8-b2d9-08e748f892c0_story.html.

90. Keshler Thibert, "O. W. Gurley (1868–1935)," Black Past, September 19, 2020, https://www.blackpast.org/african-american-history/o-w-gurley-1868-1935/.

91. Henderson, Brooke. "Meet the Entrepreneur Who Created the First 'Black Wall Street,'" Inc, December 1, 2020, https://www.inc.com/magazine/202011/brooke-henderson/o-w-gurley-tulsa-oklahoma-business-black-wall-street.html.

92. Keshler Thibert, "O. W. Gurley (1868–1935)."

93. Ibid.

94. Hannibal B. Johnson, *Black Wall Street: From Riot to Renaissance in Tulsa's Historic Greenwood District* (Austin: Eakin Press, 2007).

95. Henderson, Brooke. "Meet the Entrepreneur Who Created the First 'Black Wall Street.'"

96. Ibid.

97. Taylor, DeAnna. "JB Stradford: The Black Hotel Owner Deemed the Bezos of Black Wall Street," June 1, 2021. Travelnoire, https://travelnoire.com/jb-stradford-hotel-owner-deemed-bezos-of-black-wall-street.

98. Ibid.

99. Euell A. Dixon, "John 'the Baptist' Stradford (1861–1935)," Black Past, October 28, 2020, https://www.blackpast.org/african-american-history/john-the-baptist-stradford-1861-1935/.

Hospitality and the "Harlem Renaissance" Era

1. Bruce Kellner, *The Harlem Renaissance: A Historical Dictionary for the Era* (Westport, Connecticut: Greenwood Press, 1984), xiii.

2. Eric K. Washington, "Hotel Olga: Race retreat of the Harlem Renaissance," Historypin, entry added August 9, 2013, https://www.historypin.org/en/explore/geo/50,0,8/bounds/48.559552,-1.650696,51.398548,1.650696/paging/1/pin/168785.

3. Philip A. Randolph, "Edward H. Wilson: Proprietor of the Olga Hotel, New York's Finest Hostelry for Negroes." *The Messenger* (January 1925): 60–61.

4. Ibid.

5. Eric K. Washington, "Hotel Olga," NYC LGBT Historic Sites Project, site last updated 2024, https://www.nyclgbtsites.org/site/hotel-olga/.

6. Chris Ott., "E. Russell 'Noodles' Smith (?–1952)," Blackpast, January 19, 2007, https://www.blackpast.org/african-american-history/smith-e-russell-noodles-1952/.

7. Paul De Barros, "Hot Town—Beboppers, High Rollers and a Man Called Noodles," *The Seattle Times* (archive), September 12, 1993, https://archive.seattletimes.com/archive/?date=19930912&slug=1720529.

8. Ashley Harrison, "The Story of Seattle's Black and Tan Club and Those Who Owned It," *South Seattle Emerald*, May 15, 2018, https://southseattleemerald.com/2018/05/15/the-story-of-seattles-black-and-tan-club-and-those-who-owned-it/.

9. Esther H. Mumford, *Calabash: A Guide to the History, Culture, and Art of African Americans in Seattle and King County, Washington* (Atlanta: Ananse Pr, 1993).

10. Jill Watts and Kasandra Balsis, "The Douglas Hotel (1924–1985)," Clio: Your Guide to History, March 21, 2021, Accessed September 11, 2022. https://theclio.com/entry/122815.

11. Robert Fikes, "George A. Ramsey (1889–1963), Black Past, July 19, 2016, https://www.blackpast.org/african-american-history/ramsey-george-1889-1963/.

12. Ibid.

13. Jill Watts and Kasandra Balsis, "The Douglas Hotel (1924–1985)."

14. Sophie Capella, "Harlem of the West," University of San Diego, entry in Studies of Black History at the University of San Diego, May 7, 2019, https://sites.sandiego.edu/blackhistoryatusd/2019/05/07/harlem-of-the-west-sophie-capella/.

15. Robert Fikes, "George A. Ramsey (1889–1963)."

16. Jeff Smith, "The Douglas Hotel: The Harlem of the West—When Lady Day Sang on Market Street," *San Diego Reader*, August 5, 1999, https://www.sandiegoreader.com/news/1999/aug/05/douglas-hotel/.

17. Robert Fikes, "George A. Ramsey (1889–1963)."

18. Sophie Capella, "Harlem of the West."

19. Leland T. Saito, "African Americans and Historic Preservation in San Diego: The Douglas and the Clermont/Coast Hotels," *The Journal of San Diego History* 54, no. 1 (2008): 7; Jeff Smith, "The Douglas Hotel: The Harlem of the West—When Lady Day Sang on Market Street"; Leland T. Saito, "African Americans and Historic Preservation in San Diego: The Douglas and the Clermont/Coast Hotels."

20. Chris Guy, "Summers Apart," *The Baltimore Sun*, May 4, 2007.https://www.baltimoresun.com/news/bs-xpm-2007-05-04-0705040072-story.html.

21. Eric Murphy, "The Brightside: Henry's Hotel," WMDT, February 19, 2019, https://www.wmdt.com/2019/02/the-brightside-henrys-hotel/.

22. Chris Guy, "Summers Apart."

23. Bethany Hooper, "Henry Hotel Foundation Scores $250K Grant for Restoration Efforts," HenryHotel.org, January 3, 2024, https://henryhotel.org/henry-hotel-foundation-scores-250k-grant-for-restoration-efforts/.

24. Rose Vance-Grom, "Mathews Hotel," Green Book Cleveland (website), accessed February 7, 2025, site updated 2025, https://greenbookcleveland.org/locations/mathews-hotel/.

25. Ross Coen, "Zula Swanson (1891–1973)," Black Past, August 12, 2020, https://www.blackpast.org/african-american-history/people-african-american-history/zula-swanson-1891-1973/.

26. Ibid.

27. Ibid.

28. McKelvey, Wallace. "Black Entertainers Found a Home at the Jackson House After Being Barred from Other Hotels," September 12, 2017. *www.pennlive.com*. Updated September 10, 2020. https://www.pennlive.com/news/2017/09/jackson_house_harrisburg.html.

29. Ibid.

30. Ibid.

31. Ibid.

32. Shaniece, Holmes-Brown, "Farewell to the Jackson House Mural," Black Wall Street Pennsylvania, February 11, 2021, https://www.blackwallstreet-pa.com/articles/farewell-to-the-jackson-house-mural/.

33. Paul R. Spitzzeri, "A Beautiful Inn With A Soul": A Photo of the Hotel Somerville Lobby, Los Angeles, September 1928," The Homestead Blog, 2020, https://homesteadmuseum.blog/2020/09/26/a-beautiful-inn-with-a-soul-a-photo-of-the-hotel-somerville-lobby-september-1928/amp/; Etan Rosenbloom, "#72: Dunbar Hotel (South LA) / Hotel Somerville | Black History Month," Etan Does LA (blog), February 14, 2022, https://etandoesla.com/72-dunbar-hotel-hotel-somerville/.

34. Wikipedia, "John Alexander Somerville," last modified November 2, 2023, 02:28 (UTC), https://en.wikipedia.org/wiki/John_Alexander_Somerville.

35. Ibid.

36. Paul R. Spitzzeri, "A Beautiful Inn With A Soul."

37. Ibid.

38. Hadley Meares, "The Dunbar Hotel Was Once The Heart Of Black Los Angeles," LAist, December 27, 2019, https://laist.com/news/entertainment/dunbar-hotel-heart-of-black-los-angeles-hidden-history.

39. Paul R. Spitzzeri, "A Beautiful Inn With A Soul."

40. Nate Christensen, "Dunbar Hotel (1928–), Black Past, March 31, 2011, https://www.blackpast.org/african-american-history/dunbar-hotel-1928/.

41. Paul R. Spitzzeri, "A Beautiful Inn With A Soul."

42. Etan Rosenbloom, "#72: Dunbar Hotel (South LA) / Hotel Somerville | Black History Month."

43. Wikipedia, "John Alexander Somerville."

44. Paul R. Spitzzeri, "A Beautiful Inn With A Soul."

45. Hadley Meares, "The Dunbar Hotel Was Once The Heart Of Black Los Angeles"; Hadley Meares, "When Central Avenue Swung: The Dunbar Hotel and the Golden Age of L.A.'s 'Little Harlem,'" PBS SoCal, February 17, 2015, https://www.pbssocal.org/history-society/when-central-avenue-swung-the-dunbar-hotel-and-the-golden-age-of-l-a-s-little-harlem.

46. Eric Craig, "The Dunbar Hotel History: Its Rise, Fall, and Rebirth," The South LA Recap, accessed October 16, 2024, https://southlarecap.com/2021/05/01/the-dunbar-hotel-history-its-rise-fall-and-rebirth/.

47. Meares, Hadley Meares, "The Dunbar Hotel Was Once The Heart Of Black Los Angeles."

48. Eric Craig, "The Dunbar Hotel History: Its Rise, Fall, and Rebirth."

49. Ibid.

50. Ibid.

51. Wikipedia, "John Alexander Somerville."

52. Jeff Hannusch, "The South's Swankiest Night Spot: The Legend of the Dew Drop Inn," Satchmo (website), accessed February 7, 2025, first published 1997, site last updated 2013, https://www.satchmo.com/ikoiko /dewdropinn.html.

53. Ibid.

54. Ibid.

55. The Ponderosa Stomp Foundation, "Dew Drop Inn," WWOZ's A Closer Walk (website), accessed February 7, 2025, site updated 2025, https://acloserwalknola. com/places/dew-drop-inn/.

56. "History, Remastered," Dew Drop Inn Nola (website), accessed February 7, 2025, https://www.dewdropinnnola .com/about.

57. Jeff Hannusch, "The South's Swankiest Night Spot: The Legend of the Dew Drop Inn."

58. Karli Winfrey, "Dew Drop Inn: A historic symbol of Black resilience and resistance," Verite News (website), February 28, 2023, https://veritenews.org/2023/ 02/28/dew-drop-inn-a-historic-symbol-of-black-resilience/.

59. Courtney Stewart, "Dew Drop Inn," Reinvestment Fund (website), Insights entry, accessed February 7, 2025, site lasted updated 2025, https://www.reinvestment. com/insights/dew-drop-inn/.

60. Clair Lorell, "Dew Drop Inn Readies to Reopen With Food From a New Orleans Culinary Legend," Eater New Orleans (website), January 29, 2024, https://nola. eater.com/2024/1/29/24047046/dew-drop-inn-new-orleans-reopens-legendary-chef-restaurant.

Chapter 4: The Growth of Black Hospitality in Miami

African American Hostelries Turn Up the Heat in Miami

1. Roderick Waters, "Dr. William B. Sawyer of Colored Town," *Tequesta* 57 (1997): 67–80, https://dpanther. fiu.edu/sobek/content/FI/18/05/09/00/00057/ FI18050900_00057_00005.pdf.

2. John A. Diaz, "Four Excellent Hotels Now Available to Miami Visitors." *Pittsburgh Courier*, December 18, 1948, 27.

3. Marvin Dunn, "Dunn History: A History of Florida Through Black Eyes," Dunn History (blog), Dorsey entry, 2021, https://dunnhistory.com/black-miami/ dorsey/.

4. Wikipedia, "Dana A. Dorsey," last modified August 16, 2024, 00:15 (UTC)

5. Marvin Dunn, "Dunn History: A History of Florida Through Black Eyes."

6. WLRN Public Media, "Home of Miami's First Black Millionaire, Dana A. Dorsey, Now Open To Public," WLRN, March 7, 2019, https://www.wlrn.org/news/ 2019-03-07/home-of-miamis-first-black-millionaire-dana-a-dorsey-now-open-to-public.

7. Victor Trammell, "Meet Dana Albert Dorsey: The Black Man Who Formerly Owned 'Fisher Island,'" Black Then, May 24, 2022, https://blackthen.com/ meet-dana-albert-dorsey-the-black-man-who-formerly-owned-fisher-island/.

8. Wikipedia, "Dana A. Dorsey."

9. Marvin Dunn, "Dunn History: A History of Florida Through Black Eyes."

10. Kim Wynne, "Mogul, Pioneer, Miami's First Black Millionaire: Dana A. Dorsey's Legacy Lives On," NBC Miami, updated February 8, 2022, https://www. nbcmiami.com/discover-black-heritage/mogul-pioneer-miamis-first-black-millionaire-dana-a-dorseys-legacy-lives-on/2683869/.

11. Roderick Waters, "Dr. William B. Sawyer of Colored Town."

12. Ibid.

13. Ibid.

14. Ibid.

15. Ibid.

16. Ibid.

17. Christopher Buck, "Meet Miami's First Black Millionaire, Who Worked to Worship," Bahai Teachings, Part 43 in Series the Universal Emancipation Proclamation, August 24, 2018, https://bahaiteachings.org/meet-miamis-first-black-millionaire-who-worked-to-worship/.

18. "Florida's Playground Gets a New Hotel, Miami Meets Lord Calvert," *The Afro-American*, September 22, 1951, 9.

19. "Knight Beat at the Sir John Hotel," Going Overtown, *n.d.*, https://goingovertown.org/listing/knight-beat-at-the-sir-john-hotel/.

20. Elman et al., "The Historic Hampton House: Most Important Nexus in African American History," ArtSpeak (FIU).

21. Ibid.

Chapter 5: The Green Book Era

Vacation and Recreation without Humiliation

1. Taylor Candacy, "Route 66's Legacy of Racial Segregation," *The Guardian*, February 27, 2015, https://www.theguardian.com/travel/2015/feb/27/green-book-south-west-usa-route-66-civil-rights.

2. Wikipedia Commons, File: The Negro Motorist Green Book 1949.pdf, last updated January 16, 2023 (00:16), https://commons.wikimedia.org/w/index.php?title=File%3AThe_Negro_Motorist_Green_Book_1949.pdf&page=67.

3. "The Green Book: The forgotten story of one carrier's legacy helping others navigate Jim Crow's highways," NALC, The Postal Record, September 2013, 2.

4. Ibid.

5. Evan Andrews, "The Green Book: The Black Travelers' Guide to Jim Crow America."

6. "Harlem's Victor Hugo Green's The Green Book," Harlem World, August 11, 2020, https://www.harlemworldmagazine.com/harlems-victor-hugo-greens-the-green-book/.

7. Evan Andrews, "The Green Book: The Black Travelers' Guide to Jim Crow America."

8. Sutton, Horace. "Negro Vacations: A Billion Dollar Business." *Negro Digest* (July 1950): 25–27.

9. Ibid.

10. Jennifer Reut, "Travelguide: Vacation and Recreation Without Humiliation," National Trust for Historic Preservation, February 18, 2019, https://savingplaces.org/stories/travelguide-vacation-and-recreation-without-humiliation.

11. Leslie A. Nash Jr., "Ten Year Milestone for Travelers," *The Crisis* 62 (October 1955): 459–463.

12. Ibid.

13. Ibid.

14. Ibid.

15. "Hotels-Motels Are Better," *The Afro-American* (March 1955): 9–10.

16. J. Elias O'Neal, " Eggleston Plaza in Jackson Ward lands first restaurant tenant," Richmond BiZSense, June 4, 2019, https://richmondbizsense.com/2019/06/04/eggleston-plaza-jackson-ward-lands-first-restaurant-tenant/.

17. Samantha Willis, "A Haven on the Deuce," *Richmond Magazine*, August 29, 2016, https://richmondmagazine.com/news/features/a-haven-on-the-deuce/.

18. "Maggie Walker National Historic Site," National Park Service, https://www.nps.gov/places/maggie-walker-national-historic-site.htm.

19. Samantha Willis, "A Haven on the Deuce."

20. J. Elias O'Neal, " Eggleston Plaza in Jackson Ward lands first restaurant tenant."

21. Myja R. Thibault, "Neverett Alexander Eggleston (1898–1996)," Dictionary of Virginia Biography, Library of Virginia (1998–), 2015, https://www.lva.virginia.gov/public/dvb/bio.php?b=Eggleston_Neverett_Alexander

22. Samantha Willis, "A Haven on the Deuce."

23. "Alonzo Wright: Cleveland's First Black Millionaire," The Village of Brantenahl, Notable People entry, site last modified 2019, https://bratenahlhistorical.org/index.php/alonzo-wright/.

24. Ibid.

25. Mark Souther, "Majestic Hotel," Encyclopedia of Cleveland History, Case Western Reserve University, site last modified 2024, https://case.edu/ech/articles/m/majestic-hotel.

26. Ibid.

27. Ibid.

28. Shawn Morris, "Majestic Hotel: America's Finest Colored Hostelry," Cleveland Historical, site last modified 2024, https://clevelandhistorical.org/items/show/636.

29. Wikipedia, "California Hotel," last modified July 2, 2024, 06:04 (UTC), https://en.wikipedia.org/wiki/California_Hotel.

30. Mark G., "Wallace A. Barksdale, Washington D.C. businessman (1886–1953)," National Museum of African American History and Culture, accessed October 18, 2024, https://communitycuration.org/home/storyDetail?id=5ce69d1e63feea13b8e662fe.

31. Ibid.

32. Ibid.

33. Wikipedia, "The Hotel Carver," last modified September 22, 2024, 19:36 (UTC), https://en.wikipedia.org/wiki/The_Hotel_Carver; Zoe Nissen, "Remembering Pasadena's First Black-Owned Hotel," USC Libraries, September 23, 2020, https://libraries.usc.edu/article/remembering-pasadenas-first-black-owned-hotel.

34. Ibid.

35. Ibid.

36. Ibid.

37. Ibid.

38. Staff Editors, "Who shot the Mayor of Fillmore?" *The New Fillmore*, September 4, 2014, https://newfillmore.com/2014/09/04/who-shot-the-mayor-of-fillmore/.

39. "A Slave's Strange Story," *San Francisco Chronicle*, October 21, 1963.

40. Nicole Meldahi, "The Mysterious Death of the Mayor of the Fillmore," Summer of Love, https://summerof.love/mysterious-death-mayor-fillmore/.

41. Ibid.

42. Ibid.

43. Staff Editors, "Who shot the Mayor of Fillmore?"

44. Jaqueline Chauhan, "Remembering the Booker T. Washington Hotel," Reimagine (Race, Poverty, and the Environment Journal), excerpt from The Baobab Tree: Journal of African American Genealogical Society of Northern California, Inc., Fall 2011, https://www.reimaginerpe.org/20-2/chauhan.

45. Ben Zotto, "Looking for the Booker T.," Medium (blog), December 19, 2020, https://bzotto.medium.com/looking-for-the-booker-t-cb565824a691.

46. Staff Editors, "Who shot the Mayor of Fillmore?"

47. Jacueline Chauhan, "Remembering the Booker T. Washington Hotel."

48. Wikipedia, "Hotel Theresa," last modified August 21, 2024, 19:38 (UTC), https://en.wikipedia.org/wiki/Hotel_Theresa.

49. Landmarks Preservation Commission, "Hotel Theresa (now Theresa Towers)," New York City LPC, July 13, 1993, https://s-media.nyc.gov/agencies/lpc/lp/1843.pdf.

50. "The Waldorf of Harlem, Million-Dollar Theresa is Most Famous Negro Hotel in Nation," Ebony 1 (April 1946): 8–12.

51. Stanley Turkel, "Hotel Theresa: the Waldorf of Harlem," Famous Hotels, Reading Room entry, site last modified 2024, https://famoushotels.org/news/hotel-theresa-the-waldorf-of-harlem.

52. Ibid.

53. "The Waldorf of Harlem, Million-Dollar Theresa is Most Famous Negro Hotel in Nation," Ebony 1.

54. Ibid.

55. Landmarks Preservation Commission, "Hotel Theresa (now Theresa Towers)."

56. Stanley Turkel, "Hotel Theresa: the Waldorf of Harlem."; Stanley Turkel, "Nobody Asked Me, But . . . No. 248: Hotel Theresa, New York, N.Y. (1913)," hospitalitynet (HN), May 12, 2021, https://www.hospitalitynet.org/opinion/4104369.html.

57. Ibid.

58. Landmarks Preservation Commission, "Hotel Theresa (now Theresa Towers)."

59. Ibid.

60. "Love Woods Dies: Ran the Theresa; Hotelman Served as Host to Castro During '60 Visit," New York Times, May 30, 1967, https://www.nytimes.com/1967/05/30/archives/love-woods-dies-ran-the-theresa-hotelman-served-as-host-to-castro.html.

61. Landmarks Preservation Commission, "Hotel Theresa (now Theresa Towers)."

62. Charlayne Hunter, "Harlem's Theresa Hotel Thriving in Office Role," New York Times, October 8, 1970, https://www.nytimes.com/1970/10/08/archives/harlems-theresa-hotel-thriving-in-office-role-harlems-theresa-hotel.html.

63. Wilson, Sondra K. Wilson, Meet Me at the Theresa: The Story of Harlem's Most Famous Hotel (New York: Atria Books, 2004).

64. Ken Coleman, "Detroit's Black Bottom and Paradise Valley, What Happened?" DetroitIsIt, October 5, 2017, https://detroitisit.com/black-bottom-and-paradise-valley-communities/; "Black Bottom Neighborhood," Detroit Historical, Encyclopedia of Detroit entry, site last modified 2024, https://detroithistorical.org/learn/encyclopedia-of-detroit/black-bottom-neighborhood; Wikipedia, "Black Bottom, Detroit," last modified September 6, 2024, 07:02 (UTC), https://en.wikipedia.org/wiki/Black_Bottom,_Detroit.

65. Ibid.

66. Wikipedia, "Black Bottom, Detroit."

67. Ronald J. Stephens, "Gotham Hotel, Detroit, Michigan (1943–1963)," Black Past, March 7, 2014, https://www.blackpast.org/african-american-history/gotham-hotel-detroit-michigan-1943-1963/.

68. Dan Austin, "Gotham Hotel," Historic Detroit, site last modified 2024, https://historicdetroit.org/buildings/hotel-gotham.

69. Ibid.

70. RoNeisha Mullen and Dale Rich, "Detroit's Gotham Hotel Exuded Glamour," The Detroit News, December 31, 1999.

71. Ronald J. Stephens, "Gotham Hotel, Detroit, Michigan (1943–1963)."

72. "The Gotham Hotel & Black Bottom Hotels," Black Bottom Digital Archive, site accessed October 19, 2024, https://digital.blackbottomarchives.com/historical-sites/gotham-hotel-black-bottom-hotels.

73. Dan Austin, "Gotham Hotel."

74. Ibid.

75. Ibid.

76. "Gotham Hotel Operation Detailed," Detroit Free Press, October 11, 1963.

77. Courtney Short and Clio admin, "Marsalis Mansion Motel Historical Marker," Clio: Your Guide to History, December 2, 2017, October 8, 2017, updated December 2, 2017, https://theclio.com/entry/47235.

78. Adriane Quinlan and NOLA, "With a River Road historical marker, Ellis Marsalis Sr. gets his due," NOLA (website) and the Times-Picayune, January 8, 2015, https://www.nola.com/news/politics/with-a-river-road-historical-marker-ellis-marsalis-sr-gets-his-due/article_88bca2d8-86f7-5d6c-b266-d8d46281c0dc.html.

79. Adriane Quinlan, "With a River Road Historical Marker, Ellis Marsalis Sr. Gets His Due," NOLA (website) and the Times-Picayune, January 8, 2015, https://www.nola.com/news/politics/with-a-river-road-historical-marker-ellis-marsalis-sr-gets-his-due/article_88bca2d8-86f7-5d6c-b266-d8d46281c0dc.html.

Chapter 6: The "Black" History of Atlantic City and Las Vegas

Black Hospitality in the World's Famous Playgrounds

1. Carson Bear, "Keeping the History of African American Tourism Alive in Atlantic City's Northside," National Trust for Historic Preservation, Stories entry, January 15, 2019, https://savingplaces.org/stories/keeping-the-history-of-african-american-tourism-alive-in-atlantic-citys-northside#.Yv5o83bMLMY.
2. "The City That Never Sleeps: World Famous Atlantic City Is Queen of Pleasure-Mad Resorts from June to October," *Ebony* (October 1952): 24–30.
3. Carson Bear, "Keeping the History of African American Tourism Alive in Atlantic City's Northside."
4. Ibid.
5. James Goodrich, "Negroes Can't Win in Las Vegas," *Ebony* (March 1954): 44–53.
6. Ibid.
7. Franklin H. Williams, "Sunshine and Jim Crow," *The Crisis* 61 (April 1954): 205–206.
8. Ibid.
9. Solomon Neb, "Hidden History: Moulin Rouge's history short but very significant," 8 NewsNow, February 20, 2017, https://www.8newsnow.com/news/hidden-history-moulin-rouges-history-short-but-very-significant/.
10. Solomon Neb, "Hidden History: Moulin Rouge's history short but very significant."
11. Wikipedia, "Sara Spencer Washington," last modified August 29, 2024, https://en.wikipedia.org/wiki/Sara_Spencer_Washington.
12. Ibid.
13. "Sarah Spencer Washington," The Atlantic City Experience, site last modified 2024, https://www.atlanticcityexperience.org/sarah-spencer-washington.html.
14. Hettie V. Williams, "Sara Spencer Washington's Boardwalk Empire," Medium (blog), February 24, 2020, https://hettie-williams.medium.com/sara-spencer-washingtons-boardwalk-empire-51000437ee62.
15. Wikipedia, "Sara Spencer Washington."
16. Lianna Albrizio, "Beauty Entrepreneur Sara Spencer Washington To Be Inducted into New Jersey Hall of Fame," happi, August 24, 2021, https://www.happi.com/exclusives/beauty-entrepreneur-sara-spencer-washington-to-be-inducted-into-new-jersey-hall-of-fame/#:~:text=Glossary,Beauty%20Entrepreneur%20Sara%20Spencer%20Washington%20To%20Be%20Inducted%20into%20New,cosmetics%2C%20salons%20and%20publishing%20houses.
17. Ibid.
18. Ibid.
19. Ibid.

Democracy Hits Las Vegas

1. "The Interracial Moulin Rouge: A Gambling Paradise," *Our World* (August 1955): 24–31.
2. Ibid.
3. Wikipedia, "Moulin Rouge Hotel," last modified August 15, 2024, 08:25 (UTC), https://en.wikipedia.org/wiki/Moulin_Rouge_Hotel.
4. Tubbs, Vincent. "Why the Moulin Rouge Went Broke." *Jet* (October 27, 1955): 18–23.
5. Wikipedia, "Moulin Rouge Hotel."
6. Katie Olszeski, "Moulin Rouge Hotel (1955)," Clio, last updated by Clio Admin on January 20, 2018 https://theclio.com/entry/13039.
7. Wikipedia, "Moulin Rouge Hotel."
8. Christopher Johnson, "Hattie Canty (1934–)," Black Past, https://www.blackpast.org/african-american-history/canty-hattie-1934/; Wikipedia, "Hattie Canty," last modified June 13, 2024, 21:24 (UTC), https://en.wikipedia.org/wiki/Hattie_Canty.
9. Ibid.

80. Adriane Quinlan, "With a River Road Historical Marker, Ellis Marsalis Sr. Gets His Due."
81. Ibid.
82. Ibid.

Chapter 7: Hospitality during the Civil Rights Era

Jim Crow along the Highways

1. "Hotels on the Highway," *Ebony* 10 (June 1955): 93–96.
2. Ibid.
3. Ibid.
4. Ibid.
5. Jessica Balisle, "Alberta's Hotel: Providing Safety, Comfort to Springfield's Black Travelers," KSMU Ozarks Public Radio (website), December 16, 2021, https://www.ksmu.org/show/sense-of-community/2021-12-16/albertas-hotel-providing-safety comfort-to-springfields-black-travelers
6. Williams, Franklin H. "Sunshine and Jim Crow." *The Crisis* 61 (April 1954): 1
7. Ibid.
8. S.K. Nicholls, "Paschal's Motor Hotel and Restaurant: Historic Landmark, Atlanta GA," SKNicholls (blog), August 22, 2013, https://sknicholls.wordpress.com/2013/08/22/paschals-motor-hotel-and-restaurant-historic-landmark-atlanta-ga/
9. Christine Cooper-Rompato, "Utah in the Green Book: Segregation and the Hospitality Industry in the Beehive State," *issuu* 88, no. 1 (2020), https://issuu.com/utah10/docs/utah_historical_quarterly_volume88_2020_number1/s/11140180.
10. Katharine Allen, "Searching for Motel Simbeth," Historic Columbia (blog), Modjeska Monteith Simkins History, February 22, 2019, https://www.historiccolumbia.org/blog/searching-motel-simbeth
11. Krista Johnson, "Montgomery's Ben Moore Hotel has a Complicated Past, Uncertain Future." *Montgomery Advertiser*, January 10, 2019, Updated March 20, 2020, https://www.montgomeryadvertiser.com/story/news/2019/01/10/ben-moore-hotel-centennial-hill-ralph-abernathy-edward-davis-sr-edward-davis-jr-hatchet-man/2483233002/.
12. Delaitre J. Hollinger, "They Made a Difference—Part 1: Dorothy Nash Tookes," Florida Civil Rights Museum (website), accessed February 7, 2025, site last updated 2025, https://floridacivilrightsmuseum.org/exhibition/they-made-a-difference-part-1/dorothy-nash-tookes/; Jacob Murphey, "Tally Back Then: Checking in to Frenchtown's Tookes Hotel," WCTV, August 29, 2024, https://www.wctv.tv/2024/08/29/tally-back-then-checking-frenchtowns-tookes-hotel/; Gerald Ensley, "Effort Begins to Restore Tookes Hotel to Prominence," *Tallahassee Democrat*, June 9, 2015, https://www.tallahassee.com/story/news/local/2015/06/09/effort-begins-restore-tookes-hotel-prominence/28734865/; Benjamin Taubman, "Frenchtown History: Tookes Hotel to Welcome Guests for First Time in 40 Years as Airbnb," *Tallahassee Democrat*, April 26, 2024, https://www.tallahassee.com/story/news/local/2024/04/26/tookes-hotel-to-welcome-guests-for-first-time-in-40-years-as-airbnb/73346311007/.
13. "Gaston, Arthur George," The Martin Luther King, Jr. Research and Education Institute, Standford University, accessed October 20, 2024, https://kinginstitute.stanford.edu/gaston-arthur-george.
14. Wikipedia, "A. G. Gaston," last modified June 11, 2024, 22:26 (UTC), https://en.wikipedia.org/wiki/A._G._Gaston.
15. "A. G. Gaston: The Black Business Titan Advancing African-American Entrepreneurship in Alabama," Black History Heroes, site last modified 2023, https://www.blackhistoryheroes.com/2020/02/.
16. Ibid.
17. Ibid.
18. Gary Hoover, "Arthur G. Gaston: Entrepreneur Against All Odds," American Business History, March 8, 2019, https://americanbusinesshistory.org/arthur-g-gaston-entrepreneur-against-all-odds/.; "A. G. Gaston: The Black Business Titan Advancing African-American Entrepreneurship in Alabama."
19. Ibid.
20. Ibid.
21. Ibid.
22. Gary Hoover, "Arthur G. Gaston: Entrepreneur Against All Odds."
23. "The A.G. Gaston Motel and the Birmingham Civil Rights National Monument," National Park Service, last updated January 6, 2021, https://www.nps.gov/articles/ag-gaston-motel-birmingham-civil-rights-monument.htm.
24. Pat Byington, "Haven to headquarters, the newly restored A.G. Gaston Motel sign," Bham Now, last updated March 11, 2021, https://bhamnow.com/2021/03/11/haven-to-headquarters-the-newly-restored-a-g-gaston-motel-sign/.
25. "The A.G. Gaston Motel and the Birmingham Civil Rights National Monument"; Dwayne Mack, "A. G. Gaston (1892–1996," Black Past, June 21, 2009, https://www.blackpast.org/african-american-history/gaston-g-1892-1996/.
26. "The A.G. Gaston Motel and the Birmingham Civil Rights National Monument."
27. "A. G. Gaston: The Black Business Titan Advancing African-American Entrepreneurship in Alabama."
28. Gary Hoover, "Arthur G. Gaston: Entrepreneur Against All Odds."

29. Ibid.
30. Wikipedia, "A. G. Gaston."
31. Pat Byington, "Haven to headquarters, the newly restored A.G. Gaston Motel sign."
32. National Trust for Historic Preservation, "A. G. Gaston Motel," Saving Places, site last modified 2024, https://savingplaces.org/places/a-g-gaston-motel#.YQM5l45Kg2w.
33. Andrew Jackson Hotel sit-in;
34. NPR Staff, "Remembering A Civil Rights Swim-In: 'It Was A Milestone,'" NPR, June 13, 2014, https://www.npr.org/2014/06/13/321380585/remembering-a-civil-rights-swim-in-it-was-a-milestone.
35. Carl Nolte, "S.F. Palace Hotel sit-in helped start revolution 50 years ago," *San Francisco Gate*, March 1, 2014, https://www.sfgate.com/bayarea/article/s-f-palace-hotel-sit-in-helped-start-revolution-5279160.php.
36. Jonathan Still, "National Civil Rights Museum and the Lorraine Motel," Clio: Your Guide to History," September 26, 2021, https://theclio.com/entry/1840; Allyson Hobbs, "The Lorraine Motel and Martin Luther King," *New Yorker*, January 18, 2016, http://www.newyorker.com/news/news-desk/the-lorraine-motel-and-martin-luther-king.
37. Allyson Hobbs, "The Lorraine Motel and Martin Luther King."
38. Preston Lauterbach, "The Crucible: The National Civil Rights Museum: How the former Lorraine Motel was transformed from scarred to sacred ground," *Memphis Magazine*, January 20, 2020, https://memphismagazine.com/features/the-crucible-NCRM/.

39. Wikipedia, "National Civil Rights Museum," last modified September 24, 2024, https://en.wikipedia.org/wiki/National_Civil_Rights_Museum.
40. Wikipedia, "National Civil Rights Museum."
41. Jonathan Still, "National Civil Rights Museum and the Lorraine Motel," Clio: Your Guide to History."
42. Wikipedia, "National Civil Rights Museum."
43. James Porter, "Before the Civil Rights Act, Herman Roberts's club defined black nightlife on the south side," *Chicago Reader*, December 3, 2014, https://chicagoreader.com/music/before-the-civil-rights-act-herman-robertss-club-defined-black-nightlife-on-the-south-side/.
44. Ibid.
45. Chinta Strausberg, "Legendary hotel magnate Herman Roberts provided first class entertainment, housing," February 6, 2021, https://chicagocrusader.com/legendary-hotel-magnate-herman-roberts-provided-first-class-entertainment-housing/.
46. James Porter, "Before the Civil Rights Act, Herman Roberts's club defined black nightlife on the south side"; Chinta Strausberg, "Legendary hotel magnate Herman Roberts provided first class entertainment, housing."
47. Maureen O'Donnell, "Herman Roberts, who brought stars to Chicago (and also could work a ranch), dead at 97," *Chicago Sun Times*, https://chicago.suntimes.com/2021/3/12/22319622/herman-roberts-show-club-obituary.

Chapter 8: Beginning of a New Era

Gone but Not Forgotten

1. "Green Book Historic Context and AACRN Listing Guidance (African American Civil Rights Network)," Introduction, National Park Service, last updated January 31, 2024, https://www.nps.gov/articles/000/green-book-historic-context-and-aacrn-listing-guidance-african-american-civil-rights-network.htm.
2. WA Contents, "$3.1 million grant program will preserve historic modern architecture designed by Black architects," World Architecture, September 22, 2022, https://worldarchitecture.org/architecture-news/enehm/-3-1-million-grant-program-will-preserve-historic-modern-architecture-designed-by-black-architects.html.
3. "KFW Features Maggie Steed for Women's History Month," KFW, August 3, 2018, https://www.kfw.org/feminist-blog/kfw-features-maggie-steed-womens-history-month/; Constance Alexander, "Main Street: Maggie Steed/Betty Dobson: Women of substance," *Murray Ledger & Times*, March 23, 2020, https://www.murrayledger.com/opinion/columns/main_street/main-street-maggie-steed-betty-dobson-women-of-substance/article_a2be8020-6ca5-11ea-8863-0b77eeece874.html.
4. "Green Book Properties Listed in the National Register of Historic Places," National Park Service, last updated May 5, 2022, https://www.nps.gov/articles/green-book-properties-listed-in-the-national-register-of-historic-places.htm.

Stewards of the Legacy

1. Matt Pressberg, "How Don Peebles Became One of the Wealthiest African-American Real Estate Developers," *CSQ*, June 24, 2020, https://csq.com/2020/06/how-don-peebles-became-one-of-the-wealthiest-african-american-real-estate-developers-in-the-united-states/#.Y9RXrXbMLMY; William Booth, "Miami Agreement Ends a Costly Black Boycott," *The Washington Post*, May 12, 1993, https://www.washingtonpost.com/archive/politics/1993/05/13/miami-agreement-ends-a-costly-black-boycott/6dbd776e-5cf3-4654-b9b4-a8466eece53a/.

2. Matt Pressberg, "How Don Peebles Became One of the Wealthiest African-American Real Estate Developers."

3. "Florida developer planning $2.5 billion hotel-condo project," *Las Vegas Review-Journal*, June 9, 2007, https://www.reviewjournal.com/business/florida-developer-planning-2-5-billion-hotel-condo-project/.

4. "The Royal Palm Hotel: Miami Beach, FL," The Peebles Corporation, site last updated 2024, https://peeblescorp.com/project/the-royal-palm-hotel.

5. Tamara E. Holmes, "Miami's Royal Palm Sells For $127.5M," *Black Enterprise*, February 1, 2005, https://www.blackenterprise.com/miamis-royal-palm-sells-for-1275m/; "Royal Palm Crowne Plaza Resort," Soul of America & A World of Black Travel, accessed October 25, 2024, https://www.soulofamerica.com/us-cities/miami/royal-palm-crowne-plaza-resort/.

6. "Our Vision and History", NABHOOD, accessed October 25, 2024, https://nabhood.net/new-page-59; Breanna Robinson and Jenn Barthole, "10 Black-Owned U.S. Hotels and Resorts to Visit Right Now," Ebony, August 3, 2022, https://www.ebony.com/black-owned-hotels-and-resorts-to-visit/.

7. Donnell Suggs, "'Some people don't believe it's possible': Davonne Reaves wants to diversify hotel ownership," *Atlanta Business Chronicle*, April 12, 2022, https://www.bizjournals.com/atlanta/news/2022/04/12/black-hotel-ownership-atlanta-hospitality.html.

8. "Thomas A. Moorehead: Biography,"The History Makers, site last updated 2025, https://www.thehistorymakers.org/biography/thomas-moorehead.

9. Alex Tremblador, "What It's Like to Be a Black Female Hotel Owner," Travel Pulse by Northstar, February 24, 2020, https://www.travelpulse.com/news/hotels-and-resorts/what-its-like-to-be-a-black-female-hotel-owner.

10. "About the Historic Dunns Josephine Hotel," site last modified 2023, accessed October 25, 2024, https://www.dunns-josephinehotel.com/about-us/.

11. "Salamander Middleburg Receives Three Coveted Five-Star Awards from Forbes Travel Guide," Salamander Hotels (website), news release, February 7, 2024, https://www.salamanderhotels.com/press/news-releases/release-23.

12. Meena Thiruvengadam, "Pharrell Just Opened a Gorgeous New Hotel in Miami — and It Was Made to Be a Good Time," *Travel + Leisure*, April 23, 2021, https://www.travelandleisure.com/hotels-resorts/hotel-openings/pharrell-just-opened-goodtime-hotel-miami.

13. Nick Remsen, "Pharrell Williams and David Grutman to open new resort in the Bahamas," CNN, January 19, 2022, https://www.cnn.com/style/article/pharrell-williams-bahamas-resort-somewhere-else/index.html.

14. Savannah M. Taylor, "Multitalented Actor Hill Harper Inspires Us to Grow Our Wealth," *Ebony*, January 28, 2022, https://www.ebony.com/hill-harper-inspires-black-wealth/.

15. Wikipedia, "RLJ Holdings," last updated January 23, 2024, 05:03 (UTC), https://en.wikipedia.org/wiki/RLJ_Companies.

16. "Marriott Executive to Stake Out His Own Place in Hotel World," Capstone Development, from *The Washington Post*, December 1, 2008, site last modified 2024, https://www.capstonedevco.com/news/2015/4/28/marriott-executive-to-stake-out-his-own-place-in-hotel-world#:~:text=After%2016%20years%20at%20Marriott,time%20of%20high%20economic%20turbulence.

Financing Challenges for Black Entrepreneurs

1. Annette Richmond, "Deidre Mathis: Woman Making History," Brave World Media, March 23, 2021, https://braveworld.media/deidre-mathis-woman-making-history/.

2. Kyley Warren, "The Jenesis House: Arizona's First Female, Black-Owned Resort Brings a New Kind of Wellness to the Desert," fabAZ, January 3, 2022, https://fabulousarizona.com/arizona-best/the-jenesis-house/; Will Speros, "Black Hospitality Leaders on Building a More Diverse Industry," Hospitality Design, May 10, 2022, https://hospitalitydesign.com/people/interviews/black-hospitality-leaders-building-a-diverse-industry/.

3. Kyley Warren, "The Jenesis House: Arizona's First Female, Black-Owned Resort Brings a New Kind of Wellness to the Desert."

4. Stephanie Chen and Stacy Shoemaker Rauen, "The Brittano Group Founders Have You Covered," April 17,

2024, https://hospitalitydesign.com/people/interviews/julian-karie-brittano-rook-hotels/; "Choice Hotels' Emerging Markets Team Awards Agreement to Develop an Ascend Hotel Collection Property," Choice Hotels, 2023, https://media.choicehotels.com/2023-01-11-Choice-Hotels-Emerging-Markets-Team-Awards-Agreement-to-Develop-an-Ascend-Hotel-Collection-Property.

5. Wyndham Hotel & Resorts, "Wyndham Hotels & Resorts Debuts 'BOLD by Wyndham' Expanding Support of Black Entrepreneurs," PR Newswire, July 13, 2022, https://www.prnewswire.com/news-releases/wyndham-hotels--resorts-debuts-bold-by-wyndham-expanding-support-of-black-entrepreneurs-301585272.html; Kodisha Bivins, Contact, "The Mall at Stonecrest's New Anchor, Priví, Completes Phase II and Acquires $8.3 Million For A Food Hall and Tourism Attraction Addition," Business Wire, May 10, 2023, https://www.businesswire.com/news/home/20230510005716/en/The-Mall-at-Stonecrests-New-Anchor-Priv-Completes-Phase-II-and-Acquires-%248.3-Million-For-A-Food-Hall-and-Tourism-Attraction-Addition.

6. Charles McNair, "When It Comes to Building a Hotel Empire, Davonne Reaves Has No Reservations," Georgia State University, site last modified 2024, https://news.gsu.edu/magazine/when-it-comes-to-building-a-hotel-empire-davonne-reaves-has-no-reservations.

7. Mitti Hicks, "Meet The Black Woman Helping People Invest In Hotels And Commercial Real Estate," Travel Noire, October 21, 2024, https://travelnoire.com/davonne-reaves-helping-black-hotel-real-estate-investors.

8. Patrice Worthy, "A Black-run investment firm bets on Black travel: 'We wanted to add a layer of intentionality,'" The Guardian, January 3, 2023, https://www.theguardian.com/business/2023/jan/03/bay-street-capital-william-huston-black-investment-firm-travel-hospitality.

9. Ibid.

10. Hospitable Bridge, home page, site last updated 2023, https://www.hospitablebridge.com/.

11. Christine Killion, "'There Is Still Hope': Checking In With U.S. Diversity Group CEO Velma Trayham," Lodging Magazine, September 29, 2020, https://lodgingmagazine.com/there-is-still-hope-checking-in-with-u-s-diversity-group-ceo-velma-trayham/.

12. S. Lovey Parker, "Meet S. Lovey Parker," interview by Canvas Rebel staff, Canvas Rebel (website), October 10, 2024, https://canvasrebel.com/meet-s-lovey-parker/.

13. Christine Killion, "2021 Person of the Year: Tracy Prigmore on Creating Pathways to Raise More Women and People of Color into the Ranks of Hotel Ownership," Lodging Magazine, December 29, 2021, https://lodgingmagazine.com/2021-person-of-the-year-tracy-prigmore-on-creating-pathways-to-raise-more-women-and-people-of-color-into-the-ranks-of-hotel-ownership/.

14. Sarah Buder, "New Study Reveals the Spending Power of Black U.S. Travelers," AFAR, December 18, 2020, https://www.afar.com/magazine/new-study-reveals-the-spending-power-of-black-us-leisure-travelers.

A Way Forward

1. Maria C. Hunt, "Experience the Historic Magnolia House Once Again," National Trust for Historic Preservation, site last modified 2024, https://savingplaces.org/stories/historic-magnolia-house.

2. Ibid.

3. Cassandra Lane, "A New Hotel on Venice Beach: The Redline Venice Confronts Racism, Offers Luxury," May 24, 2024, L.A. Parent, https://www.laparent.com/new-black-owned-the-redline-venice-hotel-confronts-redlining-offers-luxury/.

4. Analisa Novak, Joey Annunziato, and Elisha Brown, "Nate Burleson and his wife explore her ancestral ties to Tulsa Massacre," CBS Mornings, February 26, 2024, https://www.cbsnews.com/news/nate-and-atoya-burleson-explore-their-ancestral-ties-to-tulsa-massacre/.

OTHER ONLINE RESOURCES

"1948: Shelley v. Kramer," The Fair Housing Center of Greater Boston, Timeline entry, accessed October 27, 2024, http://www.bostonfairhousing.org/timeline/1948-Shelley-v-Kramer.html.

"A Travel Bureau Hits the Jackpot: Philadelphian Operates The Largest Negro-Owned Travel Agency," *Color* 11 (May 1956): 8.

"Family to sell Bruce's Beach property back to L.A. County for nearly $20 million," *L.A. Times*, January 3, 2023, https://www.latimes.com/california/story/2023-01-03/bruce-family-beach-la-county.

"Finest Negro Hotel, Detroit's Carlton Plaza Sets New Standards for Hostelries," *Ebony* 5 (June 1950): 81–82.

"George T. Downing, 1819–1903: Entrepreneur, caterer, civil rights activist," Encyclopedia, *n.d.*, https://www.encyclopedia.com/african-american-focus/news-wires-white-papers-and-books/downing-george-t.

"Highland Beach, MD," Soul of American & A World of Black Travel, accessed October 27, https://www.soulofamerica.com/black-towns/highland-beach-md/#:~:text=The%20beach%20resort%20town%20of,served%20in%20the%20Civil%20War.

"Historic California Hotel Provides Affordable Housing in Oakland, California," Edge PD&R, October 23, 2017, https://www.huduser.gov/portal/pdredge/pdr-edge-inpractice-102317.html.

"History of Portland's African American Community (1805 to the Present)," City of Portland Bureau of Planning, https://efiles.portlandoregon.gov/Record/8169262/.

"Hotel Pact Ends Coast Protests; Racial Accord Is Reached on Hiring in San Francisco." *New York Times,* March 8, 1964, https://www.nytimes.com/1964/03/08/archives/hotel-pact-ends-coast-protests-racial-accord-is-reached-on-hiring.html.

"Jackson Ward: Glory Days of 'Harlem of the South,'" VOA News, October 26, 2009, https://www.voanews.com/a/a-13-a-2002-02-06-2-jackson-66275947/540139.html.

"John Sommerville, Los Angeles Businessman born," African American Registry; People, Locations, Episodes entry, site last updated 2024, https://aaregistry.org/story/a-los-angeles-institution-john-sommerville/.

"Joseph Lee and His Bread Machines," *The Colored American Magazine* V, no. 1 (May 1902): 10, Retrieved October 18, 2022, https://babel.hathitrust.org/cgi/pt?id=hvd.32044005009899&view=1up&seq=26.

"Joseph Lee—Hotelier, Restaurateur & Inventor of Bread Processing Machines," Black Entrepreneur History, February 11, 2021, https://blackentrepreneurhistory.com/black-history/joseph-lee-hotelier-restaurateur-inventor-of-bread-processing-machines.

"Lady Demos Taste Vegas Hotel Bias," *Pittsburgh Courier*, October 22, 1955.

"Marriott's Diversity Initiatives Add Five African American and Hispanic Owned Hotels Since May 2005," Hotel Online, https://www.hotel-online.com/News/PR2005_3rd/Aug05_MarriottDiversity.html.

"Mary Elizabeth Hotel and the Booker Terrace Motel. AT&T Miami-Dade County African American History Calendar, 2004/2005," The Black Archives History and Research Foundation of South Florida, Inc., Finding Aids entry, accessed October 27, 2024, https://www.theblackarchives.org/archon/?p=digitallibrary/digitalcontent&id=188.

"Models On a Tour, N.Y. Models Show a Pretty Leg as Miami Gets a Swank Hotel," *Our World* 6 (November 1951): 27–30.

"Nation's Finest Negro-Owned Hotel," *Sepia* 6 (April 1958): 28–33.

"Ohio Puts Ad Ban on Jim Crow Hotels," *Afro-American* (June 1955): 5.

"Paradise Park: Florida Amusement Park is Newest Negro Resort in South." *Ebony* (March 1953): 59–62.

"Paradise Valley Is Steeped in Detroit's History," Click On Detroit (Local 4), June 17, 2022, https://www.clickondetroit.com/live-in-the-d/2022/06/17/paradise-valley-is-steeped-in-detroits-history/.

"Paradise Valley," Soul of American & A World of Black Travel, accessed October 27, 2024, https://www.soulofamerica.com/us-cities/detroit/paradise-valley/.

"Rossonian Hotel," National Park Service, last updated August 10, 2021, https://www.nps.gov/places/rossonian-hotel.htm.

"The African American Business District that Became 'Jackson Square,'" Historic Harrisburg Association for the City of Harrisburg, accessed October 27, 2024, https://historicharrisburg.org/wp-content/uploads/2020/09/TheAfricanAmericanBusDistrictHR.pdf.

"The African American Mosaic: Nicodemus, Kansas," Library of Congress, accessed October 27, 2024, https://www.loc.gov/exhibits/african/afam010.html.

"The Henry Colored Hotel—Still Rocking!" Chesapeake Ghosts (blog), May 12, 2015, https://chesapeakeghosts.com/henry-colored-hotel/.

"The Henry Hotel," The Historical Marker Database, site last modified 2024, https://www.hmdb.org/m.asp?m=137718.

"The Sit-Ins of 1960: Excerpted from "History & Timeline," Civil Rights Movement Archive, accessed October 27, 2024, https://www.crmvet.org/info/sitins.pdf.

"The Whitelaw Hotel aka 'The Embassy,'" izi.Travel, accessed October 27, 2024, https://izi.travel/en/b6e7-the-whitelaw-hotel-aka-the-embassy/en.

"Zula Swanson: Savvy Businesswoman," Anchorage Museum, September 11, 2020.

African American Citywide Historic Context Statement (Prepared for the City and County of San Francisco by Tim Kelley Consulting, The Alfred Williams Consultancy, VerPlanck Historic Preservation Consulting), San Francisco Planning Department, January 2016, https://sfplanning.org/african-american-historic-context-statement.

Alex Veiga, "First Major Black-Owned Hotel in Miami Beach is Opening," *The Ledger*, May 15, 2002, updated June 16, 2009, https://www.theledger.com/story/news/2002/05/15/first-major-black-owned-hotel-in-miami-beach-is-opening/26528650007/.

Alex Wemm and Mortimer R, "The Hotel Metropolitan Museum." Clio: Your Guide to History, January 27, 2019, Accessed April 13, 2022, https://theclio.com/entry/281.

Alice A. Dunnigan, "A Live Wire on the Boulevard," *Service* 16 (September 1951): 11–12.

Alison Rose Jefferson, "The Inkwell, Martha's Vineyard (1890s–)," February 7, 2013. *BlackPast.org*.

Allison Espiritu, "James Wormley (1819–1884)," Black Past, February 25, 2007, https://www.blackpast.org/african-american-history/wormley-james-1819-1884/.

Amy S. Rosenberg, "A Black Woman Conquered Atlantic City through Hair in the 1920s. A New Film Tells Her Story," *The Philadelphia Inquirer*, February 9, 2017, https://www.inquirer.com/philly/news/new_jersey/The-woman-in-fur-who-integrated-Capt-Starns-created-a-black-womans-hair-care-company-became-one-of-Atlantic-Citys-original-millionaires.html.

Andrea Gibbons, "Annie Box and William Curly Neal: Race in Early Arizona," January 2, 2017, https://www.writingcities.com/2017/01/02/annie-box-and-william-curly-neal-race-in-early-arizona/.

Andy Ingraham, "Together, We Rise," Today's Hotelier, February 2022, https://www.todayshotelier-digital.com/aahom/0222_february_2022/MobilePagedArticle.action?articleId=1761234&app=false&cmsId=3987477#articleId1761234.

Ann Toplovich, "Beale Street, Hotel Clark, and The Green-Book," The Tennessee Historical Society, April 9, 2019, https://tennesseehistory.org/beale-street-hotel-clark-green-book/.

Anne-Lyse Wealth, "Less Than 1% of Hotel Owners Are Black Women. This 34-Year-Old Is Changing the Game," June 2, 2021, https://time.com/nextadvisor/investing/davonne-reaves-investing-tips/.

Annys Shin, "Highland Beach: A Historic Refuge from Racism Finds Itself at a Crossroads," *The Washington*

Post, August 25, 2012, https://www.washingtonpost .com/local/highland-beach-a-historic-refuge-from-racism-finds-itself-at-a-crossroads/2012/08/25/ 52a7ad1e-ed55-11e1-a80b-9f898562d010_story. html.

Arthur Bunyan Caldwell, *History of the American Negro and His Institutions* (Legare Street Press, 2023).

B. Bradley, "Jet Age Booms West Coast Travel Agency," *Sepia* (June 1960): 52–55. California State University, East Bay. "CSUEB Lecture on America's First Black Millionaire," https://www.csueastbay.edu/news/blog /2011/05/william-alexander-leidesdorff-americas-first-black-millionaire.html.

Baltimore Sun, August 10, 2010, https://www.baltimoresun .com/sports/bs-xpm-2010-08-07-bs-sp-joegans-anniversary-0808-20100808-story.html.

Bashir, Imani Bashir, "This Is the Future of Black Travel, According to Industry Leaders," *Travel + Leisure*, February 6, 2023, https://www.travelandleisure. com/the-future-of-black-travel-7106405.

BOTWC Staff, "Meet the Couple Behind the New Black-Owned Quality Inn in Memphis, Tennessee," January 4, 2023, https://www.becauseofthemwecan.com/ blogs/news/meet-the-couple-who-just-purchased-a-quality-inn-in-memphis-tennessee.

Brianne Garrett, "How This Unsung Black Entrepreneur Changed The Food Industry Forever—And Made A Lot Of Dough," *Forbes*, March 9, 2021, https://www. forbes.com/sites/briannegarrett/2021/03/09/how-this-unsung-black-entrepreneur-changed-the-food-industry-forever-and-made-a-lot-of-dough/?sh= 571c578b7c92.

Bryan Bowman and Kathy Roberts Forde, "How Slave Labor Built the State of Florida Decades After the Civil War," *The Washington Post*, May 17, 2018, https: //www.washingtonpost.com/news/made-by-history /wp/2018/05/17/how-slave-labor-built-the-state-of-florida-decades-after-the-civil-war/.

Charity Irby and Clio Admin, "William Alexander Leidesdorff Statue," *Clio: Your Guide to History*, December 10, 2017, accessed August 2, 2021, https: //theclio.com/entry/52477.

Chas. S. Thompson, "The Growth of Colored Miami," *The Crisis* 49 (March 1942): 83–84.

Christina Ledford et al., "American Women in History Tour: San Diego, CA," Story Maps, November 20, 2020, https://storymaps.arcgis.com/stories/ 564e59637d9e4d38952a4c37dde1acd2.

Christine Cooper-Rompato, "Utah in the Green Book: Segregation and the Hospitality in the Beehive State," *Utah Historical Quarterly* 88, no. 1 (2020), https:// issuu.com/utah10/docs/utah_historical_quarterly_ volume88_2020_number1/s/11140180.

Christopher Gray, "Fidel Castro Slept Here," *New York Times*, April 30, 2009, https://www.nytimes.com/ 2009/05/03/realestate/03scapes.html.

Clement Richardson, "The National Cyclopedia of the Colored Race (Vol. 1, 1919)," Library of Congress, accessed October 27, 2024, https://tile.loc.gov/storage-services/public/gdcmassbookdig/nationalcycloped 00unse/nationalcycloped00unse.pdf.

Clifford J. Newsome, "General History of the Atlantic City Board of Trade, Inc," *The Negro History Bulletin* 16 (November 1952): 27–30.

Conor McCormick-Cavanagh, "Watch What Develops: Rossonian Owner Submits Plan to Renovate, Add to Historic Hotel," *Westword*, December 2, 2022, https: //www.westword.com/news/rossonian-developers-submit-plan-for-88-room-hotel-15598479.

DavGreg, "Tennessee: The Lorraine Motel," National Park Service, accessed October 27, 2024, https:// www.nps.gov/places/tennessee-the-lorraine-hotel-memphis.htm.

David Christopher Kaufman, "The Black-owned Hotels for Your Next Trip: From Ski Lodges to Luxury Resorts," *The Guardian*, December 8, 2022, https:// amp-theguardian-com.cdn.ampproject.org/c/s/amp. theguardian.com/business/2022/dec/08/us-travel-industry-racial-equity-problem-black-hotels.

David J. Trowbridge, "Hotel Clark," Clio: Your Guide to History, August 24, 2014, accessed July 16, 2021, https://theclio.com/entry/6551.

Don Duncan, "Don Duncan's Driftwood Dairy," *Seattle Times*, September 31, 1967, 105.

Don Markus, "A Century After His Death, Boxer Joe Gans Finally Getting His Due," *The Baltimore Sun,* October 1, 2021, https://www.baltimoresun.com/ 2010/08/07/a-century-after-his-death-boxer-joe-gans-finally-getting-his-due/.

Donet D. Graves, "Wormley Hotel," January 22, 2016, The White House Historical Association, https:// www.whitehousehistory.org/wormley-hotel-1.

Douglass Hall, "Charlotte, N.C. Boasts Modern Hotel," *Afro-American,* April 24, 1948.

Earl Ofari Hutchinson, *A Colored Man's Journey Through 20th Century Segregated America* (Middle Passage, 2000).

Ellen Meyer, "The Origins and Growth of Franchising in the Hotel Industry," *Lodging Magazine*, April 10, 2018, https://lodgingmagazine.com/the-origins-and-growth-of-franchising-in-the-hotel-industry/.

Ellis Rebecca, "Family to sell Bruce's Beach property back to L.A. County for nearly $20 million," *Los Angeles Times*, January 3, 2023, https://www.latimes.com/california/story/2023-01-03/bruce-family-beach-la-county.

Elwood Watson, "Robert Reed Church, Sr. (1839–1912)," Black Past, November 19, 2007, https://www.blackpast.org/african-american-history/robert-reed-church-sr-1839-1912/.

Falene Nurse, "Black Entrepreneurs Built Beach Havens in California. Racism Shut Them Down," *High Country News*, October 13, 2021, https://www.hcn.org/articles/south-race-and-racism-black-entrepreneurs-built-beach-havens-in-california-racism-shut-them-down.

Garrett O'Brien, "The Hotel Olga: The Forgotten Home of the Harlem Renaissance," *Saturday Evening Post*, February 8, 2021, https://www.saturdayeveningpost.com/2021/02/the-hotel-olga-the-forgotten-home-of-the-harlem-renaissance/.

George Petras and Janet Loehrke, "A Look Inside the Green Book, Which Guided Black Travelers Through a Segregated and Hostile America," *USA Today*, February 21, 2021, https://amp.usatoday.com/amp/4357851001.

George W. Collins, "1000 Riders to Hit Route 40," *Afro-American* (December 1961): 1–2.

Gillian B. White, "Revisiting a Jim Crow-Era Guide for Traveling While Black," *The Atlantic*, January 18, 2016, https://www.theatlantic.com/business/archive/2016/01/jim-crow-green-book-mlk/424467/.

Hannah Giorgis, "The Documentary Highlighting the Real Green Book," *The Atlantic*, February 23, 2019, https://www.theatlantic.com/entertainment/archive/2019/02/real-green-book-preserving-stories-of-jim-crow-era-travel/583294/.

Harold Vazquez, "Black Couple Makes History as Hotel Owners, Acquires Quality Inn in Memphis For $3.85M," *Black Enterprise*, January 2, 2023, https://biz.crast.net/black-couple-makes-history-as-hoteliers-acquires-quality-inn-in-memphis-for-3-85m/.

Historic American Buildings Survey, Creator, Isaiah T Hatton, Joe Louis, John W Lewis, and Harrison M Ethridge, Mahon, Dynecourt, photographer, *Whitelaw Apartment House, Thirteenth Street Northwest, Washington, District of Columbia, DC*, Washington D.C, 1933. translated by Hoagland, Alison K. Mitter Documentation Compiled After, Photograph, https://www.loc.gov/item/dc0299/.

Jena Tesse Fox, "Black Business Leaders Launch Hotel Investment Fund," *Hotel Management*, September 23, 2020, https://www.hotelmanagement.net/own/business-leaders-launch-new-hotel-investment-fund.

Jena Tesse Fox, "Marriott Launches Program to Support Minority Ownership," *Hotel Management*, June 6, 2022, https://www.hotelmanagement.net/own/marriott-launches-program-support-minority-ownership.

Jerry Carson, "Mini Park Dedicated to Black City Pioneer, Big Landowner." *Seattle Times*, September 25, 1983, A16.

Jill Nelson et al., "A Summer Place." *Black Enterprise* (August 1981): 57–59.

Julia Larsen, "Nicodemus, Kansas (1877–)," Black Past, April 13, 2009, https://www.blackpast.org/african-american-history/nicodemus-kansas-1877/.

Kaleena Fraga, "Los Angeles Returns $20 Million Beachfront Property to Black Family—Almost 100 Years After The County Seized It," All That's Interesting, June 30, 2022, https://allthatsinteresting.com/bruces-beach.

Karl E. Johnson Jr. and Joseph A. Romeo, "Jehu Jones (1786–1852): The First African American Lutheran Minister," *LQ* 10 (1996): 425–444, http://www.lutheranquarterly.com/uploads/7/4/0/1/7401289/jehu_jones.pdf.

Ken Boddie, "Where We Live: The Golden West Hotel's Black History," Koin, February 3, 2020, https://www.koin.com/hidden-history/where-we-live-the-golden-west-hotels-black-history/.

Kenya Davis-Hayes, "The Green Book in California: Places of Note," Calhum, Jan 8, 2019, https://calhum.org/the-green-book-in-california-places-of-note/.

Kristian Carter, "The Economic and Cultural Importance of Preserving Jackson Square," *Historic Harrisburg*, 2019, https://historicharrisburg.org/wp-content/uploads/2020/09/The-Economic-and-Cultural-Importance-of-Preserving-Jackson-Square.pdf.

Kwin Mosby, "11 Amazing Black-owned Hotels Around the World," *Travel + Leisure*, updated April 14, 2022, https://www.travelandleisure.com/hotels-resorts/black-owned-hotels.

Lacey Pfalz, "Marriott Launches New Hotel Development Program With a Focus on Diversity," Travel Pulse, June 6, 2022, https://www.travelpulse.com/news/hotels-and-resorts/marriott-launches-new-hotel-development-program-with-a-focus-on-diversity.

Lee Lewis, "3 Black Hotel CEOs You Should Know," I Am Black Business, March 9, 2017, https://iamblackbusiness.com/post/black-hotel-owners.

Lester A. Walton, "Hotel Marshall, Place of Unique Entertainment, Closes," *The New York Age*, October 9, 1913.

Masco Young, "Philadelphia: City of Opportunity for Half-Million Negroes," *Sepia* 8 (July 1960): 36–47.

Matthew X Kiernan, *Hotel Olga, Harlem*, photograph, flickr, taken September 6, 2013, https://www.flickr.com/photos/mateox/9687227263/.

Micheal Austin, "Harlem of the West: The Douglas Hotel and Creole Palace Nite Club," (master's thesis, University of San Diego, 1994).

Michelle Ancona, "Famous Faces: Jack 'Legs' Diamond," *Travel & Leisure* (blog). albany.org, January 18, 2019, https://www.albany.org/blog/post/famous-faces-jack-legs-diamond/.

Mira Cassidy, "A Collective of Black Women Investors Became Hotel Owners and Inspire Others to Think Big," *Cuisine Noir*, December 7, 2021, https://www.cuisinenoirmag.com/black-women-investors-became-hotel-owners/.

Neil Gale, "The Negro Travelers' Green Book—Chicago Section, 1954," *DRLOIHJ* (blog), June 5, 2020, https://drloihjournal.blogspot.com/2020/06/negro-travelers-green-book-chicago-section-1954.html.

Nicole Schnitzler, "Meet Moniqua Lane, the Mastermind Behind The Downtown Clifton in Arizona," Thrillist, March 24, 2022, https://www.thrillist.com/travel/nation/meet-moniqua-lane-downtown-clifton-arizona.

Nikki Miller-Ka, "Black-Owned Hotels and Resorts in the Washington, D.C., Area for Your Summer Travel," Flipboard, August 9, 2022, https://flipboard.com/topic/hotel/black-owned-hotels-and-resorts-in-the-washington-d-c-area-for-your-summer-trav/a-kZ9In3DsQWqL3rAZGYrNQg%3Aa%3A3058872429-c7e025b0a8%2Fmacon.com.

Oriana Lerner, "Trailblazing the path to diverse hotel ownership," Hotel Investment Today, January 19, 2023, https://www.hotelinvestmenttoday.com/Change/DEI/Trailblazing-the-path-to-diverse-hotel-ownership#:~:text=%E2%80%9CI%20predict%20that%20within%20five,time%20owners%20scale%20their%20portfolios.%E2%80%9D&text=HIT%3A%20At%20an%20institutional%20level,hotel%20ownership%20making%20real%20change%3F.

Parker Diakite,"50 In 50: The Best Black-Owned Hotels & Resorts in The United States," Travel Noire, August 21, 2022, https://travelnoire.com/50-in-50-black-owned-hotels-resorts-united-states.

Parker Diakite, "A Guide To Black-Owned Hotels In Miami, Florida." Travel Noir, March 14, 2021, https://travelnoire.com/guide-black-owned-hotels-miami-florida.

Patty Wetli, "The Real 'Green Book' In Chicago: Vacant Lots Replace Black-Owned Businesses That Once Thrived in Bronzeville and Beyond," *Block Club Chicago*, February 20, 2019, https://blockclubchicago.org/2019/02/20/the-real-green-book-in-chicago-vacant-lots-replace-black-owned-businesses-that-once-thrived-in-bronzeville-and-beyond/#:~:text=Close-,The%20Real%20'Green%20Book'%20In%20Chicago%3A%20Vacant%20Lots%20Replace,got%20to%20kill%20the%20landmarks.%E2%80%9D.

Patty Wetli,"The Real 'Green Book': In Chicago, The Famous Directory for Black Motorists Pointed To Bronzeville," *Block Club Chicago*, February 19, 2019, https://blockclubchicago.org/2019/02/19/the-real-green-book-chicagos-locations-in-the-famous-directory-for-black-motorists-mapped/.

Problogic, "Black-owned or Operated Hotels of the Green Book Era," Panethos (blog), January 3, 2021, https://panethos.wordpress.com/2021/01/03/black-owned-or-operated-hotels-of-the-green-book-era/.

Quintard Taylor, "The Emergence of Black Communities in The Pacific Northwest: 1865–1910," *The Journal of Negro History* 64, no. 4 (1979): 342–54, https://doi.org/10.2307/2716942. Accessed 2 May 2022.

Reshma Kapadia, "How the Tulsa Massacre Robbed Black Americans of Multigenerational Wealth," May 28, 2021. *Barron's*, https://www.barrons.com/articles/tulsa-massacre-51622242095.

Rick Roddam, "The Legendary Barney Ford: The Former Enslaved Man Who Became One of Cheyanne's Wealthiest Businessmen," King FM, updated September 11, 2021. https://kingfm.com/the-legendary-story-of-barney-ford/.

Ronald J. Stephens, "Buckroe Beach, Hampton, Virginia (1890–)," Black Past, March 9, 2014, https://www.blackpast.org/african-american-history/buckroe-beach-hampton-virginia-1898/#:~:text=After%20the%20Civil%20War%2C%20Buckroe,out%2Dof%2Dtown%20guests.

Ronald J. Stephens, "Chowan Beach, Hertford County, North Carolina (1926–2004)," Black Past, March 9, 2014, https://www.blackpast.org/african-american-history/chowan-beach-hertford-county-north-carolina-1926-2004/.

Sabrina Carey, "Hotel Robinson," Studies of Black History at the University of San Diego, May 6, 2019, https://sites.sandiego.edu/blackhistoryatusd/2019/05/07/512/.

Sandra, Jackson-Opoku, "Places of Our Own," *Essence* (May 1988): 25, 28.

Shanique Yates, "Los Angeles County to Pay $413K A Year to Lease Land Over 24 Months As Bruce's Beach Returns To Its Black Owners," Afro Tech, June 30, 2022, https://afrotech.com/la-votes-to-return-bruces-beach-to-black-owners.

Sharon Tubbs, "Beyond Racial Boundaries," *Tampa Bay Times*, January 10, 2003, updated August 31, 2005. https://www.tampabay.com/archive/2003/01/10/beyond-racial-boundaries/.

Shelia M. Poole, "Making a Go of Getaways: Two Black Entrepreneurs Building North Georgia Resort," *The Atlanta Journal and Constitution*, November 27, 1992.

Silvia Ramirez, "The Hotel Robinson," Clio: Your Guide to History, December 21, 2020, accessed March 26, 2022, https://www.theclio.com/entry/122870.

Slavery and Remembrance, Rachel Pringle Polgreen, Circa 1753–1791, Slavery and Remembrance: A Guide to Sites, Museums, and Memory, in collaboration with UNESCO, site last updated 2024, http://slaveryandremembrance.org/people/person/?id=PP025.

Solomon J. Herbert II, "Black-Owned Hotels a Growing Phenomenon," BM&T (website), December 2009/January 2010 issue, https://www.blackmeetingsandtourism.com/Publications/Black-Meetings-Tourism/2010/December-2009-January-2010/Black-Owned-Hotels-a-Growing-Phenomenon.aspx.

The Baobab Tree: Journal of African American Genealogical Society of Northern California, Inc, Fall 2011.

Thomas Sugrue, "Driving While Black: The Car and Modern Race Relations in Modern America," Automobile in American Life and Society, archived, accessed October 27, 2024, http://www.autolife.umd.umich.edu/Race/R_Casestudy/R_Casestudy.htm.

Tyran Gardner-Davis, edited by Samantha de Vera, "The Fight for Black Mobility: Traveling to Mid-Century Conventions—George T. Downing," University of Delaware, Spring 2013, https://coloredconventions.org/black-mobility/delegates/george-t-downing/.

V. V. Oak, "Business Opportunities for Negroes, " *The Crisis* 45 (April 1938): 108–109, 126.

BIBLIOGRAPHY

Booker T. Washington, *The Negro in Business* (Hertel, Jenkins & Co., 1907), 62.

Bruce Kellner, *The Harlem Renaissance: A Historical Dictionary for the Era* (Westport, Connecticut: Greenwood Press, 1984), xiii.

Colleen Aycock and Mark Scott, *Joe Gans: A Biography of the First African American World Boxing Champion* (Jefferson, North Carolina: McFarland & Co., 2008), 229.

Ernest D. Kaiser, *The Kaiser Index to Black Resources, 1948–1986: From the Schomburg Center for Research in Black Culture of the New York Public Library* (Brooklyn, New York: Carlson Publishing Inc., 1992).

Esther Hall Mumford, *Seattle's Black Victorians, 1852–1901* (Seattle: Ananse Press, 1980), 43.

George E. Blankenship, *Lights and Shades of Pioneer Life on Puget Sound* (Shorey's Bookstore, 1987), 13.

Hannibal B. Johnson, *Black Wall Street: From Riot to Renaissance in Tulsa's Historic Greenwood District* (Austin: Eakin Press, 2007).

Harry A. Ploski and James Williams, *The Negro Almanac: A Reference Work on the African American*, 5th ed. (Detroit: Gale Research Inc., 1989).

James Louis Bacon, *Until I Am Dust: John Whitehall Lewis and the Story of the Industrial Savings Bank and Whitehall Hotel* (Georgia: Benil Publishing, 2020).

Patricia Ibbotson, *Detroit's Historic Hotels and Restaurants (Postcard History Series)* (Arcadia Publishing, 2007).

Rayford Whittingham Logan and Michael Winston, *Dictionary of American Negro Biography* (New York: W.W. Norton and Company, 1983).

The Negro Motorist Green Book: An International Travel Guide (New York: Victor H. Green & Co., Publishers, 1949), Texas Historical Commission, from the collections of Henry Ford, 15, https://www.thc.texas.gov/public/upload/preserve/survey/highway/Negro%20Motorist%20Green%20Book%201949.pdf.

Wendell P. Dabney, *Cincinnati's Colored Citizens: Historical, Sociological and Biographical* (Cincinnati: Dabney Publishing Company, 1926).

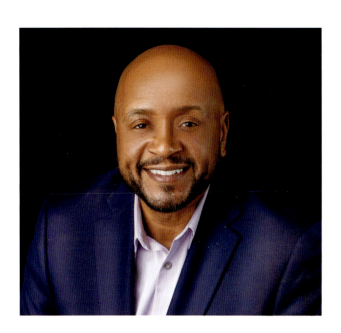

Calvin Stovall became interested in Black History early on when his mother gave him a large book featuring historically influential African Americans. While in elementary school, he was selected, along with two of his classmates, to participate in a Black History competition held at the DuSable Black History Museum on Chicago's southside. From here his passion only grew.

Calvin Stovall's career in hospitality informally began as a front desk clerk at downtown Chicago's Holiday Inn Chicago City Centre. After earning a business administration degree from Chicago State University, he would graduate with a master of professional studies from the Cornell University School of Hotel Administration. Since then, Calvin has enjoyed a nearly thirty-year career in the hospitality industry, during which he served as vice president of brand marketing with Hilton Worldwide. He has also worked in the nonprofit sector as a brand marketing strategist with ALSAC, the brand awareness and fundraising arm for St. Jude Children's Research Hospital, as well as CEO of the Soulsville Foundation, a nonprofit based in Memphis, Tennessee. In addition to currently running his own business called ICONIC Presentations, LLC, which delivers high-energy keynotes and workshops for organizations nationwide, he also serves as the Director of Executive Programs for The Advanced Leadership Institute based in Pittsburgh, Pennsylvania.

During his tenure at Cornell University, Calvin was asked by the chair and cofounder of the first chapter of the National Society of Minority Hoteliers (NSMH) to conduct research on the historical contributions of African American hoteliers for one of their first conferences—and this is where his journey with *Hidden Hospitality* began.

Calvin currently resides in Mooresville, North Carolina, with his teenage sons Caden and Carson.